The Engaging Museum

This very practical book guides museums on how to create the highest quality experience possible for their visitors. Creating an environment that supports visitor engagement with collections means examining every stage of the visit, from the visitor's initial impetus to go to a particular institution, to front-of-house management, to the way the collections are displayed and qualitative analysis afterwards. This holistic approach will be immensely helpful to museums in meeting the needs and expectations of visitors and building their audience base. Because *The Engaging Museum* offers a set of principles that can be adapted to any museum in any location, it will be an invaluable resource for institutions of every shape and size.

Especially designed to be user-friendly, *The Engaging Museum* includes:

- chapter introductions and discussion sections
- supporting case studies to show how ideas are put into practice
- a varied selection of tables, figures and plates to support and illustrate the discussion
- boxes showing ideas, models and planning suggestions to guide development
- an up-to-date bibliography of landmark research

The Engaging Museum will appeal internationally to students and teachers from a wide range of postgraduate museum courses in museology, museum studies, gallery studies, heritage studies and management, as well as those studying tourism and visitor attraction management. It is also highly relevant to any professional planning a new museum exhibition or applying for grant aid for exhibition development.

Graham Black is a senior lecturer in Museum and Heritage Management at the Nottingham Trent University. He is also a professional interpretation consultant and his exhibitions have won the £100,000 Gulbenkian Prize, a Museum of the Year award, the Special Judges Prize at the Interpret Britain Awards and the English Tourist Board's 'England for Excellence' Tourist Attraction of the Year Award.

THE HERITAGE: CARE-PRESERVATION-MANAGEMENT

The Heritage: Care-Preservation-Management is a series designed to meet the needs of both practitioners and academics in the global museums and heritage community. Each volume has strong practical foundations, integrated with awareness of the relevant conceptual frameworks.

The new generation of HCPM titles takes full account of the many developments that have occurred since the series was originated, to provide up-to-date support, instruction and insight for today's readers.

Previous titles include:

Museum Basics
Timothy Ambrose and Crispin Paine

Museum Ethics
Gary Edson

Museum Security and Protection
Edited by David Listen

Representation of the Past
Kevin Walsh

The Engaging Museum

Developing museums for visitor involvement

Graham Black

Routledge
Taylor & Francis Group

LONDON AND NEW YORK

For my parents

First published 2005 by Routledge
2 Park Square, Milton Park, Abingdon, Oxon OX14 4RN

Simultaneously published in the USA and Canada
by Routledge
270 Madison Ave, New York, NY 10016

Routledge is an imprint of the Taylor & Francis Group

© 2005 Graham Black

Typeset in Garamond 3 and Frutiger by The Running Head Limited, Cambridge
Printed and bound in Great Britain by TJ International Ltd, Padstow, Cornwall

British Library Cataloguing in Publication Data
A catalogue record for this book is available from the British Library

Library of Congress Cataloging in Publication Data
Black, Graham.
The engaging museum: an interpretive approach to visitor involvement/Graham Black.
p. cm. — (Heritage)
Includes bibliographical references and index.
1. Museum attendance—Evaluation. 2. Museum exhibits—Evaluation. 3. Museums—
Educational aspects. 4. Museums—Marketing. 5. Museums—Management. 6. Museum
techniques. 7. Museum visitors. 8. Interpretation of cultural and natural resources.
9. Cultural property—Protection. 10. Cultural property—Management. 11. Historic
sites—Management. I. Title. II. Series.
AM7.B56 2005
069—dc22 2004061484

ISBN 0–415–34556–1 (hbk)
ISBN 0–415–34557–X (pbk)

Contents

Preface

It is a wonderful time to be working in museums – at long last audiences are being given the priority they deserve. This book seeks both to add to the debate on how most effectively to engage audiences with collections, and also to support in a practical way those trying to achieve this. It makes no claims to be the only way forward, but will hopefully provide rich food for thought.

The book has two sources of origin. One lies in my role over the last 20 years as a consultant interpreter, where I have spent a lot of my time training curatorial staff in interpretive principles, planning and techniques. The other lies in my role as a teacher, introducing a new generation of future museum professionals to the delights of engaging audiences. The two came together in my need for a text that would provide the groundwork from which I could build. There are a number of excellent books introducing environmental interpretation and interpretive planning, but I did not feel that any of them really sought to apply interpretive principles and techniques to the museum world. Equally, there is a huge library of museum texts now available, but I feel strongly that museum literature has lost touch with interpretation (and vice versa) over the last 20 to 30 years, so there was nothing that specifically fitted my needs.

So the book started with the intention of introducing an audience of museum professionals and trainees to a practical interpretive approach to museum and exhibition development. From there it grew. As interpretive planning encompasses all aspects of museum and exhibition development, and as I am committed to a holistic view of the museum visit, it proved essential to provide a background for visitor studies, image projection and visitor services. Because, like many museum professionals, I am committed to sharing my enthusiasms with as broad an audience as possible, a discussion of approaches to audience development and to meeting the needs of diverse audiences was central. As interpretive planning includes defining target audiences and then setting out to meet their needs it was equally essential to include, for example, the 'building in' of relevant project work for structured educational users. Because, like all interpreters, I believe that direct visitor participation leads to learning, it was necessary to engage in the wider learning debate – and the physical impact of a commitment to learning on museums.

At the same time, I was also seeking to expand the range of 'interpretive principles' that I use to underpin my own work specifically to reflect the circumstances of museums which are, in many ways, different to those pertaining to environmental

interpreters or park visitor centres. To do so meant not just listing them (adequate for me in my consultancy work), but also providing a justification to a wider audience.

The end result is a very practical book immersed within an academic text. I make no apologies for this. The objective of the book is to outline best practice as I see it, and to support this with a thorough academic underpinning. I hope that people who use this book will not only find that it helps them to think through practical approaches to individual projects, but also that they will have no difficulty in communicating why the approach they have selected is the most appropriate for their specific circumstances.

Graham Black
Nottingham, 2005

Acknowledgements

I must begin by expressing my absolute gratitude to Lynda Kelly, head of the Australian Museum Audience Research Centre; Kym S. Rice, Assistant Director, Museum Studies Program, George Washington University; and Pat Sterry, Director of the Centre for Heritage Studies, University of Salford. They very generously agreed to read and comment in depth on the bulk of the book. Without their support, the book would not have what depth of understanding it has. Errors, of course, remain my own.

I would also like to thank, in chronological order, Diane Lees, Director, UK National Museum of Childhood; Sally Manuireva, Project Manager for the Weston Park Museum, Sheffield redevelopment; and Nick Gordon, site manager of New Walk Museum, Leicester, for helping me get to grips with the practical application of interpretive principles to major new museum developments, and for their help in tracing images.

Others who gave invaluable assistance included:

Emily Allen for allowing me to quote from her work on Musequal.

Robin Conway for saving me comprehensively when my computer tried to die.

John Cross of Adult Learning Australia for an inspiring 'virtual conversation' on the nature of adult learning and on the central importance of reflection.

Larry DeBuhr for his comments on interpretation at botanic gardens and provision of a copy of the Chicago Botanic Garden model.

Annie Delin for kindly permitting me to use some of her material on disability access and for commenting on chapter 2.

Janet Elkington and Olwyn Ince for the substantial amount of work they did to make my text usable by the publishers.

Kate Farmery, head of Marketing and Business Development, Manchester City Galleries, for her invaluable assistance on the chapter 3 case study.

Isabelle Frochot of the Université de Savoie, France, for allowing me to refer in detail to her work on Histoqual and for commenting on my text.

Nancy Fuller of the Center for Museum Studies, the Smithsonian Institution, Washington DC, for her support and for putting me in contact with a number of people in the USA.

Liz Gilmore, Outreach Manager for Families and Young People, National Gallery, London for sharing her experience with me.

Jo Graham for her commitment to young children in museums and sharing her ideas and expertise with me, particularly in the case study in chapter 2.

Pamela Clelland Gray, Manager of Education and Public Programmes at the National Portrait Gallery, Canberra, for reading and commenting on chapter 5 and for adding to my reflection/reverie conversation with John Cross.

Phil Hackett, Assistant Director Visitor Operations, English Heritage West Midlands Region, for his comments on chapter 4.

Emily Johnsson of the London Museum Hub for giving me access to her research, for her comments on chapters 5 and 6 and for her help in locating images.

Eric Langham for his comments on chapter 2, for giving me access to some key research material and for his help in tracing images.

Kevin Osbon, Steven Fletcher, Anthony Barber and Mike Lee for keeping me focused at all times (or, at least, all hours!).

Liz Wilson, of East Midlands Museum Hub, for her comments on chapters 5 and 6, and for pointing me in the direction of key additional material.

My university colleagues – Stuart Burch, Angela Phelps, Deborah Skinner and Neville Stankley – for their practical and moral support.

And finally my students on the MA Museum and Heritage Management course at The Nottingham Trent University over the last five years, who have had to put up with me as I have developed the contents of this book, have frequently halted me in my tracks with searching questions and have generally inspired me to carry on with it.

Throughout the book I have tried to credit all those whose work I have consulted or adapted over the years, or who have inspired my own thinking. If I have missed anyone, it is by accident – the result of many elements of the interpretive approach being adapted constantly over time, and of my basing this book on course notes developed over a number of years. Please bring any omissions to my attention for what I hope will be the second edition.

Where I have used figures and tables from other publications, I have made every attempt to locate copyright holders to obtain permission. Any omissions brought to my attention will be remedied in future editions.

Introduction

Meeting the demands placed on the twenty-first century museum

Opening a heritage site or museum collection to the public used to be easy. Art galleries saw their primary roles as the collection, preservation and display of artworks, and the promotion of public appreciation of these works. Museums of archaeology, history, science, etc., saw their sites as educational institutions, with a responsibility to create knowledge through the development and research of collections, and then to disseminate that knowledge through the provision of formal scholarly displays.

Both types of institution believed that they did not 'own' their sites and collections, but held them in trust for future generations. As such, they viewed the unique nature of the assets for which they were responsible as a non-negotiable background, which conditioned the purpose of and approach to their presentation. Access was almost grudgingly provided to the public in return for a sense of reverence and gratitude, reflected in an authoritarian protection of the site – 'temple' architecture, cordoned routes, glass cases, security guards, 'do not touch' signs, etc.

However in recent decades, while protection of the site or collection has remained the first priority, at least in the eyes of the profession, there have been increasing pressures for change in the way the material is presented to the public. These pressures have come from a number of directions – from above (governing and funding bodies), from below (audiences) and from within the profession itself.

From 'above', there has been the gradual development of national, regional and local strategic goals for museums and heritage sites, and the relating of these directly to sites through conditions placed on public subsidy. This can be seen most clearly in the development of the roles of museums and heritage sites in:

- supporting lifelong learning and structured educational provision
- enhancing 'access', diversifying their audience base and reflecting the make-up of their communities
- meeting the needs and requirements of local communities
- generating income in their own right
- supporting local regeneration initiatives
- supporting economic and social regeneration
- the drive by governments to enhance the quality and value for money of public service provision.

A child engrossed in a colouring and cutting activity in the Leicester Museum's 'Discovery Gallery'. © Leicester City Museums

From 'below', the growing demands of the 'traditional' white professional audience have been joined by those who have previously felt excluded from what museums and heritage sites have to offer:

- The competition for use of leisure time has given the 'traditional' museum audience much greater choice. It will only visit museums if the experience obtained matches or exceeds that provided by other activities.
- The high quality requirements demanded by visitors. The traditional audience is increasingly experienced and educated. Visitors are no longer willing to be passive recipients of wisdom from on high, but want to participate, to question, to take part as equals, and to receive as high a standard of service as would be offered at any other type of leisure site.
- The increasing competition from alternative information sources that individuals can control for themselves – not least the Internet.
- The increasing demands from previously excluded or marginalised audiences for the right to representation and to a say in how a site or museum is managed and presented.

From within the profession, despite continuing and at times heated debates around the issue of 'dumbing down', it is possible to sense:

- an increasing recognition that the traditional audience is not 'one' but a plurality – a mass of separate audiences each seeking its own experiences and outcomes from what is basically the same product
- a commitment to meeting the needs and expectations of visitors and the recognition of an obligation to meet those needs by deploying the most appropriate approaches possible
- a growing vision of the potential partnership role for museums in association with local communities, reflecting their histories and perspectives
- a belief that heritage has a role in enhancing people's lives and supporting community regeneration – to engage/involve *all* audiences/potential audiences with the available sites/collections/heritage – optimising the opportunities for visitors to achieve their full potential
- a belief that the work of museums can be used to broaden and retain support for conservation and retention of the heritage
- a continuing passion among museum professionals to share knowledge and enthusiasm for 'their' subject area.

Putting these elements together places very different demands on the twenty-first century museum. Rather than a repository and display facility for objects largely reflective of middle-class, western values worthily made available to the public, we see instead a more audience-centred role, reflected in Box 0.1.

The items in Box 0.1 reflect a huge transformation in attitudes toward the roles of museums in society. In seeking to champion such roles, this book states unashamedly that if museum or heritage site managers believe that everyone has a right of 'access' to our shared inheritance in museum collections, and that museums can make a profound difference to the lives of communities and of individuals, they should face up to the consequences and seek a practical reflection of these ideals. This is not to deny a belief in the continuing importance of collections, their conservation and research, and the documentation related to them. However, if the museum profession is to talk about purpose at the start of the twenty-first century, the focus must be on audiences and on the role of museums in society (see, for example, Smithsonian 1996, 2002c).

This book is not so much about the developing roles of museums within their communities but rather focuses on a central element of this – the concept of museums responding to audiences as partners in a joint enterprise. A key step along this route is for the museum to cease to be product-led and become audience-centred in approach. To be audience-centred means taking into account the personal context of the visitor and the holistic nature of the museum visit. Museums need to think of their role in motivating and supporting visitors as three interlinked tiers, defined in Box 0.2, of which only the third is directly about approaches to museum display. The exploration of these three elements, and of their links, provides the framework for this book.

Being audience-centred requires a commitment to gaining and constantly updating a real knowledge and understanding of visitors. Section 1 of the book explores

Box 0.1 The twenty-first-century museum

A museum is now expected to be:

- an object treasure-house significant to all local communities
- an agent for physical, economic, cultural and social regeneration
- accessible to all – intellectually, physically, socially, culturally, economically
- relevant to the whole of society, with the community involved in product development and delivery, and with a core purpose of improving people's lives
- a celebrant of cultural diversity
- a promoter of social cohesion and a bridger of social capital
- a promoter of social inclusion
- proactive in supporting neighbourhood and community renewal
- proactive in developing new audiences
- proactive in developing, working with and managing pan-agency projects
- a resource for structured educational use
- integral to the learning community
- a community meeting place
- a tourist attraction
- an income generator
- an exemplar of quality service provision and value for money.

Box 0.2 The three-tier route to visitor engagement

1. Provide the stimulus to visit in the first place – this should include site image, quality of marketing and PR, word-of-mouth recommendation by previous visitors, prior personal experiences, supporting learning agendas, reflecting leisure trends, etc.
2. Place visitors in the 'right frame of mind' on site so that they wish to engage with collections and exhibitions – this should include operational and service quality and a sense of welcome and belonging.
3. Provide the motivation and support to engage directly with the site and/or collection – this should include quality of interpretation, learning provision and displays.

what we know of museum audiences – the nature, needs, expectations and motivations of both 'traditional' museum visitors, and the broader audience of potential visitors – and what this should mean for the way museums develop. Museums need to talk to people on a regular basis and be flexible enough to respond to their needs. What motivated them to come in the first place? What are their expectations of the visit? What thoughts and experiences do they bring with them to the visit? What thoughts and memories do they take away with them? We must also spend time observing, tracking and listening to visitors to define what they actually do on site. Equally, museums must look at the barriers discouraging people from visiting and seek both to overcome these and to actively stimulate visits. Regular consultation

and evaluation is critical. The importance of this approach cannot be overestimated – it is a framework for continual improvement.

Section 2 examines the importance of the external image presented by museums and the quality of visitor services on site, in terms of placing visitors in the 'right frame of mind' to engage with collections. For visitors to have a quality experience, museums must promote a positive but accurate external image, provide a 'sense of occasion' on arrival, welcome them as equals, meet the highest possible standards of service and do their best to encourage audience motivation to become involved. From the moment of arrival, operational quality also means ensuring that belief in, commitment to and enthusiasm for the site and collections shine through.

Equally, through the visitors' stay, museums must be able to respond to their expectations in a way that meets the increasingly high demands of audiences accustomed to quality service standards elsewhere and to insist that these are provided by museums. The concept of quality has always been fundamental to museums and galleries, in terms of site, collections, etc. Now the museum profession must appreciate that quality standards should also be applied to every aspect of public provision, from front-of-house operations to exhibitions and associated services. Nor is this a one-off activity. All of us must recognise that, over time, expectations will change – so pursuing the quality agenda is a dynamic concept. Aspects of this have been recognised for some time but, beyond a few enlightened museums, visitor services specialists are a rarity and there is little momentum to achieve, let alone further develop, quality standards. A key challenge is, therefore, to seek to outline an approach that responds to the quality agenda for museums in the twenty-first century and to provide a positive direction forward for museums and galleries to enable that agenda to be achieved.

Section 3 introduces the concept of the museum as a learning environment. This issue is currently at the top of the political agenda for museums across western society, and much has been written on the subject in recent years. The section does not attempt to repeat previous work, but instead focuses on key practical questions. If we accept the potential for museums as learning institutions, what do the relevant learning theories mean in terms of the physical way that collections are presented, and the ways in which we should support this presentation to meet the differing needs of users – effectively in terms of how we develop 'learning environments'? The section looks briefly at provision for structured educational users, particularly schools, but concentrates on the non-structured learning experience of the independent visitor.

Finally Section 4, the largest in the book, attempts to bring together the conclusions reached in earlier chapters to build up a picture of the principles and planning processes involved in seeking to create the 'engaging museum', looking service-wide as well as at the master planning for individual sites and at concept development for individual exhibitions. In the past, exhibitions were the key means by which museums sought to communicate with their audiences. Now they are only one of a range of elements in a museum visit, although still the most important one. Also, where exhibition development was once the domain of the curator, it is now a team effort and where once the priority was scholarly display, the objective now is the production of audience-centred participative and engaging exhibitions, but ones still underpinned by academic rigour. A 'one size fits all' approach – the very basis of most

Exhibition previews at Manchester Art Gallery now attract a more diverse audience.
© Manchester Art Gallery

past and current museum exhibitions – will not work in presenting collections to twenty-first century audiences. Museums must seek to provide both a palette of display approaches and a layering of content, to meet the needs of different audiences and support their engagement with collections.

Finally, a brief word on the structure of the book. The approach seeks to be progressive in the sense that its contents, framed around the three tiers defined in Box 0.2, are intended to build inexorably toward chapter 10 (and beyond). Having broken the book into four sections, I provide a brief introduction to each. I then provide a structure for each chapter, finishing with a brief discussion and a 'case study'. I am not sure the latter is the correct term, but have failed to come up with a better one. What I seek to do in the case study is to highlight an issue relating to the chapter that provokes thought from a different angle. Some of these are straightforward – for example, I have a straight site case study at the end of chapter 3. Others are tangential – for example, I use the case study at the end of chapter 1 to contrast the way tourism researchers interpret the quantitative data they gather with that of museum researchers studying the same audience segments.

Section 1
Museum audiences: their nature, needs and expectations

> Instead of only placing our objects on pedestals, it's time we placed our visitors on pedestals as well.
>
> McLean (1993: 5)

Once we recognise that the public face of our museums must be audience-centred rather than product-led, the central challenge for museums at the start of the twenty-first century becomes:

- to understand the nature, motivations, expectations and needs of existing audiences, and to build an enduring relationship with them (chapter 1)
- to develop and then retain new audiences (chapter 2).

The starting point in planning a strategy to meet these objectives is to find out about visitors and non-visitors. This section explores:

- available quantitative information on the nature and extent of existing and potential audiences
- qualitative material on visitor needs, motivations, perceptions and expectations as well as the visitor response to the whole experience
- the impact of current trends in leisure activities
- the identification of non-visitors, the barriers that prevent their use of museums and ways in which these barriers can be removed or reduced.

The objectives are both to underline the need for individual sites to gain a real understanding of their own actual and potential audiences, and of how more general leisure trends are influencing these, and also to show how essential it is that museums then use this understanding to underpin future policies as they strive to develop the 'engaging museum'.

1 'Traditional' museum audiences: a quantitative and qualitative analysis

> Our mission is to educate. We cannot do that if we are not serving visitors. We cannot survive if we are not assessing and satisfying the needs of our constituents.
>
> Hill (2001: 12)

INTRODUCTION: THE RISE OF MUSEUM VISITOR STUDIES

The analysis of audiences and potential audiences for museums is usually defined as 'market research', although this term does not define the full range of participants researched (for example sponsors, corporate users, etc.). However, this type of activity represents only a part of the work now being carried out by museums as they seek to develop a fuller understanding of visitors, their motivations, needs and expectations, the way they explore and engage with exhibits, staff and each other, and what they gain from the experience. This much wider exploration now comes under the heading of 'visitor studies', still a relatively new activity in museums, although its origins date back over 80 years. A brief summary of the development of museum visitor studies can be found in Hein (1998) or Kelly (1998), and a fuller one in Loomis (1987). The visitor surveys carried out in the 1950s by David Abbey and Duncan Cameron, at the Royal Ontario Museum in Canada, are generally acknowledged to be the first systematic visitor surveys undertaken in museums (Rubenstein and Loten 1996: 3). The substantial development of visitor studies first occurred in the USA in the 1960s, although it was not until 1988 that the First Annual Visitor Studies Conference was held in Jacksonville, Alabama. In 1989 the Committee on Audience Research and Evaluation (CARE) was established as a standing professional committee of the American Association of Museums, while the USA Visitor Studies Association was formally incorporated in 1992. Visitor studies first became established in the UK and Australia in the 1970s. Across the western world, rapid growth in museum visitor studies only occurred in the 1990s. This included the establishment of the Visitor Studies Association in Canada in 1991, the Evaluation and Visitor Research Special Interest Group (EVRSIG) of Museums Australia in 1995 and the Visitor Studies Group in the UK in 1998.

Thanks to a study commissioned by Museums Australia (Reussner 2003), we know most about the current state of visitor studies in Australian museums. This

Tracking visitors in the Uncovered Exhibition, Australian Museum, Sydney. © Lynda Kelly

revealed visitor satisfaction to be the subject area of broadest interest, followed by basic attendance and postcode/zipcode data and classic visitor socio-demographics. It also reflected the established range of data-gathering techniques, from comment cards through tracking and observation and questionnaires to discussion groups and in-depth interviews. The report showed how effective visitor research can be when applied to the improvement of the visitor experience (a subject previously explored, for example, by Loomis 1993). It also revealed the limitations of what is done at present and – most worryingly – the continuing failure of many institutions to act upon the findings of the research carried out. Audience research can be an irritant to those curators accustomed to developing the museum product as they see fit. It can also provoke resistance where it challenges prefigured beliefs and assumptions. However, if museums acknowledge that they should be audience-centred, a properly resourced programme of visitor studies should be an essential, systematic element of a museum's activities, with the museum director as a key advocate.

AUDIENCE SEGMENTATION

No introduction to visitor studies can begin without a basic understanding of market segmentation. Audience appraisals and most visitor surveys provide basic quantitative data on audiences. As marketing tools, both use established market segmentation techniques to provide audience breakdowns. Classic market segmentation breaks down 'traditional' heritage audiences in terms of:

1 *Demographics*, i.e. age, gender, education, class/occupation. Family status is heavily used in heritage segmentation, as it can be such a major predictor of behaviour (dependant; pre-family; family at different stages; older marrieds and empty nesters). In the past, ethnic origin has been a rare factor in visitor surveys, but this is changing as museums seek to respond to the needs of local communities and broaden their audience base.

2 *Geography*, i.e. resident/local, day tripper, national/international tourist.

3 *Socio-economics* – although the UK government introduced a new National Statistics Socio-Economic Classification (NS-SEC) in 2000, the JICNAR (National Press Joint Industry Committee on National Audiences and Readership) classification is still the most commonly used by heritage sites and museums in the UK because it enables comparisons to be made with previous surveys. The groups are classified as:

A higher managerial, administrative or professional
B middle managerial, administrative or professional
C1 supervisory, clerical or managerial
C2 skilled manual workers
D semi- and unskilled manual workers
E pensioners, the unemployed, casual or lowest grade workers.

4 *Structured educational use*, i.e. primary/elementary (to age around 11/12), secondary/high (aged around 11 to 16/18), student (college/university)

5 *Special interest*, i.e. subject specialist, self-directed learning, booked group, for example, a local history group. This can also be referred to as a part of *behaviouristic* segmentation, linking groups of people according to interest in or relationship with particular subjects/products.

6 *Psychographic segmentation* which relates to lifestyles, opinions, attitudes, etc. This is still infrequently used, although it is becoming more common to hear references to these terms as museums increasingly take leisure trends into account.

MARKET SURVEYS

Market surveys, providing quantitative information on potential audiences, are examined first, largely because they provide essential baseline data on the nature of potential target audiences. This can allow museums both to prioritise interpretation toward the needs of defined audiences and, at a later stage, to evaluate their effectiveness in actually attracting the audiences they have set out to achieve.

Owing to the expense involved, a general market survey/assessment of audience potential (often called 'audience appraisal' in the UK) is normally only carried out as part of a feasibility study and grant application preliminary to the creation and marketing of a new or substantially revamped museum – and normally only defined in terms of actual numbers rather than other factors. Its functions are to assist in establishing the viability of the project and in drawing up the business plan, and to ensure that the proposed scheme can cater for the likely visitor numbers and types and operate within the likely available budget. Because of the links to market analyses and business plans, this sort of research also tends to concentrate on traditional audiences and to largely ignore under-represented groups which are unlikely to make an immediate impact on the perceived 'success' of a project, if this is measured largely in terms of visitor numbers.

A basic market appraisal

Much of this sort of work tends to be carried out, often at considerable cost, by a leisure consultancy, which will define the likely market in terms of the potential audience, seen through the usual market segments (see audience segmentation above) and the quality of communications. Linked to the latter, the consultancy will break down the local resident and day trip market in terms of 30-minute, 30- to 60-minute and 60- to 90-minute drive-time.

The consultancy will attempt to assess the likely level of 'audience penetration' – i.e. what percentage of the defined potential audiences a site or museum could or should aim to attract – through an analysis of the proposed 'product' in terms of contents, identity, image, branding, price and the like, and the attractiveness of this package to the potential market. It will take into account:

- the scale of the audience for other museums and visitor attractions in the catchment area of the project
- the audience for similar museums and related sites
- the physical location of the project – nationally, regionally, locally; other features nearby which could encourage additional use; long-term development proposals for the area, etc.
- the location/place of the project within the attraction spectrum.

The end result should be defined visitor projections for the museum, usually for years one, three and five after opening. They will often quote a top, median and bottom

estimate, take proposed admission charges into account where relevant – and always add the proviso that the suggested figure(s) depend on the eventual contents and quality of the product itself, its marketing and its daily operation.

Visitor projections and the business plan

Visitor projections are a crucial element in developing an ongoing business plan, particularly for a museum that is not in receipt of substantial revenue or endowment support. They will impact on both income estimates and expenditure.

Their influence on estimates of revenue income will include:

- an outside analysis of the suggested product, especially can it achieve the visitor targets sought?
- an assessment of visitor numbers, including the percentage of each target segment for the:
 - variation in numbers and nature through the year
 - estimated average entrance charge (projected from likely adult, concession, group and discounted ticket sales)
 - estimated shop spend per head
 - marketing targets to aim at
 - planned seasonal promotions.
- comment on suggested pricing levels, especially their likely impact on visitor levels
- comment on potential levels of secondary spend.

Their influence on forward planning for revenue expenditure will include comment on:

- staffing required at different times of the year to cater for projected visitor numbers
- opening periods/hours
- maintenance programme likely to be required
- marketing spend required
- timing and funding of events, temporary exhibitions, major renewals, etc., to attract and retain audiences.

Can we believe visitor targets defined by market surveys?

In recent years, the UK has witnessed a series of high profile new museums and heritage-type attractions fail abysmally to achieve their visitor targets, the most potent symbol being the spectacular failure of the Millennium Dome in London to come near its targeted 12 million visitors. The visitor projections for the chief UK culprits – the Millennium Dome, the Royal Armouries in Leeds, the National Centre for Pop Music in Sheffield, the Earth Centre near Doncaster, the Cardiff Centre for the Visual Arts and the Welsh National Botanic Garden (and others currently 'at risk') must be

seen in context, however. They formed a key element in the development of business plans that were designed to show that the sites would be financially self-sustaining in the medium and long term. Clearly those wanting to see their projects happen would be their own worst enemies here, in terms of a willingness to believe high visitor targets were both achievable and sustainable. Of course, it is not always bad news. At the Eden Project in Cornwall, visitor numbers have vastly exceeded original projections. Does this all mean visitor projections are a nonsense? Because a market survey approach has been used in the wrong way it does not make the process itself untenable. Far from it – ask any big retailer how it selects sites for stores, or check how to research locations for any roadside café chain. It is a very professional business.

So why do visitor projections for museums and heritage sites seem so fickle? There is always the suspicion that the political impetus behind these projects encourages a rose-tinted view, or at least discourages a more conservative analysis. While this can never be proven, what is certain is that market surveys carried out by national consultancies rarely take specific local circumstances adequately into account – and these will normally *reduce* the likely audience. For example:

- The precise physical location can have a huge impact – ask any retailer about this.
- The use of travel patterns for day-trippers means there will not be an equal spread from across the 60-minute drive time area. Much depends on a tradition of travelling in a certain direction.
- Unless the museum is in an established tourist destination it is unlikely to attract many independent tourists or coach tours.
- The contents of a site may put off a member of the crucial family audience and so hugely reduce your trade – for example, in the UK, the Royal Armouries specialises in weapons, not always attractive to women or as a destination to which parents wish to bring children.
- The approach the museum is proposing to take to the presentation may itself be unsatisfactory as a visitor draw, or discourage use by repeat visitors.

Each site is different – each must look at its own situation. This will vary from a need to develop a strong base within its local community to its ability to sustain high tourist figures from both the domestic and inbound trade.

How much does a market survey approach tell us about heritage audiences now and in the future?

This sort of market research, as currently carried out, is a consummate example of the use of quantitative data only. In effect the consultancy will say, here are the available market segments of the museum-going public and, using business models, here are the percentages you should receive. They pay insufficient attention to qualitative issues. They also have problems with an over-simplification of the basic segmentation process itself.

Equally, such research provides little information on the motivational structure underlying the demand for heritage visits. There are two widely accepted views of how

demand arises or is formulated. A 'consumer' view will explore mass demand arising within specific segments of the market, based on demographics or lifestyle/attitude influences and, from this, attempt to generalise demand so it can be satisfied through simple formulae of design and delivery. This is the classic market research approach. The alternative is a view that a visit to a museum or gallery is motivated by an essentially unshareable, individual, personal or social group/family interest. From this it follows that visiting groups are market segments in their own right, selecting their personal choice of site to visit and, once there, of which aspects to view and interpreting the resulting experience in their own individual ways. If this view is taken, it follows that the basic market research approach will not function – one needs to take a much more sophisticated approach to the varying needs and motivations of social and family groups within market segments.

The increasing attention being given to this latter view appears to parallel a similar shift in consumer demand toward greater freedom of choice, customisation and individual service. It is hard not to agree that segmentation approaches are at best a vague approximation because museum visitors are motivated principally by personal interest and this does not always coincide with other more convenient indicators such as age, gender, family status or lifestyle. Within at least the marketing of museums and heritage attractions, there is a real tension discernible between mass segmentation and the needs of individual visitors. Yet the museum or heritage product (the site/collection) is perceived as the opportunity to experience something out of the ordinary, something entertaining, sensorially stimulating, 'magical'. Should this make museums easier to tailor to individual needs?

A sustainable audience?

Experience suggests that maximising audiences is the wrong approach to take; yet this is the approach on which most visitor projections are based. In terms of traditional audiences, what really matters is not year-one figures for a new or largely redisplayed museum, but those achieved in years three and beyond when a project is no longer new or a tourist destination has lost its initial attraction. Most museums and heritage sites are not located in areas that are major tourist destinations. They depend on local residents, day-trippers, schools and visitors staying with friends and relatives (VFRs). For those which largely depend on admission charges for their revenue income there is a real risk, if they seek to maximise their audience, that everyone who wants to come will have done so within three to five years of opening – but the site will have no money to make the major changes needed to bring people back. Having been closely involved in it, I can refer to one such example (see Figure 1.1).

The swift decline in audience attendance at The Tales of Robin Hood exhibition, Nottingham, UK, was not due to the poor quality of the exhibition – the winner of many awards – but to the lack of a renewable audience and of the funding required to redevelop the product.

The current approach to market surveys therefore needs a careful re-examination, not only in taking both local influences and family/social group needs into account but also in the way targets are arrived at. It is far better to plan for a realistic, attainable and

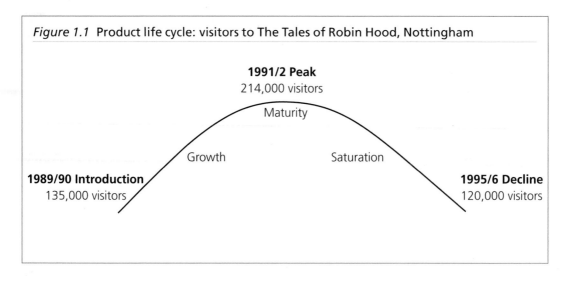

Figure 1.1 Product life cycle: visitors to The Tales of Robin Hood, Nottingham

1991/2 Peak
214,000 visitors

Maturity

Growth Saturation

1989/90 Introduction **1995/6 Decline**
135,000 visitors 120,000 visitors

sustainable audience – by which I mean a stable annual attendance. In financial terms, this will allow museum managers to work to a budget known to be achievable and to cut marketing spend, but it will also mean no museum or heritage site should rely on visitor income covering more than 50 per cent of revenue costs (for museums, with substantial collections to support, I would say preferably no more than 30 per cent). It should also enable museums to enhance the quality of the visitor experience by designing and staffing to cater for specific targets.

QUANTITATIVE VISITOR SURVEYS

Visitor surveys are much more commonplace than full-scale market survey exercises – they are in fact the most common form of visitor study. While most visitor projections are there to set overall targets (from traditional audiences), surveys will reveal what percentage of those audiences is already coming. This, in turn, can enable museums to define which groups are missing or under-represented. As in visitor projections, the information recorded is there largely to meet the needs of the marketing office but surveys can also be used to form the basis for a structured approach to audience development. Many visitor surveys will also seek to look at the impact of the museum visit, exploring visitor satisfaction, learning and other potential elements that can be measured to reflect museum or government policies. Visitor satisfaction surveys are discussed below in chapter 4, and the evaluation of visitor learning in chapter 5.

Few museum visitor surveys are published and most are site-specific rather than relating to more general audience research. However, the quantitative information they contain can give us key insights into the nature of museum audiences and into visitor trends – who the visitors are (in terms of market segmentation analysis), where they are coming from, who they are coming with, how they are getting to the site and maybe how often they are coming. Hood (1993, 1996) provides an effective summary of USA surveys. Davies (1994) remains the classic quantitative 'survey of surveys' for museums in the UK, while MORI (2001) includes analyses of life-stage

profiles, regional differences, social class and ethnicity and the attitudes of school-children as well as limited comment on the impact of changing leisure trends.

What the surveys reveal: who visits museums?

Davies suggests most age ranges are represented relatively equally in UK museum audiences, but with smaller percentages for 16- to 24-year-olds and those over 55 years old. The more recent MORI survey suggests increasing problems in attracting the adult audience under 35 years. Rubenstein and Loten (1996) place most adult museum visitors in Canada within the 35 to 44 age range. At the Australian Museum, Sydney, 28 per cent of visitors are within the 35 to 49 age range, 25 per cent are over 50 and 22 per cent are aged between 25 and 34 (AMARC 2003). People tend to visit in groups or families, as a social outing, rather than on their own, although more people go on their own to art galleries. At the Australian Museum, Sydney, 45 to 55 per cent of visitors come in family groups, 15 per cent come with a partner, 15 per cent come alone and around 15 per cent come in organised school parties.

Potentially, up to 33 per cent of museum visitors are under 16, making it highly likely that 60+ per cent of visitors include children in the group – either as families or on organised school trips. Rubenstein and Loten state that, for Canadian museums, family groups are the key audience, particularly baby boomers with their children. Percentages will, however, vary from site to site and exhibition to exhibition, depending on the approach taken to the presentation, marketing and operation of the site, and specific exhibitions and programmes.

The two genders are relatively equally represented at museums, with perhaps a slight majority of females, although this is dependent on the nature of the site – in Canada, for example, art gallery audiences are 60 per cent female and 40 per cent male (Rubenstein and Loten 1996). Much less information is available on the ethnic origin of visitors, although what there is suggests strongly that non-white visitors are under-represented. The MORI survey (2001) suggested just under 30 per cent of white and Asian people in the UK visited museums and galleries in the 12 months up to November 1999, but only 10 per cent of black residents.

For Canada, Rubenstein and Loten suggest most visitors are either local residents or tourists. In the UK, the research suggests most visitors prefer to travel no more than one hour to a museum, which is crucial in defining catchment areas. This can vary depending on the scale and popularity of the site and whether it is on a green-field location with easy access and free parking or in a traffic-packed city centre, but it rarely takes more than 1.5 hours. A market survey of museums in the East Midlands carried out in 1994–5 (one of the largest of its type carried out in the UK) showed that 83 per cent of visitors travelled less than one hour, with 60 per cent travelling less than half an hour (East Midlands Museums Service 1996). These are the classic local resident population and 'day-trippers', generally domestic residents, who make up the core market for most heritage sites and museums, except for those in some of the major tourist destinations, including London. Most museum visitors in the UK, except in central London, travel by car. In general, they do not wish to travel

Conducting a focus group with older audiences, Bathurst, New South Wales. © Lynda Kelly

too far given they have only one day or less for their leisure activity. From the limited research available, local people represent the bulk of repeat visitors, reflecting an unwillingness to travel much more than 30 minutes to revisit a site. Some day trips can require pre-planning and booking but the majority do not, which means they can be a spontaneous decision. The weather can, not surprisingly, be a real influence on choice.

For sites outside the major tourist destinations, by far the most substantial tourist audience at UK sites is the VFR and the accompaniment of VFRs also accounts for a substantial proportion of repeat visits by local residents – people want to, or feel obliged to, take visitors out and preferably to places they have been to and liked. The VFR market is notoriously difficult to measure as it is mostly domestic, comes in its own transport and does not stay in commercial accommodation – so there is very little data on its scale. The general view, however, is that it is increasing as families and friends are separated by work and other reasons and more people have cars and housing that can accommodate visitors comfortably. One perhaps surprising factor seems to be the importance of students to this market, as they study away from home, make new friends and visit each other, and are visited by family and friends.

However, the most striking evidence from visitor surveys, revealed by any analysis of adult museum visitors, is that the largest group and the most over-represented in comparison to their percentage within the general population, consists of the better educated, more affluent, white professional classes (even more extreme for art galleries than for museums). The average educational profile among visitors at the Canadian

Museum of Civilisation shows 48 per cent with some university education or higher, 22 per cent with pre-university college, 22 per cent with high school and only 8 per cent with elementary school (Rabinovitch 2003). Rubenstein and Loten (1996) reinforce this for Canada as a whole, stating that most adult visitors are professionals with post-secondary education. Visitor studies at the Australian Museum, Sydney, suggest 50 per cent of their audience have a university education or above (AMARC 2003). Hood (1993) summarised the traditional USA audience as 'in the upper education, upper occupation and upper income groups . . . This social class factor applies across the spectrum of museums – from zoos, science-technology centres and children's museums to historical sites, botanical gardens and art museums' (Hood 1993 quoted in Hein 1998: 115–16).

Why is museum visiting such a professional class pursuit? Lack of access to private transport is often given as a key reason for lack of use by lower socio-economic groups, particularly as many heritage sites are in a rural location. But visitor surveys show that, on the whole, there is no significant difference in the social class profile between rural and urban sites, where public transport is more readily available (Light and Prentice 1994: 92). High admission charges are also given as a key cause, but work by Prentice (1989) and others seems to show that manual workers were not being deterred at the gates of heritage sites by high admission charges – instead they were not arriving at the sites in the first instance. As Been *et al.* (2002) suggest, increasing the admission fee will only have a limited effect, more so for museums that are major tourist destinations rather than dependent on local visitors:

> A main reason for the limited price elasticity of visiting museums is the small share of entrance fees in the total costs of a visit: about 17 percent (Bailey *et al.* 1998). The other 83 percent consist of travelling expenses, food, drinks and in some cases even accommodation costs. The weight of these costs increases along with the distance to the museum. Therefore foreign tourists are hardly influenced by the level of the entrance fee. The research of Johnson (2000) confirms this thesis.
>
> Been *et al.* (2002: 3)

Free admission was reintroduced to UK national museums in December 2001. This has resulted in a surge in their visitor numbers, which would seem to contradict Prentice. However, it will be interesting to see a socio-economic breakdown of these new audiences – early anecdotal evidence suggests they are 'more of the same' rather than reflecting previously under-represented groups.

A central issue to consider is whether the make-up of the museum audience is limited not by constraints but rather by choice. To what extent do the professional classes see their use of at least an important part of their leisure time as comprising goal-oriented activities satisfying perceived needs, and does this go some way to explaining their disproportionate use of museums and heritage sites? Are we seeing their motivations for leisure activity deriving from learning? There is now substantial evidence that an important motive for visiting museums really is a prior interest in the past and, as a consequence, the desire for discovery, learning and understanding about the past (e.g. Thomas 1989: 86). Research suggests that the extent to which

different social groups require learning from their leisure time varies considerably. Patmore (1983) noted that those with more skilled and responsible occupations, and with a longer period in education, tend to lead a more varied and active leisure life. This group is also more likely to see leisure time as something to be used constructively. As Hood put it:

> they are attracted to the kinds of experiences museums offer and they find those offerings and activities satisfying . . . These folk emphasise three factors in their leisure life: opportunities to learn, the challenge of new experiences, and doing something worthwhile for themselves.
>
> Hood (1993) quoted in Hein (1998: 116)

Thomas (1989: 90) noted that professional and managerial workers were more likely to visit monuments to be informed, whereas manual workers were more likely to visit for relaxation and entertainment. This subject will be returned to in chapter 5.

Professional class museum visiting may also be based on past experiences. As Light and Prentice (1994: 98) put it, those activities which an individual has previously experienced as rewarding are more likely to be repeated, and so behavioural consistency is maintained. Important influences on this process will include the activities with which an individual has been socialised – and here the family is a key agent. Is professional class heritage visiting self-perpetuating, passed on from one generation to the next? Production or supply of heritage is similarly, and traditionally, in the hands of the professional classes, who make up the bulk of museum curators. So, white professional-class producers define, present and interpret museum collections, and heritage in general, for white professional-class consumers. The presentation of heritage resources inevitably reflects the values and philosophies of their producers. Museums will have to work very hard to break this cycle.

When do people visit?

It is vital to consider not only how many visitors a museum will receive and who they are, but also when they will come and how long they are likely to stay. Visitor throughput is a crucial issue for the business plan, for the physical layout, and for the provision of activities, etc., that a museum is proposing, as well as for the quality of the visitor experience. The figures given in Table 1.1 are a summary based on audience analyses I have been involved in, and from my experience of a range of sites. The figures are only a guide – it is vital to produce site-specific ones. The ones produced here may attribute too high a percentage to August, but they provide a useful starting point for comparison with actual sites.

As the table shows, there is wide seasonal variation in visitor numbers and, in the UK at least, attendance is normally linked closely to school holidays. While Easter Monday is likely to be the busiest day, the peak month is normally August, with 17–20 per cent of the annual total. The worst months are November and December, where only 2–3 per cent of the annual total is not uncommon, reflecting the poor weather in the UK and an annual engagement in the ritual of Christmas shopping.

Table 1.1 The seasonal nature of museum visiting in the UK

Month	% visitors	Example Year 1 visitors	Example Year 3 visitors
January	3.1	3,100	4,650
February	3.4	3,400	5,100
March	7.9	7,900	11,850
April	9.1	9,100	13,650
May	11.9	11,900	17,850
June	9.0	9,000	13,500
July	13.6	13,600	20,400
August	17.5	17,500	26,250
September	8.6	8,600	12,900
October	7.5	7,500	11,250
November	5.9	5,900	8,850
December	2.5	2,500	3,750
	100.0	100,000	150,000

Note: March and April figures will vary, depending on the location of Easter. May reflects UK school half-term. June and, particularly, July contain school activity day outings.

January can be equally bad, reflecting the penury to which people are reduced by Christmas excesses.

Clearly these figures will vary from country to country. Research at the Australian Museum, Sydney, suggests their busiest time is during the winter school holidays in July, followed by the latter half of January. This may be a reflection of a different sort of summer weather to that in the UK when it is so hot that people perhaps prefer the beach to a museum visit.

In business plan terms, this extreme seasonality means that, for the many UK museums and heritage sites that charge admission, income streams are concentrated into the busiest weeks in the summer, at Easter and bank holiday weekends. This makes it difficult for many of these sites to provide year-round employment and ensures that most museums live on a perpetual knife-edge of uncertainty:

> Only 28 per cent of attractions hit maximum capacity levels, and that occurs only a few days a year (13 days of 248 days open). Most operate far below capacity most of the time. Visitors are used to visiting attractions 'on demand', with pre-booking being rare.
>
> English Tourism Council (2000a: 13)

Seasonality also severely affects planning for site-carrying capacity, but is not alone in this. Visitor habits go beyond varying levels of seasonal use to the time of day when people like to come, reflected in the 'design day' analysis in Table 1.2 overleaf.

The 'peak hour' reflects the tendency of UK users to visit city centre museums

Table 1.2 'Design day' analysis: visitor numbers

Annual attendance (numbers)	100,000	150,000
Peak month (17.5% total)	17,500	26,250
Average week (22.6% month)	3,955	5,932
Design day (20% week)	791	1,186
Peak hour (40% day)	316	475

between 11.00 and 12.30 am, before going elsewhere for lunch (peak arrival at all-day attractions also tends to be around 11.00 am). Afternoon visitors also tend to like to leave early, to get home or back to their base – you frequently find museums and heritage sites in the UK relatively empty after 4.30 pm. There is no long-standing tradition of evening opening at sites or museums in the UK, although this is clearly when a working audience would be available. There has been experimentation with evening opening in recent years in London – successfully with popular exhibitions at the Royal Academy, Tate Modern, the National Gallery and the Victoria and Albert Museum – and we are now seeing opening to 8.00 pm as standard at the Lowry in Salford, where the galleries are in the same building as the theatre. However, like the lack of a tradition of travelling in certain directions previously mentioned, most traditional museum visitors in the UK do not seem to see the visiting of museums and heritage sites as an evening activity – it is primarily a leisure outing for weekends and holidays. This may, however, reflect the preference of the family audience, with old and young participants. Evening opening may be a means of reaching particularly the young adult audience, but there is a need for research on this.

QUALITATIVE DATA ON VISITOR EXPECTATIONS, MOTIVATIONS AND NEEDS

Please note that there is substantial use of qualitative research later in the book in exploring visitor responses to museums and collections.

Visitor expectations

Visitor expectations represent one of the key factors pressing museum managers to enhance their presentations. Responding to visitor expectations also underpins those other factors pushing for change, particularly the need to increase visitor numbers and, therefore, income; the need to diversify the visitor base; and the need to meet the requirements of the educational sector.

Surveys of public attitudes to museums consistently show a high level of approval and support for their activities. A survey of almost 24,000 Canadians seeking their views about the country's museums, published in 2003, found:

- 68 per cent of respondents see museums as offering both an educational as well as an entertainment/recreational experience

- 92 per cent believe it is important for children to be exposed to museums
- 96 per cent believe museums contribute to quality of life
- 94 per cent believe museums play a valuable role in showcasing and explaining artistic achievements
- 97 per cent believe museums play a valuable role in explaining the natural heritage
- 96 per cent believe museums play a valuable role in showcasing and explaining achievements in science and technology
- 93 per cent believe museums play a valuable role in explaining other regions and cultures
- 97 per cent believe museums play a critical role in preserving objects and knowledge of Canada's history
- 60 per cent believe museums can play an even more significant role in Canadian society.

Canadian Museums Association (2003: executive summary)

Traditional museum audiences see the museum/heritage visit as a relaxed, informal social outing, providing an opportunity both to learn and to enjoy oneself. However, surveys also show that the demands of these audiences are growing rapidly, as educational and mobility levels rise and as people have increased experience of other locations and other types of leisure facilities. A 1994–5 survey of museums in the East Midlands of the UK, carried out for East Midlands Museums Service, included an assessment of public perceptions of museums which suggests that a quality presentation should acknowledge that museums:

- are *educational* – 96 per cent agreed
- are *interesting* – 84 per cent agreed – a smaller but unstated percentage said they were *fun*
- provide family entertainment – 70 per cent agreed 'in some form'
- provide good quality facilities and good quality service – 60.5 to 70 per cent agreed in some form, although 37 per cent felt they did not provide good cafés
- have convenient opening times – 58 per cent agreed
- offer good value for money – 61 per cent agreed.

When people were asked what would encourage them to visit more often, responses included children's facilities (14 per cent), cheaper admission charges (11 per cent), more audio-visual and inter-active displays (10 per cent), changing exhibits (9 per cent), better catering (6 per cent) and more convenient opening hours (4 per cent).

In both the Canadian and the UK East Midlands examples, it is important to be somewhat wary of reports that produce exactly the results that the commissioning organisations want – it all depends on the questions asked. Frankly, for example, when asked whether you 'believe it is important for children and young people to visit museums to learn more about our history and achievements' (the question asked), I am surprised that 8 per cent actually said no – it is the sort of 'feel-good' question that naturally obtains a 'yes' response. Given the propensity to elicit 'yes' answers to such questions, the relatively low percentages approving of the facilities,

service, opening times and value for money in East Midlands museums does begin to reflect the increasingly high expectations visitors come with (even though there is still a tendency at least in the UK to think 'I suppose they are doing the best they can', in relation to any public sector activity).

As the museum and heritage site audience is so diverse, expectations may vary depending on the individual or group involved and the precise circumstances of their visits. I cannot emphasise enough how important it is to get to know your own audience. However, an amalgamation of the wide range of relevant research now available can provide a good starting point – beginning with ease of access; good parking facilities and public transport; convenient opening hours; good value for money; and access to staff, etc., if required.

The outline list below concentrates on 'traditional' visitors. It does not include such potentially under-represented audiences as both young and elderly people, those with specific disabilities or those from particular ethnic minorities, all of whom will have their own expectations, some of which are explored in chapter 2. There is a growing literature on museums and young people (e.g. Rider and Illingworth 1997; Baum *et al.* 2001; Kelly and Bartlett 2002; Kelly *et al.* 2002) as this under-represented group among museum audiences is increasingly targeted. There is less material available on older visitors, but for extensive research on older visitors and museums in Australia, including a detailed set of recommendations, see Kelly *et al.* 2002.

Informal visitors

For most informal visitors – in other words the vast majority of people who come – a trip to a museum is a social outing. Expectations include that:

- the visit will be enjoyable, interesting and even 'fun', it will provide family entertainment, there will be things to do together – visitors want to be more than passive recipients of written information
- there will be something for everyone, including good facilities for children
- the visit will provide an opportunity to learn something – preferably starting from familiar concepts and moving to the unfamiliar
- the site will cater for all ranges of prior knowledge, ability and age
- the site will provide good quality facilities and a high standard of service
- there will be a picnic site which is a real bonus for families.

What is clear from both anecdotal evidence and the research available is that the demands and expectations of informal visitors are rising and there is continuing pressure to improve the product further. However, the responses from the East Midlands Museums survey discussed above are quite typical – museum audiences are willing to and capable of commenting on the support facilities and services at a museum but find it difficult to comment on detailed proposals for exhibition development without substantial and prolonged association with a site. See, for example, the case study on Manchester Art Gallery at the end of chapter 3.

Families and children

With families representing such a high percentage of visitors, they are a key group to research, and it is essential both to understand and provide for their specific needs. Research with parents by the Australian Museum Audience Research Centre (AMARC 2003) suggests parents want child-appropriate exhibitions which:

- allow children to learn in an enjoyable way
- provide new experiences and insights
- complement school-based learning
- are interactive and allow them to touch and experiment
- have minimal reading
- are at an appropriate height
- provide sufficient installations to avoid queuing
- cater for a range of ages and abilities
- keep parents entertained as well!

Will the expectations of children be different from those of their parents? There is much less information available on children, at least in the UK, because of codes of conduct for survey workers which advise against interviewing people under 16 years of age, except in the presence of a parent or guardian. A 1997 survey examining children as an audience for museums and galleries, carried out on behalf of the UK Arts Council and Museums and Galleries Commission and based on interviews with children aged between 7 and 11 and their parents (Harris Qualitative 1997), suggests that:

- children enjoy experiencing the past, including the 'atmosphere' and opportunities to participate and dress up
- children like to be able to touch and 'do' – to feel involved
- children like interactive exhibits, computers, creative activities, competitions and trails – all very active elements
- children see museum visits, at their best, as an opportunity to learn as well as have fun. They gain an enormous amount from visits relating to their schoolwork
- children who have been to the site on a school trip like to come back to show their families.

To these, I would add that children tend to hammer 'hands-on' exhibits they like and these must therefore be capable of withstanding full frontal attack. They get frustrated if the experience is disappointing, if there are large queues for popular 'hands-on' exhibits, or if key exhibits are broken. Their boredom threshold is low. Children also do not want to read much, as it can be too much like school and brings in issues of reading ability and reading age. They look to their parents to support them, but parents themselves often need help and encouragement in assisting their children. The approach of children who are regular museum visitors may be different. Research in America has shown that children's concentration and self-confidence increased with regular visits, reducing rowdy and aimless behaviour. However, children's expectations are likely to be highly subjective, reflecting their feelings for the place and whom they have come with. Museums must also look at the facilities they provide for children

beyond the exhibition galleries. All children need to be able to let off steam. Children know what they want in the café and it is rarely quiche and salad! The shop is an important part of the visit for children and must include an exciting and affordable range of small items, targeted at their age range and pocket money. Finally, the needs of children as structured educational users will be explored in chapter 6 below.

The repeat visitor

I would define a repeat visitor as someone who has been to a site before and comes back infrequently for an additional visit or visits. In a non-tourist location, the only way to combat running out of visitors in the long term is to encourage people to come back, so the repeat visitor is vital to museums everywhere. The percentage of a museum audience that should consist of repeat visitors will vary, depending on how well they are catered for, on the scale of the tourist audience in the area, on the availability of competing venues and, of course, on how long the site or museum has been open to the public. Research is needed – not least on successful examples of how the percentage can be increased. A perhaps more relevant question would be – what percentage of visitors *need* to be repeats if a museum is to ensure its long-term viability? Equally, in terms of the museum's or site's role within its local communities, the percentage of repeat visits may be a crucial reflection of the success or otherwise of outreach strategies and other activities.

While the evidence suggests people will travel an hour, or even more, to visit a museum or heritage site for the first time, the little available survey work points to an unwillingness to travel far for a repeat visit – the repeat visitor is likely to be relatively local, living within a 30-minute drive area. Even less research has been done on what stimulates a repeat trip. First comes a previously memorable experience – and not just in terms of the quality of the site or collections. Almost everyone who comes to museums does so in a social or family group. The quality of the front-of-house operation is vital to the visitor experience and in encouraging repeat use (see chapter 4). Second comes the stimulus, often reflecting the need for a second visit to see everything, or the need to take visiting friends and relatives out. For Canada, Rubenstein and Loten (1996) list as the key reasons for museum visiting:

- new facilities
- special temporary exhibits
- socialisation to museum visiting as a child (with family)
- stage of life cycle (visits at family stage are high)
- customer service may be the single most distinguishing factor of why visitors go to one museum more often than another.

They speak of what may convert an occasional or repeat visitor into a regular one (Rubenstein and Loten 1996: unnumbered):

- frequent visitors value this leisure experience
- frequent visitors are aware of ongoing programme changes
- (the quality of customer service) makes the difference between a frequent and an occasional visitor.

Community consultation in action – the proposals for the redisplay of Weston Park Museum are taken out to a community gala. © Sheffield Galleries and Museum Trust

What does the importance of the repeat visitor mean for the planning of exhibition developments? Unlike the regular museum or heritage site visitor, the available evidence suggests that infrequent users value most highly the opportunities for social interaction, active participation and entertainment. To develop a repeat visitor audience will require building opportunities for social interaction into the exhibitions. The available evidence suggests we interact with an exhibition as a social or family group more than individually. Making effective use of this approach both improves the visitor experience *and* enhances understanding and appreciation. It will mean setting aside a substantial temporary exhibition area with flexible facilities, and planning for two or three major temporary exhibitions a year, rather than the monthly changeover beloved by art galleries but more suited to the needs of the regular user. This allows the marketing department to make proper use of the exhibitions and for word-of-mouth recommendation to be effective. It is also essential to ensure that there is 'always something new' happening, through the establishment of a regular programme of events and activities. For the longer term, it means building in the potential to make substantial alterations to the main presentation, perhaps every three to five years, to reflect that point when the audience is beginning to dry up. This means designing the initial exhibition in a way that allows it to be renewed easily, flexibly and cheaply. These elements, and the thinking behind them, are discussed in more detail in Section 4.

Regular visitors

Compared with casual and repeat visitors, regular visitors may seek:

- a frequently changing programme of exhibitions and events
- an incentive ticketing scheme
- an opportunity to 'belong'. This may include a Friends group, with special events, 'behind the scenes' sessions, including meeting staff, and the opportunity to participate, perhaps as a volunteer. Active involvement is not necessarily the only issue. There is also the chance to meet 'their kind of people' and to extend their emotional involvement with the site.

Overall, regular visitors will want a different type of experience. Unlike infrequent users, regular museum-goers seem more likely to show a preference for learning and enhancing their understanding and appreciation. Beware however of achieving too high a percentage of regular visits – this can suggest the museum is only appealing to a tiny percentage of the local population – see the case study on Manchester Art Gallery at the end of chapter 3.

The special interest visitor

In the past, the needs and influence of those with a specialist knowledge or interest have far outweighed their numbers in terms of their impact on museum display. However, museums must retain their role as places of learning and expertise. They have a direct responsibility to both academic researchers and more general enthusiasts. Proficiency and competence are attributes of experts. Museums must be able to respond to queries and experts must continue to have access to the full range of collections and the information available about them. Here, improved documentation and the electronic availability of catalogues have already enhanced access for the specialist. The researcher can also continue to have direct contact with the curator and thereby gain physical access to collections when required. The real display issue lies with the enthusiast. Displays must continue to incorporate key collections, accessible to all. The continuing movement toward open storage display and collection resource centres has an important role to play here.

Visitor motivations

What lists of expectations do not answer is what or who motivates people to visit a particular site in the first place – what generates their expectations. It is difficult, if not impossible, to separate visitor motivation to come to a site from expectations of the visit. This section seeks to build on the general expectation lists provided above. Even within the narrower field I am attempting to explore here, there are two separate but interrelated issues:

- why people are motivated to visit/not to visit museums and heritage sites in general
- why they choose to visit a particular location.

Museum-led literature relating to the general motivations behind museum visits overwhelmingly emphasises the importance of learning in some shape or form as a motive (see, for example, Hood 1983, 1996; Prentice *et al.* 1997; Falk *et al.* 1998; Prentice 1998; Kelly 2001a). This is never defined as the sole motivation but has come to dominate the museum agenda in the 'noughties'. Yet people have many reasons for choosing one leisure activity over another and will, over time, involve themselves in a wide range of different activities. Since individuals differ, the criteria applied in deciding what activity to engage in will differ. However, there are some commonly held motivations defined, from the museum point of view, in a 1983 article by Marilyn Hood, updated in 1996, which lists six criteria used by adults: being with people, or social interaction; doing something worthwhile for oneself or others; having the challenge of new experiences; having an opportunity to learn; participating actively; and feeling comfortable and at ease in the surroundings.

Research at the Australian Museum, Sydney between 1999 and 2001 (Kelly 2001a: 9) highlighted five main motivations: experiencing something new; entertainment; learning; the interests of children/family; and doing something worthwhile in leisure. Kelly took these motivations and added to them an acknowledgement of global leisure trends/market forces and also an awareness of individual 'predictors' (characteristics of visitors):

> Museum visiting is not evenly spread in the population. Key predictors include demographic indicators, such as where people live, age and education levels; psychographic factors such as how people see themselves in relation to what they like to do in their leisure time; personal interests and prior experiences with museums, with opportunity also playing an important role.
>
> Kelly (2001a: 3)

From this framework, she has attempted to develop a model of museum visiting, as a 'work in progress' (see Figure 1.2).

Research within the leisure and tourism field contrasts with museum-produced literature in seeing beyond the museum visit to the bigger picture of the 'day out' or holiday. The UK heritage visitor market is dominated by the day-tripper, for whom the museum visit may provide a useful focus within a leisure drive or city-centre trip, but where the social occasion of enjoying a leisure activity with family or friends is the primary motive:

> Either [museums and heritage sites] serve the purpose of occasionally offering a more specific destination in the context of a general day-trip, or they provide an alternative, and usually subsidiary, recreational activity to those on holiday in their vicinity. In either event, the role of such activities is of secondary recreational significance, but nevertheless appears to constitute an important element of leisure-based behaviour.
>
> Thomas (1989: 67–8)

There is a symbiotic relationship between museums and the leisure and tourism industry. Many museums depend on the latter to generate both visitor numbers and

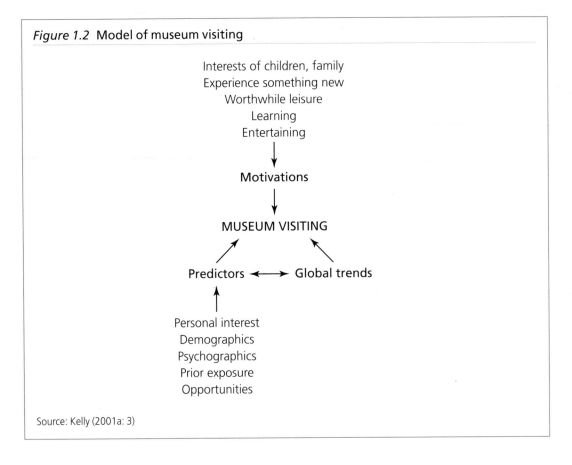

Figure 1.2 Model of museum visiting

Interests of children, family
Experience something new
Worthwhile leisure
Learning
Entertaining

↓

Motivations

↓

MUSEUM VISITING

Predictors ←——→ Global trends

Personal interest
Demographics
Psychographics
Prior exposure
Opportunities

Source: Kelly (2001a: 3)

income. To the leisure or tourist visitor, the museum will normally be part of a wider range of experiences rather than the single focus of their trip. This is explored in more depth in the case study at the end of this chapter, but a key point to make here is that an evaluation of visitor motivation cannot allow itself to be dominated by museum-learning literature and must, instead, explore the wider picture. This is not to deny the importance of the museum as a learning environment. Rather it is to emphasise the need to ensure a welcoming environment for all and a series of different 'entry levels' into exhibitions, to stimulate interest and enthusiasm.

McManus (1996), based on survey work at the Science Museum in London, sought comments from visitors on the motivation for that specific visit (see Table 1.3), and the associated expectations of the visit (see Table 1.4).

Her general conclusion was that: 'we can say that visitors are highly motivated to attend to exhibit communications within a social recreational context. Their interest is general and not focused in a studious, academic style' (McManus 1996: 59–60).

Once again, this emphasises the 'social recreational context' of the visit. One must assume that the traditional audience is drawn to the informal nature of museum presentations. We already know from basic surveys that visitors prefer to come in groups – particularly family or friends. A central motivation for their visit must be the conditions for a social outing that museums already provide. We must seek, in

Table 1.3 Motivation to visit

Family visit with children	20 per cent
Recreation	20 per cent
Reputation of the museum	18 per cent
Interest in science	17 per cent
Revisiting the venue/an exhibit	17 per cent
Museuming	8 per cent

Source: McManus (1996)

Table 1.4 Expectations of visit

Finding out/learning	26 per cent
Fun	22 per cent
General interest	21 per cent
Specific aspect of museum	18 per cent
No structured plans	7 per cent
None defined	6 per cent

Source: McManus (1996)

our operational and interpretive approaches, to enhance these. McManus also makes clear that, even after having selected a specific museum to visit, 'their interest is general'. Visitors come when they want, leave when they want and look at what they want. Their interest is general in a *personal* sense. As also emphasised by extensive research at the Australian Museum, Sydney (Kelly 2001a), visitors are motivated principally by personal interest:

> . . . in order to attract a range of visitors exhibition topics must be of interest and have some emotional appeal. Those that are more likely to appeal and attract visitors are ones where people know just enough to pique their interest, can't be seen anywhere else, have not been 'overdone' and can only be experienced at museums.
>
> Kelly (2001a: 5)

Personal interest need not coincide with other more convenient market segmentation indicators such as age, gender, family status or lifestyle. People select their personal choice of aspects to view and interpret the resulting experience in their own individual way. Again, museums must already be providing the opportunity for this, but need to do better. From the one 'heritage product' we must seek to provide a means by which individual family and social groups can experience and interpret in their own way – in effect a palette of experiences reflecting the differing needs of audiences.

As the survey took place at the start of the visit, it also suggests the *image* of the museum held by the visitors is vital, given that only 17 per cent said they had been before. Almost everyone, including those who do not visit, has a general image of

museums and heritage sites, and that is what those who come are seeking. What of those who are not among the traditional audience? Different people, social groups and cultures will value different things, making it impossible to discover a set of motives of importance that would apply to all, let alone encourage everyone to visit our museums and heritage sites. However, individual sites have proven that it is possible to greatly influence attitudes and, as a result alter and/or broaden their audience base. Between 1988 and 1998, the Museum of Science and Industry in Manchester, UK, through a combination of market research, profile raising, tactical marketing and product development succeeded in changing the gender balance of visitors from 65 per cent:35 per cent male/female to 51 per cent:49 per cent – a remarkable achievement in a subject area that has traditionally been a male preserve.

Visitor needs

In 2001 the USA Visitor Services Association produced a list of needs common to visitors, which they termed the 'Visitors' Bill of Rights':

1 Comfort: 'Meet my basic needs'.
2 Orientation: 'Make it easy for me to find my way around'.
3 Welcome/belonging: 'Make me feel welcome'.
4 Enjoyment: 'I want to have fun'.
5 Socializing: 'I came to spend time with my family and friends'.
6 Respect: 'Accept me for who I am and what I know'.
7 Communication: 'Help me understand and let me talk too'.
8 Learning: 'I want to learn something new'.
9 Choice and control: 'Let me choose; give me some control'.
10 Challenge and confidence: 'Give me a challenge I know I can handle'.
11 Revitalization: 'Help me leave refreshed, restored'.

Rand (2001: 13–14)

The nature of human needs is an important area of study, well beyond the scope of this chapter to explore in depth. However, because of the ease with which we can apply it to the issue of visitor response to the way museums are presented, the hierarchy of needs, defined by Maslow and illustrated in Figure 1.3, provides an important means of further exploring this important subject. It must be emphasised, however, that the comments below are generalised ones, while museums must cater for individual needs.

Because recognising and responding to visitor needs is a central element in visitor services provision, the comments below are all based on factors the visitor services team in a museum must take into account in supporting audience access. The issue of quality in visitor service provision is further explored in chapter 4.

Physiological needs

Our most basic needs are for a comfort break, food and drink, a suitable temperature, seating, etc. If these are not properly catered for, a need can take control of the visitor

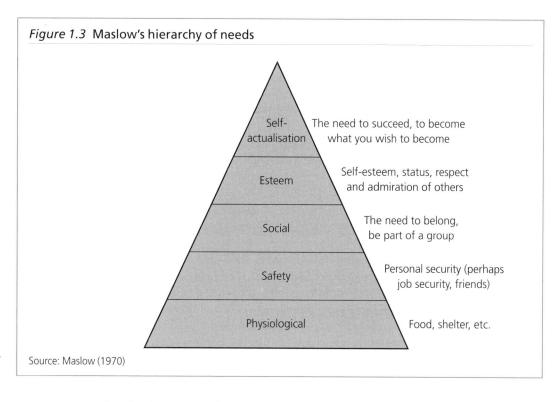

Figure 1.3 Maslow's hierarchy of needs

Self-actualisation — The need to succeed, to become what you wish to become

Esteem — Self-esteem, status, respect and admiration of others

Social — The need to belong, be part of a group

Safety — Personal security (perhaps job security, friends)

Physiological — Food, shelter, etc.

Source: Maslow (1970)

and make the quality of the site and its presentation irrelevant. Visitor services must take into account the following:

Restroom provision – a common need on arrival, not least for children, but also within larger sites and by the café. Why are there always too few women's WCs? Remember also facilities for the disabled and for nappy-changing, accessible by both genders.

Catering facilities – particularly necessary if the average visit exceeds one hour. This may be less important if there is a good range of choice within easy reach. The provision of catering can be a real problem, as its poor quality frequently lets a site down. However, after their journey to the site, many people begin their visits in the café, planning how they will spend their time. There is also substantial anecdotal evidence that what people remember most about a site are its restrooms and catering, especially if these are poor!

Climate – ranging from the temperature in a museum to the impact of weather on an open site. Consider factors like visitors wearing heavy coats in winter but coming into a warm gallery. Warmth (or lack of it) can be a major issue in historic houses, where there can be a real problem in balancing conservation requirements and visitor needs.

Noise levels – the use of interactive exhibits, for example, leads naturally to noise and bustle among visitors, and can cause congestion. Quality means careful planning and

location of exhibit types to prevent congestion; to provide clear signals to visitors on how to behave in different display types; to separate inter-actives from fragile non-touchables, etc.; and to allow for the fact that visitors in 'hands-on' displays are more likely to select their own circulation path.

Disability – in addition to suitable restroom facilities, can people with disabilities physically get into and around the gallery/site, the café and to objects? Can they follow the same route as everyone else? Is there a good provision of comfortable seats (essential for everyone, not just those with disabilities)?

Safety needs
These should be seen not only in terms of actual danger, but also in relation to orientation to, from and at the site. Visitor services must take into account the following:

Relief of trip stress means providing good pre-visit information; road signage; on-site orientation; ease of exit. If in doubt about the impact of this on the visitor experience of your site, try being lost in your car in a town you have not previously visited, with three children and an ageing grandmother on the back seat.

Visitors feel physically safe and have confidence in the quality and training of the staff; clear evidence that fire regulations and health and safety factors have been properly catered for in terms of light levels, clear routes to exits, etc. Be very aware that the fire officer can have a dramatic impact on the proposed presentation and the visitor route – involve him/her at the earliest possible stage and work together to achieve the best result. Health and safety can be a particular issue for working museums, for example with operating machinery or steam trains.

Visitors put at ease – if visitors are to be involved/challenged by the presentation, they must feel safe about, or 'comfortable' with, the approach taken. This links directly to the need for a real understanding of the nature of your target audience and the development of a sense of belonging.

Visitors have a firm sense of orientation within the site/building – good orientation within a site is essential to enable visitors to plan their time (or find the toilet). You need to consider the provision of orientation plans at regular intervals around the site and/or the supply of individual plans to visitors on entry.

Disability – will visitors with disabilities also feel safe, and certain that they will not be trapped? Can they be certain they will not fall over, or walk into unseen obstructions (such as glass casing with no obvious edging)? Does the fire alarm have a visual signal? Are guide and hearing dogs allowed?

Sense of belonging
All visitors should feel welcomed to the site, not experience a sense of exclusion. The single most significant barrier to inclusion is the visitor feeling unwelcome and being embarrassed because they do not know where to go, what to expect or what is

expected of them. If visitors do not feel 'comfortable', if they feel watched and considered inadequate, they will vote with their feet and leave. Visitor services must take into account the following:

Warmth of welcome which includes the quality of staff, signage, orientation at the beginning of the visit, and colour schemes. The external architecture of many nineteenth-century museum buildings can be off-putting, as can the colour schemes and 'atmosphere', for example, in contemporary art galleries. Many museums were once renowned for their scowling, old-fashioned attendants in quasi-Victorian police uniforms. Fortunately, much has improved.

Presentation matches target audience in terms of the media used, the language levels, and the use of foreign languages if appropriate. The presentational approach taken can vary from contemplative to highly experiential – what is most suitable for your audience?

Communicating a 'sense of place', ensuring visitors are able to comprehend what is special or unique about your site and its relevance to them.

Disability – are visitors with disabilities welcomed and treated the same as everyone else? Can they interact with friends and family, not just through following the same route, but also, for example, by using the same audio-tapes etc.?

Self-esteem

This means a recognition of the visitors' worth and respect for them as people. Visitors are equal participants, there to share our enthusiasm for the quality of the site and collections and there to offer their support for our work. Visitor services must seek to support the following:

Authenticity and integrity – the visitor has the right to assume that everything in the presentation is accurate and reflects the latest research.

Professionalism of execution – an essential means of demonstrating the worth of the visitor lies in the sheer professional quality of the presentation and its maintenance. Broken down or peeling exhibits, ill-trained or behaved staff, dirty restrooms, etc., all reflect on the site's attitude to its visitors.

Freedom of movement which enables a visitor to move at his or her own pace and recognises individual worth. This is particularly true in enabling the visitor to choose voluntarily when to leave. Clearly, this is a problem for 'dark rides' such as the Jorvik Viking Centre in York. In such circumstances, the presence of a free-flow exhibition after the ride (as at Jorvik but not, alas, everywhere) is crucial to visitor satisfaction. It gives the visitor the choice of whether to explore in more depth and of when to leave.

Hierarchy of information – our visitors will have differing levels of knowledge and interest about the site. We must provide an opportunity to explore the subject

matter to a greater or lesser degree, depending on the visitor's individual inclination. We must also ensure that there is an overall clarity of intent within the presentation – that the objectives are clear and that visitors can follow these through.

Provision for children – this is not just about developing the future audience. They are people in their own right and deserve to be treated as such. This does not mean that everything must be suitable for child use, but concept development must ensure that their specific requirements are taken fully into account.

Meeting expectations – the concept of the museum or individual exhibition must reflect visitor expectations. This is easier said than done, particularly if the development is a new one. However, once again, we are back to the issue of understanding the target audience. It also links to the way in which the site is promoted. The marketing pro- gramme should not raise expectations beyond what can actually be delivered.

Disability – is information presented in an accessible format and can it be understood without help? Can labels be read independently? Are there a variety of ways to learn about/access the collections? Is the same information or experience offered to all? Will the visitor with disabilities be able to see the presentation as an affirmation of his or her competence/achievement in understanding?

Self-actualisation

Here, once the more basic needs are dealt with, we can turn to the continuous seeking after self-fulfilment or the desire to reach our full potential – to 'become everything that one is capable of becoming' (Maslow 1970: 46). Clearly Maslow recognises that this is not achievable, but we are always seeking personal growth and working toward that end. Since Maslow published his hierarchy, there have been numerous adaptations and refinements suggested by both himself and others. Within the area of self-actualisation, there has been in particular the development of concepts of *cognitive needs*, the need to know and understand, and *aesthetic needs*, the apprecia- tion and search for beauty.

Clearly, all of this is highly relevant to visitor motivation to engage with museum collections and exhibitions, and is reflected in Sections 3 and 4. However, to com- plete this section on Maslow, I must mention that the challenge in a museum is *not* to attempt to ensure that the visitor leaves knowing 'everything there is to know'. That is impossible. Attempting to do so would demoralise all but the most specialist visitor. Concentrating on a purely information-led approach also implies that self- actualisation is solely knowledge-based. We need to take into account the personal benefits that can be gained in other ways, for example through enjoyment, aesthetic pleasure, emotional involvement, social interaction and the actual process of dis- covery. Any concept must be geared to engaging the visitor, to seeking to achieve those benefits for visitors, with the overall objective that visitors leave with that 'gut' feeling of having experienced something unique.

DISCUSSION: AN AUDIENCE IN DECLINE – TRENDS AND CHALLENGES

> Attendances at museums in Australia decreased approximately
> 3 per cent between 1991 and 1995. Between 1995 and 1999,
> the decline accelerated a further 9 per cent . . . The
> phenomenon is not specific to Australia. Evidence points to a
> worldwide trend . . .
>
> Scott (2000: 37)

It is vital for museums to understand that they cannot take their traditional audiences for granted – in fact, museums are at risk of losing a substantial percentage of them. Museum audiences across the western world are currently at best on a plateau, at worst falling steadily. The museum audience does not exist in isolation, but must be seen in the context of wider leisure trends. I can make no more than a passing mention here – this is an issue for another book – but it would be easy to define this bigger picture as a bleak one.

More means less

People can use their leisure time either by 'staying in' or by 'going out', with differing reasons for which alternative they prefer at different times. Whichever choice they make at this basic level, there are more options for how they spend their time. At home there is now a multitude of television and radio channels and a plethora of electronic equipment as well as conversation, books, etc. If people go out, they will find more choice for eating, drinking, film-going, and so forth – whatever their area of interest, there are more options – 'a greater choice of leisure options and a greater number of choices within each option' (Scott 2000: 39). And all these are, of course, alternatives to visiting a museum. Even with museums, there are now more to choose from. The end result is that a smaller percentage of the available market will select individual options.

Shopping

The major competition for museums lies in alternative uses of leisure time. One thinks of in-home entertainment, the rise of the garden centre and health club, eating out and, most important of all, shopping. Shopping is now the second biggest leisure activity in western society, after watching television. In the UK, shopping centres such as Bluewater Park in Kent, or Trafford Park in Manchester, attract between 30 and 35 million visitors a year, more than the attendances at all the national museums put together. The introduction of Sunday trading in the 1990s has had a disastrous impact on what used to be the busiest day of the week for museums in the UK. While there has been a substantial increase in both day trip and tourist visits, particularly to historic towns and cities, much of the drive behind this has

been about doing 'normal' things in a new environment – most importantly this has meant shopping. What we are seeing here is the rise of historic towns as 'consumption centres', with more and more consumption activities being added to those already available. While the attractive environment created by historic buildings remains a major draw for heritage tourists and a 'critical mass' of relevant attractions – mainly museums and galleries – is seen as an essential support, shopping and dining out are frequently the key factors:

> Visitors can experience heritage first hand in a way that cannot be achieved at a purpose built facility such as a heritage centre. They can engage with history while undertaking activities that could be carried out elsewhere, e.g. shopping . . . combined shopping and tourism trips are now just as important a reason for visiting an historic town as its heritage.
>
> EHTF (1999: 11 and 13)

Museums and galleries urgently need to sharpen up their external image and appearance to match the standards demanded by the modern consumer, and make themselves at least as attractive to the potential visitor as shopping and afternoon coffee.

The under-35 adult market

Clearly, the under-35 population is highly diverse, and should not normally be lumped together. However, as far as museum audiences are concerned, there is increasing evidence that museums and galleries are failing to attract the entire range of the under-35 adult audience. This needs to be combated urgently, but will not be an easy task.

Reasons being given for the decline in this audience at museums suggest that under-35s are more demanding, seek active experiences, have higher expectations from what is on offer and are less willing to accept poor quality. They are also leading increasingly frenetic lives – defined as 'cash rich/time poor'. Research suggests many do not like traditional museums, preferring a virtual reality, 'touchy/feely' theme-park experience. They do not want the visit to 'feel like' learning but seek a more sensual/emotional experience. They are seeking an integrated leisure experience that can provide all their requirements in one location – museum galleries; shopping; an animated public space in which to meet; eating; activities, events and changing exhibitions; and extended opening hours which reflect this usage. Sites seeking to attract this audience must be able to match the under-35 lifestyle – in these terms it is perhaps no surprise that Tate Modern in London was such an immediate success.

Yet, under-35s are also closely associated with the shift in consumer demand toward greater freedom of choice, customisation, personal involvement and individual service. The research by Kelly *et al.* (2002) on *Indigenous Youth and Museums* in Australia highlighted display elements relevant to all young people (defined there as aged 12 to 24 but in my view applicable to all those seeking a more active engagement):

- seeing themselves reflected in content, programmes and staffing
- active learning experiences that catered for their individual and collective interests and learning styles in a comfortable and supportive atmosphere
- involvement in programme development and delivery
- contemporary modes of information exchange . . .
- examination of contemporary youth issues . . .

<div align="right">Kelly et al. (2002: 4)</div>

This would suggest that, like any other potential museum audience, the challenge is to define their needs, motivations and expectations and seek to respond to these. Since heritage experiences are subjective and individually determined, museums have a potent tool for upgrading and customising their products, and for generating the necessary choice and authenticity. The essential difference for younger audiences is likely to be that their demand for participation may well go beyond engagement with collections to having a direct say in programming and content.

The tourist audience

It is quite frightening to explore tourism statistics that show a decline year-on-year in the percentage of tourists and day trippers including museum visits in their trips. In the USA, Colonial Williamsburg last saw one million visitors a year in 1990, with audiences now around 750,000 and a 2003 deficit of $30m (Koncius 2003). Ferguson (2002) cites data from the Australian Bureau of Statistics and Bureau of Tourism Research as evidence of a decline in tourist visitors to Australian museums and galleries. Despite rising international tourism, domestic tourism still accounts for 73 per cent of all visitor nights in Australia, and has grown from 46m overnight trips in 1988/9 to around 73m in 1999 – but domestic tourist visitation to museums has declined steeply, as reflected in Table 1.5.

In 1990–9, UK domestic tourism increased by 59 per cent, with increasing emphasis on short breaks of one to three nights, while leisure day trips increased 17 per cent to 5,287m between 1994–8. This picture could be described as at least partially rosy for museums. Domestic and in-bound tourism may not be rising as fast as outbound tourism, but it is still growing substantially. Short breaks and day trips both produce 'natural' potential audiences for museums:

> The lifeblood of the South-East is the day visitor drawn dominantly from socio-economic groups ABC1, and aged between 40 and 60, of whom 60 per cent are female. More than 70 per cent are from the region and visit the sites for leisure rather than for educational reasons.
>
> <div align="right">Berry and Shephard (2001: 166)</div>

Yet, how do trends in tourism and day trips compare with those for visits to museums and heritage sites? An assessment of a range of surveys and analyses (BTA 1997; MORI 2001; Richards 2001) suggests that at best overall figures for visits may still be rising slightly – but this contrasts poorly with the rising numbers of

Table 1.5 The decline in domestic tourist visitors to Australian museums and galleries

	1995/6 %	2000 %
Australians aged 15+	28	20
Domestic tourists aged 15+	15.2	4
International tourists aged 18+	25	27

Source: Ferguson (2002: 6)

tourists and day-trippers. Of perhaps even more concern, within the attraction market as a whole, the MORI report (2001) showed that the overall market for museums and galleries in the UK decreased from its 1991 peak of 44 per cent of the visitor attraction market, to around 33 per cent in 2000. It must be emphasised that all museums and galleries are not the same and that attendances are not falling at all museums and heritage sites – in fact they continue to rise at those which offer an outstanding experience. But the reality is that many museums in the UK now need to fight for survival.

If museums are to continue to rely on tourists, there must be a growing understanding of the nature and expectations of the cultural tourist. In particular, there must be an awareness of how those expectations are changing from a passive viewing of exhibits to demands for active participation:

> Our history has stayed the same, but the people and how they choose to explore and experience it have changed. Twenty years ago people wanted to be observers; now they want to be part of it. Instead of looking at old houses, visitors want to 'talk to' people from the 18th century and make 18th century style bricks.
> Timothy W. Andrews, director of public relations, Colonial Williamsburg, quoted in Koncius (2003)

In terms of future trends for cultural heritage visitors in the USA, the National Assembly of State Arts Agencies analysis of various 2001 surveys (NASAA website) suggests:

- rising affluence and education levels
- an aging population – in 25 years, 54 per cent of the USA population will be over the age of 50
- increasing cultural diversity – by 2010, Hispanics will be the largest ethnic group and Asians will show the greatest rate of growth
- the increasing economic role of women
- less leisure time and a greater emphasis on short breaks rather than long vacations
- the rising influence of technology, making visitors better informed and more demanding of accountability.

What does this mean for the future: changing the product to meet future demands?

All the research available suggests that future audiences will be increasingly demanding in terms of service quality, no matter the type of museum or heritage product they seek. Sites will require strong individual identities and will have to increase visitor choice and add novelty to their approaches. The pressure toward greater visitor participation will increase as will the demand for a subtler, more personalised interpretation – the demand will be for individual *experiences*, with the concept of the 'experience economy' rising to the fore. The demand for participation will include a desire for opportunities to see behind the scenes, to meet staff and to be involved in product development. However, most of all, it will be about opportunities to engage with collections and with each other. Retail and catering services will also have to be transformed to meet contemporary standards – quality, and the ability to match consumer lifestyles, will be key to long-term success.

This is the context in which museums now operate. Independent of a professional aspiration to engage audiences more effectively with collections, museums must become much more audience-centred if they are to retain an audience at all. A detailed knowledge of target audiences is crucial to their future survival.

Museums must also recognise that to the majority of visitors they represent one choice of leisure activity among many. In this context, they must balance their own commitment to learning with the more leisure-led, recreational frame of mind of the bulk of visitors. Worthiness is to be avoided at all costs. There is more on this in chapter 3.

CASE STUDY: LESSONS FROM TOURISM RESEARCH

The objective of this case study is to contrast how tourism researchers interpret the quantitative visitor data they obtain with that of museum researchers studying similar audience segments. It is intended as a word of warning to those who cannot see beyond their museum walls when studying visitors. Most museum visitor survey work has been generated and then analysed by museum service personnel, or at least to a museum brief, and has been applied to individual sites and not industry-wide. An unspoken assumption behind most museum surveys has been to see the museum visit as the primary motivation for the audience, rather than seeking to understand the motivations behind the bigger picture of the 'day out'.

Cultural heritage tourism

Tourism is an industry that enables people to travel to 'consume' experiences away from home. A major motivating factor behind cultural heritage tourists

lies in their desire to gain a deeper understanding of the culture and heritage of a destination. Clearly for some this will be the sole motivation for their trip but, for most, this motivation will be combined with others, to differing degrees. The cultural heritage tourist is now regarded as a key figure within the tourist industry who is likely to stay in an area longer and spend more money:

> Cultural tourism began to be recognised as a distinct product category in the late 1970s . . . Initially it was regarded as a specialised, niche activity that was thought to be pursued by a small number of better educated, more affluent tourists who were looking for something other than the standard sand, sun and sea holiday. It is only since the fragmentation of the mass market in the 1990s that cultural tourism has been recognised for what it is: a high profile, mass market activity. Depending on the source and the destination, between 35 and 70 per cent of international travellers are now considered cultural tourists . . . Today, arguably, cultural tourism has superseded ecotourism as the trendy tourism buzzword.
>
> McKercher and du Cros (2002: 1)

There is a remarkable similarity between the analysis of the cultural heritage tourist and of the traditional museum visitor, not surprisingly as they are the same people. Richards (2001), reflecting on a major survey of cultural heritage tourists in western Europe carried out in 1997, pointed out that the proportion of heritage visitors with a higher education qualification was almost double the European Union average, while more than 40 per cent of heritage visitors were aged 50 or over. Almost 60 per cent had managerial or professional jobs and this, together with their older age profile, meant their average incomes were significantly higher than the European average. Yet only 18 per cent classified their holidays as being cultural – rather, a heritage visit was just part of their holiday.

The Travel Industry Association of America (TIA 2003) suggested that in the USA the most likely tourist participants in cultural heritage were 'baby boomers and matures', making up 80 per cent of the total. They are more likely to have a graduate degree (21 per cent vs. 18 per cent), to be older (48 vs. 46) and to be retired (18 per cent vs. 15 per cent). On a highly positive note for museums, the same study suggested 26 per cent of travellers lengthened their stay by two or more nights because of cultural events.

The reality, however, is that only a small percentage of tourists are driven almost exclusively by cultural motives. Most tourists who incorporate museum visits or other cultural activities into their vacation see this as just part of their holiday. The NASAA website profile of the USA tourism industry lists the top ten activities of USA residents and overseas visitors, as shown in Table 1.6.

Any survey of holiday activities by tourists to a particular area will reveal the range of interests represented. I have chosen to present the results of a survey in Cornwall at the end of the 1980s because this period is recognised as representing the peak of heritage interest in the UK, while two in three

Table 1.6 The top ten activities of USA residents and overseas visitors, 2001

Activity	USA %	Overseas %
Shopping	34	87
Outdoor recreation	17	n/a
Historical places/museums	14	31.2
Beaches	11	23
Cultural events	10	19.6
National/state parks	10	19.6
Theme/amusement parks	7	31.4
Nightlife/dancing	8	n/a
Gambling	8	n/a
Sports events	6	n/a

Source: National Assembly of State Arts Agencies (NASAA) website

Table 1.7 The relative importance of activities to holidaymakers in Cornwall, 1988

Activity	Taking part in only – no rating %	Very important %	Fairly important %	Not very important %
Going to the beach	6.1	52.0	30.9	11.0
Walking around town	7.3	26.5	53.0	13.2
Strolling in the countryside	6.2	47.5	37.3	8.9
Climbing/hiking/rambling	3.5	29.0	24.3	43.3
Sightseeing coach	6.7	50.0	35.5	7.8
Shopping	7.7	21.6	47.9	22.8
Visiting pubs/bars	5.7	22.6	37.4	34.3
Visiting restaurants	5.7	26.2	43.3	24.8
Cinema/theatre	2.4	9.2	25.9	62.5
Festivals/outdoor show	2.2	13.5	35.4	48.9
Historic buildings/country houses	5.6	34.5	43.4	16.4
Funfair/amusement arcades	3.6	8.5	25.2	62.7
Dancing/disco	2.3	9.9	21.3	66.6
Museum/art galleries	3.4	22.6	50.1	24.0
Theme parks	4.2	16.9	44.0	35.0
Scenic railways	4.3	13.0	34.6	48.0
Miniature golf/putting	4.0	13.0	33.1	49.9
Other	6.1	59.1	22.7	12.2

Source: Greenwood *et al.* (1989)

Table 1.8 The activities of visitors to Edinburgh, 2001–2

Visitors' activities	All visitors	UK visitors	UK visitors (excl. daytrippers)	Overseas visitors
	%	%	%	%
Walk around city	85	81	86	88
Visit sites/attractions	79	72	76	86
Go to bars/restaurants	70	63	74	78
Shopping	63	61	64	66
Visit museums	38	27	31	51
Visit art galleries	36	31	34	43
Attend festival event	12	13	15	11
Organised city tour	11	9	8	9
Excursion out of Edinburgh	8	3	4	13

Source: Services to Industry Groups: Tourism Edinburgh Visitor Survey, Summary Report (2001/2:. 7)

tourists were from the professional classes and so reflect 'traditional' museum visitors. Visiting historic buildings and museums and galleries ranks high on the activity list but by no means dominates. People have choices in how they spend their leisure time and, as Table 1.7 (on p. 43) reveals, are very capable of making their own decisions.

The historic city of Edinburgh, the capital of Scotland and with a world heritage site at its core, is a major short break cultural heritage destination for tourists from the UK, Europe and the USA. A survey carried out in 2001/2 gave fascinating information on what Edinburgh's visitors do, shown in Table 1.8.

Of the actual attractions visited, only 25 per cent of all visitors went to the National Gallery of Scotland (33 per cent of overseas visitors); 20 per cent visited the Museum of Scotland (29 per cent overseas visitors); and 13 per cent visited the Scottish Gallery of Modern Art (16 per cent overseas visitors). Not surprisingly 64 per cent visited Edinburgh Castle (82 per cent overseas visitors), but the much lower percentages visiting what are major museums and galleries is of concern.

An analysis of recent USA surveys by the NASAA suggests the majority of Americans who took trips of 50 miles or more included a cultural, arts, heritage or historic activity in their itineraries – according to the TIA annual survey, 2001, 65 per cent of American adult travellers planned at least one cultural activity for their vacation, a positive increase from 61 per cent in 1998. Figure 1.4 shows the breakdown of the survey.

The lesson to be learned is straightforward. Museum researchers must look at the bigger picture when studying their visitors, and museums must compete for visitor time on the visitor's terms.

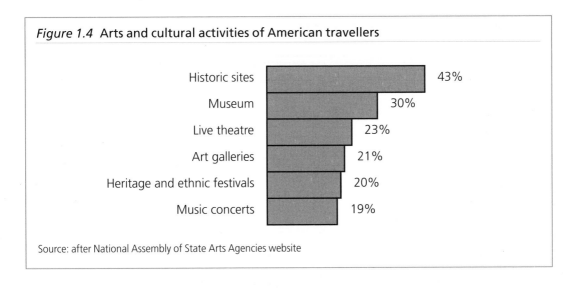

Figure 1.4 Arts and cultural activities of American travellers

Source: after National Assembly of State Arts Agencies website

2 Developing new audiences

INTRODUCTION

> Audience development is about breaking down the barriers
> which hinder access to museums and 'building bridges' with
> different groups to ensure their specific needs are met. It is a
> process by which a museum seeks to create access to, and
> encourage greater use of, its collections and services . . .
>
> Dodd and Sandell (1998: 6)

At the beginning of the introduction to this section, I stated that the central challenges for museums at the start of the twenty-first century are:

- to build an enduring relationship with existing audiences
- to develop and then retain new audiences.

This chapter looks at the second element – developing and retaining new audiences.

The scenario represented by most of chapter 1 explored only one of the worlds we are now living in – the world of the 'haves' and their increasingly sophisticated demands which would be exceptionally difficult to meet in a museum world that has seen budget cuts for approaching 30 years, even if that were the sole priority. Yet it must also sit uncomfortably alongside the other pressures on museums and heritage sites to broaden their audience base and develop strong community links.

As visitor dependent attractions, as recipients of public sector funding and as guardians of local, regional, national and international heritage, museums have been subject to increasing pressure in recent years to broaden access to their collections. This pressure is in part a response to a legislative framework in areas such as race relations, equal opportunities and disability discrimination. It also reflects the increasingly close links between external public funding and a requirement for museums to respond to current social and political agendas, not least in terms of showing evidence of a commitment to developing new audiences beyond the white middle classes. Equally, it demonstrates the impact of lobbying groups such as those from ethnic minority or disability groups who feel un-represented in our museums and excluded from them, and of staff who believe museums have an obligation to

reach out to new audiences. Overall, it is probably fair to say that in the current political climate 'audience development is not an optional activity but a way of working which needs to become central to the philosophy and function of . . . organisations' (Dodd and Sandell 1998: 6).

It is important to begin the chapter with a definition of what is meant by audience development. That also involves saying what it is not. Audience development is *not* about simply increasing audience size. The best way for a museum to increase visitor numbers is to improve the service and experiences it is offering to existing audiences. This will normally lead to greater word-of-mouth recommendation, resulting in an increase in usage by more members of the audience types the museum is already attracting, and will also encourage more repeat usage by existing audiences. Nor is audience development about increasing access to the museum, whether physical, intellectual, social, cultural or economic. Improving access is likely to make the museum more welcoming and user-friendly, and therefore lead to more diverse usage, but it is not in itself audience development. Nor is it about the contribution that museums can make to the social inclusion agenda currently at the political forefront across western society, although an audience development strategy may be targeted at groups in society that, according to government definitions, could be considered as socially excluded.

Rather, audience development implies a specific policy of reaching out to new audiences previously under-represented in the museum. This is a potentially risky business on two counts. First, the museum risks losing its traditional audiences if it focuses too strongly on attracting new ones. It is essential that, at minimum, consolidation of existing audiences and, preferably, enhanced provision for them sits alongside any strategy to develop new audiences. Second, audience development is not about increasing the number of first-time or one-off visitors to walk through the door – it is about seeking to develop and *sustain* participation over the longer term. A campaign to attract and then retain previously under-represented groups requires an active, prolonged commitment from top-level management downwards, and also a planned exercise in defining target audiences, establishing their needs and expectations, and meeting them. It also requires an equal commitment to direct involvement with the communities concerned because the museum must establish an active presence in the community. Such commitments will require the development of new provision to meet community needs, are likely to involve changing the ethos behind the presentation of museum collections, and will certainly require organisational change – a change in staff structure and a change in the nature of jobs to deliver, for example, on newly established inclusivity objectives. They also require new skills on the part of museum staff – in building relationships and working sensitively with communities, in sharing expertise, and in recognising groups as equal participants. It is not all one way – communities too must gain an understanding of wider museum goals and of what museums can and cannot do.

Audience development is, therefore, an expensive exercise, in terms of funding, the long-term commitment of staff time and, probably, the development of new collections to reflect the needs of the new audiences being sought. There is no point beginning the process without a commitment to adequate resources. Thus, without the absolute commitment of the museum's director and governing body, an audience

development strategy will fail – there will be inadequate resourcing and other staff will not give it the priority required.

SOCIAL EXCLUSION AND MUSEUMS

There is nothing new to the concept of museums seeking to broaden their audience base and appeal to a wider social mix. Alexander (1979) points to the work of Theodore Low who wrote his *The Museum as a Social Instrument* in 1942, and to the even earlier work of John Cotton Dana, founder of the Newark (New Jersey) Museum in 1909. The USA also led the world in the development of community and neighbourhood museums, which were established in poor areas of New York, Washington, Chicago, and other cities by the 1970s. Anacostia, the influential museum in a black district of Washington DC, was set up in 1967 with the help and financial backing of the Smithsonian Institution, in a small disused cinema, under a 30-year-old black youth worker, John Kinard: 'What he envisaged was something which had not existed previously, a museum which grew naturally from the life of the district, a museum with a creative flow of ideas, exhibits and people between itself and the outside world' (de Varine 1993).

The Lower East Side Tenement Museum in New York is famous not only for its on-site facilities, but has also attracted museum professionals from across the world to study its history-based community outreach and service programmes and its creative use of history as a tool for citizen engagement. Meanwhile, also in the 1970s and 1980s, more conventional museums such as the Philadelphia Museum of Art and New York City Museum, began what became known as 'outreach' activities, staging festivals and exhibitions in poor neighbourhoods both using their collections and exploring themes including drugs, violence and sexually-transmitted diseases. Alexander commented on the success of the outreach programme begun in Philadelphia in 1970: 'It has observed well the basic principles of community-oriented programmes: to respect the wishes and ideas of the groups, to help them whenever feasible, provided assistance is asked, and to keep the museum in the background' (Alexander 1979: 224).

By 1972, the American Association of Museums (AAM) had already produced a major report on these new museums and potential new audiences (AAM 1972). Alexander's description of the criticisms that gave rise to this new movement bears a striking resemblance to comments still being made today:

> [The] criticism that they [museums] appealed only to the educated few and collected objects valued by wealthy leaders, that the immigrants, blacks, and other deprived minorities as well as the poor had been ignored, their cultural contributions and needs forgotten.
>
> Alexander (1979: 14)

While community museums and outreach programmes are now a relatively common feature of the museum world in the USA, they could still not be defined as part of the mainstream. Equally, in western Europe, while the rise of social history and indus-

trial museums since the 1970s was based on a groundswell of support within communities, and while the concepts of community museums and outreach have been present since the 1970s (see, for example, Merriman 1991), they were rarely seen as a priority by museum services. What has changed since the 1970s, however, has been the rise of a political agenda that commits museums to playing a role in tackling social issues within society. Although an audience development strategy is distinct from the initiation of policies to combat what is now termed 'social exclusion', many of the groups and communities currently under-represented among museum visitors could be defined as falling within those believed to be excluded from mainstream society. It is important, therefore, to understand this political concept, and the way in which it is driving museum agendas.

Newman and McLean (2000) point out that it was in France in the 1960s, that the poorest sectors within society began to be referred to as the 'excluded', with the term 'social exclusion' itself first used in 1974. Gradually the term came to represent the process of social disintegration rather than what was seen to be the more limited concept of poverty. Within the European Union, the concept rose up the political agenda and the European Observatory on Policies to Combat Social Exclusion was established in 1989, together with the European Community Programme to Foster the Economic and Social Integration of Least Privileged Groups.

In the autumn of 1992, an International Community Development Conference was held, organised by the OECD and the Community Development Foundation. Its challenges were to explore why urban areas continued to be faced with the problems of persistent concentrations of disadvantage alongside relative affluence and to develop practical ways of challenging urban decline, of building new partnerships at local level and of empowering local communities through resident involvement.

Since then the ambition to develop policies to combat social exclusion has moved up the political agenda worldwide. By 2000 the members of the European Union had adopted common objectives of:

- facilitating participation in employment and access by all to resources, rights, goods and services
- preventing the risks of exclusion
- helping the most vulnerable
- mobilising all relevant bodies.

In the UK, the incoming New Labour government established a Social Exclusion Unit in August 1997, which defined social exclusion as:

Social exclusion is something that can happen to anyone. But some people are significantly more at risk than others. Research has found that people with certain backgrounds and experiences are disproportionately likely to suffer social exclusion. The key risk factors include: low income; family conflict; being in care; school problems; being an ex-prisoner; being from an ethnic minority; living in a deprived neighbourhood in urban and rural areas; mental health problems, age and disability.

Cabinet Office (2001: 11)

The emphasis here is on the links between the different elements and the need to understand that these can be highly complex – an initiative to solve one aspect may not be enough. There must be an inter-agency response.

The high profile of the social exclusion agenda has meant that museums and museum bodies worldwide have had to respond proactively to criticisms that they cater only for a privileged, affluent minority in society. This has led to the production of strategic documents at national level; to priority being given to the development of exhibition, activity and outreach programmes by museums to respond to broader community demands; and to the widespread commissioning of reports and other research into the impact museums can have in the field (for the UK see, for example, DCMS 2000, 2001; Dodd and Sandell 1998, 2001; GLLAM 2000; Newman 2001; and the Northumbria University School of Information Studies 2002). The extent to which this has become a worldwide phenomenon is reflected in Sandell (2002), the published papers from an international conference on museums and social inclusion held in Leicester, UK, in 2000.

Sandell, perhaps, remains the leading UK proponent of the positive socially inclusive impacts that museums can have:

> Recent research suggests that museums can contribute toward social inclusion at *individual, community and societal* levels. At an individual or personal level, engagement with museums can deliver positive outcomes such as enhanced self-esteem, confidence and creativity. At a community level, museums can act as a catalyst for social regeneration, empowering communities to increase their self-determination and develop the confidence and skills to take greater control over their lives and the development of the neighbourhoods in which they live. Lastly, museums, through the representation of inclusive communities within collections and displays, have the potential to promote tolerance, inter-community respect and to challenge stereotypes.
>
> Sandell (2003: 45)

However, he fully recognises the many barriers to making this happen, not least in the attitudes of major government funding bodies to the effectiveness of the role they believe museums can play, the current staff structure and entrenched attitudes within museums leading to inertia, the lack of diversity within staff, and external perceptions among potential users. The frustration at the difference between political statements and what is actually happening on the ground is reflected in one of the key conclusions of a report commissioned by the Group for Large Local Authority Museums (GLLAM) in the UK:

> Lack of support, lack of funding and lack of clear policies and direction combined with the fuzziness and ambiguity of the concept of social inclusion itself has led to a situation where the good work being done is frequently invisible.
>
> GLLAM (2000: 18)

Further research funded by the UK Economic and Social Research Council perhaps provides a balanced picture, reflecting the substantial impact museums can have on

individuals but suggesting the role of museums within the bigger picture of social inclusion strategies is, at best, not proven:

> The ability of museums and galleries to socially engineer society . . . cannot at present be demonstrated. A policy encouraging museums and galleries to focus on such indices of inclusion appears misguided. But so far, our research indicates that initiatives do have an impact. This might be related to the way people develop a sense of who they are. The profession and the various elements of government appear to misunderstand the importance of this. It could be a first step to inclusion for many people.
>
> <div align="right">Newman (2001: 36)</div>

Meanwhile, museums internationally continue to work toward becoming more inclusive organisations. A key theme in the museum response to the social inclusion agenda has been the need to develop exhibitions and programmes that represent and include all of society:

> Fundamental to the realisation of social inclusion in museums is the presentation of stories highlighting the diversity of a nation's population, a nation's history from the multiple viewpoints of its citizens and the celebration of people from all walks of life, all stations, all creeds.
>
> <div align="right">Museums Australia (2003: unnumbered)</div>

The central issue is whether this strategy in itself will be enough not only to enhance access to museums but also to enable museums to play an active role in combating the wide range of factors causing disadvantage. My strong view is that the strategies currently being adopted by museums are not focused enough and that the way ahead is through a return to narrower emphases on audience development and community empowerment.

AUDIENCE DEVELOPMENT

While policies to combat social exclusion are variously described as 'fuzzy' and 'lacking clarity', much more precise work has also been done on developing strategies for targeted audience development. I believe strongly in this approach. Before museums can hope to contribute effectively to what is actually an ambition to effect change within society, there needs to be a much less fragmented strategic policy framework in general and, specifically, much more structured objectives for museums to meet – and ones that museums (including the many small ones) have the ability to meet. While there is certainly evidence that cultural activity can contribute to social inclusion and neighbourhood renewal, and can make a real difference to individuals and to the groups involved in extended museum projects, this evidence is currently not strong enough to make an agenda supporting social inclusion a main driving force within a museum – nor are there the quality controls in place to make it possible to evaluate the impact of any actions. In contrast, audience development can be

Box 2.1 The journey toward social inclusion

The UK Department of Culture, Media and Sport (DCMS) has recognised that the 'journey toward social inclusion' is part of a process that has a number of stages and will take time for all organisations to achieve:

- access – become an inclusive and accessible organisation
- audience development – reaching out to new audiences, and creating events or exhibitions that are relevant to them
- social inclusion – the organisation becomes an agent of social change

Source: DCMS (2000: 12)

directly addressed and new audiences attracted by setting targeted long-term objectives. In the process, the museum can at minimum prepare the groundwork for later initiatives and, more likely, have a real and measurable impact on local communities by developing new provision that will attract these communities in and by seeking to go beyond the removal of barriers to participation to actively encourage community involvement, including in decision-making. Thus the journey toward socially inclusive museums is likely to involve a series of potential stages, as reflected in Box 2.1, rather than a single step.

Developing New Audiences for Heritage, a report commissioned by the UK Heritage Lottery Fund (PLB Consulting 2001), is a good starting point for exploring the subject, beginning with an 'at a glance guide' to under-represented groups among audiences to UK museums.

This report was commissioned by the Heritage Lottery Fund in order to examine how small and medium-sized heritage organisations in particular might better encourage people from under-represented groups to engage with their heritage and to participate in heritage-oriented activities listed in Table 2.1.

The omission of any reference to the under-representation of ethnic minority groups was due to a lack of available relevant research at the time, since rectified by, for example, MORI (2001). Equally, the groups listed may not reflect the situation in all types of museums or in all countries. Young professionals are a key audience at many art galleries, while in Australia, young professionals, families with babies and small children, and older people are all part of the mainstream museum audience (personal communication from Lynda Kelly).

Baseline research

While there is much to be gained by sharing experiences, what matters is the situation in the individual museum. The starting point is baseline research on its existing audiences and I refer back at this point to chapter 1. Museums cannot afford to neglect existing audiences, but must be constantly striving to improve the service

Table 2.1 Under-represented audiences at UK museums

These include:

- pre-school children
- teenagers
- young adults
- young professionals
- families with babies/small children
- older people
- those with disabilities
- rural dwellers
- members of JICNAR socio-economic groups C2, D and E (see p. 11 above)
- the unemployed
- the socially disadvantaged
- 'people lacking basic skills'

Source: PLB Consulting (April 2001: Table 1)

they are offered. This begins with knowing who they are and what their motivations, needs and expectations are. A combination of a visitor appraisal, to define the nature and potential scale of who the museum's 'traditional' audience segments should be, and survey work to establish who is actually coming will tell the museum all it needs to know about under-representation among those who *should* be coming to the facility they are currently providing. No one is saying museums must put into place policies to attract all under-represented groups, beyond meeting legal requirements. However, the audience appraisal should be developed to assess the museum's potential to attract visitors from under-represented groups and also to assess the barriers that must be removed to encourage such visitors.

It is important to appreciate that the under-representation of particular groups within a museum audience can have a number of causes. It may simply mean that the site is not achieving a high enough percentage of traditional museum market segments, and may come as no surprise in specific circumstances – for example, in percentage terms not enough women visit industrial museums while not enough men visit costume museums. Visitor surveys will reveal any under-representation of this type and the museum may or may not decide to respond. Under-representation may also be generic, and this is what the PLB report (PLB Consulting 2001) is referring to in terms of preschool children, teenagers, adults under 35, young professionals, families with babies/small children, and older people, and may be relevant to some or all of the members of the other groups noted in the list above. It is the potential museum world response to the area of generic under-representation that the bulk of this chapter explores.

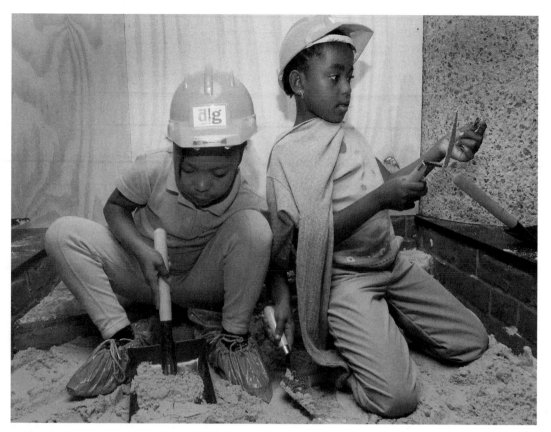

Taking part in an 'archaeological dig' at the Museum of London. © Museum of London

Breaking down the barriers

The concept of 'barriers' is an important one when seeking to understand how museums and communities must work together to eradicate past and present inequalities of access and build a new culture of inclusion. For me the concept has been most accessibly defined by disability consultant Annie Delin, who has authored a number of the UK Museums, Libraries and Archives Council (MLA) portfolio guides on disability issues (see Box 2.2).

Barriers exist within society. If museums are to move forward as active participants within their communities, they must persuade those communities to enter a partnership that can dismantle the barriers together – it is the only way this can happen. Yet the barriers inhibiting the broadening of the audience base for museums and galleries are considerable. On the museum side, they include a lack of senior management commitment; an ongoing fear of alienating traditional museum audiences; a lack of resources; a lack of confidence, or at least uncertainty; and perhaps a fear of the unknown. Taken together, these have a dramatically demotivating influence on staff – a sense that to achieve anything will involve a marathon swim through treacle.

Box 2.2 The concept of 'barriers' to access

The *medical model* (now outmoded) identifies disability as an illness or condition affecting an individual. The onus is on the individual to deal with the consequences, locating blame or responsibility around the person with the disability, leaving them to manage solutions.

The *social model* identifies barriers within society which create disability for individuals. These can be physical, organisational and attitudinal. Responsibility for solving or removing the barriers is shared by all those involved in any situation or interaction.

Source: Delin (2003: 18–19)

From the audience point of view, as the PLB report (PLB Consulting 2001: executive summary p. 5) made clear, there can be a perception of irrelevance; a lack of time; a lack of awareness; a lack of specific facilities; poor physical access to and/or at the site; a lack of intellectual, social and/or cultural access; a sense of cultural exclusion; feeling unwelcome; and costs of entry.

While it is only really since the 1970s that museums have begun to seek a more integral role within the societies that surround them, and only in the last two decades that there has been real momentum behind this work, and extended efforts to develop partnerships with communities, there is an increasingly substantial literature in the field. Many museums have successfully carried out audience development initiatives, and there are a number of relevant publications that cover these. Equally, representatives from previously under-represented audiences are now defining the initiatives required to encourage access and use by their members (see for example Desai and Thomas 1998; Wong 2002). The challenge for this chapter is not to repeat the content of these works but to seek to illustrate how museums can start to make an effective, permanent difference to their core activities. I have tried, therefore, to focus on what I see as the issues faced when seeking to develop audiences from within the diverse individuals and communities who make up modern society, and how these impact on the development of museums that seek to engage with the full range of their potential audiences.

Awareness

Museums are increasingly recognising that their regular users represent only a limited proportion of their local communities and that this situation must be addressed. Cultural, social and physical diversity are historical and social realities at local, regional, national and international levels. As museums have sought to learn about their communities, so they have become increasingly aware of cultural needs.

Many museums have sought to reflect the diversity of their communities, but until recently there has been little evidence of this issue being addressed strategically. While there is increasing recognition of the need for museums to disseminate best

practice, a lot of the initiatives that have been taken by museums represent small-scale, limited period outreach projects, temporary exhibitions, one-off events, etc., rather than the major permanent changes to sites, central displays and associated activities that are required. There has also been a tendency to speak in terms of 'the community' without an awareness of the complexity of local societies, and of 'the disabled' as if people with disabilities form a single entity separate from the rest of society:

> Unlike many other minority communities (including Deaf culture) there is no real disability community. Discrete communities do exist, because of activists and people from impairment groups who may choose to socialise together, but the world of disability is varied and non-homogenous . . . disabled people are present in all roles and social situations . . .

> Delin (2003: 14)

Attitudes and assumptions

Here also we see barriers on both sides. On the side of museums, this is often due to a lack of knowledge, understanding and training among staff. Much has been written about the institutionalised nature of racism and there is nothing of value that this book can add to the subject. Museums must continue to work to celebrate cultural diversity and promote cross-cultural understanding, and this must be planned strategically. We must also be aware of assumptions made about other people in our communities, for example, of public attitudes to the different disabilities. The challenge for museums is to look beyond the disability, to recognise and respond to the needs of the individual.

However, there are also assumptions about museums held within communities:

> there is an entrenched image of museums, which is common across a number of audiences . . . *of 'old buildings', a quiet reverential atmosphere, and a place for intellectuals or 'posh people'*, this attitude is stronger among those who rarely or never visit museums.

> (PLB Consulting 2001: main report, p. 28, including quote from Desai and Thomas 1998)

When researchers exploring usage of museums by the local Black and Asian communities for the Yorkshire Museums Council examined barriers preventing visits, they saw the attitudes and assumptions of non-users to be a key element:

> 'They don't do activities that interest me'
> 'Not enough black culture'
> 'Doesn't relate to me'
> 'Don't feel included'.

> Woroncow (2001: no page numbers)

The British Asian population of Manchester is now well represented in audiences at the art gallery. © Manchester Art Gallery

A starting point for museums is message, image and first impressions. Is the museum saying *we want you* as an audience, come in and use our services, so giving power to community groups? Or is it more a case of grudgingly giving limited access, so very passive and disempowering? The key to this is consultation and involvement. The work of the Drawbridge Group at Nottingham Castle Museum between 1995–2000 showed what could be achieved by involving a group of people with disabilities in planning and instigating change (see MLA u/d). Clearly the training and attitude of particularly front-of-house staff will make a huge difference to the quality of the visitor experience – even more so if communities are represented among the staff. The challenge then is to create an image and a reality for museums that is warm, welcoming, inclusive, supportive, child-, adult- and disability-friendly, and one that encourages involvement and discovery – in other words, an atmosphere that enables all visitors to feel relaxed and at ease. This is the amazing yet obvious thing – making improvements for one target audience frequently improves the visit for all, including existing audiences.

However, in addition to developments on site, museum staff also must go out and engage directly with their communities, seeing people as equal partners on a cultural

The development of audience provision at Manchester Art Gallery included the creation of an audio tour for the visually impaired. © Manchester Art Gallery

journey. The American Association of Museums' Museums and Community initiative, begun in 1998, has sought a national exploration of the potential for engagement between communities and their museums. Results to date include the development of a 'community toolkit'. Equal partnership is a fundamental issue here and can be supported by the concept of 'community mapping': 'the term used to describe the process of discovering the resources available in a community. It gives institutions the opportunity to tap the diverse skills and expertise of their cultural communities' (Massey 2004: no page number).

This is an important issue. An assumption often made by museum staff is that their level of expertise will be on a higher plane to community groups. There is a lesson on partnership to be learned here.

Representation

I have not included references to one of the most dynamic areas of museum development in the USA today, the rise of museums within communities such as Jewish museums, African-American museums and Native American museums. Rather than seeking fair representation within existing museums, and being 'part of the story', groups are establishing their own museums. 'In these separate institutions, each group is in the position to tell its own story, to reinforce the framework it finds compelling, and to show its difference from others' (Smithsonian 2002c: 6–7).

My ambition is somewhat different – to develop provision in existing museums to represent, respond to and meet the needs of all their potential audiences. Communities themselves have become increasingly aware of their rights to representation and participation. For example, Judy Ling Wong makes clear that the interpretation of cultural diversity is both a celebration of identity and a rooting of all in an 'inclusive heritage', a 'common history':

> The mono-cultural dominance of the official histories of many countries means that citizens whose cultures are neglected cannot begin to mould their presence and make their contribution toward an inclusive heritage. It is time for them to make their legitimate claim and situate themselves within the socio-cultural history and heritage of their countries in order to advance from the position of the normal social strength of being rooted in a common history and heritage into the future.
>
> Wong (2002: 5)

A similarly strong case about the lack of representation of disabled people in museums is made by Annie Delin:

> Within museums, disabled people might not find a single image of a person like themselves – no affirmation that in the past people like themselves lived, worked, created great art, wore clothes, were loved or esteemed . . . The heroic stories about admirals and poets, artists and craftspeople often neglect to point out when the illustrious were also unusual in the way they walked or spoke.
>
> Delin (2002: 85)

The attitude among communities that a museum 'doesn't relate to me' will only fully disappear when those communities are not only welcomed into the museum but also properly represented in it – in the collections, in the histories presented, in the programming, in the development of multiple perspectives within exhibitions, and in the staff.

Cultural, intellectual and emotional access

Barriers to intellectual access begin among those who do not visit museums owing to lack of knowledge about what is available and the benefits of visiting. Rather than

Box 2.3 Developing displays for intellectual access

- Can the interpretive material, etc., be understood?
- Does it cater for different learning styles to maximise access for people of different ages and cultures and to enhance the experience for those with sensory disabilities or learning difficulties?
- Does it use simple, 'active' language, supported by a 'layered' approach to ensure that the needs of the full audience are catered for? The issue of catering for different language needs can also be an important one, but this may be partly overcome by the use of more imagery and diagrams – something that will also appeal to young children.
- Does it reflect the reality of the lives, for example of disabled people or from the black community, in the contexts and eras displayed?
- To what extent can visitors see themselves in the display or interpretation, or identify with people or objects they see?

keeping to the normal marketing approaches, it is important when seeking to target new audiences to research how people within the communities involved access information and then to seek innovative ways of putting the message across. Research by Yorkshire Museums Council discovered the central importance of word-of-mouth recommendation. However articles in local newspapers and magazines read by the community groups may also be effective, as will television and radio coverage. The crucial issue may well be to work with some community groups to begin to develop community provision, and rely on its quality and long-term nature to build momentum.

Clearly there can also be an anxiety about visiting unfamiliar places because of previous experiences of discrimination, the uncertainty of the welcome you may receive and the difficulties you may have in 'fitting in'. This will start at or before the front door (see 'threshold fear' below, p. 190). Issues continue with the whole atmosphere of the site, and the way in which exhibits are presented. The quality of staff and interaction with them can play a major role in enhancing intellectual access, but we must also look to exhibitions that use a palette of design approaches which will be discussed in depth in Section 4. Discussions with visitors soon reveal the extent to which they can feel marginalised by displays (see Box 2.3).

Direct involvement can also play a key role. Regular consultation, the establishment of partnerships between the museum and other agencies, community groups, etc., and direct participation in the development of exhibitions and activities will all enhance intellectual access and give communities a greater understanding of what museums can and cannot do.

Physical access

Clearly physical access is an important issue for visitors with disabilities, not only in terms of entering a building and following the same route as everyone else, but also

in viewing and touching collections, reading labels or having alternative forms of access to information, having the provision of adequate resting places, having lighting of suitable quality, and so forth. However, it is important to remember that ease of physical access is a relevant issue for everyone. In the research by Yorkshire Museums Council noted above, it was discovered that physical access was a particular concern within the Asian community, who often visited in extended family groups: 'Visits would be made with elderly relatives and young children. Wheelchair, pushchair and accessibility for the infirm were considered very important in contributing to the quality of the visit' (Woroncow 2001: no page number).

Enhancing physical access, providing lifts, improving lighting and preventing reflections in cases, providing opportunities to handle collections, increasing the font size of text and providing information in a variety of accessible formats and in different languages (including perhaps sign language) will improve the experience for all visitors. Visitor comfort is equally important for all. Seating should be placed where it is needed most: for adults with children, where children will want to play independently; for those with walking difficulties who need to rest regularly; and for independent adults where they are most likely to want to take in detailed information or look for any length of time at a display. Sight lines must be considered, for example for people with disabilities or for families with young children who all need to feel that they are safe. Signage and layout work together to enable visitors to get a clear overview of what is where in the building so that they can make sensible choices and avoid confusion. Research on older visitors to Australian Museums (Kelly *et al.* 2002) also emphasised price sensitivity, the importance of comfort factors (toilets, etc.), minimising stairs and backtracking, and 'senior-friendly' exhibition design which avoids dark spaces and includes quiet areas.

AUDIENCE DEVELOPMENT PLANNING

Understanding the nature of barriers to museum usage, and how a start can be made in overcoming them, is an important element in seeking to broaden the audience base. However, it is only part of the story. Audience development planning is a long-term challenge. In setting out to develop new audiences, you are actually seeking to change human behaviour. Rather than persuading the 'traditional' audience to visit more often or to go to additional sites, you are seeking to persuade non-visitors to come – many of whom feel excluded from society as a whole, and/or feel strongly that museums and heritage sites are not for them. You are not seeking simply to get people to do something as a one-off, but for this to be a permanent change of behaviour – 'people must unlearn old habits, learn new habits, and freeze the new pattern of behaviour' (Kotler and Andreasen 1996: 393). The bottom line here is the nature of the product on offer and the relevance of this to target audiences. There must be a willingness to change what is on offer or there is no point in starting the process.

Rather than outlining my own approach to the creation of an audience development plan, I would point in the direction of what I currently consider the most useful text, provided by the UK Heritage Lottery Fund: *Audience Development Plans:*

Helping Your Application (see Box 2.4). The text speaks of social exclusion and under-represented audiences before defining audience development and what constitutes an audience development plan, and then going on to provide substantial guidance on how to create one. It is, however, equally applicable to all audiences, not just to the diversification of the audience base. The guide defines audience development as 'The actions we take to involve people, to understand their needs and interests, and to create an environment and experience that appeals to them, are the main elements of audience development' (p. 4).

Values versus targets

> The kind of culturally inclusive museum I imagine is not a static display of treasures, but a space within which we can all explore and debate values, meanings and identity through contact with objects. It is a place for storytelling, where the silent, the marginalized, the newly-arrived and the despised can, for once, be the subject of their own narratives rather than the object of other people's. It is a place of change, but one in which the consistent threads of museum values – education, for example, tolerance, trust in people, dialogue and independence – always link the past, the present and what is to come.
>
> Matarasso (2000: 6)

This chapter has come down firmly in favour of an 'audience development' strategy to encourage under-represented groups to participate in museums, rather than supporting the project-based approach adopted by most museums to develop new audiences from among previously excluded sectors of society. Does this mean the abandonment of a belief that museums should be accessible to all and seek to meet the needs of, and potentially inspire, the whole of society?

Project-based work has led to many individual successes (see, for example, Dodd and Sandell 2001). However, projects by their very nature are both short term and peripheral to the core activities of the museum. As Matarasso says with regard to the add-on project provision that is commonplace in museum outreach work: 'It seems illogical to believe that a response to social marginalization which is itself marginal to the service promoting it can have a serious or sustainable impact on the problems it has identified' (Matarasso 2000: 5).

Ambitions to develop museums as inclusive institutions will remain no more than aspirational until they are absorbed into both the ethos and the senior management teams of museums, 'arising from the heart of their values and purpose' (Matarasso 2000: 5). From the top to the bottom of the institution, the long-term and resource-heavy nature of this commitment must be fully appreciated and supported.

This is not to deny a place for project work within museums. The opportunity for individuals and groups to engage with museum collections and staff in a sustained manner over a period of time should be a fundamental aspect of the service museums

Box 2.4 An audience development plan

Before carrying out actions that are designed to attract specific audiences for a heritage activity, museums and heritage organisations need a good understanding of the environment in which they work and the stage they have reached in their own development.

Ask yourself these questions:

- What are we, as a heritage organisation, trying to achieve?
- How does audience development fit in with our corporate or business objectives?
- Are we ready to carry out audience development work?
- Do we have the necessary supporting policies (for example, access, education, equal opportunities, conservation and training)?
- Do we have the necessary skills and resources?
- Who are our audiences now?
- Who do we want our audiences to be in the future?
- How do we reach them?
- What will we offer them?

An *audience development plan* is a framework for answering these questions and for planning the specific activities that will allow you to reach your target audiences and to offer them a high quality experience.

There are four steps to creating an audience development plan. Each step involves both internal and external consultation, and should always take place in the context of the overall objectives and the particular circumstances of your organisation.

The four steps to creating your plan are:

1 assessing where your organisation is now
2 understanding your current audiences and the barriers that prevent people taking part
3 assessing your organisation's potential for audience development and setting objectives
4 setting an action plan for each target audience.

Each of the four steps above should include the four points below:

- the issues you need to consider
- the tools you might use
- the help and resources you might need
- sources of information and advice.

Source: *Audience Development Plans*, Heritage Lottery Fund

provide. Equally, no one is saying that a museum should cease to support the needs and expectations of its 'traditional' audiences. In fact, I hope that the comments above on developing provision for under-represented groups suggest that enhancing provision for specific audiences will improve the quality of experience for all visitors.

A museum cannot transform itself overnight. It is time to wheel out an ancient cliché – changing museums is a bit like trying to turn an oil tanker. Museums are like any long-established institution which had in the past a clear sense of purpose and direction, and developed its staff structure, budget, activities, etc., to respond to this. They are now facing a wide range of new demands and must somehow retain what was central to past functions while also changing to perform new tasks. The way forward is surely to establish a vision of future direction and then to focus on the achievable. Clear targets are a practical representation of that vision and the aspirations that underpin it. They are also a means of achieving early wins that provide opportunities to celebrate and support momentum among staff and within communities. In addition, as elements of these targets will be attached to every ongoing development within the museum, there will be continuing progress toward their realisation rather than the stop–start impact of a solely project-led approach.

DISCUSSION: HOW WILL AN AUDIENCE DEVELOPMENT STRATEGY IMPACT ON A MUSEUM'S PUBLIC FACE?

A museum truly committed to broadening its audience base by targeting under-represented groups and those currently excluded from society will be influenced from top to bottom by this commitment. But what does this mean in terms of the creation of the 'engaging museum'? A useful place to start is to think in terms of inclusiveness – integrated, democratic, the same experience for all – a 'stepping stone' to representation as members of staff, artists, in events, programmes, collections, exhibitions and research. As a term, it therefore incorporates not only the physical and sensory, but also intellectual, social, cultural and economic access – the removal of a whole range of barriers to participation.

An inclusive museum will take great care about the images it projects to the outside world – and will also use alternative channels to reach potential audiences. It will seek a warm, welcoming, friendly and supportive atmosphere and a responsive staff, paying particular attention to the point of arrival. Visitor orientation, both physical and conceptual, will be clear, allowing visitors to choose for themselves and ensuring no one is faced with 'not knowing how to behave'. The building and exhibits will be physically accessible to all, with all visitors able to select the same routes and take part in the same activities. Exhibitions will use a palette of display approaches and have a layered provision of support material to meet the differing needs of visitors. There will be a regular programme of activities and events to ensure there is always something new to be involved in. The museum will do its best to ensure that all visitors enjoy their experience and leave looking forward to coming back. All of these elements are discussed in more detail later in the book.

But this is not enough – the list above is largely product-led and the museum must also focus on people. There is another meaning here to the term the 'engaging

museum'. The museum must also go out and seek to engage directly with its audiences and communities. Regular surveys of, interviews and focus groups with both users and non-users will enable the museum to evaluate the impact of its work, help it to define the aspirations of communities and individuals (and therefore to tailor services to meet these), and will also provide opportunities to identify, consult and involve potential audiences. Outreach and in-reach work with community groups should form an integral part of museum activities rather than remain a marginal add-on. Forming partnerships with community groups and other organisations can reap major rewards for all sides, leading to dynamic programmes of exhibitions and associated events within the museum and within the community.

The impact of community participation should be reflected in the public face of the museum through the development of new collections representative of communities; positive representation of different communities within exhibitions; exhibitions that reflect diversity and encourage the making of connections between cultures and communities; exhibitions that bring multiple perspectives to subjects; exhibitions developed by community groups themselves, produced to professional standards because, if necessary, the groups have been trained and provided with the support and facilities to achieve those standards; a wide range of activities that reflect local communities; and the presence of volunteers and staff from local communities.

The museum must stand back and realise that it will not be able to make these changes alone. The days of museums operating in isolation are over – partnerships will bring extra support, expertise and specialist guidance, risk sharing and frequently funding. It will also not happen overnight. It will only happen in the long term and it will only happen if it becomes part of daily working practice within the museum:

> For the Grange museum the question is no longer, how can we work with black and minority ethnic groups and individuals? It is more, how can we ensure that the work we do with these groups is mutually beneficial and of strategic importance? In other words the emphasis is on building long-term partnerships which can provide long term benefit . . .
> Alex Sydney, Head of Museum, Archive and Arts, London Borough of Brent, quoted in London Museums Agency (2003: 24)

One key partnership must be with existing audiences, as museums cannot afford to lose those while seeking to develop new ones. As chapter 1 demonstrated, most museum and heritage visitors belong to the professional classes and are white. However, the good news is that the needs of existing and currently under-represented museum audiences frequently overlap, and most relate to the museum becoming much more visitor-centred in its approach. For all audiences, the real challenge for museums is to meet the basic needs of those who come, and then provide opportunities for visitors to engage with collections and exhibitions as they so choose. Section 4 of this book seeks to demonstrate how this can be achieved.

CASE STUDY: DEVELOPING MUSEUM CONTENT FOR YOUNG CHILDREN AND FAMILIES WITH BABIES/YOUNG CHILDREN

One under-represented audience on which little has been written within general museum literature is young children. The UK Office for National Statistics (2000), *Social Trends 30* (quoted in the 2001 PLB report) estimated that children aged under 5 represented around 6 per cent of the UK population and those aged between 5 and 9 another 6.5 per cent, making around 7.3 million children under 9 living in the UK, with some 30 per cent of households having dependent children. Here is an enormous and ever-changing potential audience.

Let us begin with some obvious truisms. First, children go through a range of stages between birth and becoming what is normally seen as a 'museum-suitable' child audience of 7 to 12 years of age. Second, if families have more than one child, and a museum wants the older but still dependent sibling(s) to visit, it is going to get the younger one(s) as well. Third, for babies and young children to be seriously under-represented in museum audiences means museums are not only missing them but also missing the adults who would come with them. Fourth, babies and preschool children and their accompanying adults are available while older children are at school (and I would add, from my own experience, desperate to find young-child-friendly places to go to). Fifth, if you want to engage parents of babies/young children with your collections, you are going to have to provide for the offspring. Finally, personal context is even more essential to young children than to adults. Young children have very limited life experience and it is vital that they can relate what they experience in the museum to their own lives – their home, their family, their toys, etc.

The concepts behind the innovative display approaches and programming that have contributed to the remarkable success of the children's museum movement over the years have had an important influence on the wider museum movement. Research by Gibans and Beach (1999) states that '21 per cent of other museums suggest that children's museums play a research and experimentation role in areas such as museum learning, family learning, interactive exhibitry, and even schooling' (Gibans and Beach 1999: 15). Dinosaur displays are also, of course, very much the terrain of the under-7s. However, museums are increasingly seeking to develop relevant display approaches across their full discipline range. In the UK, their success is being celebrated through *The Guardian* newspaper's annual competition to find the most child-friendly museum.

However, far more museums are still ignoring this audience. I have no idea why, given that babies and young children form such a potentially significant part of the museum audience as part of family groups, and given the scale of the research now showing the significance to later museum visiting of being taken

as a child and the experiences you had there (Falk and Dierking 1997). Creating displays and activities targeted at this audience can be great fun and very rewarding. Perhaps more importantly, in creating displays which encourage young children and accompanying adults to engage and interact together, museums will not only help the children to build confidence in themselves as capable learners, but will also help them develop quality relationships with adults, support parents and grandparents as effective teachers of the young, and support early childhood teachers in their development of quality educational provision. Equally, adults can frequently learn more on a visit when accompanied by children than when not – they need to, so that they can explain things to their children.

Children have a remarkable capacity for excitement, an overwhelming desire to get involved and vivid imaginations. They are immensely curious when encouraged, but have short concentration spans and an inability to stay politely quiet when bored – and the younger they are, the worse this is. Unsuccessful exhibits for children tend to be passive with little or no interaction, to require reading skills, to have confusing or unclear spaces, and to be not directly related to children's experiences – in other words, typical museum displays. However, it is not difficult to create successful, child-friendly exhibits and there is no need for a museum to start from scratch here. Thanks to the success of the children's museum movement, there has been specific research on what type of exhibits work with young children. Regnier (1997) identified several elements in successful designs for children's exhibits, including gross motor activities, multi-sensory activities, sand and water activities, real objects, role-playing with costumes and props, animals, places to hide, opportunities to emulate adult activities, assembly and disassembly activities, and experimentation that requires little formal instruction.

For very young children (under around 3 years of age), the most appropriate approach is almost certainly to create small safe environments within galleries, alongside displays which contain toys and other materials that children can play with:

> Young children learn by doing. Every action – including pushing, pulling, mouthing, grabbing, throwing and balancing – gives them more information to make sense of a complicated world.
>
> Young children are tuned in to myriad sensations at any given moment – the surprise at hearing a new sound, the fascination with a whirling ceiling fan, the endless experiments to see 'what would happen if?'
>
> A child's task is to figure out the nature of objects, materials and people, and how they all interact.
>
> The challenge then is to create exhibits and experiences that match the developmental levels and needs of young visitors . . .
>
> Oltman (2000: 15)

We run the risk that children will come and play in parallel to the museum rather than in response to its collections. This does not mean, however, that having young children play in the museum does not have value! Play is, after all, a key way in which children learn. Equally, if playing alongside collections means that children grow up viewing museums as fun places to go to, places to feel comfortable and welcome in, then this is a worthy aim in itself.

For children between 3 and 7 years old, museums can aim much higher than this. All children learn by doing and by imagining. It is the museum's task to provide opportunities for both. This is relevant both to structured educational use by 3- to 7-year-olds and for use during family visits. In the UK, there are defined study units and schemes of work for 4- to 7-year-olds (Foundation Year and Key Stage 1) and it is as important to 'build in' relevant project work for these children as for older ones (see chapter 6). However, it is not enough just to build an area that is specifically targeted at young children; it is as important to ensure that there are things for young children to enjoy doing on their own and with their parents throughout the museum.

A key way children will hear what a museum has to say will be through the activities provided. The challenge is to develop structured opportunities that seek to immerse young visitors into the experience – treating them not as passive observers but as participants, with opportunities for active engagement; direct and immediate experiencing of objects, people and events; encouraging and provoking children to grasp and integrate new concepts, etc. These need to be highly visible and spread throughout the collections to encourage the possibility of interaction with objects. As children will take on information about the objects both independently and through accompanying adults, it is important to consider what prompts are provided to encourage adult–child interaction and what the museum is providing to enable children to make further sense of objects independently.

Who they have come with has a substantial influence on the experience that children have. More than any other audience segment, young children will experience museum displays as part of a group, almost invariably including adults. Families should be encouraged to explore the galleries together, with parents and children supporting and stimulating each other. Participative exhibits and activities should be devised for use by family groups, using them together, rather than as individuals. As a family audience, the needs of each member – not just the children – should be addressed. Museums should also develop some basic support materials (activity sheets, drawing materials, activity back-packs, etc.) for families to take around the displays. This will be in addition to planned activities, events, etc., and could be added after the displays are completed.

Fantasy is an intimate, personal and imaginative thing. To the child there is a potential for fantasy within every experience. Interpretive displays that encourage fantasy can spark interest and involvement, even though the display itself may be quite static. Opportunities to dress up, to listen to or tell or draw or read or write or re-enact stories will all be successful with children.

An activity zone in action at the National Museum of Childhood. © National Museum of Childhood, Bethnal Green, London

The family area had proved to be a big hit. This was simply two comfortable chairs, storybooks at the side and a selection of old toys and clothes from 'grandma's attic'. They had a simple table and chairs and some colouring sheets for the children. There was a pen and simple pro forma for parents to write about their childhood memories. This week they had brought out of store an early television and parents/grandparents were asked to write about childhood memories. The serious point here is that it gives adults a distinct 'quiet area' in which to share a story. This is also popular at the weekends with family groups. The storybooks are placed just to the side.

Steven Burt (personal communication 2001) speaking of the redisplay of Abbey House Museum, Leeds

Images are vital for children. Museums should use images of real children where possible to communicate concepts to children within the context of objects both being 'the real thing' and belonging to the past. Children under 7 or 8 are only developing a sense of time and will find it difficult to place individual items within their time context. Dates do not mean anything. The passage of time is a difficult concept for young children to grasp and the use of photographs, including people in the clothes of the day, may help in building this understanding. Museums should also seek to include at least copies of paintings, engravings, etc., featuring children, to help 5- to 7-year-olds (Key Stage 1 at school) to assess information from a variety of sources. The images should occur at different scales to maximise appeal. Where images are being used to create an environment and/or presence of children they should be large – life size if possible. At least in some parts of the museum, children should be able to stand next to figures and compare themselves at that age. Where the role of the images is to provide additional layers of information, imaginative ways of presenting them should be sought, rather than resorting to interpretation panels. For example, photograph albums are a familiar format for children and one they are used to sharing with the adults in their family.

Most children under 4 cannot read. By 5, they may be beginning to but it is still a big effort. They may, however, enjoy reading single words or short phrases. As they get older, and their mastery of text increases, they often choose not to read when offered the choice of activity instead. For these reasons, communication with children will *not* primarily be through text. Young children's main connection with text will be through their parents or carers. Adults expect to read detail on behalf of their children and to some extent to re-interpret what they have read. Labels attached to objects or collections should seek to give parents the information they need to connect with children's questions or to awaken children's curiosity. Such labels need to be 'interpretive' – to encourage close observation, comparison, etc. – rather than simply giving information. There should be some simple text that children beginning to read will be able to comprehend. This will incorporate the key words defined in the relevant curricular units. One text layer will be the exhibition and section names. These will be kept easy to read and understand, offering children of 5+ years an element of conceptual orientation.

A word on freedom and safety

In developing displays targeted at young children, there are some basic commonsense practical issues to consider – using non-toxic materials; avoiding sharp edges, choking hazards, etc.; using hard and easily cleaned surfaces for messy areas. Comfort is equally important – soft areas encourage quiet play, while seats for curling up in lead naturally to story-telling. Parents also need

adjacent seating if their young children are likely to spend a considerable period in a small play area.

It is important for young children to be able to move about freely and decide for themselves where to go and what to do, *however* it is equally important for parents to be able to keep track of them. Having only one entrance/exit helps, as does an open floor plan. Children also like to test themselves in a safe environment – a darkened tunnel or a climbing area will be a guaranteed winner (they are combined in the 'chimney' at the English National Trust Museum of Childhood, Sudbury Hall).

An interpretive approach to the provision of displays for young children

From the text above you can define something of the nature, needs and expectations of an audience of young children and their accompanying adults. It is up to the individual museum to define its objectives in seeking to target this audience and the level of support and commitment it therefore intends to provide.

Art galleries have been very much in the lead here, with the use of 'art trolleys', storytelling and 'activity backpacks'. To these you could add activity trails (find out, draw, where is, etc., as a trail around a gallery or museum, preferably with a prize at the end). These are all very effective in enhancing the experience for children. They also have the great advantage of being grafted on to existing galleries rather than being display approaches targeted specifically at young audiences. They therefore require no major capital outlay, but need most of all a period of sustained piloting and evaluation before going into full use. At The Workhouse, Southwell, the English National Trust introduced a trail game – 'Master's Punishment' – based on snakes and ladders, with all the elements directly related to the workhouse punishment book. Families play together. Each member throws the dice once in each room. If your piece lands on 'See the master', you must go to the room volunteer, who will have a card with a real punishment from the workhouse. There are lots of punishments and not many rewards, to reflect life in the workhouse. The game has proven very successful – with children particularly delighted when their parents get a nasty punishment. There is an 'I survived the workhouse' sticker as a prize for completion.

Building elements into a display requires a more structured approach. Do your objectives include attracting substantial use by structured educational groups of 4- to 7-year-olds? If so, will this require a specific children's gallery – one that will also be a major signal of intent to, and heavily used by, adults with young children? Do you want to give over an entire gallery space to this audience – and would the audience come in large enough numbers to justify the outlay? Or are young children and families with young children not a priority audience, but one which you will seek to incorporate simply by placing relevant elements throughout the displays? If so, what will be the most appropriate in

your circumstances? Piloting is particularly important for this audience – it is very easy to spend a lot of money badly. The multiple use of other display elements can be particularly relevant here – for example, from incorporating images of children as well as adults in displays, to seeing 'dwell points' double up as locations for the art trolley or for storytelling. Making space for children to lie on the floor and draw in front of key exhibits is also important, while tunnels leading to glass domes in the centre of nature habitats (especially if accompanied by sound) can be very popular. Remember also that children are small – cases that begin at adult waist height are useless. You preferably need glazing down to ground level or, alternatively, steps for children to stand on.

Finally, a basic point: while the piloting of elements grafted on to existing displays can be an effective way of developing support facilities for young children and their families, it is essential to consult widely before taking the major step of creating a children's gallery. Kids' Island at the Australian Museum, Sydney, was created in 1999 after extensive research through focus groups and interviews. These found that parents/carers wanted:

- plenty of space, including outdoor areas for play, exploration, fresh air and eating
- activities where you actively participate through sensory experiences, especially touch, and where you can 'get up close'
- experiences that are content-rich, not superficial, and based on the organisation's strength
- to start with, and then build on, familiar concepts and ideas
- activities that are fun
- a mixture of physical and quiet activities
- activities that are specifically catered to the age/developmental needs of children
- activities where parents can choose to join in or just sit, watch and relax
- facilities close by (e.g. toilet, nappy change and feeding areas)
- a safe environment where children can't escape
- an Australian focus on animals and culture, including indigenous culture.

Kelly (2002: 7)

For the future, given that there is now a reasonable understanding of what types of exhibits will engage young children and their families, attention must be given increasingly to how young children actually learn in a museum environment and what we can do to enhance this learning. Barbara Piscitelli and David Anderson are members of the Queensland University of Technology (QUT) Museums Collaborative, 'investigating young children's interactive and informal learning in museum-based settings and seeking to enrich young visitors' museum experiences through research, training and staff development' (the article referred to below and others can be accessed from the QUT website,

listed in the Bibliography). As one element of this research, they surveyed seventy-seven young children from Brisbane, Australia, using interviews, a guided questionnaire and free-choice drawing. Their conclusions were that:

> . . . it was abundantly evident that their experiences to date were overwhelmingly positive . . . that children perceived museums as settings that were exciting, happy, and provided opportunities to learn and gain many ideas.
> . . . children's spontaneous recollections of museum experiences were predominantly drawn from their memories of the natural and social history museum . . . the common thread connecting young children's experiential recall centred on exhibits, objects and displays which were large in size.
> . . . children's visual recall and verbal descriptions of their previous museum experiences were remarkable for their accuracy in depicting actual exhibits and architectural features of museum settings.
> . . . children's salient recollections of their visits to museum settings centred on experiences which appeared to be non-interactive in nature, and directed toward the large-scale exhibits.
> . . . neither the art gallery nor the interactive science and technology centre exhibitions provided context or links which connect with children's everyday life experience.
>
> Piscitelli and Anderson (2001: 279)

I was particularly fascinated by the emphasis on the importance of non-interactive experiences – not surprisingly including dinosaurs. Instinctively (but based on no research) this reflects the interests of young children and their capacity for fantasy. These are fascinating results that emphasise the need for more research but already provide a categorical response to those who accuse a museum of 'dumbing down' because it seeks to cater for this audience. Museums are helping children to develop in their own right, while establishing the next generation of adult visitors.

Section 2
Operating for quality

> The stark realisation that heritage visitor attractions provide the focus for the heritage industry's involvement in a global tourist industry . . . contrasts dramatically with the knowledge that the professional management of heritage attractions, in terms of operations management, is in its infancy.
>
> Millar (1999: 1)

As previously defined in Box 0.2, the underpinning thesis of this book lies in the holistic nature of the museum experience:

- providing the stimulus to visit in the first place – site image, quality of marketing and PR, word-of-mouth recommendation by previous visitors, prior personal experiences, supporting learning agendas, reflecting leisure trends, etc.
- placing visitors in the 'right frame of mind' on site so that they wish to engage with collections and exhibitions – operational and service quality, sense of welcome and belonging
- providing the motivation and support to engage directly with the site and/or collection – quality of interpretation, learning provision and displays.

This section of the book is concerned with those factors that may influence the individual's or group's agenda toward a museum visit and ensure the right environment is developed in which visitors are encouraged to engage with collections and through this have a fulfilling experience. These factors are:

- the importance of promoting positive external images of the museum as a motivating factor (chapter 3)
- enhancing the quality of visitor services to support and encourage visitor access, in its widest sense, to collections and exhibitions – and evaluating to ensure quality standards are met and sustained (chapter 4).

3 Stimulating the visit

> [T]he ultimate objective of marketing is to influence behaviour.
>
> Kotler and Andreasen (1996: 37)

INTRODUCTION

> Zoos have been forced to change by a public that has seen on television dozens of authentic wildlife shows in which animals were roaming freely. They have found Disneyland more entertaining and educational than zoos. At the same time, conservationists have argued that the conditions in which animals were kept in many zoos were cruel and abusive. A cadre of new zookeepers wanted to try new approaches.
>
> These pressures have caused zoos to change their missions and the way they present their 'products'.
>
> Kotler and Andreasen (1996: 35)

The objective behind this chapter is to highlight the importance of the issue of external image. As I hope has already been made clear museums, like zoos, face major pressures for change. In their case too, those pressures are leading museums to change their missions, becoming people-centred rather than product-led – and we explore what this means for the museum mission and product later in the book. It is equally important that museums also face up to the need to change the way they present themselves to their target audiences. A re-assessment of the importance of the image of themselves that museums project to the outside world is long overdue. This has two immediate functions:

- to persuade people that visiting museums will be a positive, enjoyable and relevant experience that will meet their needs and represent good use of their leisure time (*Positioning the museum*)
- to prepare visitors in advance so they are motivated to engage with collections and displays when they arrive (*Influencing the visitor agenda*).

There is a need for a sustained campaign to change the image of museums in general. Alongside this must sit site-specific image projection that will attract people to a museum in particular and prepare them for the experience. These functions are closely related and equally important. It is only through new audiences coming to, and being inspired by, individual sites that more general negative attitudes will be broken down. The image you want will be hard-won and equally difficult to sustain, but your museum's future probably depends on it.

In the space available, this chapter cannot seek to define an audience development plan (see chapter 2) or a marketing strategy that will illustrate how barriers to museum visiting can be overcome – although the case study on Manchester Art Gallery at the end does provide one successful example. Every site and its audience will be different. The challenge is to make more people aware of the museum and what it has to offer (a 'cognitive' element), achieve a responding positive reaction (an 'emotional' element), and then seek to motivate a visit and put people in an active frame of mind for this (a 'behavioural' element). My view remains that word-of-mouth recommendation will always be the most effective form of marketing for museums – it will come from a friend or relative and it will enthusiastically cover all three of the elements. However, this approach is most effective with those who already visit museums. Other approaches must be sought to engage non-visitors.

AWARENESS

There is a tendency, if you work in a museum, to assume that everybody knows it is there. In fact, ignorance of your existence is a major barrier for many who might be potential visitors.

Commonsense tells you that people are bombarded with information daily, and much of that is to do with attempting to persuade them into courses of action – from advertising commercial products, through political agendas to religious and lifestyle groups. To survive this bombardment requires an ability to be selective in where people give their attention, and to be able to do this rapidly and subconsciously. We seem to have a built-in ability to screen out all those messages that do not relate to our own beliefs and interests.

The challenge museums have in reaching the broad range of audiences who currently do not visit lies initially in breaking through that screen and persuading people to notice the existence of museums. Equally important is the challenge museums have in reaching those who come only infrequently – in making people aware of how the museum is changing and of its programme of events and activities. In marketing terms, this means the museum must be positioned in a way that relates positively to people's attitudes and interests, and then should take a proactive approach to ensuring information on the museum and its programme reaches the target audiences, rather than continuing to rely solely on the brochure and other existing marketing approaches.

ENTRENCHED NEGATIVE ATTITUDES

Before someone visits a museum, he or she will already have a mental image of it. The image will define his or her attitude toward the museum and will have a major influence on any decision on whether or not to visit and on expectations of the visit. One definition of a museum's external image would be as the 'sum of beliefs, ideas and impressions that people have of it' (based on Kotler *et al.* 1993: 141). The authors distinguish between an image and a 'stereotype', with the latter defined as 'a widely held image that is highly distorted and simplistic and that carries a favourable or unfavourable attitude toward the place', while the former is seen as 'a more personal perception of a place that can vary from person to person'. Kotler and Andreasen (1996: 189) distinguish between an image and a 'belief'. A belief represents a single view (e.g. a good place for schoolchildren), while an image is made up of a whole set of beliefs. Equally, Kotler and Kotler (1998: 135) distinguish between an image and an 'attitude'. Two people can share the same image of a museum (e.g. as a treasure house of important objects) yet have completely different attitudes toward it – from inspiring, to irrelevant and boring. Attitudes, in turn, can often be referred to as preferences, as likes and dislikes.

For many museum non-users a highly negative stereotype continues to dictate their attitudes to museums. A major problem with a negative image is that it can last long after the reality has changed. Although many museums have transformed themselves over the last 30 years, they are still thought of by many non-users as dry, dusty places, with cobwebs on the displays, and staffed by surly, unwelcoming or even rude museum attendants who are clearly out to ensure you do not enjoy your visit. This is substantially what marketers would refer to as an 'organic' stereotype, one that is the result of half-remembered, distant experiences, conversations, television programmes, etc., PLB (PLB Consulting 2001: main report p. 28) refers to an attitudes survey of London museums (LMCC 1991) which discovered that a significant proportion of adult non-visitors had received a negative experience of museums as children and, unaware of modern developments, have not been stimulated to try visiting a museum again. A report by MORI (1999) stated that 23 per cent of those aged between 15 and 24 saw museums as 'boring' – the second most cited reason for not visiting museums or galleries. Meanwhile, MORI (2001) reported that 59 per cent of the 72 per cent of the UK population who said they had not visited a museum in the previous 12 months do not see museum visiting as something they want to do. (Forty-one per cent of those who said they did not visit gave as their reason 'nothing I particularly wanted to see'; a further 12 per cent said 'museums are boring places', with 6 per cent saying 'my children wouldn't be interested'.) I refer back here to p. 55 and the identification in the PLB report (PLB Consulting 2001: executive summary p. 5) of key barriers to museum visiting – a perception of irrelevance; a lack of time; a lack of awareness; a lack of specific facilities; poor physical access to and/or at the site; a lack of intellectual, social and/or cultural access; a sense of cultural exclusion; feeling unwelcome; and costs of entry.

Clearly irrelevance and boredom go together – you will be bored if you do not consider the exhibitions relevant to you. This relates directly to Tilden's first principle of

interpretation, discussed further in chapter 7 below: 'Any interpretation that does not somehow relate what is being displayed or described to something within the personality or experience of the visitor will be sterile' (Tilden 1977: 9).

However, it is not just, or even mainly, an interpretive issue. Like many of the other barriers noted above, it is crucially about perception – about the external image of museums. While there are real changes in provision that need to be made, a lack of awareness of the current situation is equally central – if you, your family and friends have not visited a museum or gallery for a long time (if ever), it is your perceptions that matter – your entrenched attitudes that must be overcome if those barriers are to be broken down. And the barriers *must* be broken down if museums are to broaden their audience base.

THE 'WRONG' POSITIVE PERCEPTIONS

Many people have what museum professionals would consider highly positive attitudes toward museums. A brand audit carried out by the Powerhouse Museum, Sydney, in 1998, to clarify the museum's position in relation to other competitors in the leisure field involved 353 respondents from the general Sydney population. It saw museums described as 'absorbing', 'intellectual', 'thought-provoking', 'educational' and 'places where one can touch the past and discover new things' (Boomerang! 1998, quoted in Scott 2000: 42).

These responses must be balanced against the attributes respondents defined for the ideal leisure experience – one which was 'fun, entertaining, exciting, relaxing, a place where one could take friends, a place where one could get lost in another world and which was value for money' (Boomerang! 1998, quoted in Scott 2000: 41).

There is substantial academic study being carried out at the moment on the concept of the 'depthless' leisure experience (Rojek 1995) – the search for leisure activities that lack intellectual commitment as a response to the rapid change and rejection of traditional structures in contemporary society. This is reflected to some degree in the external activities respondents to the Boomerang! survey participated in most frequently:

- going to restaurants and cafés – 66 per cent
- exercising and playing sport – 64 per cent
- shopping for pleasure – 59 per cent
- visiting pubs and clubs – 52 per cent
- visiting parks and gardens – 46 per cent
- going to the theatre/movies – 41 per cent
- going to the beach – 35 per cent
- attending sporting events – 34 per cent

(Boomerang! 1998, quoted in Scott 2000: 42)

Visiting art galleries and museums was a frequent event (by which the survey meant monthly) for only 5 per cent and 3 per cent of respondents respectively.

Museums need to take care here. We know that we can provide enjoyable, exciting

and stimulating experiences for families and groups of friends to participate in together, while remaining 'absorbing' and 'thought-provoking'. We must remember that the bulk of our audience is in a recreational frame of mind, seeking positive activities to fill their leisure time. Most want to 'discover new things', but not to have to work too hard at it. We have to prevent the perception of museums and galleries as intellectually challenging actually becoming a barrier to visiting. If people perceive a museum visit as always requiring serious mental engagement and hard work, they will go elsewhere:

> Museums are *fun*, they are *exciting*, they are *good places to take the family* and they offer *great value for money.* However, it appears that museums are failing to capitalise on and claim these attributes to demonstrate the valid synergy between want and what museums have to offer. The opportunity exists for museums to include in their branding not only the attributes that they meaningfully own, but also the attributes associated with an ideal leisure experience.
>
> Scott (2000: 42)

Rather than presenting an image of museums (and other forms of heritage sites) as educationally 'worthy', we need to present an image as quality leisure destinations, but then build on this by emphasising that museums 'add value' to an outing through the very positive attributes noted above – a unique, authentic engagement with the 'real thing' that differentiates us from all other forms of leisure outing.

POSITIONING THE MUSEUM

> All characteristics of a museum – both as an institution and as a physical space – condition its public image . . . The image projected by a museum should not result merely from chance, but should be consciously determined, consistent with the museum's role and directions.
>
> Royal Ontario Museum (1976: 7)

It is essential that each museum projects an external image that will ensure it has a strong, positive individual identity in the public mind, and particularly in the minds of target audiences. You need to consider the key characteristics that will attract targeted audiences to the museum, and distinguish your museum from every other one and from other types of competitors. To be able to project such an image, you need to be very clear on what you are and what you offer – and of what your target audiences want and expect.

The starting point lies in an internal and external analysis of your current position. The internal analysis will concentrate on defining what you might consider to be your key positive attributes (remarkable building, welcoming atmosphere, unique collections, participative displays, friendly staff, etc.), and highlighting those you consider of greatest appeal to the audiences you want to visit. It should also highlight

negative attributes to overcome, including changes needed to your basic product. The external analysis will concentrate on the attitudes of existing visitors and non-visitors (see chapter 1). The starting point here is baseline research on how you are currently perceived in your own right and then in comparison with your competitors.

Kotler and Andreason look in some detail at ways of measuring a museum's current image initially by an assessment of awareness of the museum among both users and non-users through familiarity measurement (see Figure 3.1).

For those who have some familiarity with the museum, the next step is to assess general attitudes to the museum through favourability measurement (see Figure 3.2).

Finally comes the analysis of semantic differentials – positive and negative responses, recorded on a scale of 1 to 5 or 1 to 7, to what the interviewee defines as the museum's key attributes (see Figure 3.3). This approach can also be used to make comparisons between museums by averaging out responses and representing these by a line which shows the average response to a museum. Thus Museum A in Figure 3.3 is viewed positively and Museum B negatively.

The East Midlands Museums Service visitor survey noted on p. 23 above highlights some obvious museum attributes that can form a useful starting point: educational, interesting, fun; provide family entertainment, good quality facilities and service, convenient opening times, and good value for money. However, these do not reflect the uniqueness of an individual site. You must build on these in direct relationship to what your museum offers, and also potentially combine the results of the visitor survey with an internally conducted SWOT analysis (strengths, weaknesses, opportunities and threats). The challenge is to establish the attitudes of your target audiences toward what you provide at present and then to define the step-by-step route that will get you to where you need to be.

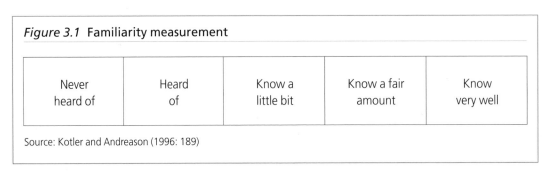

Figure 3.1 Familiarity measurement

Never heard of	Heard of	Know a little bit	Know a fair amount	Know very well

Source: Kotler and Andreason (1996: 189)

Figure 3.2 Favourability measurement

Very unfavourable	Somewhat unfavourable	Indifferent	Somewhat favourable	Very favourable

Source: Kotler and Andreason (1996: 189)

Figure 3.3 Semantic differential analysis (example)

	1	2	3	4	5	6	7	
Attractive building								Ugly building
Warm								Cold
Welcoming								Exclusive
Friendly staff								Surly staff
Fascinating collections								Irrelevant collections
Interesting displays								Boring displays
Educational								Not educational
Good activities								Poor activities
Child friendly								Anti-child
Participative								Passive
Vibrant								Dull
Safe								Unsafe
Disability friendly								Disability unaware
Good shop								Poor shop

Source: Kotler and Kotler (1998: 134–41)

This is not an easy task for museums. Let us think of some of the characteristics of what the marketing industry might call the 'museum product', and what these mean for how you stimulate visits.

Intangibility

If you are buying a car, you can test drive it. In contrast, you cannot experience a museum visit before deciding to 'buy' it. How do we get potential visitors to buy the museum product – a service/experience rather than a manufactured good? If the ultimate museum experience itself is intangible, you must take every opportunity to present 'signs' of quality to back up the experiential nature of the visit – to give the visitor the sense of being engaged in something welcoming yet special and of the highest quality. Marketers can refer to this as 'making the intangible tangible', incorporating every aspect of the external presentation of the site, the point of arrival, the quality of staff and the way they are dressed and cleanliness, all used as evidence that visitor views on the quality of the experience are taken into account (see Box 3.1).

Inseparability

Production and consumption of the 'museum product' are simultaneous. They are 'performed' on the producer's premises. Even staff members involved in the

Box 3.1 'Making the intangible tangible'

Consider:

- the messages about the site you are putting across in the media
- the quality of your advertising material and promotional literature – what does it promise the potential visitor, how does it influence expectations?
- the look and branding of your website
- the effectiveness of the signage that leads first-time visitors to your site
- the first impression of the site – for both visitors and passers-by (who could be converted to be visitors or at least be commenting to others). How does this impression compare to the expectations raised in the media and in your literature?
- the appearance/motivating appeal of the entrance
- how you actually deal with visitors on arrival – from orientation to ticketing arrangements, etc.
- all the members of staff, or volunteers, who may have any contact with your audiences from telephone to in-person contact
- how you handle enquiries, complaints, etc.

production and delivery of the product are part of the product itself. Museums must make a virtue of this, placing visitor engagement with staff as one of the highlights of a museum visit. This is all about the absolute need for customer orientation – for *all* staff to feel they are there to meet visitor needs and wants. Marketers call every encounter with a visitor/customer a 'moment of truth' for an organisation – the moment when that person is forming an instant impression of your site/museum. Most of these 'moments of truth' take place away from the immediate line of sight of the manager – how can you control their quality?

Internal marketing is essential to this – you must communicate with and spread the message among internal staff as much as to the outside. You need to communicate regularly so that all share the same sense of mission/direction; all are clear on current priorities; all are informed of current developments; all act as external ambassadors in their professional and private lives, rather than complaining about feeling kept in the dark, etc.; and all feel trust and security in the management and 'ownership' of the project. Only in this way can you hope to develop a staff ethos that is committed to your 'product' and to enthusing and engaging audiences with it. There is much more on staffing and operating for quality in chapter 4 below.

The museum product is also dependent on visitors as part of the production process. As museum visitors, we all spend a lot of time looking at each other and socialising together. Visitor attitudes and behaviour affect their own experience and that of other users. If the visitors are seen as part of the product, we must explore how to help customers consume. Clearly, most of this relates to interpretation (adapting the product to the individual customer's ability to consume) and is covered in Section 4 of this book, but it is also very much about projected image (a positive,

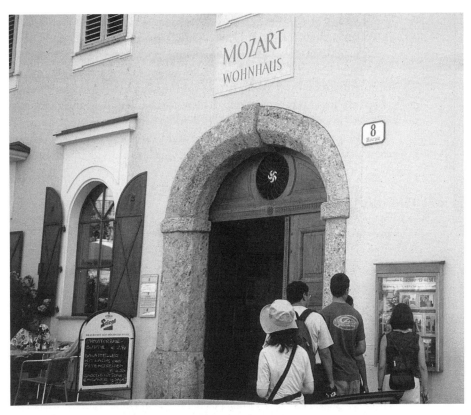

How not to greet visitors. A panel outside the Mozart Museum in Salzburg is viewed by almost all new arrivals. Does it tell them about the museum? No! It is an advertisement for a commercial photographer at the rear. © Graham Black

active motivation to visit) and about putting the visitors in the 'right frame of mind' on site.

Place-sensitivity

The museum visit is also a 'place-sensitive product' – produced, traded and consumed at the same physical location, and the location is an integral characteristic of the product. Again the marketed image, and the visitor's first impression, are crucial – ensuring visitors arrive believing they are coming to somewhere special.

Variability

The museum experience can never be a standardised product – there are too many variable factors influencing it. Quality – and how to keep it consistent – is a great concern. A major task is to select the right staff in the first place and then train them

properly and often. Next is the development of a consistent system for evaluating the quality of service provision. These issues are explored in chapter 4 below.

Now build in the other problems facing museums when they seek to project a clear individual identity. Publicly-funded museums have a particular problem where there is an assumption from 'on high' that the museum, in its external communications, will reflect the local government department it is located in or the larger museum service of which it is a part rather than its individual identity. Visitors do not want to spend a day out at the Department of Leisure and Community Services. They want to spend their time at real places that excite them, that are individual and unique.

INFLUENCING THE VISITOR AGENDA

Falk *et al.* (1998) speak of three alternative visitor strategies:

1 *unfocused* – 'whatever is here'
2 *moderately focused* – specific element matters, but not whole objective
3 *focused* – visit planned before they go.

They also speak in terms of the varying emphases visitors can place on the purpose behind their visit – from entertainment and a social or family outing to education, making it clear that most agendas incorporate all these elements to some degree.

The first section of this book looked at the nature of traditional and potential audiences for museums and methods of segmenting these. Clearly, image projection must be targeted at key segments, and must reflect their needs and build their expectations. It must do so while remaining a valid and believable representation of what the museum offers – if expectations are raised beyond what is on offer, the result will be negative comments rather than the word-of-mouth recommendation that is so essential to audience development. Equally, the challenge is not to turn the 'unfocused' visit into a highly focused one. Rather, the task is to ensure that visitors are more fully aware of what the museum offers and more prepared to engage with that offer, and that they have a positive expectation from the outset of what the museum can bring to them and arrive willing to commit their time, energy and enthusiasm to that end.

POSITIVE MARKETING

For most museum directors, the role of the marketing department (if the organisation is lucky enough to have one) remains one geared to bringing in (paying) visitors. If you can redefine the role of marketing as the first stage in engaging your targeted audiences with your site and collections, it will transform the museum attitude to marketing and PR. Marketing and PR is not about hype. The most important issue for you to think about is to understand the importance of strategic planning for marketing – of moving from day-to-day coping and knee-jerk activities to targeted actions aimed at achieving planned outcomes as outlined in Box 3.2.

Box 3.2 Strategic planning for marketing

- Define clearly what you want to accomplish – your mission.
- Base what you are doing on effective research:
 - undertake baseline research on existing audiences and when they come, and on public perceptions of your organisation/site
 - have a clear understanding of your targeted audiences and how to reach them
 - undertake baseline analysis of the existing product – does it match the objectives and needs of target audiences?
 - undertake baseline research on the cost and effectiveness of current marketing and promotional activities – a *marketing audit*
 - assess the marketing resources available
 - assess developed relationships with key media contacts.
- Choose clear goals – clarify your priorities.
- Define how you will get there – evaluate and select strategic alternatives.
- Produce a detailed written work plan linked to day-to-day implementation.
- Do not forget internal marketing – all staff must have a clear understanding of the museum mission, staff should feel they are there to meet visitor needs and wants, and all must know what is going on and what you are seeking to do.
- Commit the money/staff to achieve the strategy.
- Build in evaluation of the impact of the strategy and its modification where required.

MARKETING TO DIVERSIFY THE AUDIENCE BASE

Are the common marketing approaches equally relevant to the broader audiences museums are being encouraged to develop? The principles are the same – you must look at your objectives and to the nature, needs and wants of the target audiences. But the impact you seek can be much more difficult to achieve. You are impinging here into the realms of social marketing. You are actually seeking to change human behaviour. Rather than persuading the 'traditional' audience to visit more often or to go to additional sites, you are seeking to persuade non-visitors – many of whom feel strongly that museums and heritage sites are not for them – to come. Equally, as already discussed in chapter 2, you are not seeking simply to get people to do something as a one-off, but for this to be a permanent change of behaviour.

The bottom line here is the nature of the product on offer and the relevance of this to the target audiences. There must be a willingness to change what is on offer or there is no point in starting this process. However, there are key aspects that marketing strategies can influence (see Box 3.3).

Kotler and Andreasen highlight the two challenges facing 'social marketers':

1 creating a supportive climate of values and beliefs that make it OK for individuals to change behaviour . . .

2 actually to change the behaviour of specific individuals and households in specific ways.

Kotler and Andreasen (1996: 404)

They go on to see those two tasks as having to overcome four problems:

1 The new behaviour must be seen as socially desirable ('for people like us'); this is the *value–change problem*
2 The new behaviour must be seen as personally desirable ('for our family'); this is the *motivation problem*
3 The new behaviour must be understood; this is the *education problem*
4 The new behaviour must be practiced (i.e. begun and repeated); this is the *behaviour modification problem*.

Kotler and Andreasen (1996: 404)

Much of this is about long-term commitment and persuasion. A marketer has a key role in making other personnel aware of this.

No second chance to make a first impression

We know that the single most significant barrier to inclusion is the visitor feeling unwelcome and being embarrassed because they do not know where to go or what to expect.

Stewart-Young (2000: 30)

Much of what the site staff take for granted is fresh to the new visitor. That first impression is vital. Too many sites quickly develop a 'take it or leave it' attitude. Visitors should feel they are arriving at somewhere special and also quickly receive a sense of where they are. This orientation process must also include a feeling of welcome, as part of the experience, rather than a sense of being intimidated or of being made to feel inadequate. It needs to continue with ready access to information, not only in terms of needing to know where you are and where you are going, but also to allow each visitor to decide on the best use of his or her time. Finally, visitors need to be enthused – from the first moment we must ensure that our own belief in, commitment to and excitement about the site shine through.

DISCUSSION: SEVEN CORE ISSUES

Some final thoughts:

Know yourself
What is your museum *for*? What will make people come and, perhaps more importantly, what will make them keep wanting to come back?

Box 3.3 Developing a social marketing approach

- Research the market – defining target audience needs and wants is central to this (it is likely to be called community consultation in this context). Market research/consultation can also play a marketing role – making contacts in local communities through whom information, etc., can be disseminated.
- Customer ignorance is a major barrier. Make more people aware of what you have to offer – reassess where your literature is distributed; explore new media outlets, like community magazines, newspapers targeted at black audiences; look at the increasing role of the website, for example for people with disabilities, etc.; contact clubs, associations, churches, community centres, etc.; offer talks, etc.
- Lack of motivation to visit is another key barrier. External image is crucial. The starting point is to change *perceptions* of your service. Ensure the marketing material is attractive, focused and accurate. Be sure your brochure looks socially inclusive.
- Marketing alone is no answer, therefore product change will be essential. However, do not make extravagant claims that cannot be delivered – focus attention, and the limited funds and staff time available, on the achievable and then build from that platform.
- While gradually enhancing the main product, ensure a focus on balanced and interesting programmes that reflect the interests of the different audiences – temporary exhibitions, special tours, events for grandparents with grandchildren, etc.
- Train staff to ensure the quality of contact they have with visitors results in good word-of-mouth recommendation to other community members.
- Evaluate the impact of your marketing strategy or campaign and modify future approaches accordingly.

Know your audience

Talk to your existing audience and get to know its perceptions, needs and expectations. How far can you go toward meeting these and enhancing them?

Analyse the audience you want to attract. Will its expectations be radically different? Does it have valid claims for inclusion and legitimisation within your exhibits? Can/should these be met? What is your response to the increasingly pluralistic nature and demands of society?

Develop your 'connectedness'

Build your relationship with your local community or communities, and understand the increasing importance that is being placed on this.

Renew and be active

No site can stand still. There must be a constant process of renewal and both exhibits and visitors need to be supported by relevant programmes of activities. This is all about stimulating, entertaining, enthralling and involving your visitors.

Signage sets the scene, helping to define the strong identity of 'Eureka', the children's museum at Halifax, UK © Graham Black

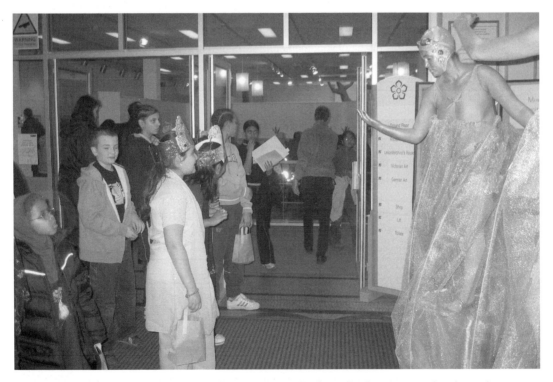

International Women's Day provided an opportunity for a lively event and to broadcast what the museum could offer to a wider audience. © Leicester City Museums

Learning matters

Providing opportunities for learning is a core function for museums and brings with it a core audience – both those in structured educational groups and the much more extensive audience using museums to support their lifelong learning.

Consider children and families

Currently, my estimate is that up to 60 per cent of museum visits include children in the group. You fail to provide for children at your peril. But, remember that they are a very sophisticated audience, particularly if you try anything electronic. Involvement and imagination work best. The bottom line is to ensure that the next generation of non-users does not cite a bad museum experience as a child.

Think about word-of-mouth recommendation

Research shows that most visitors (up to 60 per cent) come as a result of recommendation or because one of the party has been before (Berry and Shephard 2001: 166). This impacts on visitors in two ways:

1 recommendation as *the* key marketing tool
2 the impact of recommendation on visitor expectations of the visit.

Successful marketing ultimately depends on the quality of the product and how far it succeeds in meeting the expectations of the audience. No matter how beautiful your brochure, if the product advertised lacks quality or relevance, it will not affect either visitor numbers or the type of visitors who come. Personal recommendation means you have satisfied your visitors to the extent that they will tell others enthusiastically about your museum. This will always be the best way to develop audiences.

CASE STUDY: REPOSITIONING MANCHESTER ART GALLERY

Manchester Art Gallery has an internationally important collection of paintings and sculpture, decorative arts and furniture. Until 1998 the gallery was housed in two separate but adjacent buildings. The Mosley Street building was constructed 1824–35 in the Grecian style, designed by Charles Barry. The Princess Street Athenaeum building in the Italian Renaissance style is also by Barry, 1837. A fire resulted in the construction of a new lecture theatre on the top floor of the latter (now the Decorative Arts gallery) in 1874. In 1994 Manchester City Council staged an International Design Competition for the refurbishment and expansion of the Art Gallery and Athenaeum buildings which included a new building on an associated vacant car park site, joined with the two existing buildings to complete the block. Michael Hopkins and Partners were announced as winners in January 1995.

The objectives of the expansion project were:

- to repair and refurbish the two existing historic buildings
- to allow public access to historic interiors, for example the Athenaeum theatre
- to facilitate the display of more art work from the gallery's collection, a large percentage of which remained in storage
- to significantly upgrade environmental conditions within the galleries to assist in the preservation of art works
- to provide exhibition galleries to international standards in order to attract high profile exhibitions.

The total cost of the project was £35 million. The gallery closed in 1998 and reopened in 2002. On its website, the gallery described the changes as:

> Under architect Sir Michael Hopkins' scheme, a stunning new extension with a striking stone and glass façade blends with the existing buildings to provide a new landmark for the city centre. A spacious new glass atrium has been created to link the new wing with the former City Art Gallery and Athenaeum. These buildings have also been cleaned and refurbished, bringing new areas of the Gallery into public use for the first time ever. Decades of grime have been removed, restoring the beauty of the interior and exterior stonework.

But this was not just about refurbishment, expansion and redisplay to retain the existing type of product. The project also represented a transformation in the way the gallery sought to engage with its audiences. It was linked closely to ambitious objectives of both growing and widening the audience base substantially for the gallery for the long term. To achieve these objectives meant having a clear understanding of existing and potential audiences, and their needs and expectations, and ensuring that the service was developed along the lines of their needs and wants.

When bids for grant aid for the project were first made in 1995, the audience development element was based on surveys suggesting the gallery was receiving around 250,000 visits a year. In 1998, the final year before closure, a year-long study showed the mid-1990s survey had double-counted visitors (as they entered each of the two adjacent but separate buildings), suggesting the actual figure for annual visits was more like 130,000. This new study also made clear that there was a huge distinction between *visits* and *visitors*. The gallery had a loyal audience of artists, art lovers, etc., who came regularly, attending up to eight times a year. The study suggested that the 130,000 visits were made by under 30,000 visitors. The penetration rate of the potential market for the gallery was actually very low. The external image among non-users was equally disturbing – 'old', 'dusty' and 'templed'. Few of the visitors were family groups.

The decision was taken that a huge programme of market research and consultation should be central to the project. In the end, this included seven different consultation panels of users and non-users. Their views were sought on a general and specific level on an ongoing basis throughout the project:

- *general:* what they felt about art galleries in general, about gallery going, and about Manchester Art Gallery in particular
- *specific:* their views on specific proposed galleries and on plans for programming.

The more general comments proved highly revealing and set the tone for much of the redevelopment:

- People needed pre-visit confidence. The consultations revealed how fearful many people are about visiting art galleries. This reflects how limited visual education is in the UK – e.g. 'nobody ever told me how to visit a gallery or view a painting'. Many felt they would look stupid while there if they did not know how to 'behave'. In particular, many parents and carers feared not being able to answer their children's questions.
- Perhaps reflecting this lack of confidence, people wanted the gallery to act as a recognisable specialist – to act as a trustworthy guide to the worrying world of (particularly contemporary) art and to help lead them through the displays rather than being left entirely to their own devices.
- Equally, they also needed the displays to include what might be defined as recognisably good art, that is by artists whose names they recognised, who exhibited a high degree of craft skill, or whose work related to more accessible cultural strands such as social history.
- There was a strong desire for participation, involvement and interactivity.
- There was a particular need for facilities and activities targeted at families.
- As part of the whole process, the gallery needed to become more welcoming and have much better orientation.
- There was also considerable demand for more accessible information.

The responses to the more specific questions were somewhat sketchy and therefore less useful in project planning. It would have been tempting to assume that this was because plans for the galleries and programming were right first time. However – in retrospect – the gallery suspects that consultation groups were not given the time or depth of support to fully understand the proposals and lacked the vocabulary or confidence to respond to them in any detail. Alternative methods of gathering visitor feedback on programming are being investigated.

The research certainly made clear that the quality of collections was not the only influence, or even necessarily the main one, on when someone was making a decision to visit or on the audience perception of the quality of their visit. The warmth of welcome, a supportive atmosphere, an opportunity for involvement,

Box 3.4 The audience profile for Manchester Art Gallery after reopening

Visitor research established that:

- the number of visits in the first 12 months was 390,000 (up from 128,000)
- the number of visitors was 174,000 (up from 23,000), including:
 - new tourists (24 per cent)
 - new locals (28 per cent)
 - previous 'maybe' visitors (33 per cent)
 - previous 'die-hard' visitors (15 per cent)
 - average frequency of visit (2.2 times per annum)
- the new visitors have a very different profile from previous visitors. They are:
 - younger (around 50 per cent are aged 15 to 25, compared with a quarter of previous visitors)
 - female (around 66 per cent of new visitors are women, compared with half of previous visitors)
 - less traditional gallery goers (especially 'new locals', among whom growth has been above average in groups C1, C2 and E; they are also 50 per cent more likely to 'lack confidence' in themselves as gallery goers and twice as likely to lack knowledge of art)
- in contrast, among 'new tourists', half are confident art students
- nearly half the new visitors are from outside the area, and 25 per cent of these are from overseas
- on a basic satisfaction rating, 98 per cent expressed satisfaction with their visit, 93 per cent intend to return, 98 per cent agree the gallery is friendly and welcoming, 77 per cent agree it makes art accessible. There has been very positive feedback, including regular praise for the labelling scheme.

Source: Kate Farmery (personal communication)

family-friendly activities, etc., all had an important impact. It also emphasised the importance of empathising with audience needs and expectations and responding to these in terms of the product offered as well as the marketing of it.

One response of the Manchester Art Gallery was to incorporate three 'destination galleries' within the redisplay, one on each floor, which could be highlighted in marketing to targeted audiences. The need to attract family audiences was seen as vital, so one 'destination' gallery, the Clore Interactive Gallery, was targeted to be used by family groups exploring the displays together. However, this was deliberately *not* called a children's gallery because it was thought likely that adults would also want to use the exhibits – and this has proven to be the case. Feedback from potential family users stressed the need to avoid 'ghettoisation' of family groups, so further interactive family-

focused activities, including the Clore Drawing Space, were installed throughout the building. 'Wraparound' services for families, such as children's menus in the restaurant and baby-changing facilities, were also addressed.

A second 'destination' gallery, the CIS Manchester Gallery, sought to respond to public interest in the social history of the city, but to do so through art works rather than taking a traditional local history approach. It is themed rather than chronological and uses commissioned contemporary work as well as historic material. It also incorporates material created by community groups which is displayed to the same high production standards. The third 'destination' gallery takes a highly thematic approach to the display of craft and decorative arts.

In addition to the concept of 'destination galleries', a unified scheme of interpretation was applied across the whole site, incorporating every element including: the style of writing labels (using EKARV, a style of user-friendly exhibition text writing devised by Margareta Ekarv in Sweden); translation into relevant European and Asian languages; the creation of an audio tour for the visually impaired, including pieces to touch; three separate acoustiguides targeted at different user groups including families; and the injection of humour into the approach, for example cartoon labels by Tony Ross of the children's book *I Want My Potty* fame.

The marketing activities surrounding the relaunch of the gallery were equally instrumental in its repositioning as more accessible and user friendly. A new brand identity and range of promotional materials, featuring silhouettes of people looking at art, was introduced and a high profile PR and promotional reopening campaign stressed the gallery's new points of difference.

The profile of the audience since the reopening, outlined in Box 3.4, reflects considerable change from pre-closure days.

What the process reveals is the importance of a full-scale analysis of the current situation before commencing redevelopment. The information this revealed about the nature and extent of the existing audience at Manchester Art Gallery may have been a bitter pill to swallow, but it made it possible to chart a route forward. Equally, it showed how important product change is to any attempt at repositioning a museum or heritage site. Audiences are not fools, and the PR and marketing team need a relevant quality product to sell to target audiences. It has been a learning exercise in 'reaching outwards' for the curatorial team as well as other participants. The simple act of putting together audiences and curators paid dividends. There is still some way to go, but the gallery is now very much looking to the future.

4 Visitor services: operating for quality

> Customer service may be the single most distinguishing factor of why visitors go to one museum more often than another . . .
>
> Rubenstein and Loten (1996: 2)

INTRODUCTION

> When the word 'service' is used to describe the primary output of a business, it is important to realise that it refers to an activity that has value in its own right.
>
> (Sharples *et al.* 1999: 27).

Reynolds (1999: 116) defines four basic characteristics of a tourism experience that are equally applicable to museums:

1 the experience is intangible
2 the experience consists of activities rather than things
3 the experience is produced and consumed simultaneously
4 the customer has to be present and participate in the production process.

These attributes reflect the role of museums as part of the service economy. Yes museums are about 'real things' – real sites, real objects, exhibitions, programmes, etc. – but it is the visitor engagement with these that creates the individual user experience. For some visitors, the emotional, aesthetic and intellectual response to direct engagement with the site and/or collections will be all that matters. For the majority, the quality of their experience will depend on all aspects of the visit, a complex combination unique to the individual or to the individual social/family group.

Most museums now accept that they are part of the service world, and that they have many similarities to other service providers in the need to understand and respond to user demand, and to achieve user satisfaction at a time of rapidly rising expectations on service quality. There has been a widespread response to the list of demands placed on modern museums (outlined in Box 0.1). However, most of this

A gallery assistant in action at the Science in the City Exhibition, the Australian Museum, Sydney. © Lynda Kelly

response has been in terms of seeking to transform the physical product and facilities. There is still a lesson to be learned. If we truly seek to transform our museums, making them audience-centred, we must also transform the front-of-house staff who deliver so much of the service we provide.

Ways in which visitor services can respond directly to specific visitor needs are discussed above in chapter 1. This chapter touches on the standard of support facilities museums must seek to achieve for their visitors, including a service blueprint approach to evaluating these, but concentrates on the staff side of visitor services. The chapter focuses on the case for giving visitor services a central role in museum provision, how to define quality in visitor service provision, and measuring visit quality.

A CENTRAL ROLE FOR VISITOR SERVICES

> Visitor Services really is about welcoming the visitor and making the logistics of accessing our building, grounds and collections as smooth, seamless, and enjoyable as possible.
>
> (Leonard 2001: 1)

Figure 4.1 Museum visitor services

Practical support	*'Feel'*	*Staff input*	*Site*
Accurate marketing	Quality	Good telephone	Authentic
Quality pre-visit infor-	Supportive	manner	Attractive
mation and website	Child-friendly	Polite	Safe
Good directions	Welcoming	Efficient	Cared for
Parking	Sense of arrival	Well dressed	Clean
Convenient opening	Informal	Visitor-centred	Well lit
times	Relaxed	Friendly	Good temperature
Value for money	Participative	Supportive in galleries	Easy access
Queue management	Inclusive	Knowledgeable	
Orientation	Own pace	Entertaining	
Information on contents	Not 'church-like'	Access to specialists	
Internal signage	Fun	Empowered to handle	
Physical access – all	Vibrant	complaints	
aspects	Enthralling	Enquiries – quick	
Restroom facilities	Comfortable	response	
Baby changing facilities	Social interaction	Customer-service	
Café facilities – inc.	Busy areas	trained	
menu for children	Quiet areas	Good interpersonal	
Picnic site		skills	
Shop facilities		Sensitive to visitor	
Crèche		needs	
Cloakroom		Disability trained	
Comfortable seating		Diverse staff	
No queues for exhibits			
Inclusive media			
Other languages			
Can take pictures			
Available to hire			
Events and activities			
Group bookings			
Able to volunteer			
Audience research			

The primary role of visitor services is to encourage and support access to museums by all visitors and potential visitors – whatever their age, gender, education, class, race, disability, reasons for coming, etc. How we welcome visitors to our museums, respond to their needs and make them feel 'comfortable' is central to their museum experience. It will have a substantial impact on the quality of their engagement with a site and/or

collections and will in turn dictate whether those visitors become regular supporters and also recommend the museum to others.

What we create in the way we present our sites and museums is not a neutral space. Rather, it has a dramatic influence on the psychology of the visitor. We all know the need to feel welcomed, relaxed and 'good' about ourselves when we are in a strange place. If we want our visitors to be in the best possible 'frame of mind' when they enter our exhibitions or attend our events, if we wish them to involve and engage themselves with the collections and to leave with their understanding and appreciation enhanced, and if we want them to leave with positive memories, recommend the museum to their friends and return soon themselves, then we *must* ensure, through the provision of quality visitor services, that the right environment is created to make this possible.

While the rest of the service economy worldwide had recognised the importance of service quality by the 1970s, in terms of retaining customers and further developing the customer base, many museum and heritage managers have continued to view the idea of quality in museums and heritage sites strictly in terms of the site, collections, programme, etc. Yet, as Figure 4.1 shows, there is an inseparable link between visitor services and all other aspects of a museum's activities.

Visitor services 'wrap around' the site, collections and exhibitions to humanise the museum and bring the visit alive. There are no doubt other elements I have failed to include in these lists. We could also debate about whether events and activities are part of visitor services or of the exhibit provision. The reality is they are an element of both. Overall, however, there can be no denying the centrality of visitor service provision to the visitor experience. As Figure 4.1 makes clear, visitor services and facilities are also essential to the task of 'making the intangible tangible', in terms of physically defining the quality of the visit.

At the heart of visitor services lies the front-of-house staff. One only has to think about who the average visitor encounters in the gallery – it is not the curator, education officer or designer but museum attendants, gallery assistants and docents. The encounter between visitor and staff member can make or break a visit. As already mentioned in chapter 3, this is often referred to as a 'moment of truth', that point where a user comes into direct contact with a staff member (Carlzon 1987). Every writer on service quality makes this point:

> [A]nother good way to judge a store: by its interception rate, meaning the percentage of customers who have some contact with an employee . . . All our research shows this direct relationship: the more shopper–employee contacts that take place, the greater the average sale . . .
>
> [S]hoppers tend to hate . . . intimidating service. Also rude service, slow service, uninformed service, unintelligent service, distracted service, lazy service, surly service. Probably the single best word of mouth for a store is this: 'They're so nice down at that shop.'
>
> Underhill (1999: 37 and 160)

The quality of contact between staff and museum visitors can have the same impact as in a shop and, in addition, the general visitor will view anyone in a uniform located in a museum gallery as a fount of all knowledge on the museum's contents. I

am more often delighted by the friendliness and enthusiasm of museum attendants than I am appalled by groups of staff chatting to each other by a window or door. Yet I fear this has little to do with senior management. Thank heavens for the innate visitor-friendly abilities of most staff in this field, for my experience is that museum front-of-house staff are the worst paid, least well trained and most poorly supported of all museum personnel.

Why do museum managers perpetuate the ludicrous notion that museum attendants are there for security purposes only? Until quite recently senior museum staff continued to see their role as concerned solely with the management and conservation of sites and collections behind the scenes, and the mounting of exhibitions. Front-of-house was left in the dubious care of staff whose selection and training received scant attention. In these circumstances, it is no surprise to note that there is very little published on service quality in museums, with only Adams (2001) of real relevance. Otherwise one is left with more general tourism-related publications (e.g. Leask and Yeoman 1999; English Tourism Council 2000a; Drummond and Yeoman 2001; Fyall *et al.* 2003). This situation must change if museums are to face up to the challenges of the twenty-first century. Until we see the visitor services manager given a seat in the senior management team, and visitor services given the same priority as collections management, the concept of museums as being audience-centred will be no more than hot air.

Museums still have few professionally trained visitor services managers. Mostly that role is combined with others and staff are not trained in it. It is not surprising, therefore, that poor visitor services provision is a problem that afflicts museums worldwide. In Australia, the Australian Museums and Galleries On Line project (AMOL) now provides online training in visitor services (AMOL u/d). In the USA, there is a Visitor Services Professional Interest Committee of the American Association of Museums. The AAM has also begun to take the quality evaluation of visitor services seriously, as can be seen in the visitor service and public relations element of Museum Assessment Program Public Dimension Assessment, but this is limited in that it is about self-assessment rather than through a qualitative survey of visitor experiences. In the UK, visitor services training has been through a vocational qualification scheme developed by the Cultural Heritage National Training Organisation (CHNTO). Take-up in all cases has been limited. Yet, the quality of visitor management is important in meeting the needs of both tourists and local communities and broadening the audience base for museums – *and* in supporting the learning of museum visitors.

We have much in common with the tourism industry and can learn from its experience. If we step back from our insularity and look at the tourist industry in general we will see two things:

1 A similar long tradition of low pay, poor training, lack of a defined career structure and consequent high staff turnover among front-of-house staff. (Of course, many museum attendants come to the job late in their careers, viewing it as a poorly paid but secure and ambition-free occupation to last until retirement. This means there is a lower staff turnover than in the tourist industry, but is this the attitude we want from our staff?)

A casually stylish uniform and the employment of younger staff of both genders has helped Manchester Art Gallery welcome new audiences. © Manchester Art Gallery

2 An absolute emphasis on the human dimension of service quality. For example, three of the five dimensions of service quality defined in Servqual – responsiveness, assurance and empathy – depend on the quality of employee performance. (Servqual is an approach to measuring service quality – hence the term – used across most of the service industry. Its potential application to museums is discussed in the case study below.)

It is time for museum managers to wake up to the fact that front-of-house staff are central to the visitor experience. It does not matter how good the collections are, or how well they are displayed, or even how clean the restrooms are. The visitor experience will be detrimentally affected by an ill-trained, unhelpful, or even rude member of staff and substantially enhanced by a friendly, knowledgeable gallery assistant.

HOW DO YOU DEFINE QUALITY IN A MUSEUM VISIT?

Evaluating for quality, and constantly seeking to improve the quality of provision, are common features of museum life today, as managers seek to prove relevance and value to their governing bodies. But before you can evaluate for quality, you must define what you mean by the term.

For many museum professionals, the quality of a museum visit is based on the unique nature of the site/collections, their protection/conservation, the authenticity/integrity of their presentation, the dynamic nature of the programming and the opportunities offered within displays for visitors to engage with them. However, these elements represent a professional judgement of the product rather than an evaluation of the visitor experience. Clearly these elements remain central to the museum mission, but what other factors must they be linked with, to create a positive museum visit? Also, how do you judge these objectively, particularly given the immediate problem of the museum experience being seen in terms of intangible goals?

For museums and heritage sites, the 'expert view of quality' can tend to be about the opinions of judges, based on agreed criteria, for the quality awards such as the Gulbenkian Prize or the Interpret Britain Award in the UK or, more generally, as part of the Museum Assessment Program in the USA. Even with agreed criteria, these can vary between individuals. They are also rarely about the quality of the visitor experience.

If we look for a wider view of quality, other definitions emerge. Most obvious, perhaps, is *manufacturing quality*. This has varied over time from 'built to last', through 'fitness for purpose', to attempts to minimise deviations from standards set in technical specifications. Within the service economy, we see it in attempts to standardise service provision to ensure all receive the same (from 'portion control' in restaurants to the elimination of employee discretion and judgement whenever possible), something difficult to achieve in service delivery systems where it is the interactions between staff and clients which characterise the delivery of services. In museums, the use of audio tours represents a good example of an attempt at standardised service provision.

Another definition centres on value for money – *value-based quality* – where a link can be established between price and quality. It can be very important in service industries, for example in package tourism, where so many products are sold on the basis of price. There is probably a link to museums and heritage sites that charge admission fees, in terms of price in relation to length of stay, but this is as yet not proven by research.

Finally, we might consider a user-based definition of quality. This is the basis of much consumer protection legislation, that goods sold commercially must be fit for their purpose. However, it is also about individual judgement, and particularly about *user satisfaction*. Under this definition, a quality visitor experience at a museum or heritage site would be one where visitors are satisfied that both their needs and their expectations have been met or exceeded.

A quality definition based on user satisfaction has gained widespread support across service industry as a whole and has had a major impact on thinking. However, measuring user satisfaction at museums and heritage sites may be inherently difficult. Not only do we face the 'I suppose they are doing the best they can' argument so prevalent in reactions to public service provision, but also the museum and heritage product is an *experience*, or rather a series of elements that together make up that experience, rather than a single service:

> While commodities are fungible, goods tangible, and services intangible, experiences are memorable. . . All prior economic offerings remain at arms-length, outside the buyer, while *experiences are inherently personal. They actually occur within any individual who has been engaged on an emotional, physical, intellectual, or even spiritual level.* The result? No two people can have the same experience – period. Each experience derives from the interaction between the staged event and the individual's prior state of mind and being. [my emphasis]
>
> Pine and Gilmore (1999: 11–12)

User satisfaction with the museum experience will arise from a combination of individual reactions to each element of it. These will include the quality and frequency of the museum's exhibitions and programming; the quality of visitor services and the ability of the museum to respond to complaints as well as praise; and the way in which the museum supports the individual by helping to customise the overall visit. However, it will also reflect the personal context of the visitor and on individual perceptions of the quality of the site and collections as well as on responses to the service element. In fact, while poor quality in visitor service provision – the management of the site and the organisation – can seriously reduce the quality of the overall experience, a poor quality of direct visitor experience in engaging with the site, collections, exhibitions and activities may destroy it.

MEASURING VISIT QUALITY

> Quality *provided* is ultimately the subjective perception of planners, managers and front-line staff. Quality *experienced* is a matter of visitors' own subjective perceptions. Both 'qualities' must be assessed in order to monitor and manage the development of a satisfactory heritage 'product', but neither has an independent objective existence.
>
> Johns (1999: 131)

Whatever definition of quality one accepts, it is essential to realise that customer expectations will change over time, and so pursuing quality is a dynamic concept requiring continuous quality improvement. Awareness, understanding and implementation of quality is fundamental. However, continual evaluation is also critical, so the museum must establish a means of measuring the quality of its provision systematically over time – and in a manner that permits comparison with previous evaluations. Only in this way can the museum monitor the impact of changes it has made, but also any changes in its clientele, their needs and expectations.

This chapter is not about the quality of the site, collections, exhibitions and programming. These will be explored in Section 4 of the book – although they are clearly inseparable from any evaluation of overall visit quality. The discussion below focuses on the visitor services element of the museum experience and seeks to outline two approaches to its measurement that need to be used in tandem:

1 *quality provided* – service blueprints enable the museum to monitor its product and highlight opportunities for improvement
2 *quality experienced* – user satisfaction surveys enable the museum to monitor the response of its audiences to the services it provides, to ensure quality standards can be established and maintained.

To these I would add two more, not discussed here. First is to seek regular feedback from the front-of-house staff: 'The folks on the front lines – the ones who actually talk to the customer – are the only ones who really know what's going on out there. You'd better find out what they know' (quote attributed to Sam Walton, founder of Wal-Mart).

Second, I would emphasise the importance of *benchmarking* – comparing your provision to best practice elsewhere. This is difficult. To be able to benchmark means cross-site agreement on what quality means and a common means of evaluation. Benchmarking should also be not only about *what* best practice is being achieved but also about *how* it is being achieved. Only by understanding the *how* can you learn from it, and feed this back into improving your own organisation to maximise the benefits.

Quality provided: service blueprints

The concept of the service blueprint lies behind the relevant parts of the AAM's Museum Assessment Program Public Dimension Assessment. It links to the concept of 'critical incident analysis' (Johns 1999: 131), where you focus on those elements of a museum visit that particularly satisfy or dissatisfy visitors. It is also a reflection of 'customer perception auditing', defined by Johns and Clark (2001) as 'a type of appraisal structured to reflect the customer's view of service quality'. This tends to be based on the concept of the 'customer journey' (see Figure 4.2), taking in every aspect of the visitor experience from initial anticipation of the visit to the arrival back home. Museum managers only control part of the overall 'customer journey', but visitors see it as a whole – and will rarely distinguish between what is the responsibility of the museum and that which is outside its control. As a result, it is important for museum managers to evaluate all aspects of a visit, and in the same sequence as experienced by visitors, to define all those elements that the museum can control. Importantly, interaction with staff can be incorporated at each relevant stage.

One thing the concept of the 'customer journey' highlights is that the product at a museum or heritage site is not a single experience but, rather, is made up of a series of events – strolling round the grounds, visiting the café, engaging with displays, shopping for souvenirs, etc. As such, a 'product-led' approach to measuring and enhancing visit quality must use service blueprints to map the events and processes which the visitor experiences, and then seek to improve each of them, as shown in Figure 4.3.

Blueprinting is an essential part of any quality operation, but is a management-led approach rather than a customer-focused one. It will not always highlight the issues that matter most to visitors. Hence it is essential that it be accompanied by regular user satisfaction evaluations.

Figure 4.2 The 'customer journey'

Building anticipation for the visit
- quality of marketing materials and website
- positive media coverage
- good word-of-mouth recommendation
- initial visitor expectations
- impression of accessibility

How easy is the journey to the site?
- traffic ⎫
- signposting ⎭ ⎱ journey
 ⎰ stress
- ease of parking
- directions from car park
- availability of other forms of transport than car
- opportunity to calm down

How you are supported on arrival at the site?
- sense of occasion
- physical accessibility
- sense of welcome or intimidation/queues
- first encounter with museum personnel
- physical and conceptual orientation
- availability of restrooms, café, seating, etc.
- the 'moment of truth'

Are you satisfied with the range of experiences provided?
This is explored in section 4. However, one element of the 'mapping' is the concept of the 'experiential audit', analysing the current experiences available to visitors and how these mesh with the needs of existing and target audiences.

Experiences available	*Gallery 1*	*Gallery 2*	*Gallery 3*	*Gallery 4*	*etc.*
Activities for children					
Experiential zone					
Archive film					
Object handling					
Touch screen					
Study zone					
School project work of labels					
Contemplation zone					

Figure 4.2 continued

What are you feeling afterwards as you leave and journey home?
- leaving feeling you have been engaged in something special
- aware of good signage away from the site
- discussing the visit on the way home
- leaving with memories of the visit, engaged in something special, photographs, souvenirs – does the shop have a wide enough range of stock to meet the needs of the whole audience and is it of good quality?

Is there any follow-up contact with the site?
- posted letter or mail shot
- emailed 'forthcoming events' bulletin

Source: author amalgamation, based on Johns and Clark (2001:18)

Figure 4.3 Service blueprinting

1 Study the sequence of service elements experienced by a range of clients.
2 Arrange the clients' experience as a simplified flowchart.
3 Study the features of the service delivery system(s).
4 Flowchart the elements in the service delivery system.
5 Analyse customers' experience of the service delivery system to identify fail points.
6 Analyse the rationales for the crisis points in the existing service delivery system.
7 Assess the costs of service delivery system weaknesses.
8 Evaluate the opportunities for improvements and assess the costs of implementation.

Source: Laws (1999: 279)

Quality experienced: user satisfaction surveys

The companion to a product-led approach to quality evaluation must be a visitor-centred one, focused on user satisfaction. The use of user satisfaction as a performance indicator is growing worldwide. In 2000/01 the UK government introduced user satisfaction best value performance indicators (BVPIs) – to be carried out on a three-yearly basis in all local authorities – to reflect users' experiences of local authority services and to enable direct comparison with the performance of other local authorities. The high cost of random sampling and face-to-face interviews has meant that a postal survey has been the most common method adopted and the basic user-satisfaction measure adopted has relied on simple self-evaluation by those surveyed, with a typical example shown in Figure 4.4.

A similar question has been included in many quantitative surveys at museums. The trouble is, such measures reveal little of relevance and can be positively danger-

Figure 4.4 User satisfaction measurement

Very dissatisfied	Fairly dissatisfied	Neither satisfied nor dissatisfied	Fairly satisfied	Very satisfied

Source: based on MORI/LGA (2001)

Figure 4.5 Visitor satisfaction survey

	Excellent	Good	Fair	Poor	Does not apply
Parking					
Friendliness of admissions staff					
Museum staff friendliness					
The café					
Variety of things to see and do					
Ease of locating places to rest					
Readability of labels					
Content of labels					

Overall my visit was: highly enjoyable / enjoyable / unenjoyable

I will be likely to return by: 1 month / 6 months / 1 year / more than 1 year / never

Source: based on www.cincinnatiartmuseum.org/survey_visitor.shtml

ous. Because visitors are simply asked to state how satisfied they are, with nothing to compare their evaluation against, and because people have an inherent tendency not to complain, such surveys at museums and heritage sites usually result in very high satisfaction levels being reported.

One step up from this, while retaining a short visitor questionnaire approach, is to seek to split the generalised question under a number of headings, as shown for example in Figure 4.5.

This has the advantage of still being short, so that visitors are willing to spend the time to fill it in, and can even do so on the website after their visit. It focuses on key issues to give straightforward results. It clearly reflects specific information the gallery seeks. Importantly it also attempts to indicate what percentage of visitors is likely to return (although saying you will and doing so are two different things and the figure here is likely to be unrealistic). However, it is incredibly brief and seeks to combine aspects of the product alongside service elements. While it may be useful in gauging current general levels of satisfaction, it can do little to help take the museum quest for quality forwards.

The first visitor survey at the then new National Museum of Australia combined an overall rating of the visit similar to that in Figure 4.3 with an assessment of time spent in the museum and asked visitors to rate each of what the museum described as 'five key factors', outlined in Table 4.1.

Again, this has the advantage of briefness and therefore of both affordability and the willingness of visitors to participate. I also like the attempt to use a combination of elements here, and the separation of 'information provided about things to see and do' from the actual museum contents – it looks toward a separation of the support services a museum should provide from the actual content. However, the results still do little to assist the museum in defining particular problems and then going on to solve them.

As I hope I have already made clear, the measurement of user satisfaction at museums is very difficult and should involve some form of qualitative exercise. Museum visitors seek individual experiences, so standardisation of content and service is both difficult and positively unwelcome. Measuring quality in terms of individual visitor satisfaction with the overall museum experience is difficult because satisfaction must be measured within the personal context of the visit: it is dependent on the visitors' background motivation, their mood at the moment, their interaction with the people they have come with, and their level of interest and engagement with the site, collections, exhibitions and activities on the day. As a result there can be enormous variation in individual satisfaction or dissatisfaction levels. However, this is not an excuse for a failure to take action. It is essential that museums take responsibility for every aspect of the quality of the visitor experience that they can control.

Table 4.1 Five key factors in visitor satisfaction

When interviewed, visitors to the National Museum of Australia said that the most important factors are:

1 something for children
2 friendliness and knowledge of staff
3 ease of finding way around
4 information provided about things to see and do
5 quality of exhibitions and activities.

Source: after Tonkin (2001)

If visitor satisfaction is our key measure, visitor feedback must be crucial to quality measurement. Currently the main methods used by museums for 'listening to the visitor' are:

- comment cards
- staff feedback
- visitor surveys
- formal visitor interviews
- interviews with non-visitors
- focus groups with visitors and non-visitors
- observation/tracking.

Qualitative interviews and focus groups will always be the most effective way of evaluating the complexities of individual satisfaction levels and of defining shared elements. However, these are both costly and time-consuming. Equally, they are better employed in exploring the areas around the nature of direct visitor engagement with sites and collections than on more measurable issues around visitor services provision. There is still a real need for a questionnaire approach that permits regular, systematic evaluation of service quality at a price that is affordable and in a format that can be applied across different sites to enable benchmarking. The answer may be to follow the rest of the service industry and explore the application of Servqual – see the case study below.

DISCUSSION: MANAGING FOR QUALITY

Quality visitor services, including front-of-house staff, play a vital role in encouraging the visitor to engage with and learn from collections. This affects *all* visitors, even those with specialist knowledge and interests. It is a rare visitor who does not have any interaction with staff. It is particularly important, however, for those who in the past have felt excluded from museums. If we take social inclusion agendas, disability access and cultural diversity strategies seriously, quality visitor services are an essential, and quality front-of-house staff probably the most important, element (although factors like atmosphere and media used matter a lot). From top management down, visitor services must be prioritised and staff training in customer care must come first (after, of course, appointing the right staff in the first place). Museum managers *must* begin to change the environment in their own institutions.

Self-evaluation of the product

Self-evaluation of the product should look beyond the SWOT analysis. Evaluating failings in front-of-house management will include:

- lack of clear goals
- lack of management commitment

- lack of specialist operational managers
- confusion over staff roles
- poor staff morale
- lack of staff commitment
- lack of career progression, training, involvement in decision-making, and other staff incentives
- constant turnover in front-of-house staff owing to low wages and seasonality
- lack of visitor praise
- lack of cleanliness in public areas
- shabby/old displays
- lack of display maintenance – not just shabby but, for example, broken exhibits and light bulbs not replaced.

Note that in defining the faults, you are identifying areas for improvement.

Baseline research and benchmarking

Baseline research and benchmarking should be undertaken to define where you are and where you should be, and to enable you to assess whether any progress is being made.

Baseline research is about where you are now. In terms of the visitor experience, it is basic quantitative information about your audience supported by a qualitative assessment of their current visit (service blueprinting) and their satisfaction with it. It will be a key element in evaluating current processes and identifying areas for improvement. Importantly, it is essential if you are to assess the effectiveness of any changes you introduce.

Benchmarking allows you to define and examine the differences in performance and to try to explain them. It also enables you to examine how other locations have improved their performances so that you can begin to define best practice.

A vision for the future and a programme of change

The following should be undertaken to establish both a vision for the future and a programme of change that will help to turn the vision into a reality.

- Establish product development/enhancement which will probably be essential – see Section 4.
- Put in place standards and operating procedures to achieve quality, such as measurement, control, evaluation and review.
- Make it clear to all that visitor services are a priority. This involves more than a memo, it requires a change of heart. If senior managers fervently believe in high quality service, they must both personally take charge and communicate their enthusiasm to their employees – they should lead, inspire and motivate. They must be seen regularly at front-of-house encouraging and supporting staff ('walking the job').

- Establish a sense of mission, of purpose with everyone involved – governing body, managers, staff, volunteers – all must be clear on what the course of action is and be committed to it. There must be a detailed visitor services policy and training document. Give someone at senior management level direct responsibility for implementing the policy and developing 'an organisational culture emphasising sensitivity to visitor needs and a commitment to quality' (Johns 1999: 140).

- Look at the staff structure and other management issues to ensure visitor services are seen as a core element of the institution rather than of secondary relevance. Include visitor service objectives in forward plans and reflect this in budget provision.

- Appoint the right staff in the first place. They must like visitors and enjoy working with them and as part of a team. They must be sensitive to the needs of different audiences (improves with training and experience). They must want to develop their own skills. They should preferably be representative of the communities they serve.

- Put a strategy in place for continuous improvement: define tasks, objectives for them, budgets and names against them, and the process of evaluating and moving on.

- Invest in people as this underpins quality – the right people in the job – to obtain a highly motivated, well-qualified workforce. Staff training and participation should include a continuous programme of training agreed with staff, linked to incentives; staff being able to use their own initiative to solve visitor problems; and staff being encouraged to look for weaknesses, etc., and solve them (decision-making). This relies on a combination of staff knowledge of the museum's role and collections and the confidence to know when they can make decisions (e.g. in responding to a complaint) and when they must seek higher authority (e.g. in responding to an enquiry which they do not know the answer to). It also means managers being willing to surrender control!

- Provide customer service training across all the staff, beginning with senior management and including volunteers. Ensure all staff training (not just those on front-of-house) includes interpersonal skills – for example, active listening, assertiveness, interpreting body language, use of eye contact.

- Change the job descriptions of front-of-house staff to reflect the emphasis on visitor services. Replace attendant staff with gallery assistants who engage with visitors. They can also act as basic security cover, supported by CCTV and a small number of well-trained, roving security personnel.

- Ensure the visitor services/operations manager (or whoever is relevant) is involved regularly in planning meetings for exhibitions, events, marketing, etc. You will soon discover how useful that input will be. This says something, however, about the person you appoint to the post. He or she must be able to 'sell' visitor services to other staff and work well as part of a team.

- Include training on the contents of new exhibitions. Ensure that the front-of-house staff are well-informed about what is happening and give them the opportunity to develop areas of expertise (a technique already well-established in living history museums). Make their jobs interesting, as well as productive from

Box 4.1 A six-point charter to remind staff of what excellent customer service consists of

To bring history to life for our visitors it should:

1 *engage them* – show them the magic, the secrets, the stories and encourage questions supportively
2 *enthuse them* – about your site, our sites and English Heritage
3 *educate them* – explain the history, the personalities and the key uniqueness of your site
4 *entertain them* – tell the stories about the people, the place, the period and the conservation
5 *excite them* – promote self-discovery, parent to child interaction, events, activities and membership
6 *enhance their visit* – excellent customer care and service encourages the opportunity to find out more.

Only you can deliver above and beyond the expectations of the visitor, only you have the opportunity to engage, enthuse, educate, entertain, excite them and enhance their visit.

Source: Phil Hackett, Assistant Director of Visitor Operations, English Heritage, West Midlands

the site point of view. Look at their potential for running regular gallery activities, etc.

- Introduce a system that recognises and rewards outstanding customer service by individuals and teams.
- Put an evaluation strategy in place, establish an agreed means of defining how successful any changes are and of feeding this back into the overall strategy for change (or forward plan), altering it accordingly. Thus we are back again to the basic tenet that quality management must be continuous. Note that you must measure individuals' own performance levels as well as the impact of product change. You must also continue to benchmark against other institutions.
- Maintain a good understanding of your audiences (existing and targeted) as this is essential. Evaluate the visitor experience – this must be a constant feature:
 - know who your audiences/target audiences are (appraisal)
 - talk to them and find out what they want (consumer research and planning)
 - provide the expected product and service (product development; setting delivery and survey) to ensure continuously improving levels of satisfaction.
- Take time over all of this. Change cannot all come at once. Sensible targets are better than unachievable ones. However, priorities are important, for example, in staff training, begin with basic customer care and listening skills, supported by disability and cultural diversity awareness. Support this with ongoing visitor survey work and celebrate successes and improved responses. Never lose sight of the need to motivate staff – as Box 4.1 makes clear, it can be the individual encounter between member of staff and visitor that can bring your site or collection alive.

CASE STUDY: ADAPTING SERVQUAL TO MEASURE VISITOR SERVICES QUALITY

This chapter has sought to emphasise the importance of service quality in museums and to highlight the weakness of the service quality evaluations currently being carried out. Most user satisfaction surveys in museums are developed in an ad hoc fashion by individual institutions. None of the methods currently in use makes it possible to provide an effective measure of service quality for the individual museum visitor experience or – as important – to make relevant qualitative comparisons between sites. This situation must be reversed. While service quality cannot be measured objectively and remains a relatively abstract concept, based largely on the visitor's experience rather than on tangible items, this case study seeks to suggest that the work of Isabelle Frochot in adapting Servqual represents the best available route ahead and calls for industry-wide piloting to take place.

In contrast to museums, commercial service operators such as banks and insurance companies use variations on Servqual as a quality measure – in the form of a scaled questionnaire which seeks to define the difference between what users think the service should/will be like (expectations) and their views on the performance of the actual service received (perceptions) – and expresses this difference in terms of visitor satisfaction (perceptions of the service exceed original expectations) or dissatisfaction (perceptions of the service fail to live up to original expectations).

Servqual was developed in the USA in the 1980s. In the key text, Zeithaml *et al.* (1990) *Delivering Quality Service: Balancing Customer Perceptions and Expectations*, the authors state categorically (p. 16) 'the only criteria that count in evaluating service quality are defined by customers'. From an initial ten categories defined in their first proposals in 1985, they reduced this in 1988 to five 'dimensions' that the authors believe customers use to judge service quality across the sector:

1 *tangibles:* physical facilities, equipment, communication materials, and appearance of personnel
2 *reliability:* ability to perform the promised service dependably and accurately
3 *responsiveness:* willingness to help consumers and provide prompt service
4 *assurance:* knowledge and courtesy of employees and their ability to convey trust and confidence
5 *empathy:* caring, individualised attention the firm provides to its customers.

Frochot (2001: 157)

Each criterion has statements associated with it – for example physical facilities should include up-to-date equipment, while staff should be well dressed and

appear neat. Each statement has a corresponding quality score calculated by subtracting the perception score from the expectation score, based on a visitor questionnaire with a seven-point scale ranging from 'strongly agree' (7) to 'strongly disagree' (1). As a final check within the questionnaire, visitors are asked to tick one of four categories to reflect their views on the service – excellent, good, fair or poor – and were then asked whether they would recommend the service to a friend and whether they had ever reported a problem with the service. You can get an overall picture from this, and can also average out the scores within each criterion to see how each element of your service is performing. Companies can also use it for *benchmarking* by asking customers to make comparisons with competitors.

In seeking to develop an equivalent scale for period houses, Frochot recognised that one of the great strengths of Servqual lay in its understanding of the holistic nature of the user experience, rather than seeking to analyse the effectiveness of individual elements. However, a key criticism of Servqual since its introduction has concerned difficulties encountered in applying it to different services, where different dimensions and different emphases on quality elements might apply. The authors have since recognised that their scale, rather than being universally applicable, can be used as a skeleton that could be adapted as required to new contexts.

In her adaptation of Servqual – Histoqual – Frochot sought to build on the experience of a range of relevant research on the application of Servqual particularly in a leisure and recreational environment (see Frochot and Hughes 2000). As a result, she used positively worded statements only within the five dimensions, rather than a mixture of positive and negative ones (this was supported by the latest revision of the scale – Parasuraman *et al.* 1991). Crucially she also opted for a measure based on perception statements only – so based on how visitors perceived their visit rather than on the gap between perception and original expectations. This again reflected an analysis of the outcomes of similar research by others (see Frochot and Hughes 2000).

Based on this framework, Frochot initially sought to develop a pool of items representing service quality aspects in historic houses centred around the same five dimensions used in the original Servqual scale, but these were also partially changed after initial piloting. Three dimensions were retained as relevant (responsiveness, tangibles and empathy) and two new ones developed (communication and consumables). Responsiveness related to staff efficiency and the ability of a site to recognise visitor needs. Tangibles represented the environment of the site. Communications reflected the quality and detail of the information presented. Consumables brought together the additional services provided by the site, described by Frochot and Hughes as 'constituting a service situation in their own right' (p. 162). Finally, Empathy looked at how the site responded to the needs of children and those with disabilities.

Within these five dimensions, Frochot sought to identify all the points of interaction between the visitor and the site. She initially tested this on three

sites, with both visitors and managers, using a points score of 1–5 rather than 1–7. The end result was five dimensions containing a total of twenty-four assessed elements (Frochot and Hughes 2000: 161):

1 *responsiveness*
 staff always helpful and courteous
 staff always willing to take time with visitors
 visitors are made to feel welcome
 level of crowding is tolerable
 staff are well informed to answer customers' requests
 visitors feel free to explore, there are no restrictions to access
 the property and grounds are opened at convenient hours
 staff are always available when needed.
2 *tangibles*
 the property is well kept and restored
 the general cleanliness and upkeep of the property and grounds is satisfying
 the grounds are attractive
 the site has remained authentic
 direction signs to show around the property and grounds are clear and helpful
 the garden and/or park contain a large variety of plants
 interior of the house offers a lot of interesting things to look at.
3 *communication*
 the written leaflets provide enough information
 the information on the property and grounds is detailed enough
 visitors are well informed of the different facilities and attractions available at the property
 foreign language leaflets are helpful.
4 *consumables*
 the restaurant offers a wide variety of dishes and refreshments
 the shop offers a large variety of goods
 the restaurant staff provide efficient service.
5 *empathy*
 the property considers the needs of less able visitors
 facilities for children are provided.

Frochot's overall assessment of the use of Histoqual suggested it 'appeared to represent well the respondent's evaluation of the quality of the service provided and their judgement of value-for-money' (p. 163). However, it also raised a number of issues. One factor she had difficulty with (which I think is very British but Lynda Kelly assures me is Australian also) was visitors finding it hard to make a judgement and coming out with lines like: 'I suppose they do what they can' or 'I presume it costs a lot of money to look after this property

The National Museum of Childhood, at Bethnal Green, London. The redecoration of the building and removal of a large information kiosk at the entrance opened up the whole building as a welcoming space. © National Museum of Childhood

. . . in the case of public services, customers were less openly critical when evaluating quality' (Frochot 2001: 163–4).

She felt she should also include visitor attitudes to value for money and also continue the Servqual checks of seeing if they would recommend the visit to friends and family and asking visitors to describe their overall feelings, from very satisfied to very unsatisfied. Of key relevance, she contradicted the assumption that all service quality dimensions were of equal importance by

introducing *importance scores* – visitors' importance ratings for the different dimensions. Her approach was to ask visitors to mark them 1 to 5 and then she used the results to weight the overall score. The order of importance, by decreasing order, was tangibles, communications, responsiveness, consumables and empathy.

The crucial question is how relevant this work is to museums and galleries. Building on Histoqual, Allen (2001) sought to adapt Servqual to measure the quality of the visitor experience in museums, calling her experimental version Musequal. As with Frochot, this builds on the concept of the visit as a holistic experience, with quality vital throughout the series of events that together form it. Much of her work reinforced Frochot's conclusions on using only visitor perceptions as the key measure and weighting the results based on the importance ratings given to the different dimensions by visitors.

Because her research was targeted at museum use, Allen raised a specific issue over the communication dimension. In establishing her Musequal 'dimensions' Allen sought to build on Frochot but make it specifically relevant to museums and galleries. She saw *tangibles* as incorporating the physicality of the site, from exhibition maintenance to cleanliness, safety and even car park facilities where relevant. She used *responsiveness* to cover the skills, attitudes and appearance of staff, and incorporated the Servqual categories of reliability and assurance into this. She introduced *awareness*, echoing the Histoqual and Servqual dimension of empathy, to embody the key issues of social inclusion and physical, emotional and intellectual access. She paralleled the example of Histoqual in using the categories of *communication* and *consumables*. She rightly pointed out that communication is a key issue in museums, and therefore a clear factor by itself, covering orientation, operational information and support materials. As with Frochot, consumables relate to visitor amenities for purchases – the shop and café. Her experimental version of Musequal is outlined in Box 4.2.

Musequal was tested, on the basis of visitor perceptions only, at Manchester Museum of Science and Industry, and at Derby Museum and Art Gallery, both in the UK. In the nature of things, Emily Allen moved on to a curatorial career and Musequal was taken no further.

Frochot's research on Histoqual continues, with her latest work recently published (Frochot 2004). In this she segmented visitors according to the benefits sought (which compares more or less to their motivations), obtained four segments and then compared, for each of those segments, their quality perceptions and importance scores along with other behaviour variables (attendance per year, distance travelled, etc.). The research showed that the majority of the segments had a very limited interest in history. The historic houses could be consumed as a leisure day-out (especially for families), or as a leisurely historic visit (she calls this segment casual historians) or simply as a visit where the visitors did not have fairly well defined motivations. Only one segment (the historians) had a clear and motivated interest for the history of the place. However, the paper also indicates that historic sites can develop new audiences

Box 4.2 Musequal: evaluating user satisfaction with the museum visit

Tangibles
The parking facilities are satisfactory.
The reception area is pleasant and helpful.
The museum is clean and tidy.
The exhibitions are well maintained.
The museum is a safe environment.
The toilet facilities are satisfactory.

Responsiveness
Staff have an appropriate appearance.
Staff are noticeable and sufficient in numbers.
Staff are pleasant and helpful.
Staff communicate in a way that satisfies your needs.
Staff are knowledgeable.

Awareness
Opening hours are convenient.
Visitors are made to feel welcome.
There are adequate seats in the museum.
The level of noise and crowding is acceptable.
The atmosphere in the museum is in keeping with the exhibits.
The facilities for children are satisfactory.
The museum caters for the needs of less able visitors.

Communication
The promotional leaflet and/or website is useful and attractive.
Road and street signs make it easy to find the museum.
Direction signs in the museum make it easy to find your way around.
Foreign language leaflets are available and helpful.

Consumables
The café is pleasant with a good choice and quality of food and drink.
The shop has a good choice and quality of items.

Source: Allen (2001)

(particularly if they are located close to an important catchment area such as a city). The limit of this study, however, lies with its sample, as only three historic houses have been studied, making it difficult to draw valid strategic conclusions.

Of course no one, least of all Frochot or Allen, would claim that Histoqual or

Musequal should stand alone as an evaluation tool. As chapter 4 makes clear, even in evaluating service quality they must sit alongside service blueprinting and other exercises. Frochot believes her second study shows the limits of using a scale like Histoqual on its own and that we need to look also at motivations if we want to obtain a full understanding of the market. As an interpreter, I would also emphasise that support for visitor engagement with the site and/or collections is an essential part of the service museums provide, but requires a much more qualitative approach to evaluation (see Section 4). However, I have given Musequal and Histoqual a substantial amount of space here not because they have made any serious impact on the museum world to date but because they show that museums are *not* unique in the service world. It *is* possible to begin the process of effectively evaluating the quality of service we provide to our visitors, and this *is* an essential element within the quality of the overall visitor experience. I have no doubt that the principle of a service quality questionnaire can be applied effectively to museums, benefiting individual sites and enabling comparisons between sites.

The reality is, however, that the effective implementation of a quality agenda in the operational management of museums – let alone any evaluation of this – has a disgracefully low priority within the museum world. There are many reasons for this but most involve lack of management commitment, falling budgets, lack of clear goals, confusion over roles, lack of specialist operational managers, lack of staff commitment owing to lack of career progression, lack of other incentives, a constant turnover in front-of-house staff owing to low wages and seasonality, and lack of visitor praise. My somewhat cynical view is that change will not come from within the profession. It will be forced on the profession by outside pressure, either from governing bodies or from growing competition from other leisure venues and visitor demands for high standards.

Section 3
Learning in museums

Many of the museums founded in the later nineteenth and early twentieth centuries saw themselves as institutions for learning. In 1918, Benjamin Ives Gilman could write:

> To fulfil its complete purpose as a show, a museum must do the needful in both ways. It must arrange its contents so that they can be looked at; but also help its average of visitors to know what they mean. It must at once install its contents and see to their *interpretation.* [my emphasis]
>
> Gilman (1918: 280)

However, for much of the twentieth century the emphasis in most museums was on collecting, with their learning function coming a poor second. It is only in the last two decades that the educational role of the museum has become increasingly significant. Today, most museum education services have core responsibilities that extend throughout museum programming, school audiences form a core element in many museums' attendance figures and a commitment to lifelong learning underpins much adult provision.

This section begins with an exploration of learning theories as they are being applied to museums, in terms of both structured educational use and lifelong learning. Chapter 5 focuses on the impact of learning theories on exhibition development, while chapter 6 seeks to explore what museums can do to enhance schools provision and what the impact of this is on exhibitions.

5 Museums and lifelong learning

INTRODUCTION: THE RISE OF 'LEARNING' UP THE MUSEUM AGENDA

The contemporary emphasis on the role of museums as learning institutions has not come about suddenly. Five key reports stand out for their importance to the development of museum education, and its recognition as a core function for museums (see Box 5.1).

What became known as *America's Museums: The Belmont Report* (AAM 1969) explored the conditions and needs of America's museums and culminated in a request for Federal recognition and support for museums' educational role. It led eventually to the Museum Services Act of 1977 and the creation of an Institute of Museum Services in the USA (now the Institute of Museum and Library Services), which has since given Federal grant aid of over $400m to support lifelong-learning initiatives in museums. This ongoing educational commitment by museums underpinned the 1992 publication by the American Association of Museums of *Excellence and Equity: Education and the Public Dimension of Museums*, which proposed placing the role of education as 'central to every museum's activities': 'The community of museums in the United States shares the responsibility with other educational institutions to enrich learning opportunities for all individuals and to nurture an enlightened, humane citizenry . . .' (AAM 1992: 25).

In the decade since that publication, museums in the USA have increasingly put education at the centre of their public service role, viewing it as integral to their mission. This, in turn, has encouraged museums to look outwards and to develop an expanded vision of their public service role and potential, both in supporting lifelong learners and for formal educational use. Research by the Institute of Museum and Library Services suggests museums in the USA now spend a minimum of $148m a year in support of education for 6- to 18-year-olds. Equally:

> Americans of every demographic group – gender, age, education – and in every region of the country believe that museums are the most trustworthy sources of information. More than TV news, radio or magazines, and much more than the Internet . . . They are educational powerhouses that enrich millions each year.
>
> Martin (2002)

Box 5.1 Key reports important to the development of museum education

America's Museums: The Belmont Report (American Association of Museums) 1969

Musées, imagination et education (UNESCO) 1973

Museums for a New Century (American Association of Museums) 1984

Excellence and Equity: Education and the Public Dimension of Museums (American Association of Museums) 1992

A Common Wealth: Museums in the Learning Age (UK Museums and Galleries Commission) 1997

In the UK, the rise in status of museum education can be traced through the publication of *A Common Wealth* (Anderson 1997) and the establishment of the 'Campaign for Learning in Museums' (see www.clmg.org.uk); and externally with the change in the political agenda following the 1997 election of a New Labour government, with its emphasis on 'Education, Education, Education' (Tony Blair speech 1997) and the development of social inclusion and lifelong-learning strategies. Success has come in the form of central government funding for learning and inclusion-related projects in national and regional museums, and in formal central governmental recognition of the role museums could play in educational and social inclusion initiatives with the governmental publication of *The Learning Power of Museums: A Vision for Museum Education*, identifying key objectives and areas for action:

> The Government believes that education is central to the role of museums today . . . Our vision for the new Millennium is of museums inspiring and supporting a learning society as they reach out to the widest possible range of audiences . . .
>
> DCMS and DfEE (2000: 4)

In effect, UK governmental policy now states that education – in terms of both schools use and lifelong learning – *must* become a core function of museums. This policy currently dominates UK museum strategic planning, not least through conditions being attached to capital and revenue funding allocations.

By contrast, in Australia lifelong-learning policy remains focused on training for employment, developing computer skills and keeping the older population productive for longer. A recent government discussion paper on adult learning did not mention museums at all (Australian Government, Department of Education, Science and Training 2003). Public funding for museums continues to be cut and museum education departments remain primarily focused on school-aged children and teachers. There are no national or state policies focusing on lifelong-learning strategies across cultural institutions, nor is there any evidence of Museums Australia viewing lifelong learning as a 'hot topic' (for what are considered the key museum issues in Australia today, see www.museumsaustralia.org.au/hottopics.htm). However, important exceptions to this can be seen, for example, in the work of the Australian Museum, Sydney, and Museum Victoria, Melbourne (which has an adult education officer).

Thus different countries and institutions within countries are at different stages in the development and implementation of strategies for museum learning – making it a very useful time to seek to explore the basic issue of whether a policy of seeing museums as primarily educational and learning institutions can be delivered in practice.

MUSEUMS AND LIFELONG LEARNING

> Whatever helps us to shape the human being – to make the individual what he is, or hinder him from being what he is not – is part of his education.
>
> (John Stuart Mill, rectorial address, University of St Andrews, 1867, quoted in Gilman 1918: 47)

The potential for museums as learning institutions has already been explored within the context of that other prominent item on the contemporary political agenda, social inclusion (see chapter 2). It is now time to turn to the fields of 'lifelong' and 'life-wide' learning. It is important to distinguish between the two:

> Learning as a preparation for life has been displaced by learning as an essential strategy for successful negotiation of the life course, as the conditions in which we live and work are subject to ever more rapid change . . . In contemporary conditions, learning becomes not only 'lifelong', suggesting learning as relevant throughout the life course, but also 'life-wide', suggesting learning as an essential aspect of our whole life experience, not just that which we think of as 'education'.
>
> Harrison *et al.* (2002: 1)

Within the social inclusion environment, the evidence that is slowly emerging seems more to do with the contribution museums can make to life-wide learning, in helping people toward the 'Maslow' target of self-actualisation by which, through individual empowerment and the development of skills, previously excluded members of society can gain greater self-confidence and self-esteem. Linked to this is the issue of 'access' to museums and their collections, in terms not only of the physical, but also intellectual, social, emotional and cultural access.

However, it is the concept of 'lifelong' learning which has become part of the political agenda across the western world, linked to the competitive advantage accruing from a trained workforce able to respond to issues of globalisation. As 'lifelong education' or 'recurrent education' it had won some political favour in the late 1970s before disappearing under the cloud of recession and unemployment that dominated much of the late 1970s and 1980s. However, the concept of adult education and training has since been returned to with vigour:

> Just as futurists were beginning to herald the coming of the knowledge economy, a number of forward-thinking educators were talking about the transition of

America into a *Learning Society*. They suggested that if America was to fully transition into a knowledge-based economy, where information and ideas were paramount, learning across the lifespan would need to become central to the society as never before.

Falk and Dierking (2002: 3)

The recognition that jobs are no longer for life, and that continuing professional development is a necessity both for individuals and for companies seeking to maintain a competitive edge, has resulted in a massive increase in training within the workplace. We see this in both internal company appraisal and staff development programmes, and in the rise of vocational training qualifications. Field (2002: 206) points out that in the USA it is estimated that in the year 2000 the training market was worth $60 billion a year. So the concept of a 'learning society' has been grasped and acted on by industry. However, the training provided by industry is, not surprisingly, in-service, job development focused. Where do those people currently outside employment or not receiving in-service training, and therefore excluded from this learning society, look? The answer, at least in western Europe, lies with the public sector.

It is within the context of training for employment that most western governments and intergovernmental bodies have viewed lifelong learning. Lifelong learning formed a key element in the European Commission White Paper (1994) on competitiveness and economic growth, being seen as a source of competitive advantage, a response to the employment threats presented by globalisation and information technology. The White Paper stated:

> Preparation for life in tomorrow's world cannot be satisfied by a once-and-for-all acquisition of knowledge and know-how . . . All measures must therefore necessarily be based on the concept of developing, generalising and systematising lifelong learning and continuing training.
>
> European Commission (1994: 16, 136) quoted in Field (2002: 203–4)

The Commission subsequently declared 1996 as European Year of Lifelong Learning.

In Germany, the federal education ministry published a series of reports on lifelong learning between 1996–8. Policy papers also appeared from the Dutch, Norwegian, Finnish and Irish governments, and from the OECD (1996), UNESCO (Delors 1996) and the Group of Eight Industrial Nations (1999). In 1999 the UK government published a White Paper on post-16 education and training, proclaiming, 'Our vision of the Learning Age is to build a new culture of learning and aspiration' (DfEE 1999: 13). The national government in Australia has been relatively late on the scene, only publishing a major consultation paper in 2003: 'At a time when each Australian is likely to have several different occupations during his or her lifetime, learning from schooling through to mature age and beyond is vital' (Australian Government, Department of Education, Science and Training 2003: 1).

However, if we explore what has actually happened on the ground we begin to discover that, despite so much political hot air being expended on the subject – and almost universal policy endorsement in the western world – there is little in the way

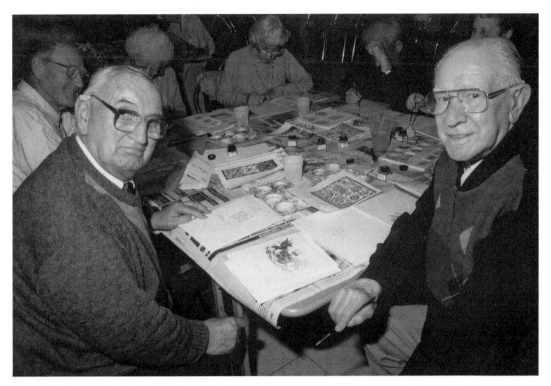

Older learners attend a painting club, Weston Park Museum. © Sheffield Galleries and Museums Trust

of specific policy measures, equally little evidence of the successful delivery of the lifelong-learning agenda by any of the agencies involved, and the beginnings of an explanation as to why this is the case. Field quotes the conclusion to a report for UNESCO by Ursula Giere and Mishe Piet (1997: 3–4) that:

> Everywhere in the world statements identify adult education as a key to the survival of humankind in the 21st century, attributing adult education with the magic to contribute positively to education for all . . . and yet, almost everywhere in the world, adult education is a widely neglected and feeble part of the official educational scene.
>
> Field (2002: 205)

Important

So, the politicians are not delivering on their hot air. Equally, while legislation can support attitudinal-change initiatives, change cannot be achieved solely by the actions of government agencies, but relies on the motivation, capacity and actions of the individual:

> [L]earners themselves will have to choose and combine learning processes and strike the right balance between available roots of learning in a way that meets

their specific needs. In other words, they will be largely responsible for directing their learning themselves.

Dohmen (1996) quoted in Field (2002: 210)

Government may be able to lead a horse to water, but cannot make the animal drink. Lifelong learners must take responsibility for their own learning and be 'prepared to invest "time, money and effort" in education or training on a continuous basis' (Watson 1999: 3, quoted in Kelly *et al.* 2002: 52).

Yet, it is within this domain of fuzzy, under-funded politics and uncertain individual motivation that much of the museum world is currently seeking to state its central case for existence. It is not enough now for museums to provide an aesthetic or inspiring experience or to seek simply audience enjoyment – audiences must be encouraged to come to learn and, at least in the opinion of national policy bodies, the nature of that learning must be measurable in some shape or form (contrast this with the image museums need to project to attract the leisure audience, as discussed in chapters 1 and 3).

This is not all a 'bad thing'. The very attempt to justify public funding by demonstrating their educational value to society has forced museums and heritage organisations to look much more closely at the nature of what they are actually providing for their users. This has led at last to the general recognition of education and learning as a core function within museum provision. Input from educators is now commonly being sought at the exhibition planning stage unlike in the past, when educators used to be presented with completed exhibitions and then had to work out how to make use of them.

LEARNING THEORY AND MUSEUMS

As part of its attempt to define principles for effective museum education and learning, a working party for the American Association of Museums Exemplary Interpretation Project stated that museums should 'Ensure that Learning Theory and Educational Research are the foundation of practice' and went on to emphasise that: 'The flexibility to integrate a variety of learning styles and learning theories is as important as the specifics of audience, content, and vehicle of delivery in providing access to all learners' (AAM 2001: unnumbered).

In this section I seek to introduce and discuss a few of the many theories of learning currently in circulation:

- to provide a fuller context for the policy initiatives on museum learning currently dominating thinking in the museum world
- to explore whether those theories can have a direct impact on the nature of museum exhibitions
- to illustrate how learning theories are impacting on strategies for learning in museums.

In recent years a number of key texts on the educational and learning role of museums have appeared, including Falk and Dierking (1992, 1995, 2000); Hooper-Greenhill (1994b); Durbin (1996); Roberts (1997) and Hein (1998). I must make clear that all I can hope to achieve within this chapter is an introduction to the subject of museums and learning, with the emphasis placed on the impact of learning strategies on museum provision for the public.

Knowledge and understanding

> Our beliefs about the nature of knowledge . . . profoundly influence our approach to education. It makes a difference whether we believe that knowledge exists independently of the learner, as an absolute, or whether we subscribe to the view that knowledge consists only of ideas constructed in the mind.
>
> Hein (1995a: 21)

Learning is both a process and an outcome – the process is about *how* we learn, and is explored below. The outcome is about *what* we gain from learning – knowledge, and the great leap from the gathering of knowledge to understanding it – and is examined first. In principle it is possible to recognise when learning has occurred and knowledge and/or understanding acquired – the learner may demonstrate that he or she knows or has insight into something that he or she did not know or could not do before; the learner may reflect new skills that have been acquired; the learner's attitudes, values or behaviour may change as a result of learning experiences. But what does this knowledge represent?

Hein (1998: 16–21) provides an effective introduction to the contrasting theories of knowledge, in particular contrasting *Realism*, the classic Platonic position that there is a body of knowledge that exists independent of the individual, with *Idealism*, which suggests knowledge exists only in the minds of individuals.

The Realist approach to knowledge has been a key feature of western intellectual history since the Enlightenment. It has been combined with an ability to organise this body of knowledge about the world rationally, independent of the individual, determined by the structure of the subject – disciplines, taxonomies, categories, etc. These could all be explained not only in isolation, but also in terms of their relationship with each other. Each also had a role in helping to make the whole function.

By contrast, under perhaps the most extreme version of the Idealist approach to the concept of the development of knowledge: 'the conclusions reached by the learner are *not* validated by whether or not they conform to some external standard of truth, but whether they 'make sense' within the constructed reality of the learner' (Hein 1998: 34).

Clearly, the acquisition of a body of knowledge in a structured manner is easier to define and assess externally than that of knowledge constructed in the mind of the individual, and thus dominates our national education systems. This domination has in turn had a dramatic impact on the approach taken in museum exhibitions, leading

to an emphasis on factual content and to an overwhelmingly didactic approach to exhibition development.

Didactic exhibitions: the transmission of knowledge to museum visitors

The concept of learning as a product – as the acquisition of fact-based knowledge – lies behind almost every museum exhibition. We, the curators, take a Realist's view of the nature of knowledge, possess certain amounts of that knowledge ourselves, and seek to transfer it to our visitors through didactic exhibitions. In this case, the *process* of learning involves 'transmission' from the teacher and 'absorption' by the learner – 'the incremental assimilation of information, facts and experiences, until knowledge results' (Hein 1995a: 21).

This is a highly passive approach, from the museum audience point of view. The curator teaches, the visitors learn. In principle, the curator breaks the information to be conveyed down into small digestible pieces arranged in a logical order, and the visitors absorb these unquestioningly, in the order and manner intended. So, how has it come about? For an historical perspective, one can look at, for example, Hooper-Greenhill (2000: 126ff). It is very easy to see the 'traditional' museum exhibition, with its cases of objects with labels attached, all supported by graphic panels, as continuing the approach established by those nineteenth-century ones Barbara Kirschenblatt-Gimblett comments on:

> In many ways, the approach to museum exhibitions . . . during the latter part of the nineteenth century should be seen in relation to the illustrated lecture . . . The written label in an exhibition was a surrogate for the words of an absent lecturer, with the added advantage that the exhibited objects, rather than appear briefly to illustrate a lecture, could be seen by a large public for a longer period of time.
>
> Kirschenblatt-Gimblett (1998: 32)

Yet it needs more than history to explain what is still the predominant form in exhibitions being created today. The answers are not hard to find and come down largely to convenience, to the nature of the museum profession and to the expectations of the traditional museum audience. The didactic approach is a convenient one because it fits easily into the institutional framework of the bulk of our museums, based as they are largely on individual subject specialisms. It is easy to define exhibition objectives based on the transmission of information relating to particular collections or fields of knowledge, and to structure this knowledge into manageable chunks suitable for display.

However, convenience is not enough to explain the absolute dominance of didacticism in museum exhibitions. Curators must also explore their own attitudes and, equally, those of the traditional museum visitor. Most curators have been brought up in the educational tradition of didacticism, and have done well out of a long formal training in their school and university days. It has made them knowledgeable in a subject-based way. Once in post, it is this expertise that underpins their authority. Traditional museum visitors have also been educated in this way (see chapter 1 – the

Young children are encouraged to talk about a painting. The art galleries at Weston Park Museum are specifically targeted at new audiences. © Sheffield Galleries and Museums Trust

higher the educational level achieved, the more often you visit museums), instantly recognise the didactic approach in exhibitions, and feel 'comfortable' with it. Thus curators continue to pontificate and compliant audiences continue to accept the result.

By their very nature, museum exhibitions must cater for a mass audience. Didacticism works best in circumstances where the audience members share a similar level of background interest, knowledge and understanding. The more that visitors seek individual experiences, and the opportunity to participate directly in that experience – and the more that museums seek to diversify their audience base and must therefore respond to different learning needs and different levels of understanding – the less suitable a strictly didactic approach becomes. The time for switching from purely didactic exhibitions to alternative approaches more suited to the needs of the full range of targeted museum visitors is long overdue. This is not to deny a place for didacticism within the new order – many visitors will still seek that approach, and their needs should still be catered for as part of the palette of approaches within an exhibition.

Experiential learning: an alternative approach to acquiring knowledge

Didacticism allows the process of learning to be seen as an activity that is both passive and short-term – a school period, a few hours – in which specific key facts can be absorbed. It is equally relevant to the school textbook, with contents following a logical, paced approach to the presentation of the subject matter. Both the school period and the textbook work well as analogies for the traditional museum exhibition, with a beginning, a middle and end, and contents that can in theory be absorbed passively in the 'correct' order during a single visit or in sequential stages over a number of visits.

An alternative view of the process of learning would suggest that 'in order to learn, students need to have experience; they need to do and see rather than to be told' (Hein 1995a: 22). Thus knowledge and resultant understanding follows on from acquiring, reflecting on and applying the results of life experiences and is not a one-off activity. This concept of learning as a lifelong process also allows us to reassess the 'product', to see it as more than the acquisition of knowledge (in the sense of 'facts') and the development of understanding.

In 2001 Resource, the strategic body for Archives, Libraries and Museums in the UK (now the Museums, Libraries and Archives Council, or MLA), published *Using Museums, Archives and Libraries to Develop a Learning Community: a Strategic Plan for Action* (MLA 2001b) as a consultation document, seeking to define the case for learning in museums, archives and libraries. The document specifically used learning as its lead term rather than education – 'a word that carries with it connotations of formal, didactic, curriculum-based, teacher-led processes' (MLA 2001a: 5). It accepted the UK 'Campaign for Learning' definition of learning:

> Learning is a process of active engagement with experience. It is what people do when they want to make sense of the world. It may involve increase in skills, knowledge, understanding, values and capacity to reflect. Effective learning leads to change, development and the desire to learn more.
> 'About Us', Campaign for Learning, 1999, endorsed and adopted by Resource
> (MLA 2001a)

Learning is still seen as including the acquisition of an independent body of knowledge, but the definition has broadened well beyond that. As such, Resource was able to suggest that every experience in a museum, archive or library had the potential to be a learning opportunity – an opportunity to acquire, reflect on and apply new experiences. This approach is usually described in terms of a 'learning cycle'.

The learning cycle

Outside structured educational delivery, most of what we learn comes from doing. The underpinning theory is quite simple – we do something, we learn from the experience, and when we do something new that is related, we seek to apply the

Figure 5.1 The learning cycle

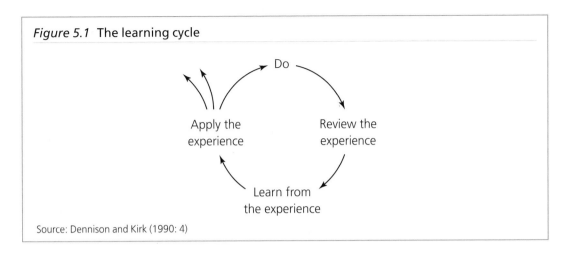

Source: Dennison and Kirk (1990: 4)

experience we have previously obtained, producing a learning cycle as shown in Figure 5.1.

This is the concept of *experiential learning* at its most basic. While single arrows will join 'Do' to 'Review the experience', 'Learn from the experience' and 'Apply the experience', several arrows will lead from 'Apply the experience', as the same experience will be relevant in different circumstances. From this simple beginning, it is possible to explore the cycle from a number of viewpoints and to develop it further. Three adaptations are directly relevant to museum display:

1 the 'virtuous cycle' v. the 'vicious cycle'
2 Kolb's theory of learning styles
3 discovery learning.

The 'virtuous cycle' v. the 'vicious cycle' (after Dennison and Kirk 1990)

The challenge within a museum exhibition must be to provide an environment in which – if audiences desire to – they can learn from the experience of their visits to the extent that they are motivated toward developing learning cycles (thus it is a guided activity, *not* an unstructured one). Experiential learning theory would suggest that this will only happen if the visitor perceives the relevance of the displays to his or her own life and can see opportunities for the application of what has been learned. This in turn generates enthusiasm for further learning – thus the outcome of experiential learning can be action or learning, or even more learning. In this way, the 'virtuous learning cycle' is created, as illustrated in Figure 5.2 on p. 134.

The starting point – the 'Effectiveness focus' – implies an initial motivation toward or interest in a field. In a perfect environment visitors, through their engagement with the displays, can then perceive the relevance of these to their own lives and needs, can apply what they have discovered immediately and gain a clear reward, and will in turn see their enthusiasm for further learning enhanced. Thus, as the Campaign for Learning definition quoted above says 'Effective learning leads to change, development and the desire to learn more'. From a museum interpreter's point of view, if the visitor is seeking an enhanced understanding and the exhibit results in a

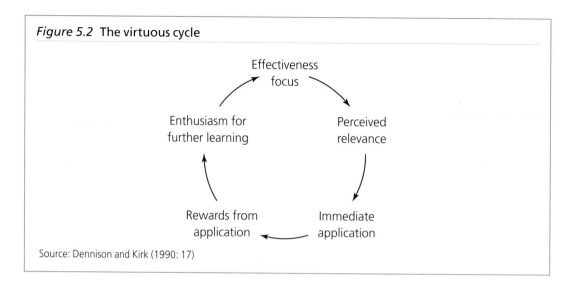

Figure 5.2 The virtuous cycle

Source: Dennison and Kirk (1990: 17)

'Now I see' or 'So that's how it works' response, there has been an immediate application and reward which will encourage the visitor to explore the gallery further – even if any impact on the visitor's life is only apparent in the longer term.

However, museum visits need not only be positive. If there is a 'virtuous cycle', one must also recognise the potential for a 'vicious' one. In museum display terms, the 'vicious cycle', as illustrated in Figure 5.3, occurs when visitors cannot translate display contents or experiences to their own situations, and can see no benefit to themselves in any associated learning. As a result, their involvement with the displays ceases, they lose interest and drift away.

Kolb's theory of learning styles

Most models of the learning cycle lead back to that defined by Kolb (1984). The starting points are similar, even if the terminology differs. Thus 'Do' becomes *Concrete experience*, 'Review the experience' becomes *Reflective observation*, 'Learn the experience' becomes *Abstract conceptualisation*, and 'Apply the experience' becomes *Active experimentation*.

However, Kolb is seeking to provide a concept that applies beyond the experiential learning models used in structured educational environments. If one is to accept the concept of a learner's active involvement in a learning cycle, one must also acknowledge that people will learn in different ways:

- *Concrete experience* focuses on being involved in experiences and dealing with immediate human situations in a personal way.
- *Reflective observation* focuses on understanding the meaning of ideas and situations by carefully observing and impartially describing them.
- *Abstract conceptualisation* focuses on using logic, ideas and concepts. It emphasises thinking as opposed to feeling.
- *Active experimentation* focuses on actively influencing people and changing situations. It emphasises practical applications as opposed to reflective understanding.

Figure 5.3 The vicious cycle

Generalised knowledge or skills

↓

Difficult to transfer to own situation

↓

Difficult to apply to your needs

↓

Absence of rewards for learning processes

↓

Full stop

Source: Dennison and Kirk (1990: 17)

Defined in this way, we are not just looking at the processes of the learning cycle, but also at the different learning styles involved – the 'concrete experiencer', the 'reflective observer', the 'abstract conceptualiser', and the 'active experimenter'. However, while Kolb saw learning as a continual process involving all of these styles, many since have suggested that individuals tend to prefer, or at least rely on, an individual style in the way they approach learning. If this is the case, then people developing learning materials, whether for structured educational use or in the form of museum displays, must reflect the needs of these learning styles in what they develop.

Thus, under the Kolb model:

- *divergers* seek to discover 'why'. They perceive new information through doing and then think through the results. McCarthy (1987) refers to these as 'imaginative learners'.
- *assimilators* are concerned with 'what is there to know'. They perceive new information through reading/thinking and then reflect further on this. McCarthy (1987) refers to these as 'analytic learners'.
- *convergers* are motivated by 'how'. They perceive new information by reading/thinking and then process it by doing. McCarthy (1987) refers to these as 'commonsense learners'.
- *accommodators* seek 'what would happen if I did this'. They perceive new information through doing and then test this in the same way. McCarthy (1987) refers to these as 'dynamic learners'.

(The McCarthy terminology is referred to here because it is used below in connection with the interpretation strategy for the British Galleries at the Victoria and Albert Museum – see p. 137.)

It is patently clear that people vary in their learning styles – or what we might alternatively refer to as their preferred way of learning. But can we accept the learning styles as defined by Kolb (see Figure 5.4)? A whole management training

Figure 5.4 Kolb's learning styles

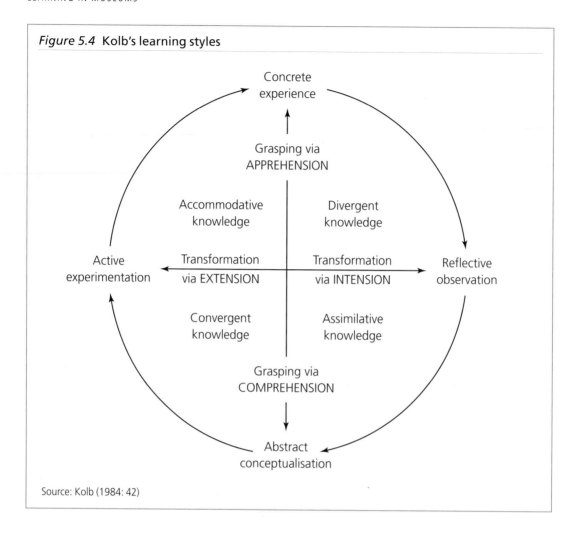

Source: Kolb (1984: 42)

industry has grown up around the theme of learning styles and these are used to help people become more effective learners, as any visit to an Internet search engine will reveal. As management trainers, for example, Honey and Mumford (1992: 5–6) have provided alternative titles and descriptions for their four learning styles:

- *Theorists* adapt and integrate observations into complex but logically sound theories.
- *Reflectors* like to stand back to ponder experiences and observe them from many different perspectives.
- *Pragmatists* are keen on trying out ideas, theories and techniques to see if they work in practice.
- *Activists* involve themselves fully and without bias in new experiences.

One must bear in mind that the use of learning styles in management training has recently been subject to highly critical review (Utley 2003). Equally, it is important

to appreciate that learning styles will be only one of a wide range of influences on what is learned or not learned by the individual, a point reinforced in Figure 5.5 on p. 138.

This puts the issue of learning styles into perspective – it only reflects one type of influence. However, its importance for the teacher, trainer or provider of museum exhibitions is immense as they can directly influence this aspect of learning. It is outstandingly relevant to museum exhibition development. Here we have, potentially, a practical concept rather than a theoretical model. First, our visitors are unlikely to achieve a virtuous learning cycle on their own – they still need curators and interpreters to structure the experience. Now, second, if our audiences seek to learn in different ways, then they must be provided with a palette of learning opportunities to meet their differing needs – and that can be done without requiring a detailed understanding of the complexities of the learning process. It even accommodates the view that people will rely on different learning styles at different stages during their visit.

Some curators have taken this on board during exhibition planning. The interpretation strategy for the British Galleries at the Victoria and Albert Museum (winner of the European Museum of the Year Award 2003) states that:

> people learn in different ways. Some people prefer to learn from museums through a practical hands-on approach while others are more interested in starting from a theory and applying it.
>
> In her recent book, *Exhibit Labels*, building on work by others over the last 30 years, Beverley Serrell describes the following groups of learners:
>
> *Analytical learners* learn by thinking and watching, prefer interpretation that provides facts and sequential ideas, want sound logical theories to consider, and look for intellectual comprehension.
>
> *Imaginative learners* learn by feeling and watching and by listening and sharing ideas, prefer interpretation that encourages social interaction, like to be given opportunities to observe and to gather a wide range of information, and look for personal meaning.
>
> *Common-sense learners* learn by thinking and doing, prefer to try out theories and test them for themselves, and look for solutions to problems.
>
> *Experiential learners* learn by feeling and doing, enjoy imaginative trial and error, prefer hands-on experience, and look for hidden meaning.
>
> Traditionally the V & A has served analytical learners but has dealt less well with other kinds of learners. The British Galleries will address all learning styles.
>
> (Victoria and Albert Museum: interpretation strategy for the
> British Galleries, unpublished)

At least one interpreter, John Veverka, has taken Kolb's theory of learning styles and sought to present this in terms of the learning responses of visitors to heritage interpretation (see Figure 5.6 on p. 139). He does not see these as stark choices. Rather they are mutually compatible, enabling the visitor to develop an individual mix that adds up to a unique personal encounter or experience. What is fascinating in introducing his version at this stage is that it incorporates *motivation* as a key element, and

Figure 5.5 Some influences on individual learning

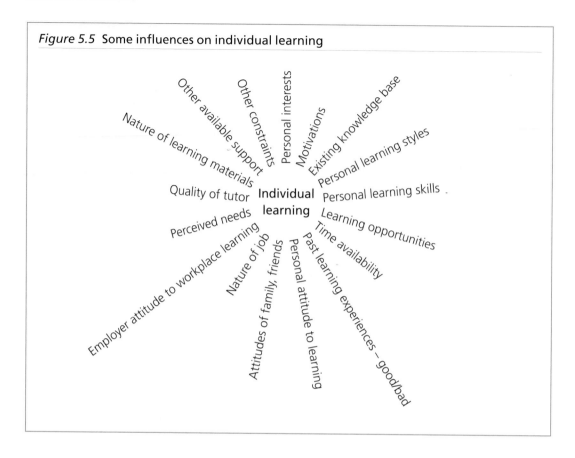

the motivation involved is about the reason or reasons for visiting a heritage site, not simply variations on the motivation to learn.

Discovery learning

Discovery learning is based on the concept of the 'Aha!' moment – 'Now I understand'. It is a form of active, experiential learning most commonly recognised in problem-solving, enquiry-based and 'hands-on' environments. It provides a direct link between information acquisition and applied use. To make it relevant to long-term learning the hands-on element, which could consist of little more than repetitive physical activity, must be transformed into 'mind-on'. This leads the concept toward constructivist learning theory (see below) as it encourages the learner to organise what he or she has discovered and construct new meanings as a result – but the objective behind discovery learning is still to enable the student to learn about and come to understand and apply ideas that exist independently of the learner.

Supporters of discovery learning suggest the approach encourages students to ask questions and formulate their own tentative answers. It supports active engagement

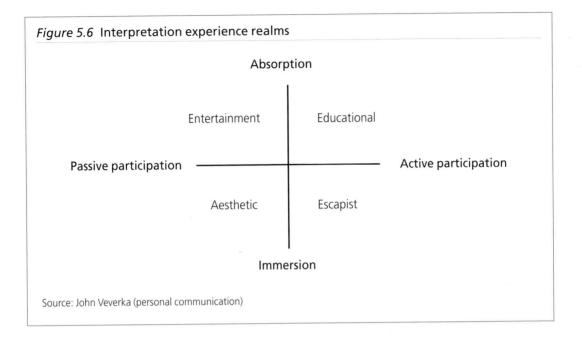

Figure 5.6 Interpretation experience realms

Source: John Veverka (personal communication)

and fosters curiosity. It enables the development of intuitive and thinking skills, important for lifelong learning, and personalises the whole learning experience. It can be highly motivating in allowing individuals the opportunity to 'do', to experiment, to discover for themselves:

> Mastery of the fundamental ideas of a field involves not only the grasping of general principles, but also the development of an attitude toward learning and inquiry, toward guessing and hunches, toward the possibility of solving problems on one's own . . .
>
> Bruner (1960: 20)

In a structured educational environment, discovery learning usually replicates a scientific model – a problem is identified, hypotheses are generated and tested against available data, conclusions are drawn and applied. But can it be made to work in an unstructured museum environment? In principle, discovery learning should offer real opportunities for museums: 'Since museums, unlike schools, value objects and learning from objects, discovery learning seems a natural approach for these institutions' (Hein 1998: 31).

Discovery learning in museums is most commonly associated with the Children's Museums Movement, with Discovery Galleries in natural history museums, and with interactive science and technology centres. It can be seen occasionally in art galleries and 'hands-on history' displays. To be object-based, it must involve opportunities for object handling and associated activities. We see this, for example, in the approach to object questioning proposed by English Heritage in its *Teacher's Guide to Learning from Objects* (Durbin *et al.* 1990).

However, there are real problems. Even in a tightly controlled and structured environment, discovery learning works best with students who are already interested in and possess a basic knowledge of a subject or problem and also an understanding of how to apply problem-solving strategies. Without a tight framework, learners in a structured environment can become confused about what they are meant to be doing, flounder and grow frustrated. In addition to these problems, interactive museum galleries can engender a 'press-button' mentality, where the exhibit has been tried but no understanding or learning results – thus users are very busy yet intellectually passive. The reality is that for a discovery learning approach to work effectively in a museum gallery requires enablers to be present and workshop sessions to be provided for all visitors, not just school groups. This is reflected in both the Children's Museums Movement and in the better science centres.

The Idealist alternative: constructivism

The theory of constructivism is based on a premise that, by reflecting on our experiences, we construct our own understanding of the world we live in. Under this theory, we have moved fully from a concept of learning focused on the activity of the teacher, with teaching as the key to learning, to the concept of 'learners as the determinants of what is learnt' (Moon 1999: 106). Thus constructivist theory views learning as an active process in which learners construct new ideas or concepts based upon their current and past knowledge (Bruner 1960). The teacher becomes a facilitator of learning rather than being central to it. In recent years, this theory has come to dominate much of museum thinking on the nature of learning taking place in museum visits (see, for example, Hein 1995a, 1995b, 1996, 1998; Falk and Dierking 2000).

Constructivism represents an Idealist approach to the concept of the development of knowledge. Hein speaks of the 'inevitability of constructivism . . . if we take the position that it is *possible* for people to construct personal knowledge then we have to accept the idea that it is *inevitable* that they do so, regardless of our efforts to constrain them' (Hein 1998: 34–5).

Where constructivism appears to differ from most other learning theories lies in its application both to how people learn and to the nature of knowledge itself. If constructivist theory is accepted as central to the nature of museum learning, the curatorial role in developing exhibitions becomes, in principle, one of providing visitors with opportunities to interact and to construct their own meanings. In practice, the curator must seek to translate the subject matter into a format appropriate to the visitor's current state of understanding and present it in a way that is structured both to be easily grasped and so that the visitor can continually build on what has already been learned. The subject matter must also be about concepts rather than facts – in order to build on existing experience to construct new meanings, visitors will require an understanding of the 'whole' as well as of parts, and parts must be understood in the context of the whole.

There are huge problems here, not least in terms of what we can expect of our visitors. Even assuming museums can create a suitable physical setting and atmosphere,

and can design appropriate displays, if visitors are to fully engage with constructivist displays they must still bring with them at least:

- the level of interest, motivation and attitudes conducive to such engagement
- some 'appropriate' level of prior knowledge and/or experience to which they can add and, therefore, construct new meanings
- the learning skills and initiative required to actively construct their own meanings and understandings.

There is little here to suggest that constructivism on its own is any more an answer to the future development of museum display for learning than unrestrained didacticism. Kelly (personal communication) would argue that museums are now moving on from constructivism to socio-cultural approaches in the experiences we offer to visitors, and in how we evaluate these (see, for example, Leinhardt *et al.* 2002; Paris 2002). My view is not to say that constructivism, or any of the other theories discussed above, has no relevance to museum display. Rather, it is important instead to concentrate on defined visitor needs, and apply learning theory where relevant and where it will clearly have an effective, practical impact on display design.

Reflecting on experience

Central to all forms of experiential learning theory is the need to 'review the experience', to establish its 'perceived relevance' and to engage in 'reflective observation'. Reflection is clearly 'intimately connected' (Moon 1999: 101) with the learning process. It is this period of reflection that enables the learner to establish relevance and learn from it, before moving on to apply what has been learned in new circumstances. Reflection – in enabling the learner to think about and make sense of the experience – therefore has a key role in enabling experiential learning to take place.

Any exploration of the concept of reflection can only lead to a serious questioning of the relatively simplistic nature of experiential learning theories when applied outside a structured learning environment. What actually goes on in the brain when we are reflecting on experience? Will this reflection take place during and immediately after the experience, or can it be many years later (MLA 2001b: 10)? Are there stages to the process of reflection?

> [M]ost writing about reflection relates to a task – such as professional development or the process of learning from experience. For example, the idea of reflection on practice puts emphasis on the manner in which reflection facilitates a reviewing of past action in order to perform better the next time.
>
> Moon (1999: 92)

This is a very structured example. How, in contrast, do we expect museum visitors to reflect on their experience of our displays to create their own framework for constructing new meanings? Does this take place during the visit, in the mind of the individual visitor or through discussion within a visiting group? Does it take place in

the car on the way home, or long after the visit? Can other museums learn from the emphasis on reflective observation that continues to form the basis of presentation in most art galleries? In an unstructured, casual visit, it all depends on the visitor. Our challenge is not to ensure that reflection takes place, but to develop exhibitions that visitors can engage with and that can support reflection.

So how can museums best support and encourage reflection within their exhibitions? Providing time, space and opportunity is essential – avoiding overfilling the exhibits and ensuring there are opportunities to relax and to socialise within exhibition galleries, including watching others. Most visitors to museums and galleries come in social groups, so their response to exhibits and experiences is frequently reflected in their interaction with each other – particularly talking, discussing, showing:

> Too often museums' efforts at education actually get in the way of (social interaction, contemplation, reflection) occurring. They are so busy telling the visitors what to think that the visitors don't feel they have the space or permission to develop their own thoughts!
>
> John Cross (personal communication)

Beyond art galleries, creating a supportive environment for reflection is little thought of in the design of museums and museum exhibitions, yet it is an essential backdrop. An intimidating atmosphere will not only put many people off visiting in the first place, it will also discourage discussion during a visit. People must feel comfortable or they will not be willing to chat with each other. (John Cross makes a strong case for the importance of allowing community use of museum facilities, including for non-museum related activities, so people learn to feel comfortable in the museum environment.) There is also a need to represent multiple viewpoints, so visitors feel they too have the right to develop and talk about their own ideas – this is a key reason why I encourage the display of comment cards, as it opens up a dialogue between visitors.

The structure of the exhibition itself will provide the best framework for on-site reflection, while restating main messages and concepts can also assist (while avoiding being patronising). A clear conceptual framework can make a huge difference, so learners can easily grasp where exhibition elements fit within the bigger picture. As always, questioning, including the use of open questions, can encourage lines of exploration. Being able to revisit parts of exhibitions can also be important. Crucially, locating enablers – gallery assistants who provide opportunities for visitors to interact with exhibits – within the exhibition galleries, and providing opportunities for directly related activities, can provide major support and encourage discussion and thought.

Adult learning

Before turning to explore how the application of learning theories to museum display can impact on exhibition approaches, it is vitally important to add a further distinc-

tion to the mix. This chapter has already sought to compare and contrast the Realist versus Idealist definition of knowledge, and behaviourist (didactic/experiential) versus constructivist learning. It now seeks to nail a further set of colours to the mast by suggesting that adult learning is different to that undertaken by children.

There is a tendency within museums to assume that either learning provision for children is more important than for adults or that adults will happily use the opportunities provided for children. Tilden (1977: 9), in defining his principles for interpretation (see chapter 7 below) stated as principle 6 that interpretation for children should be different to that for adults. The pendulum has, perhaps, swung too far the other way.

> Life experiences, considerable practice in cognitive methods coupled with capacity for empathy and spirituality, means that adults are capable of participating in modes of learning that go far beyond the didactic provision of 'closed' information, of 'facts' and figures. To really tap into the potential, learning experiences for adults have to allow opportunities for deep thinking, for problem solving, for drawing upon prior knowledge and past experiences, and for sharing these processes with others.
>
> Cross (2002: 2)

Clearly adults will also have different motivations for learning from children, and will face different barriers to their learning. They are also likely to bring a personal context of interest, prior knowledge, expertise or skill level, motivation, capacity for independent thought and even emotion. They will dislike being talked down to and, equally, they will seek to avoid situations where they are made to feel inadequate or stupid as a result of a lack of prior knowledge (see, for example, the case study on Manchester Art Gallery at the end of chapter 3).

Most learning theories seem to be based on child learning. However, Knowles's theory of *Andragogy* stands out from this crowd in attempting to differentiate the way adults learn from the approaches taken from children (Cranton 1992: 13–14, 49):

- adults are autonomous and self-directed
- adults are goal oriented
- adults are relevancy oriented (problem centred) – they need to know why they are learning something
- adults are practical and problem-solvers
- adults have accumulated life experiences.

Continuing research has built on our understanding of these characteristics (Gunther 1994; Knowles *et al.* 1998; Merriam 2001; Manning 2002 – all referenced in Kelly *et al.* 2002). The rich resources for learning resulting from adults' life experiences have been identified as the key difference between adult and child learners. The issue of self-direction is reflected in adult acceptance of responsibility for their own learning and a relishing of the freedom of choice this brings. Their motivations to learn are largely internally driven and reflect their current life styles and changing social roles as they pass through different life stages.

Adult Learning Australia has sought to establish principles of adult learning (Beddie 2002: 2), in particular suggesting that adults learn at their best when:

best way for adult

- their prior learning is appreciated
- the subject matter is relevant to their needs
- the learning environment encourages dialogue and interaction
- mistakes are seen as valuable opportunities to learn
- the subject matter is presented using a range of approaches.

So, providing learning experiences and opportunities for adults within museum displays is a challenge in its own right but, as Cross puts it (2002: 5), 'it is a challenge that museums must face'. Kelly (referenced in Kelly *et al.* 2002: 54 as 'work in preparation') suggests that adult museum learning experiences need:

teaching method to Adults

- a good understanding of prior knowledges, experiences and interests
- self-direction and choice in interpretive styles and levels of information
- opportunities to satisfy intrinsic motivation through intense and deep learning experiences
- social learning opportunities
- objects and other real material to actively use and manipulate
- mediation through knowledgeable others who facilitate discussion and sharing of opinions and understandings
- layered content
- the opportunity to engage in critical thinking and questioning
- to be based on real-life experiences
- to be relevant by making it explicit why it is important to know something.

The visitor's motivation to learn

[M]useum goers are individuals who value learning. They believe that they and their children should be continually learning, continually searching for new information, continually stretching intellectually. The primary reason most people attend museums, whether by themselves or with their children, is in order to learn. That is a major reason why museum going correlates so highly to level of education.

Falk (1998: 40)

If so much to do with lifelong and life-wide learning depends on the motivation of the individuals involved, it is essential that we look in general at the issue of the motivations behind museum visiting, and the impact of these on learning. Falk *et al.* (1998) identify six categories of motivation: place, education, life cycle, social event, entertainment and practical issues. They also define three types of visitor strategies for experiencing the museum or a specific exhibition: the 'unfocused', where visitors were open to whatever the museum offered; the 'moderately focused' where they were

aware of museum contents but had not come solely for a specific exhibition or event; and the 'focused' who had planned their visit in advance, usually with clear goals. A key conclusion of the study was that:

> individuals with a high entertainment motivation stayed significantly longer in the exhibition than did those with a low entertainment motivation . . . an individual's motivation for visiting a museum significantly impacts how, what and how much he/she learns at that museum. The motivations that yielded the greatest effect were the motivations of education and entertainment.
>
> Falk *et al.* (1998: 113–14)

In effect, all visitors interviewed combined these two factors. The differences lay in the relative importance they gave to each. The combination of entertainment and learning, however, is an important one and should help overcome all the grey worthiness that still hangs over the concept of learning. Research into the experiences of adult learners across a sample of 12 institutions in the USA, including museums, a botanic garden, art galleries and a historical society included a study of the range of reasons given for seeking learning experiences, with the *joy* of learning coming a resounding first and job related reasons coming close to nowhere, as shown in Table 5.1.

Clearly, these results will reflect the nature and lifestyles of the 860 interviewees, but they emphasise the potential for museums as major resources for life-wide learning, with, as McIntyre (2003) shows, directly work-related learning more likely to take place in the workplace itself or formally at an educational institution (see below).

A key problem in the context of the learning agenda, is the relationship between the motivation to learn and the nature and expectations of both the traditional museum audience and current non-users. As chapter 1 illustrated, a wide range of

Table 5.1 Reasons for learning

	%
For the joy of learning	79.7
To pursue a long-standing interest or hobby	57.9
To meet people, socialise	53.6
To engage in creative activity	47.2
To pursue a new interest or hobby	43.4
To fill time productively	40.0
As part of search for meaning and wisdom	37.7
To fill blanks in previous education	24.9
To fulfil community service purpose	21.2
To help my present job	4.7
To prepare for a new job or career	0.4

Source: Lamdin (1997), cited in Sachatello-Sawyer and Fellenz (2001: 18)

research into more frequent museum visitors compared with non-visitors shows that the former are better educated, in professional jobs, take an active interest in their children's education and are interested in culture and history generally. As the PLB report points out, the MORI (1999) study found that:

> the main criterion influencing whether or nor people go to museums and galleries is their own attitude to learning. Attitudes to learning are heavily influenced by formal education levels. Thus, those with higher degrees are far more likely to visit than the general population. The study found that only 17 per cent of people with no formal qualifications had visited a museum or gallery in the last twelve months, as opposed to 62 per cent of bachelor degree holders and 72 per cent of those with a Doctorate, Masters or PhD.
>
> Because social class and working status tend to correlate with education levels, it is not surprising that museum and gallery visitors are more likely to be middle class and in full or part time employment.
>
> PLB Consulting (2001: 26–7)

These comments, and those by Falk above, could be thought to build on those already made in pages 18 – 20 in suggesting that the professional classes are not only the 'traditional' audience for museums but also the 'natural' one – they come because they are motivated to learn and seek learning outcomes from their leisure activities while blue-collar workers do not come because they want to leave their brains in peace. This sort of viewpoint is clearly unacceptable, but what is certain is that these surveys emphasise the importance of initial motivation – the expectations people bring with them to a museum visit – and therefore of the importance to museums of developing a positive external image in reaching out to current non-users. If museums are to make a serious impact in attracting targeted audiences from currently under-represented groups, they are going to have to take a fundamental look at their image and at the nature of the experience they are offering. This is not a 'dumbing-down' exercise. It is about placing emphasis on ways of motivating visitors to visit as well as on museum content.

However, the issue of motivation does not just apply to targeting new audiences, it is also about retaining the support of traditional audiences in the face of growing competition from other sources. A report by McIntyre (2003) *Where do Australian Adults Learn?* highlighted the growth in the importance of the Internet. His key conclusions were that formal courses in adult education were much more significant for gaining new work-related skills than for general knowledge, and that the Internet emerges as the most preferred resource for gaining general knowledge, particularly as income rises, though print media remained a strong resource for this purpose. When asked to select from a range of venues to say where they would feel most 'comfortable' learning new skills or knowledge, only 9 per cent of respondents placed museums or galleries as their first choice, although 22 per cent overall said they would feel comfortable there – with, interestingly, more women saying they would feel comfortable there than men. There must be a serious concern, however, that museums and galleries might actually be *declining* in popularity as a significant resource for deliberate informal learning in the face of the seemingly unstoppable rise of the Internet.

Finally, while museum-based research tends to emphasise the centrality of learning to the motivation behind the museum visit, tourism-related research, as already noted in chapter 1, places much more emphasis on the social and entertainment side of the 'day out'. This is not the point at which to resume the discussion as to the relative accuracy of these two strands, but it is important to understand the impact of the primary motivation on visitors' attitudes to learning on site:

> A number of years ago I visited the Gateway Arch Museum in St. Louis, Missouri. I remember talking to one of the park rangers assigned to interpretation about differences in visitors as a function of the time of year. He explained that the fall visitors, many of them empty nesters and retired persons, were a much more rewarding audience for interpreters. These visitors would pay careful attention to his interpretation and ask meaningful questions. In contrast, the summer audience was large, somewhat hectic in nature, and motivated more by wanting to ride the tram over the Arch. They paid less attention and asked fewer questions. The summer tourist audience, made up of families and younger visitors, was a challenge for the interpretation staff.
>
> Loomis (1996: unnumbered)

Learning can take place whatever the motivation behind the visit – it is the nature and extent of that learning that will vary. The museum challenge is to create an environment that stimulates and supports learning at whatever level it is occurring – and perhaps strikes a spark that brings people back and/or encourages them to 'find out more'.

DISCUSSION: APPLYING LEARNING THEORY TO MUSEUM DISPLAY AND SUPPORT

> [W]e are witnessing a deliberate movement in museum philosophy which aims to create a learning environment; an environment which, being outside the formal educational structure, allows adults to participate at their own speed and in their own way. Unlike school or college, there is no sense of competition. Successes or failures are not measured, so there is nothing threatening in a museum learning experience. Indeed, one could argue that museums provide a near perfect setting for the adult learner.
>
> Elizabeth Esteve-Coll in Chadwick and Stannett (2000: ix)

If a museum exhibition communicates effectively, it will reveal meanings and relationships, and this in turn may enable learning, the acquisition of knowledge and enhanced understanding. There is an urgent need to stand back and examine whether there really are lessons to be learned from learning theories, in terms of how we develop our displays – and then to explore what this could mean in practice.

It really is possible to reflect learning theories directly in exhibition development.

For example, the 'traditional' museum exhibition, developed along didactic lines and reflecting a purely Realist approach to the definition of knowledge will see:

- a direct visitor route, with a clear beginning, a defined sequence and a specific end
- a breaking down of content into a logical order, delivered in 'bite-sized' pieces
- a hierarchy of content
- a didactic provision of information
- structured educational use based around an on-site 'classroom' and worksheets seeking written answers to specific questions.

Hein contrasts this approach dramatically with a potential constructivist layout:

> A constructivist exhibition . . . will provide opportunities for visitors to construct knowledge. But in addition, it will provide some way of validating visitors' conclusions, regardless of whether they match those intended by the curatorial staff. Thus a constructivist exhibition:
>
> - Will have many entry points, no specific path and no beginning and end.
> - Will provide a wide range of active learning modes.
> - Will present a range of points of view.
> - Will enable visitors to connect with objects (and ideas) through a range of activities and experiences that utilize their life experiences.
> - Will provide experiences and materials that allow students in school programmes to experiment, conjecture, and draw conclusions.
>
> Hein (1998: 35)

Didactic exhibitions lend themselves most effectively to formal, structured, intensive learning. They are frequently full of detailed information that it would be impossible to absorb in a series of committed visits, let alone in one outing. They normally require a reasonable previous level of knowledge of the subject area. Even when incorporating modern display media, the design approach taken is frequently mono-experiential rather than reflecting the diverse learning styles of visitors. They contain 'closed' information and rarely encourage deep thought. However, we know from visitor observation (e.g. Serrell 1998) that the vast majority of visitors do not follow the exhibition content step-by-step, detail-by-detail, in the systematic manner in which it has been laid out. Rather, they create their own personal, exploratory routes, missing out elements, stopping at what interests them and moving on when they are ready, not necessarily after taking in all the material presented at that particular point. In other words, visitors go a long way toward creating their own constructivist layouts, no matter what approach is taken in the display itself.

However, a planned constructivist layout is not necessarily any better. A fixed route and hierarchical layout at least together provide visitors with a physical and conceptual orientation from which they can select at will. A gallery that fails to make it clear to the visitor how to proceed and how it should be used is likely not to be used. As defined by Hein, the constructivist approach may be highly effective with

structured educational groups, but is likely to require hard work on the part of the casual visitor, not something necessarily sought by someone on a leisurely social outing. Very importantly, Hein's definition highlights the intellectual aspect of a display only. Where is the emotional and sensory impact, how does reflection fit in, and where is the opportunity for the visitor to have fun?

However, whether one takes a didactic, discovery or constructivist approach to the provision of learning opportunities in museums, what I feel is most worrying about the way learning theories are being applied to museums at the moment remains the emphasis on the virtuous learning cycle. Need museums take responsibility for the full cycle? Should we not concentrate on providing opportunities for our visitors to engage with our collections in the way and at the level they desire and to wallow in the sheer joy of experiencing? Are we not far better at providing the inspiration to want to find out more – through the aesthetic pleasure and/or excitement of discovery that our collections, exhibitions and programmes provide? 'I think the museum in many ways provides a taster and actually galvanises people to think they might want to explore this further' (Sydney parent, aged between 30 and 49, quoted in Kelly 2003: 16).

Learning theories are not enough on their own to enable us to develop exhibitions that 'work' with visitors. Alongside them must sit an understanding of the experiences visitors seek. Although relating to museum programmes rather than exhibitions, it is useful, for example, to look in this context at the responses of adult programme participants to this question recorded by Sachatello-Sawyer and Fellenz (2001). More than 70 per cent wanted hands-on activities while 80 per cent felt it was important to have access to unique people, places and objects. More than 85 per cent wanted time for questions and discussion. More than 94 per cent wanted new or challenging content. Yet 'interaction with the instructor or interaction with other program participants – or interaction with both – was regularly cited as the one thing program participants remembered most' (Sachatello-Sawyer and Fellenz (2001: 19). These comments are relevant also to exhibition design, not least in the importance of 'designing for conversation', which will be discussed in later chapters.

Section 4 of this book outlines how theories of interpretation and learning can be brought together with an understanding of audience needs to create truly engaging environments in museums, which visitors can use as they see fit. However, this chapter cannot finish without a restatement of some of the clear messages that have emerged from it:

- Orientation should be used as a means of enabling visitors to select for themselves what they want to see and concentrate their time and effort on.
- Different visitors bring different levels of interest, motivation, relevant skills and prior knowledge with them. The learning content of museum exhibitions must be layered to reflect these, to provide different entry levels that people can select from, and to provide depth for people to follow up as they desire.
- Different visitors will have different learning styles and preferences, which need to be catered for, and these may vary depending on display content. Exhibitions must provide a palette of interpretive approaches to reflect these styles and provide visitors with opportunities to select.

- The exhibitions must create conditions in which not only engagement but also reflection can take place.
- The exhibitions must provide opportunities for all visitors, not just children, to participate – physically, intellectually, socially, and with their senses and emotions – and to begin to apply the new understanding and skills that they have gained.
- Participation also means that exhibition contents should not be 'closed'. They should reflect differing viewpoints and provide opportunities for visitors to question content.
- One real strength that museums possess over other learning opportunities lies in their collections and expertise. Exhibitions must include opportunities – at least on regular occasions – for visitors to handle objects and discuss them with staff.
- Equally important, however, is atmosphere. As Esteve-Coll points out, there is no sense of competition in a museum exhibition. Visitors can come and go as they see fit, using those elements of the exhibition that they are most interested in. It is all relaxed and unstructured – we must not lose this great attribute.
- Exhibitions must also be designed to recognise that most visitors come in groups, and seek social interaction with each other and other visitors, rather than using contents as individuals.
- All visitors want to have *fun*, and will learn more if enjoying themselves. If we lose the enjoyment element of our museums, we will lose our audiences.
- All visitors deserve the opportunity to be inspired by what they discover in the museum. Our collections are wonderful. We need to celebrate them with our visitors.

CASE STUDY: EVALUATING VISITOR LEARNING IN MUSEUMS

Museums are no longer their own excuse for being. As the resources they require have become greater and greater so, too, have the expectations of those called upon to provide those resources. What is demanded today is that organisations perform, deliver, and demonstrate their effectiveness.

Weil (2003: 53)

With the growing emphasis being placed on museum learning within the profession, it is unsurprising that there has also been an upsurge in activity seeking to define the nature of that learning and how it can be evaluated. Currently, the attempt to use such evaluation has largely come to prominence within the museum community as a result of the insistence of funding bodies on evidence of value for money invested. This section does not attempt to evaluate the evaluation of visitor learning currently taking place but, rather, seeks to describe a

number of access points for this information and to highlight some of the problems involved.

In the USA, any museum that receives public money must undertake outcome-based evaluation (OBE) but this is largely related to specific programmes, workshops and events rather than to the visitor experience of the museum as a whole (Hooper-Greenhill 2004: 158). Most of the evaluation which takes place is based on target audiences and audience objectives set in advance by those organising the programmes, so the chief function of the evaluation is to assess whether the 'learning outcomes' achieved met the learning objectives set. In 2004 the Smithsonian Institution brought out a report seeking to assess the impact of these programmes, based on two sets of telephone interviews with a total of 84 museum educational staff: *The Evaluation of Museum Educational Programs: a national perspective* (Smithsonian 2004). The objective was 'to decide the extent to which systematic and effective program evaluation is currently being used to assess US museum education programs and to identify best practices . . .' (p. 1). The report explored:

- the techniques used for evaluation (questionnaires, observation, interview, focus groups, consultants, comments cards)
- the frequency with which evaluation occurred – 'limited', 'few said they evaluated programs on a regular basis', p. 14. (The demands of funding bodies was the main priority for evaluation.)
- the impact of evaluation on programming ('at least minor changes', p. 16)
- the dissemination of results (internal).

Lack of resources and of knowledge on how to evaluate were the top reasons cited, alongside management resistance, for not evaluating, but 70 per cent of respondents said there was now increasing value placed on evaluation, largely because of funder requirements (p. 22). The report highlighted infrequency and inconsistency in the studies as key issues. No one interviewed doubted the potential impact of museum education programmes on individuals, but a key conclusion was that 'the challenge for the research community is to develop methods and techniques with which to evaluate and understand long-term benefits' (p. 30).

An additional key point to make here is that the term being used to describe this work is 'evaluation' rather than 'research'. It is essential to distinguish between the two. Kelly (2001b) points to a broad discussion of the distinction, including in museum-related literature (Bicknell and Farmelo 1993; Hilke 1993; Miles 1993; Falk and Dierking 1995; Merriam and Simpson 1995; Hein 1998). She highlights the similarity in methodologies – visitor observation, analysis of comments cards and questionnaires, interviews, focus groups. However evaluation is largely practical, short term, related to a specific programme or site and carried out to give practical feedback and guidance on how to improve that programme, exhibition, etc. (Miles 1993). Research will be

more systematic and will set up and seek to find answers to the bigger questions that are relevant across the sector (Merriam and Simpson 1995: 5; Kelly 2001b: 4). If we seek answers about the nature of museum learning and how this can be enhanced, we must find ways to turn current evaluation projects into longer-term research programmes. This includes unearthing questions that need studying, providing an integrating structure and highlighting what is central in findings (Schauble *et al.* 1997).

Thus, alongside programme evaluation in the USA sits the qualitative work of individual researchers (see, for example, Paris (2002) *Perspectives on Object-centered Learning in Museums*) and the work of the Museum Learning Collaborative (MLC), funded by a consortium of public agencies including the Institute for Museum and Library Services. The role of the latter in furthering theoretically driven research on learning in museums officially came to an end in December 2003, but their research reports remain available on their website at http://museumlearning.com/default.html while Leinhardt *et al.* (eds) (2002) *Learning Conversations in Museums* is an inspiring text – frequently referred to later in this book.

In Australia, while there is little official emphasis on the role of museums in lifelong learning, the Learning in Museums Network (LIMN) is an informal forum for sharing ideas and research on how museums can better support adult learners, linked to Adult Learning Australia (ALA). Their website www.ala.asn. au/limn/#how contains a range of relevant publications and links, plus a message board. There are specific initiatives by individual museums, with the most significant contribution to date from the Audience Research Centre at the Australian Museum, Sydney (AMARC). Much of their research can be found at www.amonline.net.au/amarc/research/. Recently a new collaborative research project has been established – the MARVEL project (Museums Actively Researching Visitor Experiences and Learning) – bringing together the University of Technology, Sydney, the Australian Museum, Sydney, Environmetrics Pty Ltd and the Royal Botanic Gardens, Sydney. Its ambition is to support all types of museums to evaluate and develop their exhibits and programmes for better visitor learning, but also to use this work collaboratively to enhance the understanding of the bigger picture. There has also been fascinating work on young children's interactive learning in museums by the Queensland University of Technology (QUT) Museums Collaborative, Centre for Applied Studies in Early Childhood, which can be found at http://eab.ed.qut.edu.au/activities/projects/museum/. Other related Australian research can be found at the website of the Evaluation and Visitor Research Special Interest Group at http://amol. org.au/evrsig/.

In the UK, from 2001–3, Resource (now MLA) funded an 18-month programme (the Learning Impact Research Project, or LIRP) to establish a system for defining and measuring the nature and impact of the learning taking place in museums, libraries and archives in the UK. Central to this was the need to gain wide acceptance of a definition of learning that went well beyond the

traditional academic context of knowledge and understanding. The project therefore took as its starting point the UK Campaign for Learning definition of learning that had been signed up to by Resource in 2001:

> Learning is a process of active engagement with experience. It is what people do when they want to make sense of the world. It may involve increase in skills, knowledge, understanding, values and capacity to reflect. Effective learning leads to change, development and the desire to learn more.
>
> 'About Us', Campaign for Learning, 1999, endorsed and adopted by Resource (MLA 2001a)

Crucially, measuring impact meant there was a need to define measurable outcomes and the result has been the identification of five 'generic learning outcomes' (GLOs), listed in Table 5.2, that build on those in the Campaign for Learning definition above. The results of the research were published in 2004 through the creation of a new website (www.inspiringlearningforall.gov.uk). This sought both to explore how museums, libraries and archives could become learning-centred organisations and to outline approaches to assist organisations to measure the learning taking place.

Under each GLO comes a series of sub-headings that can be used in the evaluation of visitor comments, shown in Figure 5.7 on p. 154.

During the pilot phase of the programme, 15 museums, archives and libraries were involved in testing the GLOs in various ways. Clearly each GLO is very broad, but 'having a very small number of GLOs enables the easy quantification of evidence through the counting up of numbers of occurrences in each category' (Hooper-Greenhill 2004: 164). Substantial effort and funding is currently being put into encouraging museums, archives and libraries across the UK to implement this approach, with an emphasis not only on measuring learning impacts but on using the process to help embed learning more deeply within the organisations themselves.

There is the potential, therefore, to see a more systematic approach to the

Table 5.2 Generic learning outcomes (GLOs)

These are:

- an increase in knowledge and understanding
- an increase in skills
- a change in attitudes or values
- enjoyment, inspiration, creativity
- action, behaviour, progression.

Source: Hooper-Greenhill (2004: 154)

Figure 5.7 Generic learning outcomes (GLOs)

Knowledge and understanding

Knowing about something
Learning facts or information
Making sense of something
Deepening understanding
How museums, libraries and
 archives operate
Making links and relationships

Action, behaviour, progression

What people do
What people intend to do
What people have done
Reported or observed actions
A change in the way that
 people manage their lives

GLO

Skills

Being able to do new things
Knowing how to do something
Intellectual skills
Information management skills
Social skills
Communication skills
Physical skills

Enjoyment, inspiration, creativity

Having fun
Being surprised
Innovative thoughts, actions or
 things
Creativity
Exploration, experimentation and
 making
Being inspired

Attitudes and values

Feelings
Perceptions
Opinions about ourselves
 (e.g. self-esteem)
Opinions or attitudes toward other
 people
Increased capacity for tolerance
Empathy
Increased motivation
Attitudes toward an organisation
Positive and negative attitudes in
 relation to an experience

evaluation of learning across museums in the UK, with comparisons between institutions also made possible, thereby encouraging best practice. It may also bring benefits to the UK museum world in terms of governmental recognition and funding. Examples of GLO-related qualitative evaluation with teachers and schoolchildren will be referred to in chapter 6 (Johnsson 2003, 2004). However, it is far too early to say to what extent the evaluation of learning

impacts through GLOs will work in practice. It requires a consistency in the quality of the evaluation being carried out which may well be beyond the skills of many, particularly smaller, institutions to achieve. Given the resources required to carry out systematic qualitative evaluation, it is also difficult to see this being given a priority except, as in the USA, when it is linked to the demands of funding bodies. There is also a need to define priorities for ongoing research into museum learning, rather than simply to evaluate the impacts of individual programmes.

There are more fundamental issues, however, concerning our ability to gain a real understanding of learning impacts in museums for all our visitors through the research currently being carried out. Qualitative research into the interactions between visitors, objects and museums is in its infancy, with a wide range of disciplines and schools of thought involved. At a basic level, the research itself must be carried out in a meaningful manner – it requires people who know what they are doing both to carry out the research over a sustained period of time and to interpret it. It requires a real understanding of the situated nature of learning – what impact does the museum environment have on the nature of any learning taking place and how can our enhanced understanding of the nature of learning in museums impact most effectively on the museum environments we create? Also, using a wide definition of learning makes it imperative to be able to define what is *not* learning (Dewey 1938: 13–14, for example, suggests experiences must be organised to be educative).

Perhaps most importantly, researchers must cease to see the museum visit in isolation, but rather view it within the broader context of people's lives. This issue is discussed by Falk:

> many investigators working within the museum context reveal an unspoken assumption that learning, or its larger relative 'experience', can somehow be readily compartmentalised and captured . . . that learning is something that, functionally, 'happens' as a direct response to some unique interaction, event or 'stimulus' within the museum. In truth, learning is a continuous process, a state of becoming, rather than a unique product with distinct and totally quantifiable outcomes. I would assert that any effort to understand the visitor experience, let alone visitor learning, needs to be conceptualised within the larger context of individuals' lives. Specifically, any effort to define, observe and measure the effects of a visitor's interactions with museum objects and exhibitions, that seeks to understand how those interactions contribute to that individual's growth, change and/or development, must be conducted over a reasonably large framework of time and space.
>
> Falk (2002: xii)

It is no real surprise, given Falk's comments, that much of the pilot work carried out for LIRP in the UK was related to people taking part in projects in museums, archives and libraries over a period of time, making it possible to

observe and measure change and development, and one can also see the potential here with structured educational users. But how will it help us understand the impact museums have on the infrequent casual users who make up the bulk of visitors? Linked to this, can those carrying out the studies escape from the straitjacket that suggests all aspects of the learning cycle must be completed within the museum environment and reassess the importance of museums as sources of inspiration – as a starting point which encourages people to 'find out more', from whatever location?

Research into impact of their museum visits on users (and I deliberately keep 'impact' as a general term rather than solely related to learning) is of crucial importance to our understanding of how best to engage people with our sites and collections, as well as to the case we can make to funding bodies. However, it is an exceptionally complex exercise and we are only at the beginning of it. It is crucial that there is a sustained publication of relevant material, charting methodologies as well as evaluating impacts. This is qualitative research at the cutting edge, so we also need the publication to be rapid, including work in progress. Websites are the most effective way to achieve this. We should applaud the Museum Learning Collaborative and AMARC and hope both that their sites continue and that the same role is taken up in the UK by the Inspiringlearningforall website.

6 Use of museums by schools

> Of all the institutions in the United States that are not schools –
> and are not paid to be – few try harder than museums to educate
> the young. They conduct classes, they deliver lectures, train
> classroom teachers, design teaching materials for classroom
> use, provide a home base for teachers, often send their own
> instructors into schoolrooms to teach; and they create numberless
> programmes – mobile units, special exhibitions, studio classes,
> even didactic dramas – to 'enrich' the curricula.
>
> Newsom and Silver (1978: 259)

While there is a long tradition of museums providing educational facilities and programmes for schools, and of enlightened schools and teachers making use of museums in their teaching, it is only in recent decades that we have seen formal recognition of the key educational roles that museums can play and, with it, a considerable expansion in museum education departments and their activities. Structured educational users now form a bedrock element of many museum audiences and meeting their specific needs should be central to any museum forward plan and provide a framework for any planned exhibition development.

In the UK, the introduction of a National Curriculum for 5- to 16-year-olds in 1989, with its emphasis on the direct use by pupils of a range of sources of evidence, was a vital turning point – museums and heritage sites were seen as a readily accessible means of delivery. Those sites that have demonstrated their relevance to specific National Curriculum study units have witnessed a massive increase in schools use. The role museums can play in structured educational use has now been formally recognised by UK central government. In 1999, the Department for Education and Employment (DfEE) launched its 'Museum and Gallery Education Programme', initially funding 65 projects nationally for museums working with schools. In 2000 came a joint publication by the DfEE and the Department of Culture, Media and Sport (DCMS) of *The Learning Power of Museums: A Vision for Museum Education*, identifying key objectives and areas for action. This document (DfEE and DCMS 2000: 6) sets out the current political agenda for museums and galleries in the UK

and looks at both structured educational use and at lifelong-learning opportunities, including the ability of museums and galleries to:

- enhance delivery of the National Curriculum
- make available a rich storehouse of objects and interpretive materials that can bring classroom teaching to life
- offer opportunities for children to learn about their local communities and assist schools in their responsibility to deliver Citizenship
- set up innovative and exciting activities for children in particular subjects to develop key skills such as communication and team-working, and foster their creative abilities.

Other countries following the same principles include Sweden, where the School Act 1994 established a new curriculum, new syllabuses and new time schedules for the subjects taught and defined the ways in which the subjects should be studied with goals and evaluation processes established nationally. Again the curriculum provided clear potential for museums as excellent sites for school use (Stapf 1999: 44).

In Australia, an attempt to develop a national curriculum failed in the early 1990s, but the issue is once more (2005) out to public consultation. Meanwhile common national goals were agreed between the states in 1989, updated in 1999. There is heated debate between a syllabus-led and an 'outcomes'-led approach, but the development of new syllabuses and standards by the individual states, for example in Science, have provided important opportunities to create new museum education programmes.

In the USA, there has been federal funding of museum education services since the creation of what is now the Institute of Museum and Library Services in the late 1970s (see p. 123 above), while the issue of standards in teaching has been given increasing emphasis at local, state and national level over the last 20 years. For example, in 1998 the American Historical Association issued a *Statement on Excellent Classroom Teaching in History*, which included: 'Students need to be aware of the kinds of sources used by historians, and they should become adept at extracting meaning from these sources, comparing their findings with other evidence from the period . . .' (AHA 1998: unnumbered). So, as in the UK, the requirement to introduce students to a range of sources of evidence provides real opportunities for museum education service development.

Currently, what has become popularly known as the No Child Left Behind Act of 2001 is seen by the Bush administration as a landmark in education reform, designed 'to improve student achievement and change the culture of America's schools'. It 'represents a sweeping overhaul of federal efforts to support elementary and secondary education in the United States', built on 'accountability for results; an emphasis on methods shown to work by scientific research; expanded parental options; and expanded local control and flexibility' (EdGov 2004). Here, once more, there are real opportunities for museums to develop their provision to support schools in these new challenges.

THE AGENDA FOR STRUCTURED EDUCATIONAL USE

There are, of course, three sides to this discussion: the political agenda, the museum agenda and the school agenda. The political agenda is discussed above. Wearing both a philanthropist's and a manager's hat at the same time, one might define the museum agenda as:

- providing a unique learning experience for school pupils
- inspiring children through direct engagement with remarkable collections
- helping young people to feel at home in museums and to understand their value, as part of the process of developing the next generation of museum users
- targeting one of their key market segments
- through the make-up of school classes, reaching otherwise under-represented audiences
- using the children to market the museum to families and friends
- filling the museum with school visitors during weekdays, at times when 'traditional' adult visitors are at work and the museum would otherwise be nearly empty
- generating income for the museum.

From the teacher's point of view, while there are other elements involved in any school outing – not least adding to the child's life experiences and helping to develop social skills – the decision to make a museum visit has become increasingly curriculum focused. Museum targets for school visits will only be achieved and sustained in the long term if the museum is providing what the schools need, making it worth the effort and expense for a teacher to take pupils out of the classroom. What schools do *not* require is the creation of a classroom environment at a museum – they have come out of school to get away from that. The challenge is both to create the right learning environment and also to build relevant project work into the displays, support materials and staff allocation (this is discussed further below). Gone are the days when a curator can develop a new exhibition and then, on its completion, pass over the responsibility to the education officer to try to develop effective ways of using it with school pupils. New exhibitions *must* involve a partnership between the curatorial and education teams. The task for this chapter is to explore the development of structured educational use at a museum and the overlap between this and approaches developed through interpretation.

While museums are increasingly recognised as important educational resources, they are still not seen by teachers as equal members of the educational community. Unless this situation changes, museums will remain dependent on schools making the decision to visit and the priority is therefore on the individual museum to make a sustained effort to encourage and support school use. Museums have been very successful in doing so for parties of school-children between what are seen as the key ages of 7 to 11, but have been much less successful with those under 7 and those over 11 or 12. In the past, lack of use by older school groups has been put down to structural impediments, particularly the difficulty involved in taking groups out of school, but there is increasing evidence that, if the museum product is good enough *and* schools

159

Visitors are able to sniff spices in the Warehouse of the World at the Museum in Docklands, London. © Museum of London

know about it, both the under-7s and older pupils will attend in large numbers. Over 50,000 under-8s visit the National Museum of Childhood in London in school parties, while 12- to 16-year-olds provide the majority of school visitors to, for example, the Galleries of Justice in Nottingham and the Thackray Museum in Leeds. Research by Mathewson in Australia (e.g. Mathewson 2001) supports this view.

There can be no complacency here. The competition – not least interactive websites and software that allows schools to create their own virtual museums – is constantly improving its act and museums must do likewise. Equally, there is increasing pressure on teachers, on both cost and health and safety grounds, not to take their pupils on any school visits.

HOW CAN MUSEUMS BEST SUPPORT SCHOOLS USE?

In the past, not all curators were fully committed to the use of museums by schools:

> To attempt to put within adolescent grasp masterpieces embodying the utmost reaches of thought and refinements of expression, the fruit of the richest experience, is treachery to art in the museum . . .
>
> Gilman 1918: 287

However, by the time *The Art Museum as Educator* was published (Newsom and Silver 1978) the chief argument raging concerned whether the 'best' form of museum visit should engage children directly through participation, discovery and the stimulation of their natural curiosity or whether the group tour, although recognised as passive, remained the most suitable approach – maximising numbers and providing more formal learning. Then, as now, there was also agonising over whether a one-off visit provided any real benefit or if resources should be concentrated on those schools able to sign up for a programme of visits. There was also concern over what age was most suitable for children to visit, and over how best to evaluate the impact of the museum visit on children's learning.

In the three decades since that publication there has been a remarkable growth in museum education, both for schoolchildren and adults, and substantial development in our ideas about how people learn in museums (see chapter 5). While the group tour for schools can still be found, there is now widespread recognition that children learn best in museums through carefully planned, inquiry-based project work – and that effective project work can be developed for children certainly from the age of 4 upwards. Pressure on the school timetable has meant that a programme of school visits has become increasingly rare with a single trip the norm, so the development of resource materials that support high quality pre-and post-visit activities has become essential.

Publications as far apart in time as Gilman (1918), Newsom and Silver (1978) and Falk and Dierking (1997) show that questions have regularly been raised as to the educational value of field trips to museums. However, evaluative research on the impact of the museum visit on children – in both the short and the longer term – is now becoming increasingly common (e.g. Hooper-Greenhill 1995; Hein 1995b; Falk and Dierking 1997). Falk and Dierking make the clear point that a series of reviews (e.g. Koran *et al.* 1989; Bitgood 1989; Wellington 1990; Falk and Dierking 1992; Bitgood *et al.* 1994; Tunnicliffe 1995) 'document that some school field trips to museums resulted in "learning", while others did not' (Falk and Dierking 1997: 211), although the majority of these looked only at short-term assessments of learning.

Experience shows that the best way to develop effective schools project work is to do so in co-operation with teachers. Of course, not all teachers are the same. For example, museums need to respect and build on the expertise of experienced teachers, and to learn from the demands they make, while providing a strong supportive framework for new teachers, helping them to plan fully and build their confidence. The starting point for all, however, is to ensure that the teachers themselves are comfortable in the museum environment and have a professional understanding of how best to make use of the learning opportunities that museums provide:

> The unique learning opportunities of museums are often in contrast to the opportunities available within classrooms, while the imposed 'physical space' of museums bears little resemblance to the common classroom. Lack of familiarity in this context significantly affects the capacity of secondary educators to participate . . . This is supported by studies that have shown that many secondary educators lack confidence and competence within the museum context (Anderson 1997; Walsh-Piper 1989; Griffin 1999; Stone 1993).
>
> Mathewson 2001: unnumbered

In the USA, *Museums for a New Century* stated that 'the long relationship between museums and schools has been marked not only by success but by dissatisfaction and frustration' (AAM 1984: 67), with too many teachers and museum educators seeing an 'us and them' relationship. However, this situation has changed. A 1998 survey by the Institute of Museum and Library Services – the *Survey on the Status of Educational Programming Between Museums and Schools* – found that it is now generally the norm for teachers in the USA to work with museums' education staffs to ensure that the programmes met school needs, though museum officials retained most of the responsibility for programming (IMLS 1999). What comes out (Mitsakos 1982: 23) as most important for a good museum visit that supports learning is:

- careful planning, involving both museum and school staff
- quality advanced preparation of the pupils, and a close relationship between the visit and the class curriculum
- a focused trip involving the pupils in a structured set of activities at the museum
- a follow-up classroom session that extends and builds on the visit.

In the UK, a new programme of research on learning in museums, linked to the 'inspiring learning for all' initiative discussed in the case study for chapter 5, has included interviews with teachers on the role and relevance of museum visits for schools. Focus groups with teachers in London sought to build up baseline information on teachers' ideas about learning in museums:

> When asked if learning is different in the museum to the classroom, participants replied that they believed that learning is and can be effective in the museum because of the particular environment. Participants perceived the museum environment to be visual, engaging, 'more alive', contextualised, fun, multi-sensory, imaginative, arousing emotion, that it gave a connection to real life; a place where pupils were given opportunities to explore new skills through interplay, hands-on and minds on learning. Others suggested that learning in museums is 'added on' experience; others that it is 'inclusive' and that it is encouraged by visual and audio resources that did not exist in the classroom. This aspect was seen as particularly important for those pupils learning English as a second or additional language. One participant said that pupils are 'freer' in a museum.
>
> Johnsson (2003: 6)

Research commissioned for the UK East Midlands Museum Hub sought to consult with teachers at both primary (5–11 years) and secondary (11–18 years) level across the region to define what was required of a museum visit. The results are reflected in Box 6.1.

The same survey sought to discover what services teachers wanted from museums, and to compare the needs of primary (5–11) and secondary (11–18) teachers. The results are defined in Table 6.1 on p. 165.

Box 6.1 Teacher requirements for a good museum visit

Curriculum fit

The visit has to be justified in terms of relevance to the National Curriculum. Teachers of 11- to 18-year-olds will be very focused on specific subject curricular needs. There may be wider priorities also for those teaching under 11s.

Interaction and involvement

A good visit will offer more than just looking at objects in glass cases if it is to catch children's attention, hold their interest and provide a memorable learning experience.

At primary level, children respond well to role-play and workshop sessions, where they can touch, explore and make. Older children benefit from well presented commentaries and the opportunity to experience a historic environment. They still enter in to the spirit of role-play as long as this is well done.

Variety

It is important to have a series of activities for the children to work through, particularly the younger age group.

Staffing

Primary school teachers prefer to call on the expertise of museum staff, rather than lead the group themselves. The ability of the guide is key; enthusiasm for the subject is not enough on its own, and genuine rapport with children is essential.

Atmosphere

Museum staff are key to creating the right atmosphere where children feel welcome and involved. Session leaders must have empathy with children of the relevant age group, and an understanding of their abilities and interests – an enthusiasm for their subject is a further benefit, but is not enough on its own. This attitude is also important for other staff, not least attendants.

Practical matters

These include:

- lunch facilities
- plenty of toilets – the ideal would be for these to be supervised
- an enclosed site – less risk of pupils getting lost (primary school level) or absconding (secondary school level)
- for younger pupils, it can be easier if they are in an area with no other members of the public and no other school parties
- cloakrooms, to avoid carrying coats in galleries
- parking in a safe area to unload, avoid queuing to get in
- the shop – often controversial, a central part of the experience for many, but banned by a minority of schools.

Box 6.1 continued

Preparation – administrative aspects
Most teachers like to make a pre-visit, sometimes more than once, to look at learning opportunities, check out logistics and carry out a risk assessment.

Booking
Most teachers prefer to do this themselves, by phone, so that they can discuss requirements, modify arrangements, and get confirmation, but there is rising use of the Internet.

Preparation – education aspects
Preparation also involves checking out what is available and how this can best be used. Teachers build on experience from previous years, discuss their needs with venue staff, plus pre-visit. There is also a possible role for a venue's website, e.g. via a virtual tour.

Most teachers run introductory lessons to prepare children for the visit. Resource materials provide a valuable starting point, though most teachers will expect to adapt these.

Post-visit evaluation
Most teachers look first at the qualitative feedback that they get from the children, both at the time and after. This includes:

- interaction at the time/in the museum – if children are asking questions, discussing what they see, showing their interest, and staying on task
- the atmosphere on the coach on the way home
- feedback from parents, possibly extending to plans to go again as a family
- assessing learning content, sometimes formally via visit evaluation forms
- following-up in class – assessing the quality and content of discussions, questions, and written work
- using worksheets, or occasionally on-line activities to monitor children's motivation and the quality of their output
- expecting a visit to generate deeper understanding of the topic, and to inspire better quality of work

A further aspect is broader social development, with a successful visit building children's relationship with staff and peers, and adding an extra dimension.

Source: East Midlands Museum Hub/Childwise (2003: 18–21)

The children's view

The research above targets teachers' needs. There is much less research available on what children perceive they need from a museum visit, so the comments below are preliminary, reflecting the limited evidence available.

Table 6.1 What teachers want from a museum education service

	Total %	Primary %	Secondary %
Object loans box	63	64	57
Subsidised transport	61	65	29
Teachers' packs	61	60	69
Education resources linked to National Curriculum	52	51	62
Website or CD Rom	39	39	42
National Curriculum-based workshops	38	39	38
Cross-curricular workshops	30	32	18
Education room	29	29	28
Cloakrooms, etc.	29	31	19
Newsletter	25	25	22
In-service training	24	23	32
Exhibitions	23	23	31
Pre-visit meetings	21	21	20
Online booking	16	15	19

Source: East Midlands Museum Hub/Childwise (2003: 29)

Semi-structured interviews with 8- to 10-year-old pupils from Newham and Lambeth, two of the most deprived areas in the UK, before and after their visits to museums in London sought to create a small baseline study of pupils' ideas of museum experiences (Johnsson 2004). The majority of those interviewed enjoyed their visits, saying that they learned more than at school; that it was learning without really doing any work ('fun' learning); that you could learn in different ways and there was less pressure to perform; and that you could work with partners, discuss and help each other. Those who did not enjoy the visit as much complained of not enough time; of not being able to touch or draw, or engage in other practical ways, in the sessions they were involved in; of a lack of explicit links being made with their own lives; and of shop items being too expensive for them to buy. Generally, the children saw the museum as a place for learning. They wanted to contribute actively to their own learning and not be passive receivers of information. They wanted specifically to touch and smell objects, research their own questions, dress up in character, and play in the museum:

All the children wanted more 'hands-on' [exhibits] and engagement with objects and exhibits. They wanted sessions to be tailored to their age group. They wanted to be able to play more in the museum (a special play room), do role-play, draw and generally contribute to the experience. They wanted plenty of time in the museum. The pupils wanted more information about the objects, where they come from and how long they had been in the museum. They also wanted to know more about the museum itself and who collected the objects. Pupils

emphasised the importance of being able to afford an item from the gift shop or bring something back from the museum that they had made.

Johnsson (2004: 10)

Research at the Australian Museum, Sydney with pupils of both primary and secondary age outlined four key factors: cognitive, physical, social and emotional, outlined in Box 6.2.

The research in London noted above went beyond children's responses to their museum visits to explore their views about museums in general, and of their role. Johnsson (personal communication) believes these views strongly influence children's expectations of their visit and that much more research is needed here:

A common image of museums was that they are places where you learn about history (museums as a place for history). Pupils said that you learn about history

Box 6.2 Children's views on factors influencing school learning in a museum

Cognitive

In order to be substantively engaged in learning in the museum students need to: know how things work; be able to think through ideas; have opportunities to ask questions; be able to handle, manipulate and closely examine artefacts and exhibits; be able to seek out information from several sources in language that is appropriate to their age and stage of development; and be stimulated through various senses.

Physical

Students need to feel safe and comfortable. They want to be able to move around readily unimpeded by a number of prohibitive signs. They want the areas to be well lit and inviting and to find physical spaces that are scaled to their ages and needs.

Social

Students like learning with their friends. While they recognise that a visit to the museum is designed by their teachers to assist in their learning, they also want it to be a satisfying social occasion when they can learn with and from their peers.

Emotional

Students want to be emotionally connected while at the same time not be emotionally confronted. This is best exemplified by considering two exhibits. Year 11 students spoke of their visit to the Jewish Museum and the opportunity to speak with survivors of the Holocaust. They found this emotionally demanding, but exceptionally worthwhile. In contrast, their experience with the Indigenous Australians Gallery at the Australian Museum failed to connect in the same way. It was seen as too fragmented with some elements inadequately explained. 'It was aimed at consciousness raising, but consciousness raising about what?'

Source: Groundwater-Smith and Kelly (2003: 16–17)

in museums because they have got old things there that people in the past used (museum as a place for objects), where people put their 'discoveries' to show the world (museum as a place for openness and sharing knowledge), and where displays show what the world was *like* in the past and what it looked like (museum as a place for interpretation and contextualisation of the past). A couple of pupils mentioned that you could see things in the museum that you do not normally see every day (museum as unique place). Others made links between the past, present and the future; one child mentioned that you could not only learn about past times in museums, but also about how the world might be in the future. Another child pointed out that people in the future will learn about our time through museums, showing evidence of an understanding of being part of history and seeing links with people in the past and future (museum as an institution inherently part of human culture, museum as continuously collecting and documenting human culture and heritage). Some pupils suggested that museums are good places for research and study, and that they are practical because they keep all the interesting things in one place so people and schools can visit and look at the objects (museum as a place for research and study). A majority of children said that museums are 'fun' (museums as places for enjoyment).

Johnsson (2004: 6)

Interaction and involvement: museums and inquiry-based learning

I refer readers back to the section on *Discovery Learning* in chapter 5 (p. 138). The distinction between informal 'discovery learning' and structured 'inquiry-based learning' is usually that, in the latter, the teacher provides the questions which support the pupils as they pursue their own lines of inquiry. The role of the teacher in making all of this work in practice is considerable in:

- carefully planning the whole exercise and ensuring the relevant reference materials and equipment are available
- presenting examples
- posing the questions and then letting students try to find the answers
- helping the students to see connections
- encouraging intuitive guesses and suggesting further questions by which these may be tested.

Museums can provide a remarkable level of support for this approach to learning through providing access to a range of 'real' sources of evidence; by developing detailed schemes of work and building relevant inquiry-based projects into their displays; by providing designated education spaces and facilities and expert staff; and by developing related resource materials for use in school. They can also do so in a memorable and thoroughly enjoyable way:

Schools are not noted for providing fun as a part of the educational process. Parents would surely get the wrong idea. Many administrators would be chagrined to

hear hoots of joy emanating from classrooms . . . What does the scientist say? World famous palaeontologist John Horner puts it this way: 'From the outside, science may seem like a collection of answers, a course in "How the World Works". From the inside, it doesn't look like that at all. From the inside, science looks like a bunch of people doing crossword puzzles. It's the doing them that's fun. If you solve one, you don't stop; you look for another.'

Fox (1999: unnumbered)

Project work on site

On site, the traditional didactic display and the old-fashioned single-file tour around an exhibition accompanied by a worksheet ('death by worksheet'), go hand-in-hand. In these circumstances, the pupils notice little except what the questions were about, and obtain most of the answers from each other or from a friendly attendant. Fortunately the days of the worksheet are numbered (I hope).

Today, education visits should be supported by structured activities, differentiated to meet the needs of wide ability ranges:

- Structured activities should support the project work the pupils are doing and be linked to the development of a substantial handling collection by the museum.
- 'Dwell-points' should be included in all relevant displays to enable structured group work to take place within the galleries. They will also establish spaces for activities targeted at the general audience, when school parties are not present.
- In addition, museums are likely to require an adjacent designated education space or spaces, so that related tasks can take place there also.

My experience would suggest that the most effective structured work on-site should be built around the 'five principles' of the UK Nuffield Schools History Project or similar, applicable well beyond history-based projects. These are outlined in Box 6.3.

For most schools with pupils aged under 12, on-site project work may be single-subject-led but will almost certainly seek to provide opportunities for cross-curricular work. You need to consult teachers on how many activities to include within the exhibition and education space to ensure a quality visit. I tend to work on a principle of no more than six activities, each capable of occupying from five to ten children supported by an adult. Pupils would then 'carousel' between projects spending around 15 to 20 minutes on each – but this will vary depending on subject matter and age range.

For older pupils, particularly for age groups approaching national exams, the visit is more likely to be single subject and tightly focused on the syllabus. As such visits can involve entire year groups, with anything from 80 to 120+ pupils arriving at once, sites must be able to cope with these numbers. This usually means 'carouselling' over a substantial area, starting groups of pupils at different points around the site or exhibition. The effect of this on any display concept will be to place emphasis on the different themes or elements rather than producing a single storyline which must be followed in a fixed order. The exhibition, resource materials, etc., should be

Box 6.3 The five principles of the UK Nuffield Schools History Project

1 Questioning – discovery learning is about asking and answering questions.
2 Challenges – challenge children to persist, speculate, make connections, debate issues, understand the past.
3 Integrity and economy of sources – a few well-chosen authentic sources should be used rather than a jumble.
4 Depth – real knowledge requires study in depth.
5 Accessibility – start with what children can do and build on that.

Source: based on Fines and Nichol (1997: viii–ix)

geared around supporting children in their investigations. This will also ensure a participative approach for family visits and can also enhance the experience for adults.

Building in structured educational use

There is no need for structured educational users to be a target group for every new exhibition. The task is to define whether they will be or not and, if they are, to ensure you cater for their needs properly. However, it is equally essential that you see provision for school users as an opportunity to improve the experience for all and not as excluding other users.

The challenge is twofold. First, the museum must seek to create overall a stimulating, engaging, enjoyable and comfortable learning environment for pupils and teachers. Second, it must go beyond the provision of designated education spaces to build relevant project work based on inquiry-based learning principles into the displays and associated activities, focusing on specific curricular requirements, and support this with quality education resource materials and on-site enablers. The key point to make here is that concept development for an exhibition and the building in of relevant education project work must be seen as one and the same exercise. You cannot graft on targeted structured educational work afterwards – you either build in directly relevant content or you don't. In addition, exhibition development for structured educational use and the provision of education resource materials is one and the same thing – the two elements must be planned and produced together.

When planning on-site activities, it is important to make the project work accessible to all children. This is professionally referred to as 'differentiation'. It means that all the children in a class should be able to engage in a common activity and achieve according to their individual abilities. For example, they can describe scenes, argue in a debate, enact situations, do detective work and analyse a picture. It means finding a way to give slower, less confident learners more time. It can also mean 'scaffolding', whereby the teacher and/or more able peers support the needs of individual children, and provide extension materials of greater difficulty for the more able, combined with activities to engage them fully (see Fines and Nichol 1997: 33).

169

Children turn a Roman water wheel to draw up water from a well at the Museum of London. © Museum of London

Physical layout is equally important – you cannot conjure up space for group activities afterwards, you must build it in – and in the right places. Think group sizes. For pre-12-year-olds, you have to allow for individual school classes of up to around 36 children. For older children, schools may well bring the whole year group in the specific subject area (this can frequently mean 120+ hulking adolescents). What does this mean physically for exhibition creation?

• Thirty-six children may mean three groups of 12, each supervised by one adult but divided into two groups of six – this dictates planned project work
• A whole year group means carouselling, not all children starting at one point. Think of the difficulties this may present with a traditional linear exhibition.

Safety and supervision must be considered. For children aged 7 and above, there will normally be one adult to around 10 children. For ages 5 to 7, it will be 1:5 or 1:6. Physical layout must enable ease of supervision, both for safety, especially of the younger children, and security, especially of the older miscreants. Galleries with only one entrance/exit are best for the youngest children. Consider the layout within galleries – do you need spaces for groups of pupils/students to gather? Do they need to do activities in the galleries or in associated designated education spaces? How close are such spaces? Will gallery activities be clean/messy? Do they require staffing and/or equipment? Other things to consider: are the toilets nearby? What height are the exhibits? Are there any sharp edges? Where will the children want to lean their clipboards? Where will they put their rubbish?

Relate all of this to the time available – does the school/teacher want pupils to have a quick look around 'everything' before settling down to project work? How long per group per project? It normally does not matter if everyone does not do everything – reporting back is a very effective approach as part of follow-up activities. What about breaks? What about half-day and whole day timetables?

In summary, when considering a redisplay with structured educational users as a key target audience, the concept proposals should include:

- building in relevant project work, involving the creation of a series of projects targeted at small groups of pupils
- establishing 'dwell-points' within the displays – spaces where small groups could work on tasks together
- leaving space also in front of key exhibits for groups of pupils to view together
- producing quality education resource materials to support the displays – containing pre-visit, during visit and post-visit work all directly based on curricular-specific schemes of work
- having an education officer or trained volunteer available to lead their work on site, where possible
- a designated education space (or spaces) adjacent to the display
- an interactive website to support feedback.

DISCUSSION: ENJOYMENT AND MEMORIES COME FIRST

It does not matter how directly related to curricular requirements a school visit has been, the museum element will fail if it does not fulfil the key tasks of giving children an experience that is both really *enjoyable* and *memorable*. We want the children to enjoy the bus trip, but to go home talking about the exciting things they did, touched, experienced in the museum. We are talking not just about meeting structured educational needs here, but also of inspiring children to become museum visitors for life. School pupils are not only an audience in their own right, they are also the future for museums – we must seek to catch our audience young and then hold on to them. UK survey evidence (MORI 2001) also shows that about a third of pupils who participate in a school visit to a museum return with their families – they are a remarkable marketing tool, particularly to families who do not normally visit

Child labour in action, Morwellham Quay, Devon © Graham Black

museums. During the structured visit, but particularly in these repeat visits with families, there is also a real opportunity to take children beyond the boundaries of the formal curriculum, to explore something new and stimulating in adjacent displays. 'If you're not with the school, you feel a bit more adventurous . . . you want to go mad and do things' 10/11-year-old attender, quoted in Harris Qualitative (1997: 46).

There are, therefore, clear reasons for placing emphasis on the development of structured educational use at a museum (Weston Park Museum interpretation strategy, Sheffield, 2002, unpublished):

- to increase current use by schools groups to meet the aims of the corporate plan
- to create an enthusiasm for return visits by pupils with their families
- to encourage a sense of ownership of the site among the people of Sheffield
- to encourage a lifelong habit of museum/art gallery visiting
- to reach, through the school programme, members of society traditionally seen as non-museum visitors
- to make partnerships with organisations within the city that increase the museum's use and profile
- to create exhibitions, which cater for different learning styles, which in turn cater for the needs of all audiences.

CASE STUDY: EDUCATION RESOURCE PACKS/WEBSITES

Teachers require detailed schemes of work defining learning objectives, suggested activities through which these can be achieved, and the means by which the learning objectives can be assessed. Museums must meet these needs through the provision of high quality education resource packs as an essential tool in helping teachers to plan for a visit and for use on site. Museum education resource materials should include relevant project work to be done in the classroom before the visit – effective in its own right as well as being a preparation for the visit – on-site projects, and proposals for follow-up work. In addition, I increasingly recommend that any museum development incorporating structured educational use should also be linked to an interactive museum website so that pupils can feed back their project work for comment (also giving museums a much better means of evaluating the quality of the work done than through the usual thank-you letter).

I always produce and pilot such materials with teachers to ensure their quality. Teachers confronted with high quality, curriculum focused, and readily usable project work will reward the museum by becoming regular users. Resource materials are equally important, from the museum point of view, in going some way toward ensuring that pupils bring to the site a relatively defined level of pre-knowledge and skills. You are seeking to prepare all the children for the visit and to build their confidence, whatever their ability level, so that they can express an opinion and not fear being mocked. These materials should be copyright free for educational use and of a quality that ensures photocopies still provide a clear image.

In the UK, under the National Curriculum, the development of a planning sheet for project work is made simple by the national provision of exemplar schemes of work, including learning objectives and outcomes and suggested activities to convert the former into the latter. These can be found at http://www.nc.uk.net.

I will use the example of history-based project work because of its relevance to so many museums, but the approach is equally applicable to other subject areas. In teaching history, a good teacher will seek to introduce pupils to a variety of different source materials. In developing an education resource pack, it is important to see how many sources can be included effectively. A useful approach is to create a matrix that can ensure a spread of source materials and assist both the museum and the teacher in deciding which to incorporate in pre-visit project work, which to place emphasis on during the visit and which is best suited for post-visit use. A simple chart can then be used to plot the materials used as shown, for example, in Box 6.4 on p. 175.

An education resource pack is unlikely to be used cover-to-cover by a teacher, but will be cherry-picked. It will not be used at all if the teacher does not feel confident in using it. This is why it is best to start with the tried and

Children apply adaptations to create their own art works © Manchester Art Gallery

tested, particularly for schools for under-12s, where teachers are unlikely to be subject specialists. Images are the most effective starting point and are also inclusive, compared with written materials that can exclude some pupils with poor reading attainment levels. It is essential to make sure the pack is picture-rich (with images of at least A4 dimensions). After having used those, the teacher may be willing to use the documents, etc.

In many museums, resource packs are now being supplemented or replaced with CD-Roms and/or websites. In my view, the same principles remain – the material must be user-friendly (for pupils), consist of or be based on original material, and be copyright free for educational purposes. Websites have the great advantage of allowing the development of relationships between a museum and individual schools and classes, giving the museum the potential for much better feedback on the quality of the visit (based on the quality of the project work completed afterwards). But you must not lose sight of the school with the worn out photocopier and the impact this has on the quality of images, etc., the pupils actually come into contact with.

Resource Packs online

Box 6.4 A planning matrix for developing education resource materials

Project work	1	2	3	4	5	6	7	8
Timelines								
Archaeology								
Objects								
Pictures								
Documents								
Oral evidence								
Story								
The environment								
Maps and charts								
Art and craft								
Drama and dance								
Music								
Games and simulations								
IT								

Source: Steven Burt (personal communication)

Section 4
Planned to engage
Using interpretation to develop museum displays and associated services

This section seeks to apply interpretive principles to museum display and associated activities. Too many museum presentations are information-led. Interpretation twists the approach around to make it *audience-focused*. Visitors are as aware as museum curators that you can get the same information as is found in museum displays, and usually much more, from books, documentaries, videos, the Internet, etc. They come to museums for the experiences only such sites can offer. The challenge is to arouse the visitors' curiosity, to involve them directly with the site and collections. Through this, visitors are encouraged to think for themselves, to want to participate and to seek to discover more.

This section begins with an introduction to interpretation, the principles underpinning it and how these can be adapted and extended to create highly effective museum exhibitions that also work as learning environments. It draws on my own experience in the field, as well as on various other examples, while acknowledging that the approach recommended is so new that it is changing and developing all the time. It then brings all the material in the book together over two chapters to introduce interpretive master-planning and concept development for museum display. It finishes with an attempt to define the 'engaging' museum and to explore interpretation and object display.

7 Applying the principles of interpretation to museum display

▌INTRODUCTION: WHAT IS INTERPRETATION?

> An educational activity which aims to reveal meanings and relationships through the use of original objects, by first-hand experience and by illustrative media rather than simply to communicate factual information . . .
>
> Tilden (1977: 8)

We can talk of interpretation from both the product point of view – what we provide for our visitors – or from the direct, individual interpretive responses that visitors make to our presentations. This chapter explores the former – the product. The latter has already been introduced to some extent through exploring the theories about how people learn and is reflected in many of the interpretive principles outlined below. It is returned to in chapter 10.

For the origins of the profession of interpretation, I have relied on Brochu and Merriman (2002) and, for its early relationship with the museum world, Gross and Zimmerman (2002). The origins of the profession lie in the environmental movement in the USA in the second half of the nineteenth century, so what we see today is based on over a century of experience. The National Parks Service (NPS) in the USA employed rangers and interpreters almost from its creation in 1916 (ten years after the American Association of Museums was founded). Nature guiding was already a thriving national movement in the USA by the mid-1920s. Today, there are more than 350,000 nature guides in the USA alone and many thousands more worldwide (Brochu and Merriman 2002: 13).

John Muir, the son of a Scottish immigrant preacher, who was primarily responsible for getting Yosemite dedicated as a National Park in 1890 and could be described as the founding father of the National Parks Service in the USA, was probably the first to use the word 'interpret' in a context that the modern profession would understand, when he wrote: 'I will interpret the rocks, learn the language of the flood, storm and the avalanche. I'll acquaint myself with the glaciers and wild gardens; and get as near the heart of the world as I can' (Browning 1998 quoted in Brochu and Merriman 2002: 12). In searching for his own understanding of the world, he demonstrated a remarkable ability to help others understand and appreciate, and inspired future generations of conservationists.

In 1884, at the age of 14, Enos Mills began building his own log cabin near the base of Long's Peak in Colorado. Five years later he met Muir in California and was inspired to develop his own abilities as a naturalist and public speaker. By his death, he had led more than 250 parties to the summit of Long's Peak, as a nature guide, and published 16 books and numerous articles. Brochu and Merriman speak of him as the first modern writer to identify the role of a guide as an interpreter, 'someone who translates what is seen and experienced to others with less experience' (p. 13), describing a nature guide's role as being to 'illuminate and reveal'.

Muir and Mills were both prolific writers. However, better known to the modern audience is Freeman Tilden, whose book *Interpreting Our Heritage*, first published in 1957, remains a definitive text for interpreters. Tilden was the first writer on interpretation to seek to set down specific principles to follow, seeing these guidelines as much more important than a definition of interpretation itself – although his definition, quoted at the start of this introduction, remained the standard in the field for four decades. The six principles he established have been added to since his time, but remain the foundation for the profession (see Box 7.1).

Revealing the meanings behind the natural or cultural resource remains the critical objective of interpretation, the challenge being to provoke thought among visitors so that they seek to discover for themselves rather than simply passively receive cold facts.

William Lewis published the first edition of his small classic *Interpreting for Park Visitors* in 1980. It remains a key resource for park interpreters and guides. His book defines the primary elements of the interpretive approach as including:

- making use of visitors' knowledge and interests
- using all the senses
- using questions
- variety through structure
- organisation.

He emphasises the importance of theme selection and looks in detail at how to make interpretive principles work in practice.

More recent writers on environmental interpretation have built on the foundations laid for the profession, in the way that we all build from successful experience (see Box 7.2).

However, it would be wrong to label interpretation as solely an approach to the presentation of the environmental resource as it was initially closely associated with museums in the National Parks. The first museums in National Parks were developed in the 1920s. Herman Bumpus, director of the American Museum of Natural History in New York, developed Glacier Point Museum in Yosemite while John Merriam, another member of the AAM committee, created Yavapai Point Museum in Grand Canyon (Gross and Zimmerman 2002: 265–6). It was not until the 1950s that park museums were largely phased out and replaced with visitor centres. Tilden referred specifically to the relevance of interpretation in the creation of visitor centres. The USA National Parks Service and numerous state services within the USA now have long experience of creating and running visitor centres, and have been involved

Box 7.1 Tilden's six principles of interpretation

1 Any interpretation that does not somehow relate what is being displayed or described to something within the personality or experience of the visitor will be sterile.
2 Information, as such, is not interpretation. Interpretation is revelation based upon information. But they are entirely different things. However, all interpretation includes information.
3 Interpretation is an art, which combines many arts, whether the materials presented are scientific, historic or architectural. Any art is in some degree teachable.
4 The chief aim of interpretation is not instruction, but provocation.
5 Interpretation should aim to present a whole rather than a part, and address itself to the whole man rather than any phase.
6 Interpretation addressed to children (say, up to the age of 12) should not be a dilution of the presentation to adults, but should follow a fundamentally different approach. To be at its best, it will require a separate program.

Source: Tilden (1977: 9)

Box 7.2 Recent writings on environmental interpretation

Beck, L. and Cable, T. (1998) *Interpretation for the 21st Century* took Tilden's six principles and expanded them to 15.

Brochu, L. (2003) *Interpretive Planning: The 5-M Model for Successful Planning Projects* is a step-by step guide to developing an interpretive plan linked to the USA National Association for Interpretation Certified Interpretive Planner qualification.

Cornell, J. (1998) 2nd edition, *Sharing Nature with Children* is a classic nature awareness guidebook for teachers and parents.

Ham, S.H. (1992) *Environmental Interpretation: A Practical Guide* is a remarkable text, combining a theoretical underpinning with step-by-step approaches. Ham built on Lewis's concept of the theme as central to the interpretive approach.

Knudson, D.M., Cable, T. and Beck, L. (1995) *Interpretation of Cultural and Natural Resources* is the best basic textbook on interpretation currently available.

Veverka, J. (1994) *Interpretive Master Planning* is a core text for those looking at exhibit planning and development, and an important influence on this book. Veverka has also published many relevant articles on his website: www.heritageinterp.com

I would also refer readers to the USA National Park Service's Interpretive Development Program website at www.nps.gov/idp/interp and to the website of the National Association for Interpretation in the USA, at www.interpnet.com

in interpretive planning on both a grand scale and for site-specific projects since at least the 1960s. Some interpreters have also sought to apply the principles developed in personal interpretation and the development of visitor centres to the fields of historic sites, period houses and museums.

It would be equally wrong to restrict this outline of the development of the field of interpretation to the USA. The first interpretive strategy in the UK was carried out by Don Aldridge for the Peak National Park in the mid-1960s. Today the UK Association for Heritage Interpretation, founded in 1975, is thriving – see its website at: http://www.heritage-interpretation.org.uk and the site created by Scottish interpreters at http://www.scotinterpnet.org.uk. UK interpreters are also playing an active role in the development of a Europe-wide body, Interpret Europe – see www.interpret-europe.net. Interpretation is also playing a major role in the rapid rise in the practice of sustainable tourism, particularly around the Pacific Rim. A remarkable amount of work is currently coming out of Australia, where the Interpretation Australia Association was founded in 1992. Readers should visit, for example, the manual provided for the Australian Ecoguide Program: www.ecotourism.org.au/guidebook.pdf.

So, what is interpretation? Tilden himself spoke of spending over 25 years thinking about concepts and definitions, but never being totally satisfied (Beck and Cable 2002: 7). As professional associations and organisations have grappled with developing training programmes, and with the need to broaden understanding of the profession, the importance of an agreed definition has become increasingly recognised. In 1996, the USA National Parks Service established a base rubric as a guide for its competency assessments. This states that

[The product] is:

1. Successful as a catalyst in creating an opportunity for the audience to form their own intellectual and emotional connections with meanings/significance inherent in the resource; and

2. Appropriate for the audience, and provides a clear focus for their connection with the resource(s) by demonstrating the cohesive development of a relevant idea or ideas, rather than relying primarily on a recital of a chronological narrative or a series of related facts.

Source: www.nps.gov/idp/interp

National professional associations have sought to develop their own definitions, usually worded more broadly than the NPS statement above to reflect the wider interests of the profession, so covering museums, visitor centres, historic sites, zoos, etc., as well as national and state parks.

Thus the USA National Association for Interpretation defines interpretation as 'interpretation is a communication process that forges emotional and intellectual connections between the interests of the audience and the inherent meanings in the resource'. Interpretation Canada prefers: 'Interpretation is a communication process designed to reveal meanings and relationships of our cultural and natural heritage to the public, through first hand involvement with objects, artefacts, landscapes or sites'. The Australian Association for Interpretation uses: 'Heritage Interpretation is

a means of communicating ideas and feelings which help people understand more about themselves and their environment'. Simplest of all, the Association for Heritage Interpretation in the UK uses: 'The art of helping people explore and appreciate our world'.

MODERN MUSEUMS AND INTERPRETATION

Interpretation is a word that is now in widespread use within the museums profession and by design companies who work in the field of museum display. But, what do museums mean by the term? I have traced the use of the word 'interpretation', in terms of helping people appreciate and understand museum collections and displays, back at least to Gilman (1918: 280, quoted above p. 121) – he makes no fuss over the term so it is almost certainly relatively commonplace by that date. There is also a great similarity between his understanding of the term and that of Enos Mills, discussed above.

By 1979, Alexander could refer back to Tilden and speak of an expanded definition, suggesting:

[G]ood interpretation contains at least five basic elements:

It seeks to teach certain truths, to reveal meanings, to impart understanding. Thus it has serious educational purpose.

It is based on original objects, whether animate or inanimate; natural or man-made; aesthetic, historical or scientific. Objects have been around much longer than language and, when properly arranged, have innate powers to impart and inform.

It is supported by sound scientific or historical research that examines each museum object, undergirds every program, analyses the museum's audience, and evaluates its methods of presentation so as to secure more effective communication.

It makes use, wherever possible, of sensory perception – sight, hearing, smell, taste, touch, and the kinetic muscle sense . . . The sensory approach, with its emotional overtones, should supplement but not replace the customary rational avenue to understanding provided by words and verbalization; together they constitute a powerful learning process.

It is informal education without the trappings of the classroom, is voluntary and dependent only on the interest of the viewer, and is often enjoyable and entertaining. It may furnish one with strong motivation to read further, to visit other places, and seek other ways of satisfying one's newly aroused curiosity.

Alexander (1979: 195–6)

This definition is still very similar to that being used within the environmental movement. Alexander goes on to mention the range of media available to support the process of interpretation. Since then, in many museum exhibitions, there has been an increasing focus on the display media used rather than on the audience as actively involved – a one-way process of communication from museum to audience rather than a two-way process involving museum and audience as equal partners. This can

be seen for example in the definition of interpretation in a 1997 article in *Museum Practice*:

> It is the process of using displays and associated information to convey messages about objects and the meanings which museums attach to them; and of selecting appropriate media and techniques to communicate effectively with target audiences.
>
> *Museum Practice* (1997: 36)

When *Museum Practice* returned to the subject in 2000, it avoided definitions and concentrated on case studies, from the production of interpretation strategies to the writing of inclusive display texts.

In 1998 the American Association of Museums (AAM) established a National Interpretation Project which adopted a working definition of interpretation as:

> The media/activities through which a museum carries out its mission and education role:
>
> • Interpretation is a dynamic process of communication between the museum and the audience.
> • Interpretation is the means by which the museum delivers its content.
> • Interpretation media/activities include but are not limited to: exhibits, tours, web sites, classes, school programs, publications, outreach.
>
> AAM (1999: 81)

In April 1999 a central advisory committee on the project set out the 'characteristics, elements and outcomes of exemplary interpretation' under content/strategy, enabling factors, and access/delivery. The elements set out under each heading can be seen in Box 7.3.

Having established the interpretation elements in outline, six regional study groups studied them in more detail, conducting institutional self-studies first without the 'exemplary interpretation' criteria and then using them. They then analysed the difference between the first and second self-studies to measure any impact. The results were reported to the 2001 AAM Professional Education Seminar on Interpretation and published as a loose-leaf folder by the AAM (edited by Victoria Garvin) as *Exemplary Interpretation: Characteristics and Best Practices Seminar Sourcebook*.

The sourcebook begins with a range of definitions of interpretation, many of which are taken from those involved substantially in environmental and historic site interpretation rather than museums – including Tilden, Lewis, Alderson and Low, Ham and the USA National Association for Interpretation. It then moves on to a wide range of material, including perspectives from the AAM standing committees on education, exhibition, media and technology, curators and audience research and evaluation; a statement of principles of experience design; a panel discussion on a specific exhibition; sample documents from the regional study groups and suggested additional readings and resources.

It is clearly exciting to see a major professional museum association setting out to

Box 7.3 A model for interpretive planning

Plan:

WHAT you wish to present – such as specific site/resource issues, themes, etc.

WHO you are targeting the presentation at – consider the nature of the target audiences, their needs and expectations.

WHY you wish to develop/change the presentation – by identifying specific objectives and *outcomes*. What are the *benefits* for the visitor, for the site/collections, for the organisations, and how are these benefits to be *evaluated*?

HOW you intend to present the museum – the *interpretive strategy* and *gallery concepts* – to achieve the objectives set and the outcomes required.

Source: based on Veverka (1994: 32)

explore interpretive best practice in detail and then seeking to disseminate and promote this. It should result in an improved experience for visitors and an enhanced appreciation of collections and of the role museums play in society. Yet somehow Alexander's underpinning principles – including celebrating the innate powers of objects, emphasising the revealing of meanings, incorporating the sensory and the emotional, and speaking also of interpretation being enjoyable and entertaining – seem to have been sidelined. It is impossible not to feel a lack of an underpinning philosophy (the elements listed in Box 7.4 on p. 186 include reference to demonstrating attention to the interpretive philosophy but nowhere does it say what this is) – and to feel that what has been produced represents a product-led outlook rather than an audience-centred one, and reflects process without the underpinning beliefs. It is time to look at an alternative approach to defining interpretation – based on an equal partnership between a museum and its visitors, and the concept of the museum visit as a journey and a three-way conversation between museum, audience and collections – and then to explore how this can be put into practice in the creation of museum environments and exhibitions, and associated programming. That is the function of the rest of the book.

DEFINING INTERPRETIVE PRINCIPLES FOR MUSEUM DISPLAY

My own attempt at a definition of interpretation seeks to bring together what I see as its underpinning principles, to reassess these in terms of relevance to museum display and to express them in an atmosphere which emphasises the partnership approach I believe in – by which I mean seeing the audience as equal and active participants rather than passive recipients of information.

Interpretation is an approach to presenting the heritage which seeks to engage and involve the audience with the 'real thing', to encourage participation and, through that, to assist visitors to develop the skills to explore for themselves and so enhance their own understanding:

Box 7.4 The characteristics, elements and outcomes of exemplary interpretation

Under content, a museum engaged in exemplary interpretation:
- demonstrates knowledge of the subject
- selects content carefully and conscientiously
- reflects the complexities of a changing community
- declares its point of view
- makes content relevant and part of a broader, contemporary dialogue
- engages in important issues.

Under strategy, a museum engaged in exemplary interpretation
- has a clear statement that describes the purpose of their interpretation, relates it to the mission and describes its goals and methods
- has evidence of effective interpretive planning
- has broadly stated values
- takes its educational role seriously
- involves its community.

Under enabling factors, a museum engaged in exemplary interpretation
- demonstrates internal clarity, agreement and attention to the interpretive philosophy
- views interpretation as an ongoing responsibility
- sets goals for individual interpretive programs
- holds cross-institutional discussions
- employs learning theory and educational research
- uses evaluation
- knows its audiences
- creates a continuing relationship between the museum and its audience(s).

Under access/delivery, a museum engaged in exemplary interpretation:
- provides multiple levels and points of entry: intellectual, cultural, individual, group, etc.
- has inviting design in the presentation of ideas, concepts, and objects
- is guided by the overall interpretive philosophy
- creates a bridge between the audience and the content
- expresses a clear idea, or set of ideas, and those ideas are apparent to the audience
- uses interpretive media/activities that are appropriate for the goals, content and audience.

Source: AAM (1999: 81)

- It cannot be seen in isolation, but depends on the visitor's motivation and the quality of visitor services management. A museum or heritage site visit is an holistic experience, reliant on an environment that is welcoming, engaging, stimulating, participatory, and rewarding.

- It is an educational activity which seeks to support the visitor's physical, intellectual, emotional and aesthetic access to the heritage.
- Ultimately it seeks a sense that understanding has been enhanced and that the audience is aware that it has had access to and been engaged with something special, resulting in personal enrichment and fulfilment.

Like Tilden, I see interpretation as a means to an end, rather than an end in itself, so what matters to me is not so much a definition of interpretation as the development and application of a philosophy and practical principles by which I seek to engage audiences. It is now time to examine some of these principles in more detail and to explore how they relate to museum display. It is actually quite easy to prepare a brief for a traditional didactically-led glass case and graphic panel exhibition. It is much more difficult to develop an interpretive brief which sets out to engage and involve a diverse audience. However, the end product will go much further toward meeting the needs of museum visitors.

1 Interpretation is inclusive

Inclusivity underpins all the principles of good interpretation outlined below, and is given its own heading here as a reminder. An interpretive approach will emphasise the audience-centred nature of what we do and seek to engage as diverse an audience as possible.

2 External image is vital

What image do people have in their minds when they consider visiting a museum (or, specifically, your museum)? If the image the visitor brings with him or her supports participation and engagement – and the visitor therefore expects to participate in all aspects of what the museum has to offer – then much of the interpreter's job has already been done successfully.

Achieving such an external image among 'traditional' museum visitors is not as hard as it might seem. Simply put, our visitors like museum visiting otherwise they wouldn't come! Some sites or collections have the ability to strike us to the core, to stir our emotions deeply. However for most people, most of the time, the response is gentler. In recent years a distinction has been drawn among social psychologists between cognition, emotion and affect. Affect is about preferences – a response to a stimulus which is an immediate feeling rather than an emotion:

> Affect seems to work in this way. When we encounter an unknown object or situation for the first time, we appraise it, that is we find out whether it is good or bad. In the case of ice cream, we taste it . . . The next time we encounter that object, we do not have to go through this process of appraisal . . . The theory states we are similarly tagging everything we experience.
>
> Webb (2000: 17)

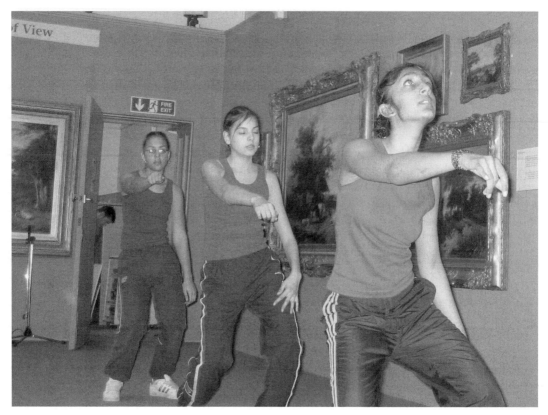

'Staying Alive' workshop. Events like this dance workshop and activities for children (opposite page) on International Women's Day can both ensure a permanent buzz at a museum and incorporate culturally inclusive activities. © Leicester City Museums

Most of the 'traditional' audience consists of 'repeat museum visitors', not in the sense that they regularly come back to one particular site. Rather, they enjoy visiting museums and heritage sites. They have been to museums and galleries often enough to feel comfortable and confident during their visit – the museum challenge here is to support this.

However, the development of a positive external image is much more important in terms of the people who do not come and do not see museum visiting as something they want to do. In the MORI (2001) report, 41 per cent of those who said they did not visit gave as their reason 'Nothing I particularly wanted to see'. A further 12 per cent said 'museums are boring places', with 6 per cent saying 'my children wouldn't be interested'. It is our challenge to change that perception and then to support and encourage new visitors who feel uncertain how to 'behave' – particularly at that crucial point of arrival (see principle 4). We want as broad an audience as possible to find pleasure in the 'museum experience'.

3 Interpretation emphasises the overall visitor experience

As has been stated already, interpretation cannot be seen in isolation. It must be viewed in the context of the entire visit – from the stimulus that led to the decision to visit, through the journey to the site, the visit itself, the journey home and the sharing of memories. We must never lose sight of the journey, the crucial sense of occasion engendered on first arrival, the sense of welcome and inclusiveness, the quality of the overall operation, etc. They provide the framework for the event of the visit. We must *map* the normal visit to ensure everything possible is done to support the user (see chapter 4).

4 The threshold is all-important

We know that the single most significant barrier to inclusion is the visitor feeling unwelcome and being embarrassed because they do not know where to go or what to expect.

Stewart-Young (2000: 30)

Gurian (2004) speaks of 'threshold fear' in terms of the point at which the unconfident visitor can turn away. This may begin with the external museum image and continue with route-finding, the overbearing impact of the 'temple' architecture we associate with many museums developed in the nineteenth century, and the charging point. In the latter element, she emphasises that it is not necessarily about cost, but about interaction with strangers – the charging point can become an entry barrier to an unfamiliar location (although, of course, a fee can prevent casual repeat use). In the same way as visitor blueprints are discussed in chapter 4, Gurian emphasises the need to identify, isolate and reduce these barriers. She feels it is particularly helpful if 'novice' visitors can observe the process of entering from a distance first, through a glazed entrance, large lobby, etc.

As mentioned in principle 3, fear must be replaced by a sense of occasion and of welcome. This also needs to be supported by a 'landing strip', described by Underhill in terms of shoppers, but equally relevant to museum visitors:

> What happens once the customers get inside? You can't see it but they're busy making adjustments – simultaneously they're slowing their pace, adjusting their eyes to the change in light and scale, and craning their necks to begin taking in all there is to see . . . These people are not truly in the store yet . . . If you watch long enough you'll be able to predict exactly where most shoppers slow down and make the transition from being outside to being inside . . . whatever's in the zone they cross before making that transition is pretty much lost on them . . . shoppers need a landing strip.
>
> Underhill (1999: 46–50)

5 Atmosphere matters

The atmosphere must become less rigid and more user-friendly than in the traditional museum – welcoming, inclusive, less church-like – providing support and encouraging involvement and discovery. The exterior should both give a sense of occasion and entice people in. Within the building, the colour scheme should enhance the warm informality of the space. There should be close links between the physical environment, interior design and interpretive approaches to achieve this. 'The fact that the museum had a laid back environment where we could just talk and hang out was really good for us' (comment from a girl's high school pupil, quoted in Groundwater-Smith and Kelly 2003: 11).

Clearly the friendliness and supportiveness of front-of-house staff will have a huge impact on visitor perception of the atmosphere within the museum (see chapter 4).

Equally, as noted in chapter 5, providing opportunities for communities to use museum premises even for non-museum related activities can be an important means of enabling people to feel more comfortable in museums and therefore more likely to use them.

6 Through orientation, interpretation gives visitors the power to select

Caulton (1998: 27) divides visitor orientation into four main elements: geographical, psychological, intellectual, and conceptual. I find it simpler to think of two elements:

1 Physical

All the elements relating to visitor motivation point to an audience which wants to make up its own mind on where to go, what to do, what to look at, how long to spend, etc. The intention in providing clear orientation, both at the entrance and within displays, is not to prescribe the route an audience should follow, the nature of the exhibits they should view, the order in which they should do so, etc. Rather, it is simply to make sure the organisational structure is clear so that visitors know exactly what part of the museum or individual exhibit they are entering and can select for themselves. At base level this is a safety issue, applicable to all. It is also a psychological issue, in terms of both self-esteem and visitor empowerment.

The direct relevance of physical orientation can best be seen when comparing the behaviour of first time and repeat visitors, and the amount of time and effort first-time or rare visitors put into the issue of orientation. It is also important to recognise that people need differing types of orientation:

> For those who learn by reading . . . we provide maps, signage, brochures and other pamphlets. For those who want others to show them how to experience the Museum, we provide frontline staff . . . Lastly, for those who just want to forge ahead on their own . . . we try to make the experience as intuitive as possible.
>
> Andrea Leonard, *Visitor Services Defined*, in Adams (2001: 1)

2 Conceptual

Visitors should also be provided with a *conceptual frame of reference*. What is this museum/exhibition/activity about? What has it got to do with me, the visitor? How is it organised, thematically and physically (how long will it take)? What can I, the visitor, expect to gain from it? This framework should be restated at relevant points.

There is nothing new about this – 'tell people what you are going to do, tell them when you are doing it, and tell them when you have done it'. Yet it is depressing how rarely this orientation is provided. Within an exhibition, activity or presentation, it should also be made clear to the visitor when he or she is leaving one section and entering another. Each section should form a coherent whole, and contain a defined hierarchy of material. Clarity is all. It allows visitors to concentrate their energies on what matters – engaging with collections and creating their own meanings – rather than on trying to work out what is going on.

Providing a conceptual framework also supports 'connectedness' – the ability of visitors to make connections between different parts of an exhibition (so link this also to careful planning and theming). In evaluating the use of the Frogs exhibition at the Exploratorium in San Francisco, Allen (2002: 296) was surprised to discover that visitors made such connections at only 5 per cent of exhibition elements. She acknowledged Hilke's study (1988) that suggested the visitors' primary agenda was

Figure 7.1 A model of museum learning and enjoyment

	Training				Entertainment		
Agony	Effort	Achievement	Satisfaction	Pleasure	Fun	Hilarity	Rave

Interpretation

Source: Piersenné (1999: 141)

not to look for relationships within exhibition content but between content and their own knowledge/experience (and see principle 9 below). However, she also suggested that the failure of visitors to recognise links might be due to a lack of coherence between multiple exhibition goals. Connections will be much easier to make if the visitors have a clear conceptual framework within which to seek them.

7 Interpretation is enjoyable

Museum visitors are there of their own free will and mostly on casual, leisure-centred visits. The general principle among interpreters has always been that visitors come on a social outing to enjoy themselves, but also to learn in the process – they link the two (see Figure 7.1).

To engage this audience, the approach taken should be imaginative, interesting and enjoyable. However, it is not simply entertainment. Our visitors do want to learn (otherwise they would have gone elsewhere) and will be disappointed by a shallow presentation. Visitor comments actively support this view, for example:

> People felt that entertainment can *add* to their learning, not take away from it . . .
> Parents, in particular, value the entertaining and fun aspects of museum learning:
> '[museums can] present history to kids who are otherwise not going to be able to
> see it except in a school text book, which is pretty boring, or on the computer,
> which is pretty boring too.' (Sydney parent, 30–49 years).
>
> Kelly (2003: 12)

There is a substantial body of work exploring the variety of ways in which people in a 'recreational frame of mind' can be motivated, all supported by our own experience and commonsense. The challenge is to provoke thought, to stimulate interest, in a pleasurable way. This is not difficult if we put our minds to it – most of us are human after all. A sense of humour can encourage involvement and learning. Curiosity did not just kill the cat; it underpins all our desires to 'find out'. Shock or surprise, used positively, can lead people in to objects and sites. Personalisation of sites and objects – seeing them through the eyes of the people who lived there or used them – can transform visitor interest and fire their imaginations. Taking part brings an activity

A contrast in listening – the isolation of users (above) at an English Heritage monastic site (© Graham Black) contrasts with a communal feeling (below) maintained at the Museum of London (© Museum of London)

alive. Movement fascinates – far better a moving machine than a motionless one in a corner. Variations on the idea of the 'Trivial Pursuit' game, using questions with multiple choice answers, can add an enjoyable competitive edge to a gallery display. Making decisions and then comparing your view with that of other visitors leads both to fascination and to deep thought. Evocative vocabulary can transform a talk or exhibition.

However, I have used the term enjoyment deliberately, rather than 'fun'. Enjoyment can work on many levels. One of these, which remains central to the museum mission, is the sheer aesthetic pleasure that can come from engaging with beautiful objects. The interpretive approach also works as a means of enhancing opportunities for that pleasure.

8 Interpretation should be based on the latest audience research

I refer back to Section 1 of the book. Remember that there are two elements to this:

- the latest research in general on museum visitors and non-visitors, their needs and expectations, what motivates them, how they learn and what we can do to enhance the quality of their visit and of their learning
- site specific research on visitors and target audiences.

9 Interpretation seeks to use the visitor's personal context to build on pre-existing experience, skills and knowledge

> Any interpretation that does not somehow relate what is being displayed or described to something within the personality or experience of the visitor will be sterile.
>
> Tilden (1977: 9)

Interpretation seeks to elicit a response directly related to a site and/or collection through:

- direct visitor contact and involvement, not by being talked at
- a mix of the senses and emotions
- building on previous experience, skills and knowledge
- encouraging a questioning approach and the extrapolation of meanings from fragments
- the visitor(s) constructing personal meanings rather than accepting outside opinion.

All of this relies on the visitor being willing to become directly engaged and committing to the involvement required. This normally depends on how relevant the presentation is to visitor needs, interests and understanding – effectively, to visitors' lives: 'the museums or exhibitions visitors find most satisfying are those that resonate

with their entrance narrative and confirm and enrich their existing view of the world' Doering (1999: 81).

We each bring our past with us - our experiences, interests, prior knowledge, etc. We each have our own feelings, attitudes and perceptions about museums and heritage sites – in fact, every one of us sees the world uniquely. We are each directly influenced by our experiences of that particular day and by the company we are in. The term 'entrance narrative' as used above by Doering is an alternative way of exploring personal context. Based on 12 years of visitor research at the Smithsonian Institution, Doering could speak of an 'entrance narrative' with potentially three distinct components:

- a basic framework, that is, the fundamental way that individuals construe and contemplate the world
- information about a subject matter or topic, organised according to that basic framework
- personal experiences, emotions and memories that verify and support this understanding.

I feel this underestimates the social context of the visit (who you are with seriously affects your experience) but, together, this background will have a considerable influence on the expectations each individual and/or group has of the visit and on the responses he or she will make to the presentation. If we want to encourage visitors to engage with the collections emotionally and intellectually, and gain from the experience, we must use the need for personal relevance as a positive element in the approach taken to the presentation. The interpretive approach attempts to do this through *self-referencing* – by relating the collections to the visitors' own lives, experiences, interests, and knowledge – making new information and ideas relevant and interesting to our visitors by connecting these with themselves and their own experiences, in effect, personalising them. Often this means seeking a *human-interest* approach to presentations: '. . . real items trigger one's imagination in a way that even pictures cannot. Add people to the artefacts and the attraction is irresistible' (Webb 2000: 20).

This is not only about people relating to people. As Webb makes clear, it also reflects how often we respond to things because of how we feel about them – our emotional response to them – rather than from some form of objective viewpoint (Webb 2000: 21).

10 Interpretation is planned

Exhibition development should be based on an outline *interpretive plan*. There are many alternative ways of devising the plan. Because it has worked for me for many years, I take an approach based on Veverka (1994) (see Box 7.3).

The interpretive approaches adopted should be developed as the most appropriate response to the answers you define to the questions what/why/who, but will also be influenced by other factors, as previously discussed.

As an 'appropriate' response, it must also be possible to *evaluate* its effectiveness. Chapter 8 looks at interpretive planning in detail.

11 Interpretation emphasises clarity of vision

Clarity of vision is central to careful planning. If you are not clear in what you are trying to do, what chance does the visitor stand? The central point is 'what do we want the visitor to leave with?' What you should be seeking is the *big idea* (Serrell 1996). This brings both clarity of intent and the communication of what is usually defined as the 'essence' of the museum. It will hold together the overall presentation and give everyone a sense of direction.

It is infinitely preferable to have the heated discussion on what is meant by this at the start of a project rather than muddling through and leaving both yourself and the visitor confused. I recommend wholeheartedly that the 'big idea' is agreed by all those taking part in preparing the presentation, and then *written down*. It is astonishing how fast people can be drawn in different directions and, unless the team can focus on the whole, you will find yourselves lost.

12 The interpretation itself must be selective and themed

A powerful exhibition idea will clarify, limit and focus the nature and scope of an exhibition and provide a well-defined goal against which to rate its success – 'a strong, cohesive exhibit plan – a theme, story, or communication goal – that sets the tone and limits the content . . .' (Serrell 1996: 1).

Collections contain a vast range of potential information. To attempt to convey even a fraction of this would utterly overwhelm most visitors and prevent them 'seeing the wood for the trees'. An interpretive approach must be focused on well-defined outcomes for the museum and for the visitor. Good presentations are organised, easy to follow and concentrate on key objectives. Prioritisation of content means constantly referring back to objectives and target audiences.

In most cases, while the big idea holds the overall presentation together, it is essential to break it down into elements. The central point here is 'what are the primary messages required to reinforce the big idea?' This is about conveying ideas or meanings, not facts, and is best achieved through a thematic approach. Let me make a distinction between topics and themes. A *topic* is the subject matter that a display is about. A *theme* is the message or storyline you use to help audiences understand the topic. A topic might be 'death from infectious disease in the industrial towns of Victorian England'. The theme used at Thackray Museum, Leeds, UK, was – like all effective themes, a single idea expressed in a short sentence – 'Infectious disease had a horrific impact on people living in the slums of Victorian Leeds'. This was explored through a reconstructed slum and the lives and deaths of its individual occupants.

Defining themes has a huge advantage for the interpreter. It helps in the detailed planning of the content needed to deliver the themes, while visitors enjoy a thematic approach much more than the straight delivery of information, and therefore

engage more fully. Reflecting the importance of self-referencing (see principle 9 above), and as adopted in the reconstructed slum at the Thackray Museum, the themes used should normally have a strong human interest content – people relate to people. In this way, we draw people into the big idea and make them a part of the interpretation.

13 Sound interpretation requires sound research

A basic professional and ethical principle is that whatever is presented to the public is accurate and reflects the latest research. This is true of any approach to the development of a museum display. Kelly (2003) argues strongly that 'the museum needs to become a mediator of information and knowledge for a range of users to access on their own terms', quoting Friedman in stating: 'The role of museums in the future . . . lies in legitimising information and information processes and in being an advocate for knowledge as the province of the people, not the sole property of the great institutions' (Freedman 2000: 303, quoted in Kelly 2003: 1).

Quoting her own research, and work carried out in Canada and the USA, she reveals the level of trust people have in the information museums provide, when compared, for example, to attitudes people hold toward news media and the Internet:

> Among a wide range of information sources, museums are far and away the most trusted source of objective information. Thirty-eight percent of Americans believe museums are one of the most trustworthy sources and eighty-seven per cent believe they are trustworthy overall.
> Lake Snell Perry and Associates (2001: 2) for the American Association of Museums, quoted in Kelly (2003: 7)

This is summed up in the comments of one member of an Australian focus group:

> I really think museums have a reputation like university professors, and you expect them to show things which have the backing of scientific method. It's not just some ratbag spouting some propaganda, it's a well thought out established viewpoint (Sydney, 18–30 years).
> Kelly (2003: 6)

14 Sound interpretation recognises multiple points of view

The interpretive approach is reflected much more strongly in the nature of the actual content presented and how this is done. By accepting visitors as equal partners on a journey, who are being offered an opportunity to explore material for themselves and reach their own decisions, there is much less likelihood of information being presented anonymously, as if by a voice of authority from on high. Equally, the presentation is more likely to attempt to provide a balanced point of view, rather than being 'interpreganda' (Brochu and Merriman 2002: 17) that presents one argument,

oversimplifies facts, skews the presentation toward a foregone conclusion and does not allow visitors a personal perspective:

> Visitors do not want museums to be telling them what to think: 'Material should be presented in a way that lets you make up your own mind. I don't like being told what to think, and I wouldn't want my kids to be told what to think'.
>
> Sydney parent, 30–49 years, quoted in Kelly (2003: 14)

There is an outstanding example of good interpretation at Bolsover Castle in Derbyshire, UK, where in an audio tour of the 'Little Castle' the conservator takes visitors into her confidence to speak of mistakes made in the past and the difficulties in the decisions made when new conservation work was carried out in the late 1990s. This is one of the best examples I know of visitors being treated as equals.

15 Interpretation is committed to active visitor participation

> It is generally recognised that people retain about: 10% of what they hear, 30% of what they read, 50% of what they see, 90% of what they do.
>
> W.J. Lewis (1994: 27)

Active participation does not necessarily mean pulling levers or pressing buttons. Physical involvement is only a means to an end. The real ambition is to engage the visitor's mind, to generate a sense of discovery – what is now referred to as 'mind-on', rather than just 'hands-on'. Within museum exhibitions, the interpretive approach of engaging visitors and encouraging participation, both physical and intellectual, has gained increasing favour over time, reflecting ongoing research on the nature of the learning that takes place in museums (see chapter 5). We can generally suggest that – while each individual is unique and will learn within his or her own balance of elements – visitors learn by a mixture of:

- doing
- thinking
- watching
- reading
- listening
- imagining
- interacting (with staff and each other)
- discussing
- assimilating.

As already discussed, the learning unit in a museum is not normally the individual, but the small group (see above, p. 142). We must therefore plan and design our displays to be used by groups. This means not only devising exhibits that can be used by

groups together but also more importantly, 'designing for conversation' (Paris 2002: 297) – see principle 19 below.

Participation also means enabling and encouraging visitors to comment on exhibitions. Incorporating opportunities for visitor feedback is an important element in recognising exhibitions as a two-way conversation, and becomes more meaningful still if visitor comments are then displayed for all to view and discuss in turn. Quoting Kelly's research once more:

> Eighty-six percent of Australian War Memorial visitors, eighty-nine percent of Canadian visitors and eighty-nine percent of the Australian Museum sample agreed or strongly agreed that museums should be *Places that should allow their visitors to make comment about the topics being presented*. Participants wanted museums to provide opportunities for visitors to have a say through feedback forms, suggestion boxes, tours, lectures/seminars and discussion groups with guest speakers, with the option to opt out if you wanted to . . .
>
> Kelly (2003: 9)

16 Interpreters believe learning occurs as a result of visitor participation

Tilden's definition given at the start of this chapter (page 179) places the educational role of interpretation to the fore – it is an 'educational activity'. Developing people's skills; enhancing understanding; encouraging active involvement in every sense; revealing meaning; widening support for conservation – all these elements point to an educational role. Yet this role must be achieved in the context of a casual, social visit when the audience is seeking to enjoy itself rather than feel it is being made to work hard.

All interpreters start with the visitor and speak in terms of initial visitor motivation as central to learning. We speak of what we see as the key features of 'non-captive audiences'. Ham contrasts the captive and non-captive audience (see Box 7.5).

In further discussing the motivation and inspiration of non-captive audiences, interpreters also point to the influence of physical context, the relationship between informal learning and the environment in which it occurs – in our case:

- an informal, unpressured atmosphere in which they feel 'comfortable'
- the context of a real site and/or real collections
- an environment in which both the site/objects and associated ideas are made readily 'accessible', in every sense
- an environment which encourages them to connect what they see, do and feel with what they already know.

The informal settings of museums, etc., contrast dramatically with the structured educational environment. The museum approach also supports the basic human inclination toward curiosity – arousing interest and motivating people to learn.

Curiosity itself leads on to the other key issue of *attention*. As interpreters, we have

Box 7.5 Captive and non-captive audiences

Captive audiences	*Non-captive audiences*
Involuntary audience	Voluntary audience
Time commitment is fixed	Have no time commitment
External rewards important	External rewards not important
Must pay attention	Do not have to pay attention
Will accept a formal, academic approach	Expect an informal atmosphere and a non-academic approach
Will make an effort to pay attention, even if bored	Will switch attention if bored
Examples of motivations:	Examples of motivations:
grades	interest
diplomas	fun
certificates	entertainment
license	self-enrichment
jobs/employment	self-improvement
money	a better life
advancement	passing time (nothing better to do)
success	

Source: Ham (1992: 7)

two tasks – to grab the visitor's attention and then to hold it. Attention is a remarkable attribute – an ability to concentrate on one element from within a myriad of competing attractions. Without an ability to do this, normally subconsciously, our daily lives would be unbearable. The grabbing and then holding of visitor attention is central to what museums do, but also limits what the visitor will, or can, do:

> First, attention is *selective* – when we focus attention on one thing, we tend to ignore others . . .
> Second, attention has *focusing power*. If highly motivated, we can focus our attention on something with considerable concentration . . .
> Third, the *capacity of attention is limited*. There is only so much of this cognitive resource available and it dissipates with time and effort.
>
> Bitgood (2000: 33)

We need to focus on the factors involved in capturing and holding visitor attention, while recognising that it is limited. This is a major problem, if we believe in enabling visitors to explore, select and discover for themselves rather than force-feeding them our opinions and concepts in our own selective manner. How do we get around the practical issue of limiting content while not limiting visitor choice?

17 Visitor participation means 'pacing' displays

Even museum professionals exhibit typical museum visitor behaviour – we start off viewing every element of an exhibition but then gradually speed up and by the end are rushing through. Sometimes this is called suffering from 'museum fatigue'. Basically, although it will vary between individuals and circumstances, there is only so much we seem able to take in during a single visit. We run out of energy, our attention wanders, we lose our concentration and the museum exit becomes the most attractive element in the exhibition. Partly this is due to being overwhelmed by content quantity, but much is due to a lack of understanding on the part of museums of how people use exhibitions. If attention is limited, a key challenge within displays is to seek ways to renew it, to enable visitors to regain their concentration. The most effective means of achieving this, after limiting content, is through 'pacing':

> The concept of pacing is proposed as a means of reducing both physical and mental fatigue for the museum visitor. Specific issues related to pacing include: the creation of diversity and contrast throughout the museum; the effect of crowds and circulation; and the provision of appropriate resting places and other amenities.
>
> Royal Ontario Museum (1976: 37)

Too many museum displays, even when they contain lots of modern media, are single pace – the visitor is faced with one type of content or 'mood'. A change of mood stimulates visitors. Effective displays seek to change mood and to appeal to different modes of apprehension, from the experiential to the contemplative, at different times. Contrasts between exhibitions and non-gallery spaces can be equally helpful in recharging the visitor's batteries and reigniting their interest.

Equally, individual displays can bombard a visitor with 'a multiplicity of simultaneous sensations' (Royal Ontario Museum 1976: 37), including object and media overload, overcrowding, heat and noise, etc. – all competing for physical and intellectual attention. While the museum should seek to enable the visitor to concentrate on what it sees as the most important elements, it should also use orientation to assist visitors in selecting what is most important for them, therefore pacing their visit in a way most appropriate to their own needs.

The approach should also ensure that an exhibition finishes on a high note rather than fizzling out – we need our visitors to leave on an emotional and intellectual high, supportive of the work we are doing and ambassadors on our behalf to other potential visitors.

18 Visitor participation also means rest, recuperation and time for reflection

Equally important in terms of supporting visitor concentration is the need for rest and recuperation (R & R) – to have regular areas of seating where visitors can collapse (mentally as well as physically) for a short time before moving on. This links back to

the role of orientation within displays. Allowing visitors a break enables them to select what to concentrate on next. This is a much neglected area within museums. Space is precious, so is given over to display. It is also a constant battleground with designers, many of whom seem to have an in-built objection to seats cluttering up their spaces. People need seats:

> I love seating. I could talk about it all day. If you're discussing anything having to do with the needs of human beings, you *have* to address seating. Air, food, water, shelter, seating – in that order. Before money. Before love. Seating.
>
> Underhill (1999: 87–8)

But the provision of seating areas is not just about R & R. In fact, Gilman's view was the opposite of this:

> We are at sea on the question of the best way to provide seats in a museum until we catch sight of the truth that their foremost office is not to restore from fatigue, but to prevent its advent. They are most useful, not when they afford the greatest ease and when they most exempt the visitor from the temptation to go on examining things, but when they afford just enough ease to make it comfortable to go on looking and are conveniently distributed among the exhibits for this purpose.
>
> Gilman (1918: 270)

I too view seating as an *active* part of an exhibition. It is an opportunity to provide mental space, providing time for some reflection on what has gone before. This can be enhanced by the provision of relevant support material and books, in case people want to explore an element in more depth while comfortably seated. More relevant to most visitors, it provides a space in which to discuss each other's experiences and thoughts ('designing for conversation' – see principle 19). I always recommend that seating be placed around circular tables rather than in lines. Sitting in a close circle encourages conversation.

Also important for reflection is providing spaces where people can stand and watch, or even listen to, other visitors. Much of human behaviour is learned observationally, and the opportunity to compare how other visitors are using a display, or individual exhibit, with your own experience can encourage thought and add substantially to understanding.

19 Visitor participation means encouraging social interaction

While interpretation will seek to build on the individual's personal context (see principle 9) the development of an interpretive approach is more complex than that, because museum visits are rarely made alone. While most of the research has focused on families rather than other social groupings, the evidence suggests that the exhibits that most effectively engage an audience are those encouraging social interaction, discussion and involvement within and beyond the groups involved. This, in turn, both

broadens and deepens their understanding. So we must think in terms not just of self-referencing but also of group-referencing and group dynamics. Practical issues include:

- encouraging conversation
- enabling 'people watching' between groups, so they can learn from each other
- creating exhibits which the group can explore together (a major problem for computer interactives which tend to be devised for use by one person at a time)
- building spaces into the exhibition where staff/gallery assistants can interact with the audience
- varying exhibit heights so that all of the group can use them (important for those with disabilities as well as for children).

The issue of encouraging and supporting group interaction has already been referred to under principles 15 and 18 above. Central to this is the concept of 'designing for conversation', discussed by Paris (2002) and previously mentioned in chapter 5. It combines a need to build in conversation spaces and also to consider 'what do we want our visitors to talk about in the exhibit?' as part of the planning exercise for an exhibition. Workshops on this issue organised by Paris and Perry led to the identification of ways that conversations can be promoted:

> Suggestions include space for groups to stand together, controlling background noises, labels that can be read aloud or at a glance and shared with children, interpretation that brings in voices or encourages visitors' voices, areas for docents or teachers to sit on the floor and ponder an object, objects that are familiar and connected to daily experience or likely to be more familiar with one generation to promote sharing, and providing opportunities to engage in dialogues of inquiry.
>
> Paris (2002: 297)

20 Visitor participation requires an impact on the emotions and senses as well as on the intellect

What are the nature of the experiences that will bring people to museums, historic sites and other places of informal learning? One thing most interpreters accept is that the motivation will have much more to do with the *feeling* component of the experience than the informational one. If we are to reveal meanings and provoke thought we must seek to go beyond knowledge – to engage the senses and emotions of the visitor: 'This is what art does to you. It enraptures and arouses . . . it circumnavigates the brain and appeals directly to the senses' (Januszczak 1998: 2).

The appeal to the senses and emotions does not come only from the most magnificent aspects of sites or collections. It is as likely to arise from a detail, something which affects us directly on an individual level – the smell of a peat fire; the volume of noise from a textile machine in operation; the sight of a mummified baby; touching a cat's paw-print on a Roman tile. Active participation requires the use of the senses and the stimulation of emotions and, in turn, substantially enhances the

quality of the visit. Yet even today in most museum presentations the visitor is sensorially deprived – left with visual contact and little other involvement:

> the European tendency has been to split up the senses and parcel them out one at a time to the appropriate art form. One sense, one art form. We listen to music. We look at paintings. Dancers don't talk. Musicians don't dance. Sensory atrophy is coupled with close focus and sustained attention. All distractions must be eliminated . . .
>
> Kirschenblatt-Gimblett (1998: 57)

So much museum display is still conceptualised and organised within a narrow academic view of how people communicate – words, supported by images and visual access to objects, and perhaps by the introduction of modern information technologies. Compare this with the real world, where human beings use all their senses to relate to and interconnect with each other in a multitude of ways (see, for example, Finnegan 2002).

I would not seek to downplay the importance of sight. After all, the impact of images can be powerful and long-lasting (especially if our emotions are involved). However, there are strict limits to what the visual can reveal and, even within those, people are highly selective in what they look at and read. Our other senses – sound, smell, touch and, if possible, taste, can add enormously to a visitor experience and therefore to understanding:

> Sight is the least personal of the senses. Today in the West it is also the most powerful. The deployment of sight requires a certain focal length, a distance, from its target: otherwise things are 'out of focus'. The other senses, on the other hand, require proximity. Touching, tasting and smelling need us to be close to things, and are in that way senses which require intimacy and which enable familiarity. They involve the body more, through demanding an immediate close presence.
>
> Hooper-Greenhill (2000: 112–13)

We hear sounds even in the womb. Smell is immediately evocative both in the real (for example, of a coal fire) and in the imagination (discovering that travellers to mid-nineteenth century towns in England could smell them before seeing them – no sewage removal systems). Touch provides direct physical interaction – physical contact is an essential part of humanity. We think of only four types of true taste – sour, sweet, salt and bitter – but this belies all the sensations that taste can impart to us and the memories and insights that these can reveal. It is rare that we can incorporate items to taste within exhibitions (soda farls cooked over a peat fire at the Ulster Folk Museum or clam chowder at Old Sturbridge Museum). However, between 80 and 90 per cent of what we conceive as 'taste' is actually due to our sense of smell – it is this that helps us to develop the mouth-watering flavours we associate with favourite foods today. Text, copies of historic menus and smell can allow us to contrast past preferences with those of today and give an alternative insight into past lives.

A sixth sense: or even more? – discuss

But are there more than the five traditional senses to consider? Should we be looking also at something which combines them, yet is more that a sum of their parts – something that links the senses directly to the emotions?

> The Japanese have a word to describe an extra fifth flavour, unrecognised and unnamed by western palates. Sweet, sour, salty and bitter are the usual four; the fifth they call 'unami'. Perhaps savoury is the closest translation. I was reminded of the Japanese term from being at Uluru [Ayer's Rock]. This place made me feel that there is a further sense in addition to seeing, hearing, touching, tasting and smelling.
>
> What remains in my mind most vividly are the colours and shapes of the land-scape – the red earth, the silvery-grey of the ghost gums, the graceful form of the desert oaks, the bold shape of the rocks and monoliths, the taste and texture of the bush tucker that I tried, the rhythmic speech patterns of the Aboriginal people, the sounds of the many birds.
>
> Tania Stadler, University of Tasmania, quoted in Atkins (2001:4)

Stadler goes on to say that she has not yet defined the term, but that 'sense of place' perhaps comes close. For me, what matters is the way in which all the senses play their part, but come together in an enormously emotional response to the experience. This is something she will never forget.

And what does one think about a sense of the *passage of time*? Here also, it is through linking the 'traditional' senses to emotion that the past is really brought to life for visitors. The opportunity to touch something made or used by another human being thousands of years ago, to smell and listen to the 'normal' sounds in an eighteenth century living history site, to listen to period music in the long gallery of an historic house. A written text can never provide an adequate substitute.

Finally, I frequently wonder whether also to define our response to music as an additional sense. Music seems to be unique to humans. We know its importance stretches back well into prehistory. Every culture creates and responds to music. Our response to music appears to be both physical and emotional. The same piece of music can affect us differently at different times. The appropriate use of music can transform a visitor's reaction to a site or display.

The importance of sensual involvement to our ability to engage with the world of course extends far beyond the walls of museums. It is depressing, however, to compare what most museums offer their visitors against the true delights of shopping:

> shopping is more than the simple, dutiful acquisition of whatever is absolutely necessary to one's life . . . The kind of activity I mean involves experiencing that portion of the world that has been deemed for sale, using our senses – sight, touch, smell, taste, hearing – as the basis for choosing this or rejecting that. It's the sensory aspect of the decision-making process that's most intriguing because how else do we experience anything? But it's especially crucial in this context because virtually all unplanned purchases – and many planned ones, too – come

as a result of the shopper seeing, touching, smelling or tasting something that promises pleasure, if not total fulfilment.

Underhill (1999: 161–2 and 165)

Senses are a key means by which we can engage our audiences and add additional unexpected meanings to their visits.

21 Visitor participation requires a palette of approaches and a layering of content

Taking personal relevance into account is not simply about the use of strong human-interest themes within presentations. It is also about educational achievement and advancement. Our visitors come when they want, leave when they want and look at what they want. They display uneven previous knowledge about the subject matter. They learn in different ways and react in different ways to different media.

Interpretation needs to allow for contrasting learning styles and build upon the pre-existing experience and knowledge levels of the visitor. This makes it essential to use a *palette of different approaches* and also to provide a *layering* of material, meeting individual needs in terms of entry and exit points and ensuring the availability of different levels of information. Even within the one site visit, people will want different types of activities. The challenge is to establish an approach to presentation from which each visitor can select, as he or she prefers. Layering means individual visitors can select the depth of their exploration of a particular concept or theme.

A clear understanding of your audience is essential before the interpretive approach is defined and appropriate media selected. The selection of media should depend substantially on the objectives for the presentation and the anticipated nature of the audience. However other key factors such as budget and the nature of the space have considerable influence. Everything depends on how *effectively* the medium is applied, and also on the quality of the particular example. The best form of interpretation will always be person-to-person, but the worst form will also be person-to-person, where the interpreter is dire. This same basic issue arises for whichever medium you look at. The real challenge, having selected the most appropriate medium, is to use it effectively.

22 Interpretation must also relate to the detail

The challenge is to both grab the visitor's attention, then to hold it by engaging the visitor directly with content and then, as a result, encourage reflection. This involves every aspect of exhibition detail. An interpreter:

- will keep collections to the fore and use media and other means to support visitor engagement, not leave the objects looking like window-dressing
- will look to display layout as crucial to highlighting collection contents
- will seek to break material down in a structured and prioritised way, using an approach based on the definition of primary, secondary and tertiary messages.

This content will then be 'layered', to enable visitors to select the level of material they want.

- will use a palette of interpretive media to meet the needs of different users
- will 'pace' the exhibition, changing mood and incorporating other elements, to retain visitor interest and concentration
- will give visitors the opportunity to participate wherever possible and in a variety of ways, including the opportunity to touch
- will use texts which are short, active and inclusive.

These issues will be returned to in chapter 10 when I attempt to explore the concept of visitor engagement.

23 'Staying alive' – the interpretive approach will enable regular change and a continuous programme of activities and events

One of the great joys of permanent collections is the opportunity to redisplay them and, therefore, enable visitors to view them afresh. Rather than setting out to create permanent displays which then do not change for ten years or more, change should be 'built in' to the displays. It *must* be possible to alter content on a small and large scale, easily and cheaply.

Museums and galleries have long been aware that an effective temporary exhibitions programme and a vibrant activities and events programme are essential in attracting both regular and repeat visitors. In a programme of exit surveys carried out at the Australian Museum, Sydney, between November 1999 and January 2001, 'experiencing something new' was the highest rated factor given for visiting museums and galleries in general, with 77 per cent of those interviewed rating this as high or very high in terms of reasons for visiting. 'Experiencing something new is also closely aligned with entertainment, learning and worthwhile leisure, other factors scoring highly in the survey' (Kelly 2001a: 9). While temporary exhibitions and special events can be planned independently of individual displays, it is essential that space for a regular programme of activities should be seen as part of individual gallery interpretation from the planning stage. These should be a mainstay in terms of providing opportunities for visitors to participate and for encouraging repeat visits as there is always something 'new' happening:

- The museum must develop its handling collections and make them accessible to the general public within displays rather than only to schools.
- There should also be support materials, activity packs, etc., available for use by family groups at all times.
- Rather than traditional attendant staff whose primary function is security, at least a percentage of front-of-house personnel should become 'gallery assistants', supporting visitors and running a daily programme of activities within the galleries linked directly to the displays, including object handling.
- There should be a timed programme of activities throughout the day, with visitors able to see what is happening, and when, as they arrive. This could be run

with one gallery assistant moving to different locations, but it is a wonderful opportunity to stimulate a range of staff and encourage them to develop, evaluate and improve the programme continuously.

- Spaces for these activities must be built in to the displays as 'dwell points'. These have a range of functions, from school project work to planned activities for informal users, linked directly to the displays in their immediate vicinity.
- Social interaction is critical to knowledge acquisition. Dwell points have an important function in encouraging this. They support and encourage involvement in informal group interaction. They are a neutral territory, where visitors can see activities going on before making a commitment to join in, so people feel comfortable and unthreatened. They must be comfortably furnished and include 'activity generators' at all times, not just when there is a planned activity in progress. Chairs should be clustered around a (preferably) circular table for easy eye contact.
- The museum should also consider a specific programme of events through the year. These could be small scale, like story telling, or major events. It is crucial to consider the potential for these in advance of building and design work.
- The presence of the gallery assistants still provides some basic security support. This would be re-enforced by CCTV and a small number of security personnel who move around the building.

DISCUSSION: THE IMPACT OF INTERPRETIVE PRINCIPLES ON MUSEUM DISPLAY

There are many times when I feel that the 'principles' I have outlined above are no more than a commonsense approach to museum provision. Yet, underpinning them, is a true interpretive philosophy which:

- believes entirely in an audience-centred approach to exhibition development
- sees the museum visit as an opportunity for the museum and its visitors to take part in a journey and in a conversation together.

Given this philosophy, it is incumbent on the museum to seek to attract as diverse an audience as possible, to welcome and support its visitors warmly, to make the visit easy and pleasant so that visitors can concentrate on what really matters (the site and collections), to stimulate visitor engagement with the collections, and to encourage conversations between visitors, and between visitors and itself.

I believe strongly that the principles I have defined above can help the museum to achieve those objectives. Where possible, I have included examples of research that support this belief. Hopefully, this book will stimulate some more – plus other work that perhaps reveals other elements equally important to enhancing the visitor experience.

However, these principles cannot be achieved within a museum by accident. Their application will be the result of a carefully planned exercise, and it is to this process that I now turn, in chapters 8 and 9. However, in doing so, I must emphasise that the purpose of such a tightly planned approach to exhibition development is not to

remove the creative impulse from the process, but to provide a framework within which such creativity can flourish in a way that truly engages the visitor with the collections.

CASE STUDY: EXHIBITION STANDARDS/GUIDELINES

In 2002 the Office for Policy and Analysis at the Smithsonian Institution, Washington DC, published a range of 'white papers' on aspects of exhibition development. All are essential reading. One, focused on *Exhibition Standards* (Smithsonian 2002d), sought to provide an overview of the nature and function of standards and/or guidelines for exhibition development as reflected in the available literature. These were explored in terms of both 'process', or the professional protocol behind an exhibition, and 'product', or the audience experience. The definition of the standards for the product reflects many of the principles discussed above. The latter were seen as falling under 'three pervasive themes' outlined in Box 7.6.

These have much in common with the interpretive principles discussed above, suggesting there is considerable scope for the AAM's national interpretation project to take exhibitions forward in a practical way that will have the positive support of many museum professionals.

Box 7.6 Three pervasive themes characterising externally focused exhibition standards

1 Exhibitions should be developed and executed with a focus on the end-user (visitor) and his/her experience within (as well as before and after), expectations for, access to, and navigation of exhibitions. Visitors should feel that their exhibition experience was stimulating, relevant and enjoyable. For example:
 - Exhibitions should be memorable, aesthetically beautiful and enjoyable.
 - Exhibitions should relate to visitors.
 - Exhibits should be designed to be accessible and easy to use.

2 Information and objects should be presented in a way that provides for visitors engaging in experiences. For example:
 - The 'why should I care?' should be clear throughout.
 - The emotional impact of an exhibition should sharpen understanding.
 - Exhibitions should offer visitors choices, feedback, and indicators of success that personalize the visit for them.
 - Exhibitors should support direct experience in the exhibition.
 - There should be support for follow-up educational experiences.
 - The exhibition should reach out to visitors to engage them with the message.

Box 7.6 continued

- The exhibition should surprise and inspire visitors.
- A variety of experiences to match a range of abilities and skills should be provided.
- Exhibits should provide real and genuine objects and phenomena that provide for intellectually and emotionally involving experiences.

3 Messages should be presented in a clear, coherent manner and through multiple media. An exhibition should allow for differing viewpoints on a subject. Visitor engagement is facilitated by the interpretive and communication strategies that support the messages of the exhibition and their relevance to the visitor. For example:
- Information should be presented in multiple formats, and decisions should be based on the intended audience.
- Communication strategies that are clear, appealing, relevant, and engaging should be developed.
- Texts and other communication media should be accurate, honest and clear, yet allow and present differing points of view.

Source: Smithsonian (2002d: 8–9)

8 Interpretive master planning

INTRODUCTION

As discussed in chapter 7, principle 10, interpretation is a planned exercise. The objective for this chapter is to introduce the central role of interpretive planning in the development of museum displays. Because interpretation proposals are intertwined with almost every other aspect of a museum or site's operation – positioning in the market, image projection, target audiences and audience development plans, access plans, operational management, collecting policies, outreach programmes, etc., as well as exhibitions and associated activities, and structured educational use – the process of developing an interpretation plan has come to be known as 'interpretive master planning'.

Long before the term interpretive master planning was coined, the Royal Ontario Museum produced its masterful *Communicating with the Museum Visitor: Guidelines for Planning* (1976), a book that provided the framework for the development of my initial approach to exhibition development and that I still return to regularly. John Veverka, a leading exponent of the concept of interpretive master planning, is best known in the UK for his book *Interpretive Master Planning* (1994). Like so much in interpretation, Veverka's book is geared toward visitor centres and trail development. There is a useful chapter on 'Planning for interpretive exhibits', but this is not specific to the development of museum exhibitions incorporating collections. The series of reports by the Office of Policy and Analysis at the Smithsonian, culminating in *The Making of Exhibitions: Purpose, Structure, Roles and Process* (Smithsonian 2002a), discussed above in the chapter 7 case study, has been a major achievement in reflecting current museum practice in the USA. More recently, Lisa Brochu's *Interpretive Planning: The 5-M Model for Successful Planning Projects* (2003) has added a further important text, based around the Certified Interpretive Planner training offered in the USA by the National Association for Interpretation. To Brochu, I must express gratitude for a reminder of that key term 'it depends'. Every site, collection, exhibition, audience, set of objectives, etc., is different. Interpretive planning is a flexible support, not a rigid structure. The challenge is to seek the most appropriate route forward in your specific circumstances. Finally, I would refer to a slim but first-rate text produced by the Chicago Botanic Garden (undated 2003/4) *Creating Interpretive Programs in Natural Areas: Chicago Botanic Garden Model.*

Figure 8.1 The interpretive planning process

Gathering of information

↓

Analysis

↓

Appraisal of options

↓

Selection of approach

↓

Action

Source: based on Brochu (2003: 51)

It is essential at this stage to appreciate that interpretive master planning is a *process*, not a product. The end product – the plan/strategy – records the decisions already made and analyses the factors influencing those decisions. The process by which you reach these decisions is what matters – it is during this stage that the thinking takes place and we are called upon to weigh up the options available and use our professional judgement in deciding which approach or approaches will be most appropriate. Individual interpretive planners will vary in the way they bring material together. As previously stated, I follow the Veverka route of 'what, why, who, how'. Brochu is committed to the '5 Ms – management, markets, message, mechanics, media'. Whichever approach taken, however, will be overlain by a basic five-stage process – information, analysis, options appraisal, approach selection ,action (see Figure 8.1). At each of the stages, the 'What', etc., or the 5 Ms must be covered.

Interpretive master planning can be employed on a number of levels. The National Parks Service in the USA has used the approach for decades as part of its development of strategic plans for individual parks or regions. As the NPS has sought to balance conservation and access issues, the interpretive plan has been developed to:

- manage access to a site/movement around the site, etc.
- inform people about an area, site and/or collection
- encourage people to support conservation
- make people aware of/supportive of the relevant heritage organisation(s).

In the USA, national and state parks tend to have one owner, either national or state government. It has proven much more difficult to develop regional or National Park interpretive plans in the UK, where there tend to be a multiplicity of owners and management bodies, each with its own agenda. The first attempt in the UK was a blueprint for the Peak National Park in 1966 and there have been a number since, notably for Wirksworth, Calderdale, the Portsmouth area and Dartmoor. A new

version for the Peak National Park was produced in 2001. The UK is also increas-
ingly seeing interpretive strategies being produced as part of the management plans
for world heritage sites such as Hadrian's Wall. Goodey (1994) provides a useful
introductory text.

However, what matters for this chapter is the application of interpretive master
planning to the museum environment. Here, there is a direct advantage in applying
the process: to the development of service-wide strategies for multi-site museum
services; to providing the framework for the redisplay of multi-collection museums;
and to the development of a brief for the redisplay of an individual gallery or single
subject museum. It is, of course, equally effective in the interpretation of industrial
or archaeological sites, or period houses. It can also have major relevance in the pro-
duction of applications to grant giving bodies.

In my own work, I have tended to use the term *interpretation strategy* rather than
interpretive plan. My desire is to see an end product that is a working document
which is there to meet the needs of targeted audiences and support public access to
sites and collections. As such, it seeks to achieve two key tasks:

- to set out a shared vision, which is both creative and practical, for the 'public face'
 of the museum. This on its own would be the interpretive plan.
- to define an effective framework for interpretive planning and design that goes a
 long way toward ensuring that the aims and objectives of the project are achieved
 and actually meet the established needs of the targeted users. This is what turns
 the plan into a strategy for action.

Thus, starting from Veverka's model (1994: 32), an *interpretation plan* will seek to
establish a long-term 'vision' which is unlikely to change (see Box 7.3). This will fit
around a basic framework of:

- *context* – factors, external and internal, influencing the interpretation, e.g. national
 and local strategies, the ethos of your organisation, available budget, nature of
 proposed space, timetable
- *what* you wish to present – the nature, strengths and weaknesses of the site and/or
 collections; specific site/resource issues; themes, etc., to be presented
- *why* you wish to develop/change the existing displays, etc. – the aims and object-
 ives of the responsible organisation, specific objectives, defined outcomes
- *who* you are targeting the approach at – nature of target audiences, needs of audi-
 ences, expectations and perceptions of audiences.

The interpretation strategy will incorporate the plan, but concentrate on its delivery
rather than on the underpinning discussion about its creation, and so include:

- *how* you intend to present the material. The 'how' should be developed as the most
 appropriate response to the answers you define to the questions 'what/why/who'
 and the context in which the interpretation is taking place
- the *impact* of implementation and operation – priorities, capital and revenue impli-
 cations, timetable, effects on staff structure, effects on collecting policies, etc.

Evaluation and revision

As a delivery document, the strategy can change over time, to reflect the practicalities of the situation (new opportunities, changing short-term priorities, etc.), but should continue to reflect the vision defined in the plan.

The plan/strategy document can occasionally stand alone, but is more likely to be supported by a range of other documents, and/or form an element in a forward plan or a feasibility study on the creation or major revamp of a museum. This chapter will explore the development of interpretation strategies at service-wide and multi-collection level – in other words, their role as a management tool. Chapter 9 will then look in detail at how an interpretive approach influences concept development and the design of individual exhibitions.

DEVELOPING AN INTERPRETATION STRATEGY FOR A MUSEUM SERVICE

It is now the exception for a museum service not to have a forward plan. Effective forward planning demands a fundamental look at the nature of the organisation, focusing upon what it is there for. Such plans play an essential role in defining a realistic future for heritage resources in general, and in achieving agreed goals during what is a period of rapid social and economic change. An agreed plan will balance the demands of conservation against demands for enhanced access and the needs for management accountability and revenue generation. It is also an essential tool in monitoring performance, using both financial and non-financial methods. The interpretation strategy is part of this forward plan. As such, it will be influenced by other elements of the service and must be subject to regular evaluation, updating and revision.

The development of a service-wide interpretation strategy will only be effective if all relevant staff can be involved. It is a team effort and must consider the long-term strategy for the service and its operational, curatorial, educational and marketing requirements. Particularly where the service is public sector funded and managed, such involvement must extend outside the service to include other sectors, such as community development and neighbourhood renewal, cultural services and tourism – and consultation with local communities and groups, and other stakeholders. The end product is likely to be a substantial document, but from this a succinct working tool must also be produced, with a clear statement of the way ahead and a route-plan to get there. It is this shorter document that can also be presented to management boards, the local community, etc., so that there is a truly shared vision of the route ahead.

The full document is likely to consist of three elements:

- *a contexts paper* – the national, regional and local strategies, policies and factors influencing the plan
- *a vision* – the interpretation plan
- *delivering the vision* – the interpretation strategy.

The contexts paper

Anyone planning for the long-term future of their museum service will see this within the context of those factors, at national, regional and local level, most likely to influence the activity of the service in the future. It is from such an analysis that I came up with the list of museum roles I included in the introduction to this book and repeat here. It should be:

- an object treasure house significant to all local communities
- an agent for physical, economic, cultural and social regeneration
- accessible to all – intellectually, physically, socially, culturally, economically
- relevant to the whole of society, with the community involved in product development and delivery, and with a core purpose of improving people's lives
- a celebrant of cultural diversity
- a promoter of social cohesion and bridger of social capital
- a promoter of social inclusion
- proactive in supporting neighbourhood and community renewal
- proactive in developing new audiences
- proactive in developing, working with and managing pan-agency projects
- a resource for structured educational use
- integral to the learning community
- a community meeting place
- a tourist attraction
- an income generator
- an exemplar of quality service provision and value for money.

These, however, are quite general statements. An individual service must explore what each of these statements means for it and assess the likely impact. The starting point is a classic planning exercise in self-evaluation – where are you now? – in terms of the defined contexts. As an example, the enhancement of community participation is currently high on the museum agenda. If museums are to be seen as relevant by their governing bodies, and by the communities they serve, they must respond to this. It should mean museums becoming much more outward-looking and responsive to public demands. A serious response to this change might also be reflected in a move in staff structure away from specialist curators and toward outreach and access officers, and much closer working with other agencies. Clearly, it will also require a change in the nature of exhibitions toward a much more participative approach, meaning not just 'hands-on' galleries but displays where local people have the opportunity to take part in the selection and interpretation process.

Another example would be to define the service response to the needs of a multicultural population. The city of Leicester will be the first in the UK with a majority non-white population. Currently the city museums use particularly their temporary exhibitions and activities programming to reflect contemporary city communities, but its service-wide interpretation strategy has placed emphasis on collecting policies, on representation and participation for local communities within permanent

displays and on the need to explore the contribution of Leicester's diverse communities to the city's development particularly since the 1950s.

The contexts paper therefore highlights and assesses current and future trends and the responses the service needs to make to these. Clearly, there are difficulties in this as political agendas in particular can change with remarkable speed. The challenge is to see through the froth and the political fuzziness to define long-term trends, their likely impacts and the museum responses required.

The vision – the interpretation plan

An interpretation plan is there to support the objectives of a museum service as a whole. As such, it should be a visionary document. It should stand aside from the current state of the service, to explore how it can best meet the developing needs and expectations of its visitors and its local communities, and how best it can deploy and further develop its collections to engage as wide a cross-section of the public as possible.

Separating vision from current practicalities makes it possible to plan for the long term and then to move on to view the current position in that context. This does not mean the vision statement should lose all touch with reality – it is about defining what the service should be delivering before moving on to 'getting there'. Clearly a vision of the future does not come from nowhere, nor is it entirely based on current political agendas. It will be rooted in the strengths of the service and reflect the numerous factors that influence it – from collections and audiences to available resources. The challenge, as always, is to build from the present for the future.

The development of the plan will be based on:

- establishing the *strategic context* influencing the direction in which the service must move for the future – so, extracting relevant material from the contexts paper
- defining *why* the service wishes to develop/change its displays – the aims and objectives of the service, specific objectives, defined outcomes
- establishing the targeted audiences for the service (*who* the service wishes to target its museum displays and associated activities at), the nature of target audiences, the needs of audiences, and the expectations of audiences
- outlining *what* the service wishes to present – the nature, strengths and opportunities of the collections; major themes; approaches to be adopted to meet the needs of different audiences, etc.

Defined aims and objectives need to include both visionary and quantifiable elements. They should also be expressed both from the point of view of the service and from the outcomes sought from visitors.

Thus, for example, *service aims* might include:

- engaging audiences with the collections
- introducing children, families and local communities to the concept and experience of museum-visiting

- responding positively to the cultural diversity of local communities
- developing a leading role as a community resource
- education embedded at the heart of the service's activities
- enhanced intellectual, social and cultural access to displays, collections, sites and services
- acting as an innovator also in the development of museum exhibitions as activity-based learning resources, for schools, family groups and members of local communities
- meeting the specific needs of schools with regard to the National Curriculum
- developing specific strategies to increase attendances
- developing a strategy for contemporary collecting and for the reinterpretation of existing collections to meet the needs of today's communities.

Visitor outcomes can be suggested in terms of broad headings (based on those defined by the National Museum of Childhood, London):

- *access* to the service and its collections – physical, cultural, intellectual, social, emotional and psychological
- *engagement* directly with the collections through the use of a wide range of interpretive techniques
- *involvement* by a wide spectrum of the local community in the activities of the service, from the planning stage onwards
- *enjoyment* of what the service has to offer
- a sense of *inclusion* and welcome
- development of individual potential through *lifelong and life-wide learning* opportunities
- *understanding* and awareness of the role of the service, leading in some to active support for its work.

All of these are exceptionally difficult to evaluate. Visionary documents still need to be rooted in reality. How will this proposed vision for the future of your service be justified, in terms of practical, measurable achievements? These may include (based on some of those defined within the City of Leicester Museums' service-wide strategy):

- the development of relevant new collections
- increased usage by existing and targeted audiences
- increased average length of stay
- improved qualities of customer care – and a means of testing service quality introduced
- increased media coverage
- increased word-of-mouth recommendations to visit
- specific and significant improvements to resources for structured educational use, through the building-in of project work and development of associated resource materials and taught sessions. Structured educational provision is recognised to be of the highest standard.

- direct community involvement in planning including increased support for the development of individual skills, knowledge and confidence through lifelong and life-wide learning provision and developing recognition of the service as a major and enjoyable learning resource, and implementing the work of the service
- the development of successful partnerships with other agencies, community groups, artists, etc.
- increased range and amount of outreach activities
- a focused programme of events, building from what is already successful
- increased use of the website
- increased involvement by volunteers in the work of the service, reflecting increased awareness of opportunities.

Defining *target audiences* is central to the plan. This will begin with a basic quantitative analysis of *existing users* and *non-users* to define core users and their requirements, the nature and percentage of repeat visitors, average lengths of stay, under-represented groups, etc. It will go on to define *target segments*. Potentially, these will include:

- adults with children (families, grandparents with children, adult and child groups, etc.)
- an audience reflecting the ethnically diverse population of the area
- an audience reflecting local communities and neighbourhoods
- young people
- structured educational users
- specialists and enthusiasts
- independent learners
- tourists, including visitors staying with friends or relatives (VFRs)
- day trippers from across the region
- repeat and regular visitors
- corporate users, including wedding parties.

For each segment there should be a breakdown of likely needs and expectations from the service. This is the central issue – the target audiences are not evaluated in marketing terms, but in terms of their implications for interpretation. So, for example, responding to the needs of an ethnically diverse population may require a range of actions, including:

- positive regular representation in the displays
- collections development to make such representation possible
- interpreting existing collections, e.g. through 'hidden histories' so they have a poignancy and resonance for today's audiences
- an active and sustained programme of outreach and in-reach work within local communities
- working with diverse organisations and relevant communities in the creation of displays and activities relating to their cultural memory
- aspects of the structured educational programme
- links between displays and temporary exhibitions across the service

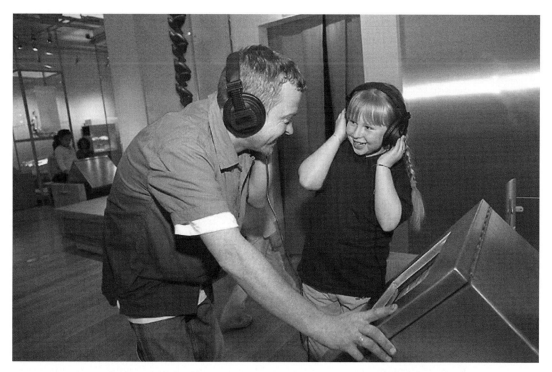

The creation of Destination Galleries was a key feature of the masterplan for Manchester Art Gallery. A key objective of one of these, the Clore Interactive Gallery, was to create exhibits that parents and children could engage with together. © Manchester Art Gallery

- a sense of welcome and inclusion throughout every site
- possibly specific cultural and language needs.

Effectively, redisplay within the service presents a real opportunity to research, document and celebrate the contribution of all members of the local community to the area's development and to foster local partnerships.

An analysis of *existing collections* should follow. The strengths of the collections in most multi-site museum services lie in their size, breadth and diversity. The breadth and depth of such collections provide remarkable opportunities for visitors to engage with material of world quality as well as of real local significance. It should also mean there is enough material to change displays regularly, enabling additional material to be exhibited and particularly popular elements to be viewed in a new light.

Each collection needs to be assessed through a *collections audit* and its individual strengths highlighted, in terms of international, national, regional and local significance, and also in terms of the stories they can tell, resulting in the production of a *collections statement of significance*. The audit and statement of significance should form a separate chapter, to emphasise the underpinning role of the collections. The emphasis within an interpretation plan will not be about the merit of the collections in

curatorial terms, but about the themes or stories that you wish to draw out about them. A major issue lies in defining priorities between collections. How much space should each receive? Should they be displayed within 'old' disciplinary boundaries (with which curators and traditional visitors are all familiar) or should the service seek to break down such barriers to reflect the different needs of audiences?

The document should also seek to define requirements for *new collections*. While the era of major collection development is over for most museum services, there can be specific defined needs. The two most obvious are to reflect and represent the multi-cultural nature of the local population, and to develop specific handling collections for use in the galleries and/or by structured educational groups.

An analysis of *existing public provision* is an essential element if the service is to move forward. This should incorporate an evaluation of every element of the 'public face' of the service, including its buildings, displays and activities, structured educational use, operational quality, signage, catering and shop, physical access, parking, market-ing, etc. The standard approach for this is a SWOT analysis (strengths, weaknesses, opportunities, threats). My own preference is to concentrate on strengths and oppor-tunities (a SO–SO analysis!). The latter includes a much more positive approach to weaknesses and threats. Thus surly front-of-house staff are not a weakness but an opportunity to retrain or replace. Equally, a competing attraction is not a threat but an opportunity for synergy in drawing more visitors to your area as a whole. This is not an exercise in blandness or political correctness, but in defining everything in terms of drawing up an action plan. Many organisations use outside consultants to carry out this evaluative work, to ensure objectivity and to remove any criticism from a personal level, but I believe that in-house staff must be involved, as part of the team-building exercise and to ensure long-term ownership of any proposals.

The central issue here lies in how you seek to define a strength and an opportunity. These have to be evaluated not in isolation, as usually takes place, but in terms of the aims and objectives you have set for the service as a whole. The production of this analysis is also not a short-term activity. To take one example, an evaluation of the existing visitor experience must involve tracking, interviews and questionnaires to define who they are, what they actually do on site, and their perception of the visitor experience. This will not only assist in planning your future interpretive approaches, but also give baseline information to evaluate the future visitor experience against.

All the material outlined above represents baseline research (combined with some practical illustrations of its potential impact on the interpretation strategy). Much of the rest of the potential contents will be produced concurrently rather than in any fixed order – each element impacts on the others.

A visionary document must define the *image* sought for the service – this, in turn, reflects the aims and objectives that have been set and the proposed central themes defined for the service's displays. Equally, the image must appeal not to a single mass audience but to a plethora of different audiences with different needs and expectations. This means the image proposed may contain different elements, to be broadcast to separate target audiences – but these must support and enhance each other, not be mutually incompatible. In Leicester, the service defined its ideal image as:

- a treasure house of objects and art with a direct appeal to the people of Leicester and beyond
- a service that celebrates Leicester and the diversity of its inhabitants
- a warm, welcoming, supportive service, inclusive and accessible to all
- a dynamic, buzzing, inspiring, enjoyable service where there is 'always something new' happening
- somewhere you would want to take your children, your friends and your relatives
- a service that goes out into communities as well as inviting people in – a major community resource
- a very effective learning environment for schools and the general audiences
- a service where specialist information is readily available
- a service that is constantly evaluating and seeking to improve what it is doing
- a service with a national and international reputation.

The most difficult challenge of all is to define service-wide themes and approaches. Establishing a mission statement for the public face of the service is the starting point for this. The interpretive plan for the redevelopment of Weston Park Museum in Sheffield, UK, defined its overall vision as:

> The experience of visiting the site will be one of discovery and learning for a wide range of audiences. The site will provide excellent and entertaining experiences, displays and programmes. Visitors will find it welcoming and inclusive and will be inspired to return.
>
> Sheffield Galleries and Museums Trust (undated)

As a 'vision' for an interpretive plan this is entirely written from the audience point of view. It outlines the nature of the visitor experience – the approach to be taken in developing displays and associated services – not the precise contents. It fits in well with the image of itself that, in this case, the Sheffield Galleries and Museums Trust wishes to project.

However, the definition of a mission statement by any museum service also leads directly to a consideration of the public provision that service believes it should provide. Will there be exhibitions, guided tours, an education service, an information point supporting other facilities in the area, catering and retail facilities? Will the service actively develop collections? Will there be an opportunity for people to become actively involved, for example through a friends group? Will there be outreach and in-reach programmes? Will there be direct community participation? Will the service disseminate information, and support staff contacts with similar sites elsewhere? This list could go on – resources are limited and the vision must be able to define priorities.

Alongside this interpretive approach must sit the major elements or themes that the service as a whole will seek to present. These will vary from service to service, depending on location, strengths of collections, etc., and so are difficult to illustrate as well as to agree. But agreement is essential – this is the 'big picture' around which the service and its staff must unite and focus. Once the themes and approaches have been defined, it is time for an initial evaluation of the document, including

community consultation and input, before a final version is produced. The final document will require approval by the service's managing body before becoming the engine behind the future direction of the service.

Delivering the vision: the interpretation strategy

This third and final element is about *delivery*. With the main objectives for the future of the service defined in the plan itself, the delivery document must concentrate on just that – how to turn those objectives into reality. It should be an operational guide, defining how the plan can be put into practice within the current environment for the museum service. It should be a practical, viable document, reflecting the current state of the service and the opportunities it has to develop to provide a realistic product for the future.

The document should include an *options appraisal* to define the most appropriate route ahead. This in itself is a significant and essential element. There will be a series of alternative means of achieving the same end. Analysing each, and comparing them with each other, is a crucial element in defining the most appropriate way forward. On completion of the options appraisal, it should be possible to suggest a specific way forward and to agree priorities in timetabled developments over the short, medium and long term, including outline costings and revenue implications, but recognising that these might change with time. It should also assess the potential impact of longer-term possibilities.

It should incorporate a 'communications strategy' (see p. 246) as well as site-by-site proposals and an enhanced role for outreach and in-reach activities and neighbourhood involvement. Because we live in the real world, it should also recommend 'quick wins' to illustrate how the new approach will enhance the quality of the museum experience for all, to establish momentum and to create early successes for staff, visitors and the governing body to celebrate. It should then form the basis for the development of more detailed proposals for individual sites.

As a working document, it can never lose sight of key practical parameters. Clearly, it must deliver on the objectives of its governing body, whether a local authority or trustees, and do so both by making the most effective use of limited resources and also by delivering a plan that is sustainable within agreed revenue funding levels. In the modern environment, it must ensure that the service is seen to become more outward looking, to be responsive to wider community needs and to be encouraging a more diverse range of users. As a practical document, it will always be a 'work in progress', subject to immediate fortunes and regular reviews. The challenge is to ensure that, while 'getting dirty' on the detail, the real vision of the overall interpretation plan is not lost.

The primary task for the interpretation strategy is to take the defined aims and objectives for the service and establish how these can best be met through the existing service framework (sites, collections, staff structure, budget) or through achievable changes to that framework over time. What improvements are required service-wide (e.g. role of museum assistants, development of handling collections, outreach and community consultation, website)? What will be the role of individual sites and which

of these will be the most appropriate location for specific collections and displays, so that the needs of users are met service-wide? Are entirely new gallery types required (e.g. a children's gallery)? Which displays should be multi-disciplinary and which single-discipline?

It must also take a wide range of very practical issues into account:

Sites

As part of the long-term planning involved in developing the interpretation strategy, there must be a detailed evaluation of the sites currently occupied by the service. Consideration should be given to:

- the museum sites currently available and the likelihood or otherwise of this situation changing. Are there any that should be closed? Are new ones likely?
- the space available at the individual sites
- the potential for development at individual sites
- the suitability of individual sites for museum display and visitor access, e.g. will planning permission be given to install a lift within an historic building?

Capital funding and revenue budgets

Funding will always be a central issue. The interpretation strategy must reflect a realistic assessment of:

- the likely overall capital costs, and their breakdown over the established timetable
- the likely capital funding opportunities – do these match requirements or does something fundamental have to change (e.g. new funding, changed objectives, extended timetable)?
- the objectives of any external funding bodies
- the likely timetabling of capital funding and the impact of this
- the impact of the proposed changes on likely revenue requirements. The likelihood or otherwise of an increase (or decrease) in revenue budgets and the effect this may have on the proposals. Can any gap be met? – if not, what needs to change?

Collections

The interpretation strategy will be underpinned by the existing and potential collections held by the service. Careful consideration must be given to:

- the need to decide for collections
- which existing collections are relevant to the strategy, including those that do not initially come to mind
- which existing collections are not relevant to the strategy and address how to deal with them

- how the collections need to be developed and enhanced to meet current and future needs, and address how to deal with this
- the need to develop handling and loan collections further as an integral part of the service
- the need to decide the most appropriate locations for displaying different types of material
- the need to develop the strategy alongside a collections resource centre, for collections in store, that both enhances their protection and widens access to them.

Project management

There is little training within the museum field for managing major projects through to completion – mostly people have to learn on the job. In putting the interpretation strategy into action it is essential to have someone in charge to drive things forward and to remove most other duties from that person. However, at the planning stage the service management team must also:

- define the overall timescale involved and, within it, the individual timetable required to achieve specific goals – this is likely to be accurate in the short term and projected for longer-term proposals
- assess the current staff structure and its relevance to the interpretation strategy as well as the availability of staff with the expertise to achieve the proposed developments
- consider the number of initiatives under way at any one time and whether or not it is feasible to take staff off other work to concentrate on the achievement of the strategy
- appreciate the need to develop effective working partnerships with other groups and agencies and actively commit to this
- evaluate the potential impact of concurrent proposals from other sources within the area in which the service operates and elsewhere
- understand the need for 'early wins' at every site that can also act as pilots for future development, in terms of both exhibits and staff development.

Audience retention, development and support

Baseline research on existing audiences and the creation of audience development and access plans will provide an essential framework within which the interpretation strategy can be both developed and implemented. This will include:

- establishing the existing and target audiences – numbers, expectations, needs
- defining an audience development plan, including target audiences, for each site
- establishing and carrying through a programme of community consultation and feeding the results back into the strategy
- the specific requirements of structured educational users

- the practicalities of developing and operating activities programmes
- producing an access plan for each site, including carrying out access audits and timetabling the alterations necessary to ensure equal physical access for all
- establishing and meeting the specific access requirements of certain types of potential users, for instance carers and children, people with physical and learning disabilities, or cultural and language needs
- redefining the role of museum assistants as enablers, and employing or retraining relevant staff.

Image, marketing and PR

The development and implementation of the strategy is meaningless if the ambitions and activities of the service are not projected outwards into surrounding communities. A strategy for developing an image for the service, and that of individual sites, that is both positive and relevant to targeted audiences is an integral part of the implementation of an interpretation strategy. This will include:

- establishing an overall external image and profile for the service
- developing the individual identity of each site
- developing positive PR campaigns to support changes.

Interpretation and learning

Finally comes the establishment of agreed approaches to interpretation and the provision of opportunites for learning, which will include:

- maximising the effectiveness of interpretation and display
- 'pacing' displays
- building in education project work as well as meeting the needs of informal learners
- building in an activity programme so that there is 'always something new' happening
- building in opportunities for permanent display change and temporary exhibitions
- incorporating other elements of service delivery, such as in-reach and outreach
- building in opportunities for community involvement. This can include developing new collections and exploring new ways of interpreting existing collections, responding to the wider interests of diverse communities, working with organisations and communities on the creation of displays, etc.
- ensuring the needs of specialists and enthusiasts continue to be met
- developing the service's website as an integral part of service delivery, not just a marketing tool
- looking outside museum sites to define the role of the service in interpreting its hinterland – perhaps through guided and self-guided trails, but also by signposting visitors to other locations.

Any multiple-site museum service risks establishing a domino effect in putting forward far-reaching proposals for change. Clearly there is always the risk of unforeseen repercussions following on from major developments, although most issues should be aired through the consultation process associated with the creation of the plan and strategy documents. The bigger issue is the 'you cannot do this until you have done that' syndrome, that can take everyone around in circles if you are not careful, and prevent change ever happening – a situation not unique to museums. A central challenge in preparing the delivery document is to establish priorities that can be achieved, then to establish a timetable, and then to get going. This syndrome is also a key reason for the inclusion of 'quick wins' in the delivery document. It is essential to establish and maintain momentum.

A central reason for separating the plan itself from the strategy for its delivery is that priorities can change over time – this may be the direct result of careful planning and evaluation or, equally, the result of funding opportunities or political whim but, whatever the cause, you can go with them as long as they fit within the overall interpretive vision for the service.

DEVELOPING AN INTERPRETATION MASTERPLAN FOR A MULTI-COLLECTION MUSEUM

I have in my mind here a typical 'comprehensive' city centre museum with a wide range of collections, from Fine Art to the Natural Sciences. It may be a stand-alone facility or part of a larger service. Developing an interpretation plan and strategy for such a site – often called a *masterplan* – incorporates much of what has been written in the previous section of this chapter, and that material will not be repeated here. Where it differs from a service-wide approach lies particularly in the fact that we are dealing with a single site – an attraction in its own right and seen by visitors as such – rather than an amorphous 'service'. Issues become much more practical, reflecting the operational nature of the individual site. Exactly what range of services should be provided by the site? How much space is involved for each? What themes and collections should be displayed here? How much space should each receive? What specific audiences will be targeted? What are the projected audience attendance figures? What is the projected length of stay? How much space do we therefore need to allow for visitors and visitor facilities? How much space should be allocated for a temporary exhibition programme? If I have mentioned space a lot, it is because the prioritisation of space becomes a battleground in its own right. However, in my initial development of an interpretation plan for a multi-collection museum I try to avoid becoming bogged down in the realities of the building. A key initial task in determining the interpretive vision for the site is to define thematic/display and visitor service priorities and define space in terms of need rather than availability. Equally, too early a definition of visitor routes can imprison the creative imagination required.

Thus, either from scratch, or building from a service-wide plan, the interpretation plan for a multi-collection museum will initially seek to include both a visionary statement and an analysis of more general practical implications, while trying to avoid detail that might unnecessarily limit ambitions. It should include:

- a statement of overall aims and specific objectives for the site
- a statement of the factors influencing the plan and their impact
- a statement of heritage merit on the building
- a collections audit and collections statement of significance, including prioritisation between collections
- an audience appraisal, for both existing and targeted audiences, leading to a definition of target segments and their needs, overall annual and seasonal target figures, with a breakdown per segment, and estimates of average anticipated length of stay for each segment. You will want to estimate likely audience levels after years 3 to 5, when the project is no longer 'new', as well as at opening
- an evaluation of current provision, its strengths and the opportunities offered, including comparisons with similar sites
- an access audit to define present conditions for physical access and develop appropriate solutions to ensure that, as far as possible, everyone can follow the same route and have the same experiences
- an evaluation of how the museum can, in practice, make itself more outward looking and responsive to a wider range of local communities, encouraging more people to value it and how it should seek to meet the needs and expectations of a diverse range of audiences
- an examination of how any redisplay can ensure that learning (structured, lifelong and life-wide) and access (physical, intellectual, social and cultural) can be at the heart of the museum, its displays and associated events and activities
- an assessment of how existing and any new collections can be redisplayed so they have a poignancy and resonance for today's audiences and reflect current local populations, issues, etc.
- a statement of priorities in terms of the redisplay, based on the museum's ambitions, the collections audit and the audience analysis. What collections should be displayed, what spatial priority should be given to each and what stories should they be used to tell? This will include key interpretive themes, gallery-by-gallery. Each theme should have a brief summary so that an overall sense of the museum contents can be achieved, but then be given an individual chapter in an appendix to give a real 'feel' for the proposals. The 'overall sense' is crucial to ensuring a range of experiences for visitors.
- an assessment of the likely support facilities required.

In the process of turning the plan into an interpretation strategy, museum staff must put and answer a series of key questions. The answers reached must, at all times, be seen in the context of the capital and revenue implications. There is no point in seeking to develop proposals that cannot be delivered, or that cannot be operated in the longer term. These questions are:

- Given the overall ambitions for the site, what alternative interpretive options are available and how can the museum define the most appropriate? – the *options appraisal*.
- What are the minimum, median and maximum spatial requirements for each proposed display? Display designers must be involved by this stage to illustrate

alternative approaches in outline, for spatial impact and to enable an assessment of likely costs.

- 'Access for all' – what should be incorporated in an access, communications and learning strategy that will define the overall approach to audience engagement to be applied across the site?
- How can the redisplay ensure that provision for structured educational use, in terms of both built-in project work and dedicated spaces, fully meets teacher requirements?
- What will be the likely operational impact of implementing the strategy?
- How best to redefine the role of front-of-house staff?
- At what scale and quality to provide support facilities, including their spatial and operational implications? This may include external signage, the nature of the foyer/reception, visitor circulation routes, perhaps a cloakroom, washrooms, café and storage, designated education/lecture room/meeting room space, shop and storage, performance space, exhibitions workshop area and storage, conservation facilities, utility room, etc.
- What are the facilities required for the defined level of temporary exhibitions space sought, and how can these be achieved – depending on the types of exhibitions the museum wishes to see here?
- In outline, what would the temporary exhibition programme seek to cover over a period of five years, to reflect the museum mission?

At this point the strategy is developed far enough to tackle the challenge of how best to handle the building. What are the overall spatial requirements, and can they be achieved – based on the estimated requirements of visitors, displays and support facilities? How do we define visitor routes, gallery spaces, etc.? What is the carrying capacity of the site – is it adequate to cope with the likely audience? How do we extend gallery spaces? How do we enhance access? What are the issues in gaining consent for any alterations or extensions to the fabric? What building works are required to achieve the project? How much will it all cost? These practical issues are key to the delivery of the strategy.

An imaginative architect and exhibition designer, sensitive to the museum's needs, are both central characters in the final development of the strategy. Here we see why it is important, when developing initial gallery proposals, to include minimum, median and maximum requirements – we are into the world of horse-trading against space availability, the possibilities of extensions (if any) and costs. Failure to achieve agreement on the way ahead can only lead back to a reassessment of priorities (if it is an issue of inadequate space) and/or of timeframe (if the spatial requirements could be achieved but only at too high a price in current circumstances). Further material on spatial analysis for individual galleries can be found below, at p. 250ff.

The strategy document itself is likely to be supported by more in-depth reports such as:

- links to the service's development strategy/forward plan and mission statement
- a full collections audit and statement of significance
- a conservation plan for the building(s)/site

- a full quantitative analysis of the existing audience and a qualitative assessment of their current experiences during visits
- a full analysis of the service's target audiences, including reference to policies/information on social inclusion, disability access and cultural diversity
- a copy of the service's policies for structured educational use and the promotion of lifelong learning
- a detailed assessment of the likely capital and revenue implications. Potential costs, etc., will need to be built into the timetable of not only the interpretation strategy but also the overall development strategy/forward plan.

Equally important is the need to turn attention to the mechanisms needed to achieve the project which include:

- how to ensure the project can be delivered on time and within budget
- considering if the building can be kept open to the public during its redisplay or must it close for a period (implications)?
- the best way of managing it and who is going to do what to take it forward
- appointing an exhibition team with individual responsibilities
- a statement of what specific concept documents will be produced
- the public consultation process and any other evaluation elements
- 'building in' structured educational use
- priorities and timescales, including a detailed timetable
- fundraising, grant application process, etc.

Because every aspect of a museum or heritage site development is so intertwined and inter-related the route-plan outlined above on the production of an interpretation strategy for a single site incorporates most of what would be included in a *feasibility study* for a new development or a major refurbishment/redisplay project. These studies have become a common feature of museum life, particularly for major projects seeking grant aid. They are normally carried out by a multi-disciplinary team combining museum staff and outside specialists. In the USA, Veverka has argued that the lead in this sort of study be taken by the interpreter, seeing the project as an example of what he has termed 'advanced interpretive master planning'. Certainly the team leader, whether in-house or an external appointee, must be aware of the overall vision behind the proposal and drive the project to achieve that vision. My own experience has been of a similar team make-up across a wide range of projects, but my preference has been for a specialist project manager as team-leader, someone who can keep everyone on board, on target and on time, supported by a quantity surveyor who can keep costs under control. This allows me, as interpreter, to concentrate on working with the curatorial and design team on the creative side of the task. I discuss the role of the project manager in the case study at the end of this chapter.

Whatever the route taken, eventually the document is produced, supported in consultation and approved by your managing body. The time has come to move on to concept development for individual galleries. Of course, much of this has been done in the process of developing the overall strategy, but for the sake of some sort of logical progression in this book, I am ignoring that. The next chapter will look at

concept development, either for a single-subject museum or for an individual museum gallery. It should be read in the context of what has already been presented.

DISCUSSION: THE ROLE OF THE PROJECT MANAGER

The complexity of masterplanning and then redisplaying a multi-collection museum means that a quality project manager is likely to prove essential to the success of the project. The project manager should be brought on board at the planning stage and his/her role starts with an objective evaluation of the proposals which are:

1 What is the best way of doing the project?

Have you carried out a full options appraisal and fully justified the resulting decision?

2 How practical is your proposed way of doing it?

- Have you got all the necessary consents?
- What does your business plan reveal?
- Do all your team members believe it is achievable – on time, in budget?
- Have you done a full risk assessment and planned to manage the following risks?
 technical (e.g. structural problems with building)
 financial (e.g. shortfall in revenue funding from public organisations)
 economic (e.g. collapse in property market)
 market (e.g. strengths and weaknesses of competition, market trends, forecasts of future growth/reduction)
 management (e.g. loss of key personnel, shortfall in volunteers)
 legal (e.g. changes in legislation)?

3 Are the funding elements of the project realistic?

Have you assessed the clarity and effectiveness of the project plan and the fundraising plan?

4 How will you guarantee the quality of the project?

You must:

- get evidence that you obtained advice from relevant organisations
- obtain evidence that the project fits in with relevant national, regional and local strategies

- ensure all work – from building conservation to planned activities – meets relevant national standards and best practice
- ensure relevant high quality training for those involved
- obtain evidence that the project is environmentally sustainable – from the recycling of materials, through energy consumption to ensuring access to the site by means other than private cars and consultation with local people affected by the scheme.

5 How will you ensure the project is managed effectively while carried out and after completion?

You must:

- provide CVs of project managers
- provide evidence your organisation/or people within it have successfully carried out similar projects – within budget and the agreed timescale
- identify the governing body and staff, and volunteer training
- establish a minimum 10-year building conservation/land maintenance plan
- provide plans for ongoing development
- provide evidence of how you will maintain the social benefits and involvement in the long term
- provide, of course – the business plan.

6 How will you evaluate/measure the success of your project?

- Your project needs to have clear, measurable aims.
- These aims must be supported by an action plan to show how you will achieve them.
- You also need to define the standards by which your achievements will be measured.

The primary roles during development and construction work are:

- to provide leadership and co-ordination
- to ensure the project meets its objectives
- to ensure the project is on time, on budget and of the quality envisioned
- to ensure the project is completed with minimum disruption to other activities.

To achieve these roles requires:

- a regular schedule of meetings
- regular personal contact, plus the project manager must be readily accessible and involved
- a schedule for communication – this is vital

- full documentation of every stage of the process
- ensuring all team members see where their work fits into the bigger picture
- quality financial tracking
- quality timetable tracking
- tight control of the building works to ensure they remain on time and within budget, and to both keep disruption to a minimum and plan in when it is unavoidable
- progress chasing – probably the most demanding element. If possible, spotting problems before they arise and dealing with them. If necessary, rapidly identifying the key causes of any problems and putting them right.
- motivating the full team to get on with the project (and with each other!) and dealing with any personal problems if necessary
- controlling and monitoring design changes and ensuring these are circulated to everyone affected
- an effective system of delegation, with guaranteed report-back built in
- quality planning/co-ordination of all the disruptive elements
- auditing of quality/standards of all elements
- keeping everybody happy.

The project manager can stand above the detail to ensure project delivery. Even small in-house exhibitions need someone to perform this role, obviously on a lesser scale. Delivering in-house displays on time is a major headache when team members are meant to continue carrying out their normal duties alongside delivery. The project manager is there to fight their corner and get them the necessary time, but then make sure everyone delivers.

CASE STUDY: PROCESS MAPPING

One thing at least should be clear from this chapter – the process of interpretive planning or masterplanning is a highly complex one. To ensure it runs smoothly requires making the process itself a planned exercise. Most people involved in this sort of project will use a Gantt chart as a basic project planning tool to chart the timing of associated tasks in relation to each other. These charts are easy to create and simple to understand, with each task being given one horizontal row and the allocated time slot shown as a bar. The chart shows, at a glance, the tasks that need to be incorporated and their time allocation, as shown for example in Figure 8.2 on pp. 234–5. Many Gantt charts also build in 'milestone' points (often using a diamond) to recognise the completion of specific elements.

It is advisable for all participants involved in the project to take part in drawing up the Gantt chart. This ensures that all relevant elements are incorporated and adequate time is allowed for each. This is important – the chart is a key tool in assessing how long the project will take to complete, provides a

breakdown of the tasks involved and defines the order in which these tasks must be done. It also provides a clear statement of the resources, at least in staff time, required to achieve the project. A central factor in project planning is that some tasks cannot begin until others are completed. These will show up on the Gantt chart as sequential items. Many of the tasks, of course, run in parallel with each other or overlap, and this will again be reflected in the chart.

Once the chart is completed, everyone must then sign up to it, after which it becomes the task of the project manager to ensure that the timetable is adhered to. The chart becomes an essential tool for mapping progress – as the project develops, the chart can be used to show what has been achieved, and makes it possible to compare this with what should have been achieved by that date. It will quickly reveal any problems and can also help to solve them by providing an at-a-glance guide to other commitments.

However, Gantt charts also have severe limitations. It is difficult on the chart to define critical dates when specific tasks *must* be completed by if the project is to succeed, and others where there is much more freedom in timetabling. This has led to the development of 'critical path analysis' as an alternative, but I have yet to find that I need this. I much prefer Gantt charts because they are so easy to follow. Much more importantly, it is very difficult from a Gantt chart to understand the *process* through which the project will be achieved. For this reason, projects really benefit from the production of a process flow chart alongside the Gantt chart, like that shown in Figure 8.3.

The process flow chart will show the tasks that need doing, how the various tasks relate to each other, who will be doing them and for how long. It is a graphic means of showing the sequence of events and any inherent problems in the process. Because it is so visual, it provides a very effective way of analysing the proposed work before you begin. It will reveal individual work overload and any potential sources of delay or bottlenecks (my favourite is always the inverted pyramid, with the curator at the bottom and all other team members needing information from him/her at the same time). It will also clearly show role ambiguity – of the 'who exactly is supposed to be doing this?' type. It will allow a reassessment of the precise location of individual tasks within the schedule, prevent duplication, and may even allow you to eliminate some. It will define key stages when executive decisions are required, making it possible to build in the necessary time for these.

The example of a flow chart shown in Figure 8.3 is unusual in that it consists of boxes only. Normally, up to five specific symbols are used. An *oval* defines the start and end points of process steps. A *box* represents an individual activity within the process. A *diamond* shows a point when a decision must be made (e.g. yes/no). Any paths leading from the diamond will be labelled with the appropriate answer. A *circle* indicates that a particular step is connected to another part of the flow chart. A *triangle* shows where a measurement point occurs.

I find the flow chart to be most useful as a means of analysing the Gantt chart while the latter is being created. It allows you to test the sequencing and

Figure 8.2 Extract from a Gantt chart, New Walk Museum, Leicester

Task name
Strategic context (service-wide and New Walk specific)
Research local/regional/national museums' strategies (and confirm key contacts)
Consider involvement in local/regional/national partnerships
Research and determine objectives of and links with key cultural/heritage/arts/education/tourism/conservation strategies
Determine political structure in order to identify likely local/regional/national stakeholders/funders
Research and determine existing/potential links to current/planned projects and initiatives
Research and determine existing/potential social inclusion/regeneration and community agendas
Confirm key strategic issues and objectives in terms of core HLF criterion
Interpretive strategy
Service-wide strategy
Strategic context/collections audit/audience profile/site conservation audit
Service-wide consultation/staff training sessions
Service-wide SWOT analysis/position/statement/aims and objectives
Prepare and issue first draft of service-wide interpretation strategy
Consult with LCMS to discuss draft interpretation strategy, implement agreed amendments
Finalise service-wide interpretation strategy
Issue service-wide interpretation strategy
Interpretive concept, New Walk Museum
Undertake site specific detailed research
Consult with LCMS staff to discuss collections, audience, education, views of staff
Working sessions with LCMS to analyse options and their potential impact on building
Site specific consultation/staff training sessions
Develop interpretation brief
Issue draft interpretive proposals
Consult with LCMS on draft of interpretive proposals, implement agreed amendments
Finalise interpretive concept, New Walk Museum
Issue New Walk Museum interpretive proposals

Task ◆ Milestone Summary

Source: reproduced courtesy of Focus Consultants Ltd

Client responsibilities	Duration	June			July		August		September		October	
		27/05	10/06	24/06	08/07	22/07	05/08	19/08	02/09	16/09	30/09	14/10
	35 days											
Provide details of existing relationships (discuss initially)	15 days											
Provide details of existing partnerships (discuss initially)	15 days											
Provide details of existing and proposed links (discuss initially)	15 days											
Discuss politics (discuss initially)	15 days											
Provide details of existing links (discuss initially)	15 days											
Provide details of existing position (discuss initially)	15 days											
Input into determination of strategic issues and objectives	20 days											
	83 days											
	63 days											
Partnership working to develop baseline information	38 days											
Set up and input into training days	15 days											
Partnership working to develop information	15 days											
	15 days											
Review/add to draft proposals	5 days											
Confirm approval of service-wide interpretation strategy	5 days											
	0 days											
	30 days											
	10 days											
Set up and input into consultations	10 days											
Attend and input into working sessions	10 days											
Set up and input into training days	2 days											
	5 days											
	0 days											
Review/add value to draft proposals	10 days											
Confirm approval of interpretive concept	5 days											
	0 days											

Figure 8.3 Extract from a process map, New Walk Museum, Leicester

NEW WALK MUSEUM MASTERPLAN

Work remaining to finalise Masterplan.

Key target date – 16th April 2004, completion of draft Masterplan to inform 19th April 2004 Presentation to LCC Cultural Services

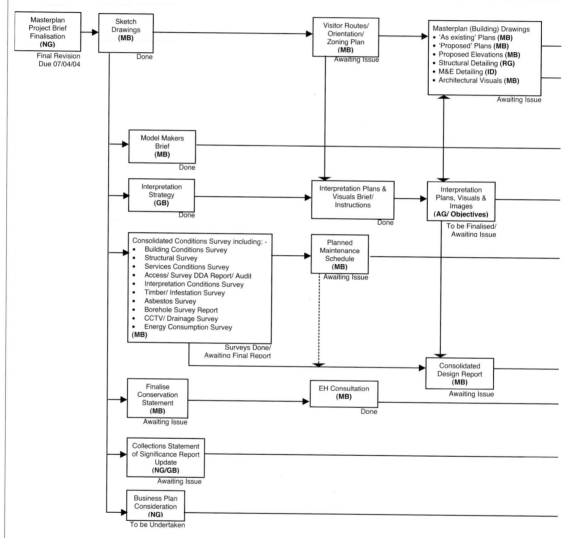

0420/Figure 8

Source: reproduced courtesy of Focus Consultants Ltd

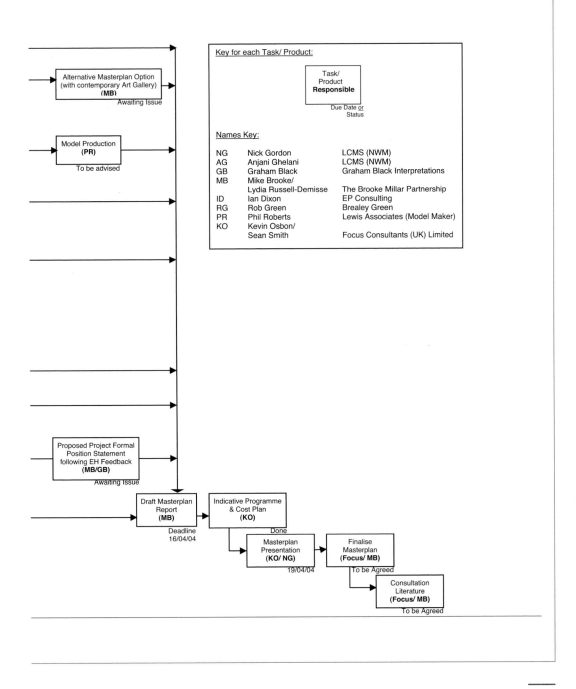

Key for each Task/ Product:

```
┌──────────────┐
│    Task/      │
│   Product     │
│  Responsible  │
└──────────────┘
   Due Date or
     Status
```

Names Key:

NG	Nick Gordon	LCMS (NWM)
AG	Anjani Ghelani	LCMS (NWM)
GB	Graham Black	Graham Black Interpretations
MB	Mike Brooke/	
	Lydia Russell-Demisse	The Brooke Millar Partnership
ID	Ian Dixon	EP Consulting
RG	Rob Green	Brealey Green
PR	Phil Roberts	Lewis Associates (Model Maker)
KO	Kevin Osbon/	
	Sean Smith	Focus Consultants (UK) Limited

Alternative Masterplan Option
(with contemporary Art Gallery)
(MB)
Awaiting Issue

Model Production
(PR)
To be advised

Proposed Project Formal
Position Statement
following EH Feedback
(MB/GB)
Awaiting Issue

Draft Masterplan
Report
(MB)
Deadline
16/04/04

Indicative Programme
& Cost Plan
(KO)
Done

Masterplan
Presentation
(KO/ NG)
19/04/04

Finalise
Masterplan
(Focus/ MB)
To be Agreed

Consultation
Literature
(Focus/ MB)
To be Agreed

timetabling of the project objectively before commencing. Taken together, the Gantt chart and flowchart come as close as I feel it is possible to get in ensuring a professional and achievable structure for the project's development.

Smithsonian (2002) *The Making of Exhibitions: Purpose, Structure, Roles and Process* includes a section commenting on the documentation of the exhibition process being applied in museums in the USA:

> The general criticism of formal processes and attendant documents is that they stifle creativity and innovation and promote a bland, standardised product. However, the majority of commentators thought that a formal process was important and could, by standardising the details, free up time for creativity . . . One senior exhibition manager (said): 'We tend to use these tools to help people understand their roles, gauge project progress, to create milestones that jog action and development activities at the proper times, etc.'
>
> According to the director of exhibition and education programs (at the Field Museum): 'Since we have implemented our process, we have experienced greater efficiency, felt increased camaraderie among staff, witnessed a heightened sense of empowerment on the teams, and seen more attractive, innovative and successful exhibitions. We have never been over budget or opened late.'
>
> Smithsonian (2002a: 22–3)

I am absolutely committed to process mapping. It provides a framework the whole team can sign up to, enables the project manager to manage, and enables the rest of the team to concentrate on their creativity.

9 Concept development for museum galleries

INTRODUCTION

This is a subject I have written about on two previous occasions (Black 1999 and 2000). This chapter should be seen as the latest stage in my exploration of the issue. My objective remains not to provide a specific framework for 'how to do it?' This would be impossible, as every site and its audiences is unique. Rather, this chapter sets out to explore the factors that influence concept development and to define a planning framework and some principles that should assist in ensuring the quality of the end product.

Here, we return to the basic framework of the interpretive strategy (after Veverka 1994: 32) which outlines:

- *what* you wish to present – the nature, strengths and weaknesses of the site and/or collections, specific site/resource issues, themes, etc., to be presented
- *why* you wish to develop/change the existing displays, etc. – the aims and objectives of the responsible organisation, specific objectives, defined outcomes
- *who* you are targeting the approach at – nature of target audiences; needs of audiences; expectations and perceptions of audiences
- *how* you intend to present the material.

Interpretive planning is a process that will vary from project to project. Because it involves both creativity and structure, there is no 'right' way to do it. Brochu (2003) uses what she has defined as the '5 M approach' (see Box 9.1).

The reality is that people develop their own approach over time and adapt it to the individual circumstances of specific projects, and I feel most comfortable with 'what', 'why', who', 'how'. My challenge in this chapter is to show how this is used to develop the gallery concept and then develop that into a design brief. I have already written at length in this book on 'what', 'why' and 'who'. They will be mentioned again in passing, but the emphasis in this chapter will be on 'how'.

Box 9.1 The 5 M approach to interpretive planning

Management: an understanding of management requirements, needs and capabilities.

Markets: an understanding of current and prospective customers and market position.

Message: a strong and appropriate story about the available resources.

Mechanics: an understanding of the physical opportunities and constraints of the location.

Media: an appropriate mix of methodologies to deliver the message(s) to the market(s) within the constraints of management.

Source: Brochu (2003: 15)

WHAT: THE COLLECTIONS AUDIT

I refer back here to the concept of the collections audit and collections statement of significance discussed in chapter 8, p. 219–20.

The audit should identify not only those aspects of the collections seen by the management or curatorial team as being distinctive but also attempt to define the elements most likely to attract a response from the visitor. It plays a central role in defining the objectives for the concept development and is key to the establishment of the main messages, themes and storylines used in the presentation. It also provides a basic inventory or record for the collections that can be accessible to all and can act as a framework for the conservation strategy which must underpin the presentation.

WHY: AIMS AND OBJECTIVES

Again, I refer back to previous chapters where the establishment of aims and objectives has been covered in depth. The key point to make here is that, even though aims and objectives may have already been spelt out in detail for the museum service, and/or for the museum as a whole, there will be some that are specific to an individual gallery or single-theme display. It is essential that they be clearly defined as part of the initial concept brief. It is impossible to develop a gallery concept unless there is a full and approved understanding of what it is meant to achieve, and who will benefit. There is little point in attempting to move forward unless and until realistic aims are spelt out and agreed.

Equally, a clear definition of aims is essential for staged evaluation as the concept develops – will the proposals as they currently stand meet the original aims? I always recommend putting them in *writing* and ensuring every member of the team signs up to them – as everyone who has worked on displays will know, it is amazing how

easily and rapidly you can go off at a tangent, and how disagreement can arise among team members about what you are actually seeking to achieve. Interpretation plans and strategies are paper exercises. Concept briefs end up as expensive three-dimensional realities. There is no room for grey areas.

Finally, on this subject, it is vital to remember that one of the key definitions of quality in concept development is clarity of message and clarity in the presentation of the message. Unless initial aims and objectives are defined clearly, this is impossible to achieve. Another way of putting this is that if you do not know what you are trying to achieve, what chance does the visitor have? The statement of objectives, therefore, cannot be a fuzzy document. It must be clear and quantifiable, and the outcomes for visitors must be capable of being evaluated.

WHO: SPECIFIC AUDIENCE TARGETS

> even visitor-friendly interpretations only reach those visitors to whom those interpretations are indeed friendly.
>
> Roberts (1997: 74)

As I hope the book so far has made clear, one can no longer base exhibitions on the concept of a single mass audience. Within a multi-collection museum, there is no need to expect that every member of every target audience segment will need or want to be catered for in every gallery. What is essential is that, for each gallery, the target segments are defined and priorities are agreed. The priority segments dictate the core level of the presentation – in terms of collections layout as well as the provision of support media – on to which other elements can be grafted, to meet the needs of other segments.

This sounds like commonsense, but is quite a revolutionary statement. The classic advice for putting together a museum display used to be that it should be targeted at all users, and all texts should be written for an assumed reading age of about 12. Because we are now talking about 'modern' displays, the curator and designer will graft on a variety of modern media – an interactive exhibit, access to the collections database in case an enthusiast/specialist wants to look something up, etc. The underlying principle in most museum displays remains the same, however – appeal to all, and so rarely meet the full needs of anyone. Strip away the modern paraphernalia and the bulk of our displays remain Barbara Kirschenblatt-Gimblett's illustrated Victorian lanternslide lecture converted to three dimensions (see p. 130 above).

If your priority audience for a gallery is school groups, you are going to have to ensure the displays precisely meet the needs of the relevant curricular study areas and inquiry-based teaching requirements, incorporate physical spaces where groups can work together, and include display on a grand scale as well as in detail – for example a Viking house interior that children can go into, not just a drawing of one.

This does not mean the gallery can only be used by school groups. Families will love and use the same facilities. You can include a substantial research area, with objects displayed for close inspection and supported by back-up information, that can be used in comfort. Children will use the object displays for collection-led

inquiry (equally, most archaeologists I know will want to frolic in the house). The large font size used for children and the seating areas provided for group work will be a gift from heaven for elderly visitors (many of whom will also enjoy just watching the children enjoying themselves). The issue is not exclusion, it is prioritisation.

It is also not 'dumbing down', it is raising up standards overall. If your priority audience consists of adult art lovers, you can provide the perfect contemplative gallery space but support this with a film on the artist in an adjacent room for those who do not know the work, and an art trolley or activity backpack for families (if the children are happy, the parents might even get to enjoy the paintings). Atmosphere is key in an art gallery – supporting the art, but welcoming the uninitiated rather than intimidating them. None of this is rocket science. But it emphasises the importance of prioritisation. An art gallery with a priority audience of families would be quite different to one targeted at knowledgeable art lovers and, if your site includes a series of galleries, it would be highly advisable to devote at least one to exciting and engaging families and children – as has been done, for example, at Manchester Art Gallery, while still welcoming adults into this space and still providing facilities for families throughout the rest of the museum, to encourage exploration.

HOW: DEVELOPING THE CONCEPT AND TURNING IT INTO REALITY

So let us assume that the collections audit has been done, that the display objectives are clear, that we have agreed the target audience segments and the priorities within these, that the physical requirements of visitors have been taken fully into account, that the site or gallery space is suitable in principle, that the academic research has been incorporated, that the capital and revenue budgets are adequate, that the local community has been consulted and is content, etc.

Finally we come to the *creative* aspect of the process – the actual development of the concept. This section explores the elements involved in the task:

- building the team
- developing an understanding of targeted audiences
- defining the communications strategy
- developing the themes
- building in structured educational use
- agreeing priorities in the use of the space
- developing the design brief.

Let us examine each of these in turn:

Building the team

Developing a new display is a truly multi-disciplinary activity. Except on the largest projects, one person will play more than one role, but every museum exhibition will require input from most of the skills listed in Box 9.2.

Box 9.2 The exhibition team

The *museum director/manager* will set the overall site objectives and seek to ensure the individual gallery proposals help to meet these. He or she will also need to relate the proposals to the business plan, and organise any fund-raising and operational requirements.

The *project manager* must make it all happen on time and within budget and without team members falling out with one another (see case study, chapter 8).

The *architect, historic buildings adviser, planning officer, access adviser, conservation officer, fire officer, etc.* will define and approve any building alterations – this is crucial to what you can actually achieve in the site/gallery.

The *curatorial team* will provide the academic vision and define the exhibition theme and objectives; will provide expertise and define the collection content, availability, strengths and potential messages; must ensure that the conservation and security requirements are met; and has a major input into all other aspects of the project.

Where relevant, the *curator, conservator* or *collections manager* will also strip out the previous exhibition, carry out any conservation required by the exhibits, and arrange storage – a major commitment to include in the project timetable and budget.

The *interpreter* will work with the in-house team to create the concept and its themes, and to write everything from the concept brief to the final presentation.

The *audience researcher* will provide up-to-date information on the nature, needs and expectations of the targeted audiences, enabling informed decision making when developing the interpretive approach.

The *researcher* will locate and bring together the material required for display, administrate the process and ensure everything reaches the designer when required. This can include background research on themes, location and copyright approval of images, liaison with academic advisers, etc.

The *structured education adviser, teacher advisers, etc.* will ensure that quality investigative project work is built into the displays and produce education resource materials, based on curricular guidelines, to support the project work.

The *lifelong learning adviser* will input the relevant learning needs of the wider audience into the overall exhibition or presentation content.

The *community consultant* will lead in involving, and seeking input from, local communities – not least when the site seeks to reflect that community or a particular culture in its displays, but also as part of ongoing outreach.

Box 9.2 continued

The *access adviser* will help work toward equal access for all, contributing advice on physical access issues but also on interpretation, marketing, staff training, public programmes and employment.

The *academic adviser(s)* will work to ensure that the exhibition content is accurate and reflects up to date research.

The *marketing officer* will take the lead on creating the audience development plan, as well as explore marketing opportunities during exhibition construction, and plan for the opening. He or she may also be involved in fund-raising. He or she must also take responsibility for defining and carrying through post-completion evaluation of the project. There is an additional marketing role in informing potential visitors of the closure of existing displays (or even the temporary closure of the museum).

Designers, audio-visual specialists, etc., will bring their creative input into ensuring the objectives and concept can become a reality. I like them involved at the concept development stage so they also have the opportunity for creative input into that.

The *ICT specialist* will ensure any ICT requirements can be properly defined and can be built into the exhibition at development stage, and that ICT operation and maintenance is provided for.

The *operations manager/visitor services manager* must ensure the operational and main-tenance needs of the proposals can be met and that the proposals will function in practice after opening, meeting the defined needs of audiences, staying within agreed revenue and staffing limits, and without breaking down. He or she will also be responsible for the appoint-ment and preparation of staff and/or volunteers to operate the project on a daily basis.

Staff trainers are needed to guarantee the quality of service provided to visitors. Their role expands if it is intended that exhibition staff will interact with visitors as enablers, or as first or third person interpreters.

The challenge with such an unwieldy team is to break the tasks down under the three fields of building work, display work and long-term operation. An example of how this can be achieved is shown in Box 9.3. The project manager should be placed directly in control of the building works to ensure its coordination and tight control of costs and timetable. Some people appear on more than one list and the operations manager and designers on all three, because every aspect of the proposals must be tested against operational practicalities. Different people may take the lead on the three teams at different times. For example, the interpreter will lead his/her team until the final design brief is approved and passed to the designer. The designer will then take over the leading role.

Box 9.3 A suggested team structure for a major redisplay

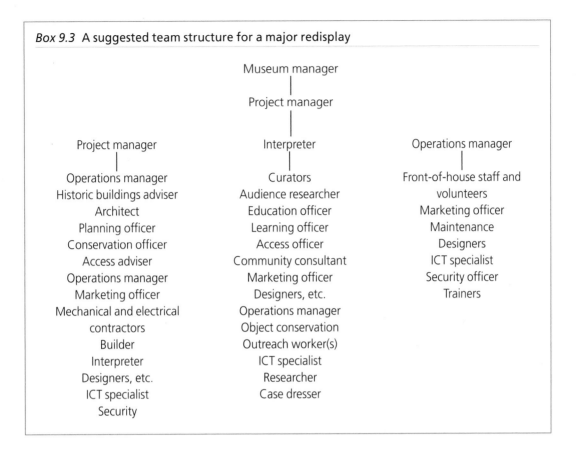

Developing an understanding of targeted audiences

Once the audience segments have been defined and priorities agreed within them, it is essential to define key needs and expectations. With access a central issue, these can be stated in terms of physical, intellectual, social and cultural requirements. The good news is that many will overlap between audience segments. The bad news is that segmentation can change depending on which requirement you are evaluating.

Thus, for example, for intellectual access you will be looking at learning needs not traditional demographic segmentation. When the Victoria and Albert Museum was developing the interpretation strategy for its British Galleries, the team defined its visitor segments as:

- independent learners (individual adult visitors)
- specialists, amateur and professional
- the local community
- foreign visitors
- ethnic minority groups (especially South Asian and Chinese groups for whom the museum runs special programmes)
- families

- school groups
- further and higher education groups.

As an example, it defined independent learners and stated their needs (Victoria and Albert Museum interpretation strategy for British Galleries, undated):

> ... individual adults who manage their own learning rather than being driven by a formal curriculum. They are motivated by curiosity and internal incentives and are not restricted by conventional subject boundaries. They bring varied experiences to the learning process and often operate through word-of-mouth and networks. Outside their own area of expertise they will be novice learners.
>
> Needs:
>
> - since all content is potentially of interest to independent learners they are the group for which we have to think least about what to say; for them it is how we say it that matters. We will concentrate on providing information at different levels and in different ways to tie in with their varied learning styles.
> - we will provide the capacity to interrogate databases for further information and to make print-outs
> - because they often learn through networks we will encourage the developments of contacts through address lists of relevant groups and through bulletin boards and methods of feedback in the galleries
> - ample seating.

As noted already, in chapter 5 (p. 137), the strategy also went on to look at *learning styles*. Thus, we see here the development of a very focused approach to ensuring a clear understanding of audiences and their needs and a commitment to meeting those needs. You will see the application of this approach later, when we explore experiential audits.

Defining the communications strategy

Museums pride themselves on communicating with their visitors, yet it is actually rare to see someone write down a 'communications strategy' for a gallery. The challenge in such a document is to outline the ways through which the museum will seek to encourage its visitors to engage with its collections and displays. It is a combination of interpretive principles and very practical outcomes.

Box 9.4 lists elements that you might want to include in a communications strategy targeted at local people, including families and structured educational groups. Many of these clearly reflect the interpretive principles outlined in chapter 7 above, but you are equally welcome to consider many of them as no more than commonsense.

Box 9.4 Potential contents of a communications strategy

It should include:

- a warm, welcoming, supportive child and adult-friendly image and environment
- an informal, unpressured atmosphere in which visitors feel 'comfortable'
- good physical and conceptual orientation, so visitors can choose what they want to do and readily understand what the displays are about
- themed displays, conveying ideas and meanings, not just facts
- clear hierarchies in presentation to ensure a readily understandable display structure for visitors
- care in the interpretive detail of the displays as well as in the 'big picture'
- displays in which the collections are to the fore and visitors are encouraged to engage directly with them – in which both the objects and associated ideas are made readily 'accessible', in every sense, and which give visitors the opportunity to participate wherever possible and in a variety of ways, including the opportunity to touch
- displays that have a 'layering' of content, so that users can enter at a level appropriate to them
- displays that use a palette of approaches to meet the needs of different users
- displays which are 'paced', with changes of mood and of types of visitor interaction – and also rest points – to retain interest and concentration
- displays in which there is 'always something new' going on – kept alive by a programme of activities led by gallery assistants, including object-handling sessions
- displays where high quality, relevant structured educational projects have been 'built in' to ensure they meet curriculum needs
- displays in which visitors feel represented, with personal stories to the fore with which visitors feel they can associate
- an environment that encourages visitors to connect what they see, do and feel with what they already know
- an environment that encourages visitors to connect with each other
- an environment that is safe for young children
- an environment that incorporates a limited number of 'dwell-points' where small groups of schoolchildren can do project work and the same spaces be used for activities for the general public, including limited object-handling.

Developing the themes

In an interpretive approach to exhibition development, the theme is the central idea of any display. As discussed in chapter 7, it is the message or storyline you use to hold the presentation together. You should be able to summarise this theme in one, prefer-ably short, sentence. As such, the theme provides clarity of purpose for the display – the 'big idea' behind it. Equally, if the audience leaves remembering nothing else, they should absolutely remember that theme.

Once the main theme is decided, everything else you do is targeted at presenting that theme statement to your audience – and this helps to establish the organisational structure for the display. You take your theme and define the key messages you want to put across about it. These in turn define the sub-sections your display is divided into. Each may stand alone, each will have a thematic statement of its own, but each will also support the overall gallery theme. Thus, at the Thackray Museum, the main theme for the surgical galleries was that 'For surgery to become successful, it had to overcome the three problems of pain, infection and blood supply'. You can guess what the three sub-themes were.

The themes should be supported by objectives that are driven by defined visitor outcomes and are measurable. Veverka quotes a useful example for a guided trail:

> For example if we had the interpretive theme: *Wetlands benefit us in amazing ways* then we need to develop interpretive objectives that would help illustrate that theme, such as: *At the completion of this program all participants can identify three ways that wetlands benefit us.*
>
> Veverka (u/d)

I quote this example, although it relates to a guided tour rather than a museum display, because it is straightforward and easy to understand. In fact, there are a variety of ways in which supporting objectives can be defined. Veverka speaks of these in classic environmental interpretation terms as *learn – feel – do*. Using the example above, people will learn at least three reasons why wetlands should be protected; as a result they will feel positively about the conservation of wetlands in general and about the good work being done at the site they are visiting; and as a result of that will want to visit the wetland exhibits in the nature centre at the site and potentially contribute financially to the work or even get directly involved.

Defining the central theme

There are various ways of doing this. The usual way I approach the task, at least to begin with, is to say to the display team – if visitors were to leave remembering just one thing about this gallery, what would you want it to be? Encouraging the different members of the team to write down their answers as one sentence and then to share these usually leads to a creative discussion. The reality is that collections can tell a range of stories, and be displayed in a range of ways. Many factors can influence the choice of the central theme:

- the museum mission statement
- the key curatorial strengths of the collection (and the weaknesses)
- the key stories the collection can tell
- the priority audiences. Returning to the structured educational use analogy above, a gallery on Victorian Leeds targeted at a priority schools audience could have a main theme 'Many children led horrific lives in Victorian Leeds', or similar, because 'the lives of children in Victorian England' is a key history study unit in the UK.

- community consultation
- visitor targets – pressure to increase visitor numbers may lead to displays concentrated on what are deemed to be more 'popular' themes.

It may seem from what has been written so far that a theme must always be a means of presenting factual information. This is anything but the case. One of my favourite exhibitions in which to be involved was a small gallery at the Gladstone Pottery Museum in Stoke, UK, devoted to decorative tiles. The main theme was that 'Decorative tiles are objects of beauty to be enjoyed.' We sought substantially emotional and aesthetic responses both on a large scale, as many were architectural pieces, and also from the detail, given the aesthetic quality of the individual pieces.

In reality, there are two levels of decision-making involved here. The first concerns the best stories that the collection selected for a specific gallery can tell. The second concerns what the targeted visitors will be interested in – what use is this theme you are talking about to them? (Think back here to Tilden's first principle – 'any interpretation that does not somehow relate what is being displayed or described to something within the personality or experience of the visitor will be sterile'). The selection of the main theme should come out of discussions that balance the two but still end up with something that is exciting to work on and will be fascinating to visit. I would normally recommend that targeted audiences should be consulted on potential themes – including displaying simple elements for visitors to view and talk about – before spending vast sums of money on the real thing.

Supporting the main theme: the magic number 7 plus or minus 2

As stated, the main theme cannot normally stand alone but must be broken down into sub-themes, as a means of structuring all but the smallest or simplest display. Clearly there must only be a manageable number of sub-themes but – unless these are immediately clear – how many is 'manageable'? Ham (1992) introduced me to the concept of the magic number 7 plus or minus 2, referencing an article by Miller (1956) on the amount of information people are capable of handling at any one time. Miller's principle still stands – most people are capable of making sense out of only 7 plus or minus 2 separate and new ideas at one time. In these circumstances, as Ham points out, 'it makes sense that the number of main ideas in a presentation of information unfamiliar to an audience ought to be limited to 7 plus or minus 2. But as some of us can handle only as many as 5 (that is 7 minus 2), the actual number of main points should be five or fewer' (Ham 1992: 20–1).

Ham was commenting on talks or guided tours. I find the principle equally applicable to museum displays. Being able to say to the exhibition display team that they must break their proposals down into five sub-themes, each of which supports the main theme, is a very effective means of getting people straight into the practicalities of exhibition development and always works. You can fight over including an extra one, because this forces those involved to absolutely justify their views – but it is in fact more likely that you will cut the number of sub-themes to three or four. In the run of 15 display areas that make up the British Galleries at the Victoria and Albert Museum, displays were broken up chronologically into three main periods, Tudor and Stuart, Hanoverian and Victorian, and the same four sub-themes applied to each.

The Victoria and Albert Museum interpretation strategy for British Galleries is:

- what were the styles?
- who led taste?
- fashionable living
- what was new?

Building in structured educational use

This element was explored in chapter 6 above. It only remains to repeat here that concept development and the building in of relevant education project work must be seen as one and the same exercise. You cannot graft on targeted structured educational work afterwards – you either build in directly relevant content or you do not. This is both a physical and a conceptual issue. Physically, you cannot conjure up space for group activities afterwards, you must build it in, and in the right places. Conceptually, you must include exhibits that are both directly relevant to the appropriate curricular areas of study and lend themselves to inquiry-based study.

One of the most important issues is the establishment of 'dwell-points' within the displays – spaces where small groups of pupils can work on tasks together. Few museums have space to incorporate these purely for schools use. These spaces should be seen as suitable for a plethora of roles, performed at different times – not only for schools use, but for public activities, as study zones, for rest and recuperation, and so forth. The dwell point is a classic example of how museum spaces must be made to work hard for their very existence.

Agreeing priorities in the use of the space

There are two separate challenges here. The first lies in defining the quantity of space required overall. The second lies in agreeing the spatial breakdown between the different elements of the exhibition.

Few people, except those building new museums from scratch, will have the opportunity to define and achieve their perfect spatial requirements and even in new projects there are normally severe limitations in space owing to the available budget, etc. However, the replanning of comprehensive multi-collection museums does present a real opportunity to link spatial requirements to collection/display needs. My starting point here is invariably to create a 'wish list' in terms of square metre needs before turning to realities, so that the best possible compromise can be reached (see p. 226–8). This wish list is not, however, created out of thin air. It reflects the priority given to a particular exhibition or collection in the overall site interpretation plan. It also reflects the scale of the collection to be displayed (is it a priority to maximise the number of objects on display and how big are they?), the target audiences (the numbers expected, their needs and expectations of the gallery and their anticipated length of stay), and the overall objectives set for the gallery.

The size of the individual objects in the collection can obviously have a huge

The National Museum of Childhood, Bethnal Green, London. The redisplay of its doll's house collection was based on the idea of a 'market square', which left a lot of space in front of each house and a central activity area, Notice the 'street signage' to different displays. © National Museum of Childhood, London

impact, but so will the way in which you wish to display them. Open storage will clearly require less space than major contextual exhibits. Paced display requires grand gestures, to take the breath away, as well as detailed presentation, but grand gestures take up room. Does each object require space for its presentation or are there compromises that can be made – for example, if all the items in a collection are to be incorporated, can many be placed in themed drawers under the glazed cases?

People in themselves take up a lot of space, so a gallery that is anticipated to

receive a lot of visitors will need to leave substantial room just for the audience and for audience circulation. Maximea (2002) suggests:

> In a very crowded timed exhibition, visitors would probably put up with 20 square feet [1.8 m^2] per person (including space for exhibits) . . . More usual visitor densities for museum exhibitions range from 30 to 50 square feet [2.8 to 4.6 m^2] per person for discovery and contextual exhibitions (at peak times) to 100–200 square feet [9.3 to 19 m^2] per person for more expansive contextual and aesthetic exhibitions.
>
> Maximea (2002: 90)

Perceptual overcrowding occurs at a much lower density than actual overcrowding.

Equally, providing facilities for visitors also adds to spatial requirements – 'dwell points', activity areas, study zones and seating areas all add to needs. Thus, there are battles to be fought between visitor and exhibit requirements and the results will be unique to each location. My view is that each element must be able to justify its existence against the objectives set and the agreed communications strategy. To date, in most museum galleries, visitor needs have invariably lost out. This imbalance needs to be rectified if visitors are truly to be encouraged to engage with collections.

Equally, the balance between exhibition elements requires careful analysis. There are two aspects here. The first lies in the priority for display given to different aspects of the collections and different themes. This is a decision that can only be based on the vision and objectives for the gallery. The second concerns ways of displaying – not just the best way to present collections, but also to meet audience needs. A key element in defining the latter objectively lies in the creation of an *experiential matrix* (see Box 9.5). This level of planning allows you to define the palette of display approaches you seek within each structural area of the gallery (perhaps within each sub-theme, or separate spaces off, etc.).

Not only does this help you define spatial requirements within the display, it also enables you to check visitor provision across the gallery and effectively gives you an initial 'tick list' against which to evaluate display proposals as they develop.

In the interpretive planning for the British Galleries at the Victoria and Albert Museum, the team stated:

> During the planning of this project we will constantly check the balance of our interpretive ideas to make sure that we are dealing with the needs of all our audiences and the variety of their learning styles. We accept that not every display will appeal to every visitor but we intend that whatever a visitor's learning style and reason for visiting, they will find something in most galleries that relates to their needs and interests.
>
> Victoria and Albert Museum interpretation strategy for
> British Galleries (undated)

Planners for the gallery placed most of what they called their 'interpretive devices' close to the objects concerned, to help visitors engage directly. However, they also created regular 'discovery zones', set adjacent to but apart from the display areas, tar-

Box 9.5 The experiential matrix

Gallery element	A	B	C	D	E	F
Contemplation						
Experiential						
Interactive						
Activity area						
Support information						
Dwell point						
Family activity						
Seating						

Source: based on J. Veverka (personal communication)

geted at families and experiential learners, where they grouped together 'some of the more messy activities'. In addition, they built in space for activities such as story-telling. In *all* cases, the interpretive approaches they defined did not exist in isolation but were directly focused on encouraging visitors to engage more effectively with the objects on display.

Developing the design brief

A design brief is one stage on from concept creation. It is a preferably short working document that is there to brief the exhibition designer on your proposals and based on which the designer will develop an appropriate design response. It can be written in isolation by the in-house exhibition team but, in my view, it should be seen as the latest point at which a designer should become involved in the project. My own preference is to bring the designer in at an earlier stage, as part of the team developing the concept document. However, even by involving the designer in helping to produce the design brief you can avoid potential flights of fantasy where budgets and space can seem to present no obstacle, and it ensures the designer shares the ethos and vision of the project, vital if the end product is to achieve what you want it to. Equally, the creative input that a designer can bring may well raise ideas and issues relevant to the brief that you had not thought of.

The primary role of the designer is to take your concepts/design brief, research, texts and images, etc., and transform them into an effective reality within the available space, budget, time, etc. It is a creative and a practical input – his/her involvement will lead to changes in your suggested approaches that should enhance the quality of the exhibition and the visitor experience.

Here I must stand on my soapbox for a moment. Exhibition development can be hijacked by designers and there is a real risk in many displays of the objects becoming little more than window-dressing within an expensive layout of design media. I do not blame designers for this. They are specialists in spatial planning and in the use of the media they employ. On their own, they can make effective use of the space available, can ensure most exhibitions 'look good' and, given their background experience, can frequently incorporate media elements that work effectively with audiences. Many are highly creative. However, exhibits that look good do not necessarily engage audiences and even popular display media may not necessarily support visitor learning. And that is before the obvious statement that no curator should want display media that compete with or take attention away from collections. The end result can be very expensive exhibitions that do not meet the original objectives in terms of visitor outcomes and which curators cannot change because of the costs involved.

The key way to prevent this happening is to ensure that the design brief is a model of clarity. This goes all the way back to the exhibition team being clear about the outcomes it wants and writing them down – but effectively means you have a document to evaluate any design proposals against. A second essential element is to keep telling the designer and yourselves that the function of the exhibition is to enhance public engagement with the collections. For each element of the design proposal you must be able to understand *how* such engagement will be enhanced. The third way is to ensure that the initial response sought from the designer includes an *options appraisal* that examines alternative approaches to achieving those outcomes and provides an opportunity for the exhibition team and others to be involved in the selection of the route ahead.

Evaluation of the process therefore takes place at a number of stages and in a number of ways. The interpretation strategy and concept document/design brief must be consulted and approved. Spatial divisions must be assessed against agreed priorities. The design proposals put forward must be tested against the original vision and objectives, against the design brief, against the question of how they will enhance visitor engagement with the collections and against the experiential matrix already drawn up for the gallery. They should then, preferably, be put out to wider consultation. Where relevant, they must also be tested against defined structured educational needs.

I regularly dream of piloting exhibition proposals. A lot is written about this but, because of timetables and budget provision, it is all too rarely carried out. There is a particular problem in grant-giving bodies providing funding only for a single-phase final product. This is incredibly risky. Piloting can make a huge difference in terms of the actual development of very expensive displays, in a sense of visitor empowerment, and in building word-of-mouth recommendations for the new gallery. At the National Museum of Childhood in London, the initial piloting of ideas for over a year while fundraising was under way resulted in an overall 26 per cent increase in visitor

attendance (personal communication from D. Lees). It also ensured the finished displays achieved the objectives set.

The chapter ends at this point because it is not the objective of the book to define how to work with designers to create final exhibitions. Museums are in an unacceptable position over commissioning exhibition design. If a building falls down, or even if the roof leaks, we can refuse to pay, or sue the builder or architect. If an exhibition or even an element in an exhibition fails to achieve the established objectives of engaging audiences, we still pay the design fee. This is partly because design is seen as purely a creative process. However, it must be a result largely of failing to provide a full brief to the designer that can enable design proposals to be evaluated objectively against original objectives. Taking an approach based on interpretive planning is not intended to remove creativity, but is intended to make it more likely that the original exhibition objectives will be achieved. The challenge is to ensure throughout the process that the established needs of the collections and targeted users lead the way forward rather than becoming lost in the detail of texts and design layouts. An effective working concept document and design brief is the best way to ensure this – do the design proposals meet the defined criteria?

DISCUSSION: THE IMPACT OF INTERPRETIVE PLANNING

> Until about twenty years ago, museums generally developed their exhibitions using a 'linear' or 'curatorial' model. One individual (generally a curator) had sole responsibility for development and implementation and, under his or her supervision, the exhibition moved sequentially from one support professional to the next. In the linear model, still common in some natural history and many art museums, the curator has both authority and responsibility for the exhibition.
>
> In the past twenty years, the organisational structures and processes used to create exhibitions have undergone major changes . . . One result is that . . . responsibility for exhibition development is now shared among multiple players.
>
> Smithsonian (2002a: 12)

If only because of all the demands now being made on modern museums, the days when the curator could make all the decisions on a new exhibition are passing. It is impossible to see the development of a major new permanent exhibition, and unwise to view a major temporary exhibition, as other than a team effort, and this means accepting the repercussions of a team approach:

> On a team, the mix of people is crucial. There are particular areas of expertise that must be represented and individual team members have a responsibility to

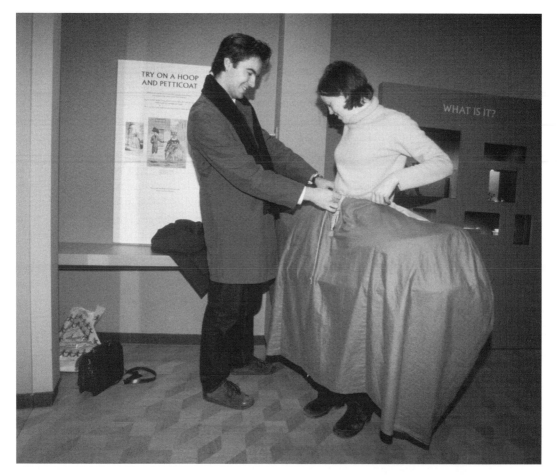

Trying on a crinoline – one of the activities at the Victoria and Albert Museum British Galleries © Victoria and Albert Museum

represent a particular point of view. Majority rule and reliance on position of authority are not the interaction styles for a team; compromise and collaboration are.

Munley (1986: 31) quoted in Smithsonian (2002a: 13)

The Smithsonian Institution looked at the development of the team approach to the creation of museum exhibitions in the USA, beginning with the Kellogg Project at the Field Museum of Natural History in 1982 and continuing with the work of the National Association for Museum Exhibition (Smithsonian 2002a). But interpretive planning is about more than structure and process. It focuses on the quality of the visitor experience. It places the interpreter, learning specialist and other audience advocates on a par with the curator. It is a real means of ensuring the end product meets or exceeds the ambitions of all those involved in the exhibition development

Box 9.6 Evaluation of the British Galleries

The evaluations carried out in the new British Galleries since they opened in 2001 show a dramatic improvement in visitor approval compared with the old glass case galleries they replaced. Before the redesign, 50 per cent of visitors went through the eight galleries of the lower floor (the more popular ones, near the entrance) in eight minutes or less. The interactives appeal to all kinds of visitors – adults as well as children – of all learning styles; only 1 per cent of visitors say they would prefer the new galleries without them. Most visitors (64 per cent) said they used the interactives and almost all of these say they helped them understand the themes of the galleries. The average rating of those visitors who said they learned something from the galleries rose to 8 out of ten (compared with only 4 out of ten in the traditional galleries). Over 90 per cent of visitors said that the new galleries are 'just as a museum should be'. The stay time in the eight lower galleries is now an average of 54 minutes – four times as long as before. 92 per cent of visitors said these methods of display 'brought the objects to life'. 80 per cent of visitors said the interactives made them 'look more closely at objects'. The message from visitors about what they want from galleries could not be more explicit – they want this kind of interpretation.

. . . It is also clear from research on the British Galleries that it is possible to achieve aesthetic goals as well as visitor goals. And the new British Galleries have been almost universally acclaimed by academics in its field. So there is no 'dumbing down' here either.

Source: Anderson (2004: 4)

and also meets or exceeds the needs and expectations of the audiences. It allows clear objectives to be set and prioritised – and, therefore, evaluated against. It ensures clarity of vision in terms not only of exhibition content but also of defined audiences, their needs and how these can be most appropriately met. It cannot guarantee that the end product is perfect (the process is too creative for that), but it helps.

I have already looked at the impact of strategic planning through the case study on the Manchester Art Gallery in chapter 3. It is time to mention another. In a sense, I have used the development of the British Galleries at the Victoria and Albert Museum in London as an ongoing case study since chapter 5. The interpretation strategy here had clear objectives that placed a learning focused, audience-centred approach alongside the requirements of aesthetic display and ensured clear and consistent planning and guidelines throughout. The end result has been a stunning achievement, acclaimed within the profession and by the public at large. The strategy included evaluation at development stage and investment in both summative evaluation and in ongoing research on visitor learning. Anderson's comments in Box 9.6 reflect what the research has revealed.

CASE STUDY: A DESIGN BRIEF FOR A SMALL GALLERY AT NEW WALK MUSEUM, LEICESTER, UK

This example is included to illustrate what is meant by a design brief. This is the initial document produced to state the museum's needs and to seek a creative design response to these. It would be accompanied by clear information on the gallery space and budget available, detailed object lists, a timetable, staff involvement, etc.

'Connections' – decorative arts and world culture

1 Introduction

1.1 This new gallery will move away from the current Decorative Art Gallery approach at New Walk Museum and instead will seek to provide insights into the vast range of human creativity and skill which has gone into making and decorating objects for daily use.

1.2 The artefacts shown will come from many cultures and historical periods. Displays will draw from all of these on a thematic basis rather than a traditional chronological, geographical or art historical sequence. Instead it will look at the stories behind the objects, of the maker, owner, user, rather than concentrate on art historical narratives.

1.3 The term 'connections' has been chosen deliberately at this stage (although it may not be the final gallery title) to include the following:

- For the gallery to reach its potential as a medium for greater inter-cultural understanding, it must challenge the visitor's perception of the 'other' and celebrate the connections between many faiths, cultures and identities.
- The hidden histories of the objects also need to be revealed using multiple perspectives and voices that cut across cultural, religious and historical barriers.
- Finally, the real challenge for the gallery is to assist visitors in making connections in their own heads. The approach to interpretation and display should seek to gain attention, support engagement directly with collections and also provide opportunities for reflection.

1.4 This gallery should be seen as very much a first step toward a larger world culture display and should be viewed as building the foundations necessary for something truly inclusive and representative:

- We need a flexible, modular approach that will allow, for example, one thematic display to be removed and replaced with another. This also means case flexibility to cater for a wide range of object types, materials and sizes.
- The display approaches taken will at times be experimental, as we explore different ways of engaging audiences; will require evaluation; and must allow for change to reflect visitor responses and needs.
- An important aim of the gallery will to be develop strong links with Leicester's diverse communities, currently under-represented within both the museum collections and permanent displays and its visitor profile. These links will be used to develop the displays further, and add stories to the objects on display. They are also essential to collection development.

1.5 While the gallery will be strongly object-focused, we also seek to 'people' it, both as part of the process of making connections and to assist visitor engagement. We see film, images, audio, stories, etc., all playing a role.

2 Target audiences

2.1 The priority audiences sought for this gallery are:

- a culturally diverse audience – this gallery will have links to communities from all over the world and links to some of those communities who have moved to Leicester
- families – particularly for intergenerational learning
- people with interests in other cultures
- people with interests in the decorative arts.

2.2 There is also direct relevance to:

- people using the gallery for artistic inspiration, schools, amateurs and professionals
- the VFR audience.

2.3 An analysis of the needs and expectations of each of these audiences can be found in the New Walk Museum interpretation strategy.

3 Display themes (to be developed from topic headings below)

3.1 Main theme: connections – common threads and differences.
Objects have cultural value and can encompass many different meanings. An object's 'meaning' is not static and can have many different interpretations depending on the perspective of the individual or group.
　　The gallery will seek to explore these different stories and use objects as a window onto the world. By taking a thematic approach it will look at those

things that unite different cultures but then explore how these are expressed differently within these cultures. It will seek to reveal our common threads and differences using extraordinary and everyday objects.

3.2 Sub themes

3.2.1 Natural world
Across cultures, makers and designers are inspired by the natural world. Sometimes the desire is simply to create a thing of beauty but often there are deeper layers of meaning. The natural world plays a major role in spiritual and religious life, as symbol, as moral example (good or bad), in stories and folklore. It also provides many of the materials used to make objects.

3.2.2 Memories
Objects can have powerful associations recording memories of events, people and places. These can range from the functional, such as religious meaning, or to celebrate or remember an event, act or person, to the purely personal with little or no relevance to the purpose for which the object was made.

3.2.3 Choices
Objects we own are mostly of our own choosing, especially those that we wear or put on show in our homes. If they are not there because we like them, why do we have them – inheritance, sentiment, tradition, cultural or social conformity, or the desire to be fashionable at all costs? The choices include:

- *Who am I?* – objects can be badges of identity, showing our membership and position within our society or culture. They can indicate status, gender, religion, etc., or membership of our chosen peer group.
- *Tradition v. fashion* – some things either continue unchanged or evolve slowly, others can change almost overnight. Some things are classic, some are cutting edge, some have lasting appeal, some are passing fads.

3.2.4 Mystery objects
The meanings, use and stories of many objects cannot be understood merely by looking at a selection of unusual, strange and extraordinary objects. This section will contain a range of objects with a series of clues, background information and ultimately an 'answer' as to the meaning(s) or use(s) of the object.

Multiple meanings can be explored from different perspectives such as maker, collector and user, to show the different interpretations and significance different people bring to an object.

3.2.5 Community choice
A community curated section will enable a community group to explore the

stories of objects of their own choice. These could be objects sourced from the community group themselves, objects from museum collections (or loans from other institutions) or both.

3.2.6 Study collection

This substantial space will provide a flexible opportunity as an open storage approach to the display of other elements of the museum collections and loans from community groups. Functioning as a temporary display area looking at particular themes or specialist collections it will provide facilities for individuals and community groups to record stories about objects on display. To include seating, access to the collections database and access to relevant texts.

4 Interpretive approach

4.1 The visitor experience

4.1.1 This is largely a *contemplative* gallery space, where we encourage people to explore and enjoy wonderful collections, and 'make connections' with and between them and with their own lives.

4.1.2 Linked to this, there is a principle we would seek to apply to all aspects of the interpretation. We cannot hope to incorporate substantial information, or make all the connections, about every object on display. We seek to encourage visitors to explore and engage for themselves. Within each theme we will seek to highlight a small number of key objects and examine the stories we can build about these. We *hope* this will then encourage people to seek to develop connections and understanding for themselves about other objects on display.

4.1.3 A thematic approach has been chosen deliberately to encourage thought and the making of connections, both between elements of the displays and in terms of visitors relating display content to their own experiences. It also enables us, even in the context of a contemplative space, to seek to pace the displays by selecting different interpretive priorities for each theme. Through this, we will also seek to reflect the likely different learning styles of the diverse range of visitors we seek to attract to the gallery.

4.1.4 Because visitors will come with different prior levels of understanding, and because we hope to encourage people to want to explore, it is also essential that we take a layered approach to the provision of support information. The priority layer will support enjoyment of the sheer beauty of the collections and the creativity that enabled their creation. Below this, there must be a huge range of material, from trails for young children to published texts and material on 'how to find out more'.

4.2 Lifelong and life-wide learning

4.2.1 Leicester Museums Service is committed to providing lifelong and life-wide learning opportunities for all. For a general background to the building in of learning opportunities to galleries at New Walk Museum, see lifelong and life-wide learning in the interpretation strategy.

4.2.2 The priority learning audiences for connections are:

- self-directed adult learners.
- inter-generational families from Leicester's diverse communities. There is a particular opportunity for elders to introduce third and fourth generation children to material from their background cultures.

4.2.3 Through trails and links to other galleries, there will also be real learning opportunities for families with pre-teen children.

4.3 Structured educational use

4.3.1 This gallery is not seen as a priority for building in enquiry-based project work.

4.3.2 The most immediately relevant elements of the National Curriculum are within Art and Design: Unit 6c 'A sense of place' and Unit 9gen 'Visiting a museum, gallery or site'.
 There is also potential for substantial use at GCSE and A level, but in both cases with small groups at a time rather than large classes or year groups.

4.3.3 The dwell point noted in 4.6.13 will be an important facility for schools use, as will be the associated handling collection.

4.3.4 Part of the reason for ensuring flexibility in display will be to enable small exhibits to be developed with and for school pupils. There is real scope here for links to the museum outreach programme and to community groups.

4.4 Access

4.4.1 Leicester Museum Service is committed to ensuring full access for all – physical, cultural, intellectual, social. For a general background to ensuring access to galleries at New Walk Museum, see the access plan in the interpretation strategy.

4.4.2 Languages
A particular issue for the gallery, given its commitment to attracting a culturally

diverse audience, will be the extent to which languages other than English are included. The views of the designer on potential approaches to the provision of alternative languages would be welcomed at this stage. There is additional funding avaiable to support piloting.

4.4.3 Written text

Whether or not other languages are present, written English text will underpin the gallery. It is essential for all users that all primary level texts are produced in a clear, concise and active style. We will wish to experiment with writing styles in the gallery, so it must be easy and cheap to replace many texts, from introductory theme panels to individual object labels.

4.5 Orientation – physical and conceptual

4.5.1 *Physical orientation* – this gallery can be entered from one of two directions, and its displays will be modular. There is no fixed route, but each thematic area should be clearly defined and should 'stand alone'.

4.5.2 *Conceptual orientation* – the central themes concern creativity and connections between cultures through the objects they make and the elements and functions that inspire these. Because there are two entrances, the gallery will require a substantial panel at each, with a very brief, bold statement of purpose. A large panel should also introduce each sub-theme.

4.5.3 Conceptual orientation will also depend on the appearance and 'feel' of the gallery – this is about objects of beauty and the people who made and used them. The objects must be superbly displayed and lit.

4.6 Interpretive media

4.6.1 The themes must be clearly differentiated. The visitor needs to be able to visit one themed area and leave knowing what the gallery message is. It should be a gallery that visitors can dip into and come away from or spend many hours in.

4.6.2 The gallery should not consist of permanent displays, but instead have an interchangeable, modular approach – so that, for example, a display on 'death' could replace a display on 'food' – with sub-themes that will come under broad overall themes. It must be cheap and easy to remove one display and replace it with another.

4.6.3 The casing must enable quality of access for all to view, admire and engage with the collections on display and be flexible enough to be used for a wide range of materials. The first line of interpretation will be the selection and sheer quality of objects and their display and lighting. In principle, much of

the casing should be glazed to ground level, but there is a range of potential exceptions to this, discussed below

4.6.4 The objects in this gallery will need a social and 'people' context. By giving objects context the visitor will instantly have a familiarity with some of the material in the gallery making it easier to get to grips with the objects, which may not be familiar. The familiar will create a link to the unfamiliar.

4.6.5 While we can see a similar range of interpretive media in use across the gallery, we would seek different ones to be prioritised in different themes, so that we achieve a paced approach rather than a mono-experiential one. There is plenty of scope at this stage in defining which medium to prioritise under which theme. The priority mode of interpretation should be determined as far as possible by the objects and the stories they tell.

4.6.6 Most graphic panels containing any text should be located within the casing, so that content can be associated directly with the objects. The exception will be the two panels introducing the gallery. There is potential for large images to be located around the gallery, to help to 'people' it. If there is to be a range of graphic panels in use, there should be a clear hierarchy that will be obvious to visitors.

4.6.7 We would expect each theme to be accompanied by some form of flip-book(s), some giving additional details about the collections on display, while others may reveal stories or provide additional images.

4.6.8 Film has an important potential function, reflecting object makers and users. We admire the approach in the British Galleries at the Victoria and Albert Museum, where the film is used to highlight aspects of individual objects. This ties in well to our key interpretive approach (see 4.1.2).

4.6.9 There is also the potential to incorporate a large plasma screen in the gallery showing a range of short clips relating to the displays and incorporating people as well as objects.

4.6.10 Oral histories or testimonies will also be needed to tell the stories of the objects and show the significance they hold in communities throughout the world. This will be achieved with the help of individuals, groups and organisations in and with links to Leicester.

4.6.11 There are various potential uses of computer support. The priority is to define where and if a touchscreen interactive can be effectively related to object displays. This seems most likely in association with the study collection. It could potentially be supported by a database of the service's decorative arts collections.

4.6.12 There should be a small study area associated with the study collection, consisting of a small circular table, chairs and shelving for books, etc.

4.6.13 There should be a much larger 'dwell point' close to the centre of the gallery, with good circulation around it. This would be used for:

- rest, recuperation and reflection
- discussion
- reading
- drawing and colouring
- school project work
- object handling sessions
- demonstrations, etc.

There should be a mobile 'art trolley' associated with the dwell point, containing materials and activities related to the gallery, to enhance the experience for pre-teen children.

4.6.14 Touch and object handling should be built in to the gallery as a normal element of the display. A sense of texture, etc., is essential to understanding objects. Objects should be bought and commissioned specifically for handling. The museum will include a budget for replacement and maintenance, but there is a need to agree the range of handling material to incorporate.

Film may also have a role here. If, for example, an Indian sculpture is commissioned, the work could be filmed and an edited version incorporated alongside the actual object in the gallery which visitors can view and touch.

4.6.15 As noted in 4.6.3, there will be a need to incorporate some casing with cupboards under the glazing. This could be to:

- hold the object-handling collection for use in regular gallery activities
- contain drawers holding additional related material (particularly if it is flat)
- contain doors to open, feely-boxes, etc., for younger children.

4.6.16 The interpretive displays will be supported by theme trails targeted at different ages of children, and potentially also at adults.

4.6.17 To keep up the momentum of a dynamic gallery and to ensure repeat visits, the museum will also be seeking to develop a strong events programme to complement existing themes and help develop new ideas. Such a programme could include artists demonstrating pattern making, dance, music, a particular craft or telling stories. The events should reflect gallery content and add a dynamism and greater interaction to the gallery themes. The dwell point noted in 4.6.13 above will be relevant to this.

10 The engaging museum

Engage (verb) employ or hire; employ busily, occupy; hold fast (a person's attention); bind by a promise or contract; interlock (with e.g. gears); come into battle; take part (e.g. in politics); pledge oneself.

Engaging (adjective) attractive, charming
Oxford Compact English Dictionary (1996: 324–5)

When I first thought of the title for this book, I was not thinking of museums as being attractive and charming, or of seeking to employ visitors busily – let alone engaging them in battle. My thoughts were on ways of gaining visitor attention and then holding it fast, so that museum audiences would be encouraged to commit the time and mental energy needed to interact fully with collections and exhibitions. As the book has progressed, so my personal definition of 'engaging' has developed with it. I *do* want museums to attract audiences, so they must be attractive and perhaps even manage to charm. I *do* want our audiences to view their visit as a journey and a conversation that they want to take part in and that will employ their minds, if not necessarily their bodies, busily. I *do* want museums to bind themselves, by promise or contract, to respond to the needs and expectations of all their visitors and support people in their exploration. I do not seek to battle with visitors (although, deep down, I want museums to be so popular that, just sometimes, you have to fight off the crowds) – but I *do* want museums to be able to deal with the controversial and engender at times heated debate. Thus, the title has remained unchanged throughout the process, but has become much more meaningful to me.

For most of the twentieth century, the primary role of museums was to collect objects, classify, document and conserve them, and put them on display. The museum was generally recognised as an important public institution, even by those who would not dream of visiting it. But, as discussed in the introduction to this book, times changed and new demands arose – museums today must justify their existence much more effectively, must generate far more of their own income, must

broaden their audience bases, must reflect their communities, and must enhance their role as learning institutions. Society has also changed. The 'traditional' audiences for museums are far less willing to put up with the second-rate (let alone pay for it) or to accept a passive role. There are many more demands on their leisure time, and many more competing alternatives for that time. Equally, previously excluded communities are now demanding representation and opportunities for direct involvement. Of course, the very act of these demands shows that communities continue to see the relevance of museums within modern society.

Museums must change or die. They must compete in the modern world for their audiences and their resources against other leisure activities and – in a time when there are too many museums and other heritage attractions with new ones still opening and the audience at best static – against each other. They must also respond to the twenty-first century demands being made of them: 'a role for the museum that bridges its aesthetic past with its populist and market-oriented present' (view of Zaha Hadid, architect, quoted in Schwarzer 1999: 47).

This will increasingly mean offering a range of experiences, both to meet the varying needs of different audience segments and individuals, and also to reflect the basic fact that most visitors will seek a multiple range of experiences during their stay. It will also mean museum directors must increasingly pay equal attention to the quality of the three totally intertwined, inter-related and inter-dependent elements that make up the museum visit:

- the image projected to the outside world and the impact this has on the expectations of the visitor
- the contents (buildings, collections, exhibitions, associated activities, etc.)
- the operations.

As has always been the case, the quality of the overall experience will influence whether the visitor will return or will recommend the museum to others.

The role of museums in the twenty-first century is as it has always been, to seek contemporary ways to engage audiences with their collections. This does not mean throwing out all that was good about past approaches to display, but the keeping of the best and the introduction of effective new methods, proven through research. It also means an approach that is both much more scientific and much more business-like – if museums are to justify their existence, they must prove they know what they are doing, to the satisfaction of both their governing bodies and of their audiences. If not, the latter at least will vote with their feet. The challenge in this final chapter is to pull together the threads of the book to seek to outline how a museum, whatever its size or budget, can turn itself into an 'engaging' environment.

Museums vary in size and resources. They vary in their collections, in their staff and staffing levels, in their architecture, in their locations and in their audiences. They differ in their opening hours, in their exhibition programmes and in the services they offer. They differ in their governing bodies and in their individual histories. The American Association of Museums estimated in 1994 that 55 per cent of the 15,000+ museums in the USA were historical museums and historic sites, 15 per cent were art museums, and 14 per cent were nature and science-and-technology

oriented, including zoos and botanical gardens (Kotler and Kotler 1998: 6). In the UK, while the British Museum can attract over 4.5 million visits a year, most museums in the regions are very small. Over 50 per cent attract fewer than 10,000 visits a year while 66 per cent attract fewer than 20,000 visits. Clearly not all the elements discussed below will be applicable to (or affordable by) any individual institution, but I believe that the principles underpinning them apply to all.

I have already said all I can about the importance of external image and front-of-house management (except for the enabling role). What I have concentrated on below is twofold:

- the range and variety of museum experience elements that go together to create a quality visit
- the encouragement of direct visitor engagement with objects.

Clearly, the two elements overlap – another way of looking at the chapter would be in terms, first, of the 'big picture' and then of the detail.

THE 'BIG PICTURE' – A MUSEUM FOR THE TWENTY-FIRST CENTURY

> The most successful museums offer a range of experiences that appeal to different audience segments and reflect the varying needs of individual visitors . . . successful museums provide multiple experiences: aesthetic and emotional delight, celebration and learning, recreation and sociability.
>
> Kotler and Kotler (1998: xx)

In the past, the core public function of a museum was the creation of displays and the provision of public access to them. The display was both the primary feature of the museum and also the primary means by which the museum sought to engage audiences with its collections. In the twenty-first century museum, display will form only part of the visitor experience and will represent only one of the means used to respond to audience requirements: 'Like the modern consumer desiring to use her free time effectively, the museum is multi-tasking. Current museum priorities include access and comfort, eating and shopping, flexible exhibiting and engaging the visitor' (Schwartzer 1999: 42). These priorities will, of course, reflect a requirement to generate income and to meet the needs of a leisure-oriented audience as well as an ambition to engage visitors with collections.

Thus, on a 'big picture' level, museums must learn to engage visitors more effectively and to encourage them to return regularly through the range of services they provide. Box 10.1 seeks to give an 'at a glance' impression of the range of provision that a contemporary museum must now make for its visitors – representing a much more holistic approach to the overall museum experience. The *core product* of the museum will continue to be its site and collections and the associated expertise of its

Box 10.1 The 21st century museum: a holistic approach to the visitor experience

Core product

Collections
Collection documentation
Site/building
Expertise

Tangible elements

Orientation and signage
Displays
Layered display content
Palette of interpretive media
Temporary exhibitions
Events and activities
Handling collection
'Always something new'
'Something for everyone'
Education programme
Outreach and in-reach programmes
Guided and self-guided tours
Website
Opportunities to volunteer
Diversity of staff
Members organisation
Physical accessibility
Seating
Café/restaurant
Shop
Restrooms
Opening hours
Pricing differentials
Marketing materials

Underpinning ethos

Clear sense of direction
Diversity of thinking
Quality, regular audience research
Community relationships
Local partnerships
Commitment to service quality
Planned framework
Service blueprinting

Intangible elements

External image
Sense of welcome
Staff friendliness, courtesy
Staff responsiveness to visitor needs
Supportive, stimulating atmosphere
Sense of belonging
Safety
Inclusive
Informal
Empathy
Responsive to visitor needs
Innovative
Appealing/interesting
Enjoyment/fun
Enriching
Supports social interaction
Stimulating
Engaging
Participative
Multiple points of view
Encourages discovery
Encourages reflection
Supports learning
Memorable
Sense of the special
Engenders a sense of achievement

staff. What is changing and developing enormously, however, is the huge range of both *tangible* and *intangible elements* through which visitors can access this core product. Also developing rapidly is the *underpinning ethos* of the museum, characterised by a clear sense of direction, a detailed understanding of audiences, a commitment to quality and an outward-looking agenda.

This is not to say that only museums with substantial budgets will prosper. Much of what is listed in Box 10.1 can cost little or nothing beyond what museums are already spending – it is more a way of thinking than a budgetary matter. Equally, it is not about making all museums the same. Much of what appeals about museums stems from their individuality – this is why such a high percentage of the 'traditional' museum audience consists of repeat visitors, not in the sense of returning to the same place, but because of the pleasure they gain from the act of museum visiting. A key role of a masterplan will be to emphasise the uniqueness of each museum, but it must also focus on commonalities and the absolute need for planning.

Most importantly, the core values remain:

- emphasis on the sheer/unique quality of the site and/or collections
- the quality of the protection/conservation and research of the site and collections
- authenticity – in the site/collections and their presentation. This is associated in turn with sensitivity in terms of any related events, etc.

These have now been supplemented by other values, equally relevant to the twenty-first century museum:

- absolute care in the image presented – both externally and at the point of arrival
- quality in the provision of associated leisure facilities, particularly the shop, restaurant and restrooms
- quality of research and response to the needs/expectations of all the audiences, including a commitment to engagement/involvement
- taking the needs of local communities into account and, preferably, encouraging active involvement and a sense of ownership
- setting standards, self-evaluation and benchmarking in all aspects of the operation
- quality in the selection, training and motivation of all staff, not just those in front-of-house roles. Interpersonal and customer service skills are essential tools for all
- quality in the provision of both structured and informal learning opportunities
- putting an appropriate funding regime in place
- having a professional approach to income generation
- setting long-term planning linked to a quest for continuous quality improvement, including product development, training, and community involvement.

The end result should be an alive, buzzing, forward-looking institution, firmly rooted in its community and both actively and regularly supported by its audiences, striding confidently into its future, and reflected in a new form of museum architec-

ture that enables the museum to perform its multiple tasks (for this latter aspect see, for example, Schwartzer 1999). However, it should also be an institution embedded in a philosophy that positively encourages and supports direct engagement with the collections it holds. All aspects of its product should be geared to this end, and it is to this close encounter that I now turn, for the final element of the book.

DIRECT ENGAGEMENT WITH OBJECTS

> Most visitors come to museums specifically to see the objects on display and to read the labels in exhibits. Visitors spend most of their time looking at, and presumably thinking about, the objects and labels in exhibits, and leave with images of them.
>
> Falk and Dierking (1992: 67)

The devil is in the detail. A museum can be a showpiece on the surface for everything modern, but what matters most is the depth and quality of the individual encounter with the 'real thing'. From the beginning, I intended to include a chapter on object display in this book, but the more I wrote, the more I realised that the chapter should turn into a book in its own right, and preferably an edited one, so that it could draw on a range of experiences, rather than be single-authored. The result is that all I feel I can do here is to touch briefly on some of the issues, with the proviso that I hope to return to the subject in more depth at a future date.

Underpinning the concept of museum collections is the study of material culture, on which there is now a substantial literature. Equally, much has been written theorising on issues around object meanings. There is also an increasing literature seeking to evaluate visitor use of galleries. However, there is surprisingly little on the practice of object display in museums. Museum researchers have shown that visitors remember most about those displays to which they have paid most attention (see, for example, Csikszentmihalyi and Hermanson 1995: 37). Yet it is as if budding and existing curators and exhibition designers are expected to know by magic how to most effectively put objects in cases or on open display in a way that will engage visitors directly with them. It is certainly worth comparing this situation (very unfavourably) with the staff training and display manuals employed by leading retailers, who are also in the business of attracting attention to their objects and very aware of the impact quality display can have. Retailers know that attention leads to sales: 'Nothing is left to chance: every item, image, sign, display, fixture, and the position of every service desk, point-of-sale and walkway is tested, and its effects on sales calculated' (Cummings and Lewandowska 2000: 139).

I say throughout this book that the primary role of exhibitions and associated activities is to engage audiences directly with collections – to gain visitor attention, to hold it and to encourage reflection. Of course, as Brochu (2003) would say, it all depends – there is no single route to perfect object display. The reality lies in defining the most appropriate way forward in your particular circumstances, and recognising that times and society have changed: 'In addition to comfort, access, amenities and

flexibility, the market demands that the museum's core feature – its exhibits – become more exciting. Static, scholar-focused displays do not engage or satisfy today's impatient consumer' (Schwarzer 1999: 46).

There are, however, tried and tested methods that can help. Every stage in the process is relevant – from the 'big picture' development of an exhibition concept; through the establishment of themes and sub-themes and of hierarchies in presentation; to the final selection of objects for display and the display approaches and contexts deemed most appropriate; to the selection and use of associated interpretive support and design media; and finally to the placing of an individual object on display and the attachment (or not) of an associated label. But this does not lose sight of the basic centrality of the object:

> The nature of people's interaction with objects depends upon the qualities of the object . . . the personal significance the visitor gives to it, the exhibition environment (crowded, hot, stuffy, dark, quiet, animated), the context of the object in the exhibition (how it is placed and what it is related to), and the value attributed to the object (and how it is interpreted) by the exhibition or institution.
>
> McLean (1993: 22)

I will attempt to introduce some aspects of object display here, but look forward to returning to the subject much more fully in the future.

Concept development: putting objects first

I refer back to chapters 7 to 9. As an interpreter, I believe in a welcoming but very structured approach to museums and their exhibitions that in the end ensures the visitor can concentrate his or her effort on the exhibition contents rather than on working out what is going on. Thus the first stage in supporting direct engagement with objects comes with the establishment of the conceptual framework within which the exhibition is developed, and the priority given to objects within this. The starting point is the development of the exhibition concept and the selection of the main theme and associated sub-themes. Are the collections at the heart of this process or are they there, from the outset, to support and illustrate a storyline? If the latter, will the displays seek to concentrate on those elements that can best be explored through the available collections, or is the objective to tell the 'whole story', with the objects as illustrative support? Do you limit the concept of 'collections' to 2D and 3D objects, or do you include photographs and other relatively modern images, manuscripts, oral history, historic film, etc.?

I have been as guilty as any other curator of concentrating on the overall theme rather than focusing on the relevant stories the available collections can tell. History galleries and museums of the city are particularly subject to this problem, with the collections displayed to illustrate and authenticate the story rather than being the focus of the story being told:

Object stories placed in a flip-book directly in front of a case encourage engagement at Nottingham Castle Museum. © Graham Black

> Case displays, free-standing artefacts, room interiors, shop reconstructions, paintings, photographs and much written material are skilfully and efficiently combined . . .
>
> In the Museum of London artefacts are essentially used to authenticate the social description written around them. 'Written' because the museum is in many ways a book around which the visitor may wander.
>
> Shanks and Tilley (1992: 74–5)

I agree with Fleming (1998: 145) that 'collections can never be more than symbolic of urban issues', but they can and must be more than window-dressing in a gallery. This is achieved by selectively focusing on the elements of the story they bring out and using other methods to provide the information on elements of the subject that the objects do not cover (film, books, computer, flip-book, etc.). If a full description of the 'story of the city' in all its aspects were the absolute priority, a better and much cheaper solution would be to publish an illustrated book. History galleries should

play to the strengths of what museums offer, and those all involve direct encounters with the past through the objects and other material that has survived.

Selecting the appropriate approach to object display

The theory of museum display taught in museum courses across the world acknowledges the complex range of meanings that individual objects possess, and the even greater complexity involved when objects are grouped together in exhibitions. It emphasises the selective nature of display – the choice of objects and of how they are grouped for display, the selection of the information and messages to accompany them, etc., while currently also teaching that visitors select for themselves from what is on offer and create their own meanings.

For all the talk about the multiplicity of object meanings, most visitors need help to bridge the communication gap between themselves and the object(s). There is no 'right' way to display objects and no sharp distinctions between alternatives. A decision on the most appropriate approach to object display in your specific circumstances must be based on the message(s) to be communicated and what combination of objects and interpretation will do the job most effectively. Frankly, there is a limited range of alternative display approaches you are likely to encounter, as outlined in Box 10.2. Each of these approaches represents conscious curatorial decisions on the selection of objects, on the messages they are expected to communicate, and on the behaviour and response expected of visitors.

The use of an open storage approach, whether in a public gallery or for reserve collections, reflects an ambition to increase access to the collections held as a whole. Displays like this are now frequently supported by a computer database containing collection documentation, and in many museums there are also fixed times when staff are present to discuss the collections and perhaps to enable limited object handling and other means of access beyond the visual. However, most open storage displays crowd together similar objects that are likely to be of interest to the specialist only, but will be meaningless and monotonous to most people (see Miles 1988: 65). The real appeal for most visitors lies in going 'behind the scenes' into areas not normally accessible to the public – and this is now being reflected in the development of collection resource centres focused on enhancing public access to objects in store.

Object display for intrinsic interest is typical particularly of artworks and some decorative arts exhibitions. Artworks are expected by curators to communicate directly with the visitor and require to be given the space, and the 'neutral' and contemplative environment in which this can happen. There is clearly a selective process, in which the curator chooses the artist(s) and work to be displayed, and then the mystery of the 'hang', the decision on where each piece is to be located, how much space it is to be given around it, and what works it is to be adjacent to. All this is fine for the art-trained and aesthetic elite but, as for every other form of object, the issues arise over how most appropriately to support the communication process between artwork and uninitiated viewer. Equally, the supposedly neutral environment can actually intimidate the non-gallery user, no more so than in the 'white cube' approach beloved by contemporary art spaces. I refer back here to the case study on Manchester

Box 10.2 Object display approaches

Open storage – a mass display, with minimal information, designed to give the general public visual access to collections that would otherwise be in the museum store.

Object display – the presentation of a collection for its intrinsic interest, with the objects expected to 'speak for themselves'.

Object-oriented – the collections remain central to the displays. The focus is on an aesthetic or classification approach, supported by limited information and interpretation.

Learning-focused – the displays are accompanied by substantial supporting information/interpretation.

Thematic – the collections are displayed around a theme.

Concept – objects are present within the display in a supporting role only. The visitor's attention is focused on the message or information, whether or not collections are available or relevant.

Art Gallery in chapter 3 and the results of public consultation that revealed the lack of confidence people felt when thinking of visiting art galleries and the consequences of this.

Object-oriented displays, focusing on the aesthetic or classification approach, are typical of much that one views in national museums and in galleries devoted to the decorative arts and crafts. The example Shanks and Tilley use is the Greek antiquities displays at the British Museum, but it could equally well have been any one of a host of other examples, not least the Metropolitan Museum of Art in New York. Here we have historic objects displayed as art gallery material, each item with a simple, short label like a painting. Personally, I love it when the object quality simply soars and each item is given the space and setting to sing for itself. However, it also separates the objects from their originators and their time, and can once more convey the concept of an art-trained elite who alone share and appreciate the timeless quality of what is on display:

> The artefact is displayed in splendid remoteness from the prosaic, from the exigencies of day-to-day life. The concrete and historically variable practice of production and consumption is collapsed into the 'aesthetic', an isolatable and universal human experience. Instead of abstract objectivity, the abstract experience of the aesthetic becomes the exchange value of the artefact . . .
>
> Shanks and Tilley (1992: 73)

However, this is not just an issue relevant to aesthetic display. The classification approach has doomed the display of many collections since the technique was transferred from natural history to human anthropology in the nineteenth century. As an

ex-archaeologist, I regret to say that it has proven particularly popular for the display of archaeological artefacts and can still be seen regularly in exhibitions being produced today. The curator's fascination is with the objects, so the displays of the different, artificially created archaeological time frames are entirely object-based. There is no sense of the people who made or used the objects:

> The objects stand solitarily. The people who made them are irretrievably out of sight and out of mind.
>
> The cases themselves represent empty time, time as a container, formal and devoid of social content, but nevertheless filled with the content of archaeology – objects; objects in cases; objects in time. . .
>
> Shanks and Tilley (1992: 69)

A basic tenet of archaeology is that we study the physical remains of the past to learn about the lives of the people who lived in that time. A basic principle of interpretation (see chapter 7, principle 9) lies in the use of the human context to engage audiences – people relate to people. Archaeology in itself fascinates people – the idea of being able to discover how our ancestors lived and, particularly, the emotional impact of being able to *touch* something last used hundreds or even thousands of years ago. This is light years away from the object fixation of curators; from the concept that you can order and classify archaeological objects in the same way that you do natural history specimens.

Much of this book has examined different aspects of the development of 'learning-focused' exhibitions and there is no point in repeating that material here beyond once again referring to the need to layer support material, use a range of interpretive media and build in facilities, space and specific curricular requirements to enable effective structured educational use. Thematic galleries have also received their fair share of attention already, while the city history galleries already referred to in this chapter represent classic examples of the concept approach.

Contextualising the object display

> An exhibit case with a total hodgepodge of objects with no obvious visual or informational relationship is unsettling. It will appear haphazard and chaotic to the visitor, while a display of row after row of seemingly identical objects, neatly laid out without variation, has a mind-numbing effect.
>
> Falk and Dierking (2000: 126)

Beyond the basic approaches to object display outlined above, there are also a range of *display contexts* within which an individual object or group of objects will be viewed by the visitor:

- on a gallery wall or in a glass case – this instantly gives any object the preciousness of an art object

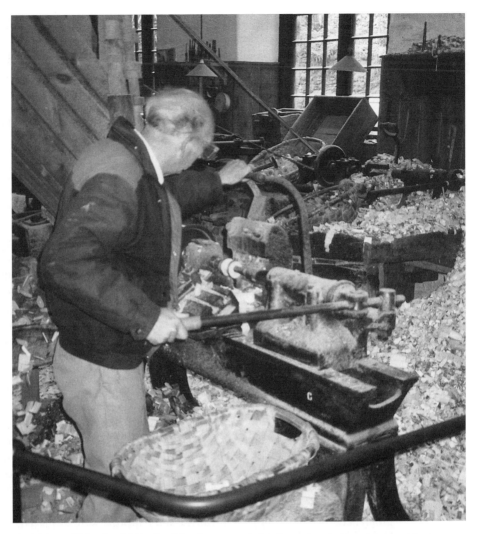

At Stott Park Bobbin Mill in the UK Lake District, an original worker brings his working environment back to life. No amount of description could have captured this scene.
© Graham Black

- grouping related objects together (for example, of the same type) to give contexts, associations and contrasts
- using props or supports for aesthetic or contextual enhancement (from placing objects on boxes of varying heights within a case to, for example, placing a costume on a mannequin)
- a suggestion/representation of the context or environment in which the object was originally made or used (for example, a large back-drop historic photograph of the interior of a warehouse to contextualise relevant industrial objects, or a wildlife garden diorama supporting relevant natural history exhibits)

- a re-creation of the environment from which the object was taken (for example, a room set)
- in its original environment with other associated material
- accompanied by 'living history'/demonstrators
- through use of replica or real objects that visitors can handle.

Contextual requirements will vary depending on the objectives of the individual exhibition. Miles (1998: 70ff) and Dean (1994: 32ff) are rare texts, exploring lighting, colour, labelling and object positioning and sequencing, with Dean also looking at visitor behavioural tendencies. Showcasing individual objects by giving them space or specific locations can transform visitor response to them, while lighting and gallery colour, and even music, can add dramatically to the occasion:

> Several visually striking pieces were showcased by being placed by themselves on enormous walls or by having a lot of empty space around them. Others were placed so that they were framed by doorways as the visitor surveyed the galleries . . . visitors were able to see most of the artwork at close range without the interference of plastic. There were no railings. Labels were unobtrusive and low so as not to overwhelm the eye. The walls had been painted saturated shades of cool colours . . . while African music played in the background.
>
> From a description of the exhibition *Soul of Africa* in Stainton (2002: 217–18)

Selective grouping of objects can support messages, and encourage the visitor to recognise associations and connections, e.g. from providing new insights into influences on artists to exploring development of pottery over time. Representations or re-creations of original contexts can support visitor understanding, particularly by enabling them to relate to their own lives and experiences. Cornes (2002) points to the wide range of research showing that visitors clearly get more from displays where the objects are presented in some kind of context, while Hooper-Greenhill (1994a: 75) cites a study at the Royal Ontario Museum showing that when visitors were given a choice as to how a group of decorative art objects, furniture and sculpture were displayed, they preferred either a room setting or a thematic presentation. It is no surprise that furniture stores use contextualisation through setting up room displays to encourage sales. This is back to people being able to relate what they are viewing to their own lives – if they can imagine the objects in the context of everyday living, sales will increase.

Good design matters

This relates directly to contextualisation, and I have already mentioned issues such as lighting and colour. Lakota (1976: 249) stresses the role of orientation, saying that if visitors know what to expect, it 'increases their motivation, attention and therefore learning'. Bitgood (2000: 32) and Serrell (1996: 47) highlight the importance of the label, label design and placement: 'Good labels can attract, communicate, inspire, and help visitors get what they are seeking'. Bitgood (2000: 38) also explores effective ways of seeking to engage visitors through the label, using

questions, evoking mental imagery, using flip labels and handouts, and encouraging social interaction.

Cornes (2002: 15) discusses issues around competition between objects, and between objects and design media, contrasting the approach in shops with that in museums. In shops, display technologies and product proximities are used to create what is called a 'pinball effect', to keep shoppers inside the store for longer and to encourage them to impulse buy beyond the original intention behind the shop visit. In contrast, researchers suggest this should be avoided in museums where competition can lead to the visitor's attention constantly being distracted when what is required is focus. In looking at retail layout, Mills and Paul's (1982: 2) discussion of good display speaks essentially of following basic principles of design, namely balance, emphasis, harmony and rhythm. They include general rules to follow, such as limiting the number of objects in each display, giving the objects rather than their supportive props prominence, and giving the display one dominant motif. They go on to cover the same issues discussed by Miles and Dean, concerning the role of colour, lighting and object size.

Design must reflect how visitors use galleries and exhibits

Alongside these comments sits what I consider to be the most important evaluative analysis to date of the visual evidence of how visitors use museum exhibitions, Serrell (1998) *Paying Attention: Visitors and Museum Exhibitions*. Here we see the application of tracking techniques similar to those used in shops by Underhill (1999) to the observation of visitors to museum exhibitions, to help to establish what makes them work or fail. Key elements of visitor behaviour that her studies confirmed (Serrell 1998: 9) included:

- Visitors generally turn right and follow a right-hand wall through a gallery. (Note that this is in the USA. Underhill found the same in shops, but found that in the UK people turn left!)
- Few people move into the centre to explore island exhibits.
- Exhibit elements near an exhibition's entrance often get more attention than those at the end.
- Large exhibitions have different averages for total time spent than small ones.
- The exit has a strong attraction; visitors often leave at the first opportunity.
- The time available for holding visitors' attention is very limited.

To these, I would add from my own experience and my trawl of available literature, including a repeat of some of the points I have already made:

- It is important to think through the likely visitor circulation pattern, to try to avoid 'hot spots' and 'cold spots'.
- Giving an object *space* will emphasise its importance – isolation encourages attention because it encourages visitors to perceive the objects as important. Large, isolated, spot-lit objects will most easily attract attention. Objects crammed into cases will lose individuality.

- Linked to this is the significance of the most prominent sight lines – focal points that can be viewed from distance or from a number of locations within an exhibition. Kabos (2003: 21–2) argues convincingly that: 'Once the exhibition team has established the exhibition's objectives . . . the next task should be for the team to decide on key objects that best illustrate those objectives so that these can be placed in the major sight lines'.
- *Competition* can remove attention from the objects. This competition can come from the design media being used as well as from other objects. If you want people to focus on the objects, you must remove or minimise distracting factors.
- The way you actually place/group objects really will make a difference to whether and how people look at them. Objects must be organised to increase their impact and to emphasise the importance of each.
- A *contrasting* background makes objects more noticeable. Think hard about the most effective colour combinations.
- *Lighting* can be crucial. It can, for example, transform a display of glassware. Contrast in lighting between object and background can be an effective way of leading visitors' eyes to the object. Good lighting and an absence of reflections are also essential in preventing 'visual fatigue', as well as supporting use by people with visual impairments.
- *Sight levels* are very limited – what does this mean for displaying objects above or below these? What about sight levels for children, or for people in wheelchairs? Should cases be glazed to floor level and glass shelves used?
- Do visitors need to see all *around* the object or its top/bottom?
- Multisensory associations can help a lot –what is there for visitors to *touch* that you can associate with the objects?
- Are *drawers* a suitable way of expanding quantities on display?
- The most effective *labels* will be placed in line of sight, well lit and preferably directly in front of objects. People really do use labels (McManus 1989).
- Using handling collections in a gallery can transform the way visitors explore similar material behind glass.

The label remains a major interpretive tool

We set objectives for the labels:
- Attract the readers' interest and draw them in.
- Anticipate and answer their questions.
- Use a reader-relevant approach.
- Address the reader directly.
- Write in language that's easy to understand.
- Use a friendly, conversational tone, active voice and vivid language.

Every label was rooted in the desire to increase the visitors' interaction with the scene in front of them . . . and with each other.

Ramberg *et al.* (2002: 307)

In the CIS Manchester Gallery, the social history of the city is explored through the fine and decorative arts. © Manchester Art Gallery

Whole books have been written on labels (e.g. Serrell 1996). I cannot add anything useful in the space available here beyond emphasising their absolute and fundamental importance.

A plea for enablers and docents

Gilman (1918) claimed that the office of docent was first introduced experimentally at the Museum of Fine Arts in Boston in 1896, but with planning for a new museum underway it was not until 1907 that gallery instruction was made an official function at the museum. In the intervening period, a similar approach was piloted at the Louvre and at a number of German museums, but the function has never really taken hold in Europe. By 1910 there were 'museum instructors' also at the American Museum of Natural History and the Metropolitan Museum of Art in New York. The concept spread across the USA and the new word 'docent' emerged and gained general acceptance.

The original function of the docent was to act as a knowledgeable companion for the visitor, directing his or her attention and supporting their understanding. It was directly related to museums' perceptions of themselves as educational institutions. Today, the docent as educator and gallery enabler remains a mainstay of the USA museum system:

> Docents are at the very center of the museum-visitor interface. They are responsible for sharing the fundamental intent of the curatorial staff, a staff that remains largely invisible and anonymous to visitors. It rests with them to prompt visitors to see the careful design decisions that are made, and to support an understanding and appreciation of the specific objects or the concepts that are being shared . . . The docents participate in training, practice their roles, and gradually gain experience that moves them from being peripheral participants to occupying a central position in the daily activity of the museum.
>
> Abu-Shumays and Leinhardt (2002: 47–8)

Some docents are paid, many are volunteers. There is no equivalent of the docent in the UK, although there is a long tradition of volunteering, mostly working with collections rather than audiences. The closest equivalent in the UK is probably in the developing role of the volunteer room steward in the National Trust – reflecting the Trust's 'vision for learning' strategy in its current forward plan. What most visitors meet in UK museums will be attendant staff whose primary function remains security. This issue was discussed above in chapter 4, but is returned to here specifically because of the essential need for enablers in galleries to support direct visitor engagement with collections through the provision of an activity programme. Social interaction, between visitors and between visitors and museum enablers/docents or curators is a critical, but hugely underestimated component in engaging visitors directly with collections and in visitor learning (see Cunningham 2004).

Museum experience worldwide shows that frequent replacement of major exhibitions does not happen. If there is to be 'always something new' happening (see chapter 7, principle 23), it can only consist of the temporary exhibition programme and the provision of a continuous programme of activities and events. While events can be one-off, activities must be built into the displays. Most obviously, if 'dwell points' are built into galleries to support structured educational use, they can also provide natural locations for an activity programme when not being used by schools. By having a table at the dwell point, with cupboards underneath, handling collections directly related to the adjacent cased exhibits can be stored and brought out for regular use. By minimising the effort involved in setting up the activities, a timed programme can be run at weekends, in school holidays, etc., including object handling, gallery tours, art trolleys, and many other possibilities. None of this is new thinking – it simply needs to be applied systematically and made available to adults as well as children.

For me, the opportunity to handle and discuss objects directly related to those in adjacent displays will always remain the primary need. However, I also recognise the many other ways in which individuals and groups of visitors can be encouraged to look more closely, to think about more deeply, to make connections and explore

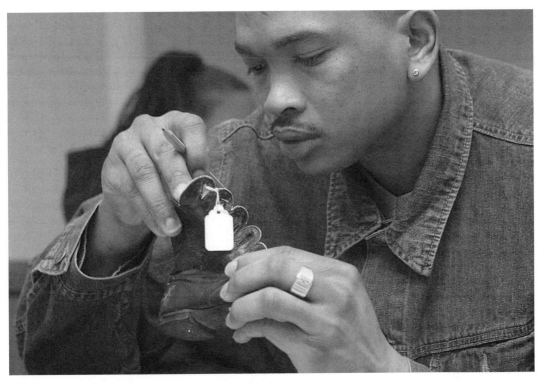

Object handling and exploration, here, by a visitor with special needs, is an unrepeatable experience for all. © Museum of London

meanings. The challenge is to experiment, evaluate and improve over time. Gallery enablers have a key role in developing and running these programmes.

Encouraging parents through their children

One of the great hidden benefits of providing art trollies and activity backpacks for children is that they always need parental support. A guaranteed way to ensure that a parent spends time with an object or artwork, finding out about it and observing it carefully, is to have a child need help drawing it or completing a quiz or other associated activity. Children will insist on asking questions that parents will have to find the answer to. If the parents are not careful, they end up discovering things as well and thereby enhancing their own understanding.

Evaluating visitor engagement with objects

Research into the quality of the visitor's direct engagement with collections is still relatively in its infancy. It combines the observation of external evidence of

visitor engagement through tracking and timing – see, for example, Serrell (1998) – with qualitative study of the less observable internal responses, through comment cards, visit diaries, qualitative interviews and 'real-time' study of visitor conversations – see, for example, Hilke (1988), Silverman (1995), Falk and Dierking (2000), Abu-Shumays and Leinhardt (2002), Allen (2002) and Leinhardt *et al.* (2002). Three of these articles are included in Leinhardt *et al.* (eds) (2002) *Learning Conversations in Museums*, a remarkable book which has transformed my own understanding of how visitors respond to objects, reflected in Table 10.1 based on Fienberg and Leinhardt (2002: 17).

Overall, museums need to do much more observing, tracking, interviewing and recording in 'real time'. We also need to make visitor comments a much more relevant element in exhibitions – as part of the museum's conversation with its visitors but also as an integral part of its evaluation. We need to learn from each new exhibition and seek to apply the lessons in the next one. This has to be the next priority in the development of visitor research.

DISCUSSION: SATISFYING MUSEUM EXPERIENCES AND VISITOR TAKE-AWAYS

> Daily watching the tired and listless wanderers that chiefly populate our galleries, we see plainly how little they gain compared with what can be gained . . . Are such things the affair of the exceptionally educated only? Unfortunately for this belief, the exceptionally educated neglect our museums even more conspicuously than the unlettered. There must be general underlying causes . . . Pondering this question we have surmised that the great need of the public was preparation of mind for what is shown; and we have accordingly multiplied labels and catalogues and guides; and of late years have developed a new museum service in the guise of personal companionship by docents, instructors, and demonstrators. All these things help. Nevertheless, what is more needed is that the works of art themselves shall have the opportunity of making their impression.
>
> To do this they require, among other things, time . . . Viewed from this angle, the problem of the use of the museum by the public becomes a problem of inducing visitors to stay . . .
>
> Gilman (1918: 274–5)

I have quoted at length from the eminently quotable Gilman because, if one ignores the difference in language, the issues he was facing and the solutions he sought to apply seem remarkably relevant to those of today, while the conclusions he came to – that the key issue is time and that the primary need is to persuade visitors to spend longer in the galleries, or visit more often – remain absolutely central. In addition to his support for the use of docents, and for other forms of 'interpretive instruction',

Table 10.1 Explanatory engagement reflected in verbal responses

- Listing: simple, one-dimensional response, such as identifying the object or reading a list of features.
- Analysis: analysing underlying features of the object/process concept.
- Synthesis: integrating a range of ideas from across different sources.
- Explanation: a combination of analysis and synthesis to evaluate how/why something exists/works/happened.

Source: based on Fienberg and Leinhardt (2002:170)

Box 10.3 Four types of satisfying experiences

1 Object experiences

These are:
being moved by beauty
seeing rare/uncommon/valuable things
seeing 'the real thing'
thinking what it would be like to own such things
continuing my professional development.

2 Cognitive experiences

These are:
enriching my understanding
gaining information or knowledge.

3 Introspective experiences

These are:
reflecting on the meaning of what I was looking at
imagining other times or places
recalling my travels/childhood experiences/other memories
feeling a spiritual connection
feeling a sense of belonging or connectedness.

4 Social experiences

These are:
spending time with friends/family/other people
seeing my children learning new things.

Source: after Doering (1999:83)

Gilman's chief recommendation is more seating: 'a movement to change their galleries from places to stand about in to places to sit down in. To induce a man to stay anywhere, he must be made comfortable while there' (Gilman 1918: 275).

Gilman was a rarity in his day in seeking to evaluate the visitor experience. I started this book with a chapter introducing the range of visitor analyses currently taking place in museums. Given my commitment to a visitor-centred approach, it seems fitting to return to this subject at the end of the final chapter. I believe strongly that visitors come to museums with their own agendas, which we might be able to influence but certainly cannot control.

The primary role of the museum is to support the visitor and seek to provide inspiration, stimulus and aesthetic pleasure. To be able to do this, we need a much greater qualitative understanding. Twelve years of visitor research at the Smithsonian Institution, USA, led the visitor studies team to the conclusion that 'the museums or exhibitions visitors find most satisfying are those that resonate with their entrance narrative and confirm and enrich their existing view of the world' (Doering 1999: 81). From this, the team sought to categorise the experiences their research suggested visitors found most satisfying, placing 14 key types of experience under four main categories, outlined in Box 10.3.

Here we have, perhaps, the beginnings of an understanding of what we want visitors to leave museums with – the 'visitor take-aways' (Rennie 1996) that alone can define the quality of the individual museum experience. Museums exist to enhance the quality of people's lives, to satisfy their needs in every sense – physically, socially, intellectually, emotionally, spiritually: 'museums are not simply places of enjoyment. They are places designed to uplift the spirit and enlighten the mind' (Alt and Shaw 1984 cited in Rennie 1996: 57).

Our challenge is to make every effort to achieve this end. I hope this book will at least provoke thought on how best to proceed.

CASE STUDY: THE VISITOR RESPONSE

So, what difference did it make that your museum was there?

Weil (1994: 43)

As someone committed to the museum visitor, I felt the book should end not with my words, but with those of the audience.

Arrival

When I first saw the Met, I was struck by the beauty of the building itself, especially the two beautiful fountains and the enormous staircase out front,

with all the people sitting on it sunning themselves. They somehow reminded me very much of seals I saw in San Francisco harbor who were always lounging and playing in the sun. I think it was because these people seemed happy to be sitting on the steps . . . and that left me with the impression that the Met was a fun place to be.

Molly, quoted in Leinhardt *et al.* (2002: 113)

Response to objects

You know, like I was talking about the Yaka mask back there. I've seen . . . in books, they're in every book. But coming face to face with one the first time in the 50 years I've been looking at art, that's a totally new experience.

Interviewee, quoted in Leinhardt *et al.* (2002: 251)

Interviewer: What did your visit to the museum do for you today?
Visitor: Brought back memories. Yes, most of all.
Interviewer: Is that a good thing?
Visitor: I think it is. I live on memories. You get older, when you get older, people always say older people talk about the past . . . What does the bible say about that? 'Old men dream dreams and young men have visions.' So maybe my visions are mostly gone. But I saw so many things that brought back memories, and I think memories are good.

73-year-old white male, quoted in Leinhardt *et al.* (2002: 420)

Response to other visitors

I will carry the image of those children sitting on the floor in front of various quilts and slowly warming to the lure of the cloth, the design, the stories. They did get involved. They did understand the ideas the quilts were picturing. They made me understand ever more surely that the quilting carries a tradition that is beyond the traditional bed covering. They are a way to make art that touches the soul.

Anne, quoted in Leinhardt *et al.* (2002: 118)

Schools

This home where we went to, with the bomb shelter and they had to hide. And you start to think of it, and they were talking really sad and they were bleeding and everything.

School pupil, London, quoted in Johnsson (2004)

I did the Roman soldier last time but the best was what we did yesterday, and a woman performed a play, and she just happened to be black. And that was really magical. She was very, very, good and the kids were just – I never realised there were black people then. My school is ninety per cent Afro-Caribbean or Asian. Amazing. And that sort of led into . . . we did a lot of follow up work.

School teacher, London, quoted in Johnsson (2003)

I think you open the door. For one child it might be . . . I mean, we might be coming for Ancient Egypt, but somebody in my class might have seen the ostrich egg. I might bring them for one thing and they come away with something different. It's about opening their minds isn't it? They are not going to get it from television, if they are going into central London they are going to a different universe. The children who live on our estate, if they are travelling to Catford they are going very far. And to come to a museum like this, you are actually saying – wow, look at this world that we've got. And you might only have one child who is going wow at the same time as you, but that's what education is about, isn't it?

School teacher, London, quoted in Johnsson (2003)

Bibliography

AAM (1969) *America's Museums: The Belmont Report*, Robbins, M.W. (ed.), Washington DC: American Association of Museums.

AAM (1972) *Museums: Their New Audience, A Report to the Department of Housing and Urban Development by a Special Committee of the American Association of Museums*, Washington DC: American Association of Museums.

AAM (1984) *Museums for a New Century: A Report of the Commission on Museums for a New Century*, Washington DC: American Association of Museums.

AAM (1992) *Excellence and Equity: Education and the Public Dimension of Museums*, Washington DC: American Association of Museums.

AAM (1995) *New Visions: Tools for Change in Museums*, Washington DC: American Association of Museums.

AAM (1998) *Museums and Community Initiative*, accessed on 24/04/04 at www.aam-us.org/initiatives/m&c

AAM (1999) National Interpretation Project: exploring standards and best practices for interpretation, *Museum News*, September/October 1999: 81.

AAM (2001) Principles of effective museum education, draft for review and comment, June 2001, Washington DC: AAM Standing Professional Committee on Education.

AAM (2002) *Mastering Civic Engagement: A Challenge to Museums*, Washington DC: American Association of Museums.

Abu-Shumays, M. and Leinhardt, G. (2002) Two docents in three museums: central and peripheral participation, in Leinhardt, G., Crowley, K. and Knutson, K. (eds) *Learning Conversations in Museums*, New York: Lawrence Erlbaum Associates, pp. 45–80.

Adams, R. (2001) *Museum Visitor Services Manual*, Washington DC: American Association of Museums.

AHA (1998) *Statement on Excellent Classroom Teaching in History*, American Historical Association, accessed on 30/03/04 at www.historians.org/teaching/policy/ExcellentTeaching.htm

Alexander, E.P. (1979) *Museums in Motion*, Nashville TN: AASLH.

Allen, E. (2001) Can the neglect of defining and evaluating service quality in museums be effectively addressed by Servqual?, unpublished MA thesis, The Nottingham Trent University.

Allen, S. (2002) Looking for learning in visitor talk: a methodological explanation, in Leinhardt, G., Crowley, K. and Knutson, K. (eds) *Learning Conversations in Museums*, New York: Lawrence Erlbaum Associates, pp. 259–303.

Alt, M.B. and Shaw, K.M. (1984) Characteristics of ideal museum exhibits, *British Journal of Psychology* 75: 25–36.

AMARC (1999) *Musing on Learning*, a seminar held at the Australian Museum Sydney, accessed on 05/01/04 at www.amonline.net.au/amarc/research/learning.htm

AMARC (2003) website of the Australian Museum Audience Research Centre, accessed on 05/01/04 at www.amonline.net.au/amarc/

AMOL (u/d) *Training for the Collections Sector*, accessed on 02/03/04 at http://amol.org.au/training/index.asp

Anderson, D. (1997) 1st edition, *A Common Wealth: Museums and Learning in the UK*, London: Museums and Galleries Commission.

Anderson, D. (2004) *Reluctant Learners: Art Museums in the Twenty First Century*, presentation at the National Museum of Art, Helsinki, 4 February

2004, accessed on 20/04/04 at http://www.fng.fi/fng/rootnew/fi/kehys/teema04/materiaalit/reluctant.pdf

Anderson, D. and Piscitelli, B. (2002) Parental recollections of childhood museum visits, *Museum National* 10 (4): 26–7 accessed on 24/02/04 at http://eab.ed.qut.edu.au/activities/projects/museum/

Anderson, D., Piscitelli, B., Weier, K., Everett, M. and Tayler, C. (u/d) *Young Children's Interactive Experiences in Museums: Engaged, Embodied and Empowered Learners*, accessed on 24/02/04 at http://eab.ed.qut.edu.au/activities/projects/museum/

Armitage, A., Bryant, R., Dunnill, R., Hayes, D., Kent, J., Hudson, A., Laws, S. and Renwick, M. (1999) *Teaching and Training in Post-Compulsory Education*, Buckingham: Open University Press.

Ashworth, G.J. and Larkham, P.J. (1994) *Building a New Heritage: Tourism, Culture and Identity in the New Europe*, London: Routledge.

Atkins, R. (2001) Travels through culture, space and time: pre-conference field trip to Uluru – Kata Tjuta National Park, *Interpreting Australia 20*, December 2001, p. 4, accessed on 23/04/03 at www.interpretationaustralia.asn.au/infofiles/newsletters/IAANL20-01Dec.pdf

Australian Government, Department of Education, Science and Training (2003) *You Can Too: Adult learning in Australia. A Consultation Paper*, accessed on 02/02/04 at www.dest.gov.au/research/publications/nov03/you_can_too.htm

Bandura, A. (1977) *Self-efficacy: The Exercise of Control*, New York: W.H. Freeman.

Bailey, S.J., Falconer, P., Foley, M., Graham, M. and McPherson G. (1998) *To Charge or Not to Charge: A Study of Museum Admission Policies*, undertaken by Glasgow Caledonian University. London: Museum and Galleries Commission.

Baillie, A. (1996) *Empowering the Visitor: The Family Experience of Museums*, presented at Museums Australia Conference, November 1996, accessed on 30/06/04 at http://amol.org.au/evrsig/pdf/baillie96.pdf

Baum, L., Hein, G. and Solvay, M. (2001) In their own words: voices of teens in museums, *Journal of Museum Education* 25 (3): 9–13.

Beck, L. and Cable, T. (1998) *Interpretation for the 21st Century*, Champaign IL: Sagamore Publishing.

Beck, L. and Cable, T. (2002) The meaning of interpretation, *Journal of Interpretation Research*, 7 (1): 7–11.

Beddie, F. (2002) *Adult Learning: Implications for Lifelong Learning*, address to the State Library of Victoria, 30 October 2002, accessed on 24/03/04 at www.ala.asn.au/docs/SLV_address.pdf.

Been, I., Visscher, C.M. and Goudriaan, R. (2002) *Fee or Free?*, paper presented at the 12th biennial conference of the association for cultural economics international (ACEI), Rotterdam, The Netherlands, 13–15 June 2002.

Beer, V. (1992) Do museums have a 'curriculum'?, *Patterns in Practice: Selections from the Journal of Museum Education*, Washington DC: Museum Education Roundtable, 84–6.

Berry, N. and Mayer, S. (eds) (1989) *Museum Education: History, Theory and Practice*, Reston: National Art Education Association.

Berry, S. and Shephard, G. (2001) Cultural Heritage Sites and their visitors: too many for too few, in Richards, G. (ed.) *Cultural Attractions and European Tourism*, Wallingford: CABI Publishing, pp. 159–71.

Bicknell, S. and Farmelo, G. (eds) (1993) *Museum Visitor Studies in the 90s*, London: Science Museum.

Bitgood, S. (1989) Bibliography: School field trips to museums/zoos, *Visitor Behaviour* 4 (2): 11–13.

Bitgood, S. (2000) The role of attention in designing effective interpretive labels, *Journal of Interpretive Research*, 5 (2) winter 2000: 31–45.

Bitgood, S., Roper Jr, J.T. and Benefield, A. (eds) (1988) *Visitor Studies: Theory, Research and Practice*, Jacksonville, FL: Centre for Social Design.

Bitgood, S., Serrell, B. and Thompson, D. (1994) The impact of informal education on visitors to museums, in Crane, V., Nicholson, H., Chen, M. and Bitgood, S. (eds) *Informal Science Learning*, Washington DC: Research Communications Ltd, pp. 61–106.

Black, G. (1999) Developing the concept for the Thackray Medical Museum, in Leask, A. and Yeoman, I. (eds) *Heritage Visitor Attractions: An Operations Management Perspective*, London: Cassell, pp. 251–9.

Black, G. (2000) Quality and concept development, in Drummond, S. and Yeoman, I. (eds) *Quality Issues in Heritage Visitor Attractions*, Oxford: Butterworth-Heinemann, pp. 97–135.

Boomerang! Integrated Marketing and Advertising

Pty Ltd (1998) *Powerhouse Museum Brand Audit and Positioning Options*, Sydney: internal report for the Powerhouse Museum.

Borun, M. and Korn, R. (eds) (1999) *Introduction to Museum Evaluation*, Washington DC: American Association of Museums.

Brochu, L. (2003) *Interpretive Planning: The 5-M Model for Successful Planning Projects*, Fort Collins CO: interpPress.

Brochu, L. and Merriman, T. (2002) *Personal Interpretation*, Fort Collins CO: interpPress.

Browning, P. (1998) *John Muir: In His Own Words*, Lafayette CA: Great West Books.

Bruner, J.S. (1960) *The Process of Education*, Cambridge MA: Harvard University Press.

BTA (1997) *Overseas Leisure Visit Survey 1996*, London: British Tourist Authority.

Buchli, V. (ed.) (2002) *The Material Culture Reader*, Oxford: Berg.

Cabinet Office (2001) *Preventing Social Exclusion: Report by the Social Exclusion Unit*, London: Cabinet Office.

Cacioppo, J.T., Petty, R.E., Kao, C.F. and Rodriquez, R. (1986) Central and peripheral routes to persuasion: an individual differences perspective, *Journal of Personality and Social Psychology* 51: 1,032–43.

Canadian Museums Association (2003) *Canadians and Their Museums: A Survey of Canadians and Their Views About Their Country's Museums*, conducted by TeleResearch Inc. for the Canadian Museums Association, accessed on 12/01/04 at www.museums.ca/Cma1/ReportsDownloads/surveyanalysis2003.pdf

Cantor, Jeffrey A. (1992) *Delivering Instruction to Adult Learners*, Toronto: Wall and Emerson, pp. 35–43.

Carlzon, J. (1987) *Moments of Truth*, New York: Harper and Row.

Carter, J. (ed.) (1997) *A Sense of Place: An Interpretive Planning Handbook*, Inverness: Highlands and Islands Enterprise Board, also available at: www.scotinterp.org.uk

Caulton, T. (1998) *Hands-on Exhibitions: Managing Interactive Museums and Science Centres*, London: Routledge.

Chadwick, A. and Stannett, A. (2000) *Museums and Adult Learning: Perspectives from Europe*, Leicester: National Institute of Adult Continuing Education.

Chicago Botanic Garden (undated 2003/4) *Creating Interpretive Programs in Natural Areas: The Chicago Botanic Garden Model*, Chicago Botanical Garden.

Classen, C., Howes, D. and Synnott, A. (1994) *Aroma: The Cultural History of Smell*, London: Routledge.

Cornell, J. (1998) 2nd edition, *Sharing Nature with Children*, Nevada, CA: Dawn Publications.

Cornes, R. (2002) Can museums learn from department stores in creating effective object displays? unpublished MA thesis, The Nottingham Trent University.

Crane, V., Nicholson, H., Chen, M., and Bitgood, S. (1994) (eds) *Informal Science Learning*, Washington DC: Research Communications Ltd.

Cranton, Patricia (1992) *Working with Adult Learners*, Toronto: Wall and Emerson, pp. 13–15 and 40–63.

Cross, J. (2002) *Adult Learning and Museums*, paper presented at a Why Learning? seminar, Australian Museum/University of Technology, Sydney, November 2002, accessed on 19/12/03 at www.amonline.net.au/amarc/conferences/why_learning/index.htm

Csikszentmihalyi, M. and Hermanson, K. (1995) Intrinsic motivation in museums: what makes visitors want to learn? *Museum News* May/June 1995: 34–7 and 59–61.

Cummings, N. and Lewandowska, M. (2000) *The Value of Things*, London: August Media.

Cunningham, M.K. (2004) *The Interpreters Training Manual for Museums*, Washington DC: American Association of Museums.

Dana, J.C. (1917) *The New Museum*, Woodstock VT: Elm Tree Press.

Davies, S. (1994) *By Popular Demand: A Strategic Analysis of the Market Potential for Museums and Art Galleries in the UK*, London: Museums and Galleries Commission.

DCMS (1999) *Museums for the Many: Standards for Museums and Galleries to Use When Developing Access Policies*, London: The Stationery Office.

DCMS (2000) *Centres for Social Change: Museums, Galleries and Archives for All*, London: Department of Culture, Media and Sport.

DCMS (2001) *Libraries, Museums, Galleries and Archives for All: Co-operating across the Sectors to Tackle Social Exclusion*, London: Department of Culture, Media and Sport.

DCMS and DfEE (2000) *The Learning Power of Museums: A Vision for Museum Education*, London: Department of Culture, Media and Sport.

Dean, D. (1994) *Museum Exhibition: Theory and Practice*, London: Routledge.

Delin, A. (2002) Buried in the footnotes: the absence of disabled people in the collective imagery of our past, in Sandell, R. (ed.) *Museums, Society, Inequality*, London: Routledge, pp. 84–97.

Delin, A. (2003) *Disability in Context*, London: Museums, Libraries and Archives Council (available on the MLA website www.mla.gov.uk as part of the Disability Portfolio).

Delin, A., Dodd, J., Gay, J. and Sandell, R. (2004) *Buried in the Footnotes: The Representation of Disabled People in Museum and Gallery Collections*, Phase I report, September 2004, Leicester: RCMG, accessed on 19/11/04 at www.le.ac.uk/museumstudies/rcmg/BITF2.pdf

Delors (1996) *The Treasure Within*, report to UNESCO of the International Commission on Education for the Twenty-first Century, Paris: UNESCO.

Dennison, B. and Kirk, R. (1990) *Do, Review, Learn, Apply: A Simple Guide to Experiential Learning*, Oxford: Blackwell.

Department of Health (2001) *Valuing People: A New Strategy for Learning Disability for the 21st Century*, London: The Stationery Office, accessed on 03/09/04 at www.archive.official-documents.co.uk/document/cm50/5086/5086.htm

Desai, P. and Thomas, A. (1998) *Cultural Diversity: Attitudes of Ethnic Minority Populations toward Museums and Galleries in the UK*, BMRB report, London: Museums and Galleries Commission.

Dewey, J. (1938) *Experience and Education*, New York: Simon and Schuster.

DfEE (1999) *Learning to Succeed: A New Framework for Post 16 Learning – White Paper*, London: DfEE.

Dodd, J. and Sandell, R. (1998) *Building Bridges*, London: Museums and Galleries Commission.

Dodd, J. and Sandell, R. (2001) *Including Museums: Perspectives on Museums, Galleries and Social Inclusion*, University of Leicester: RCMG.

Doering, Z. (1999) Strangers, guests or clients? Visitor experiences in museums, *Curator* 42 (2): 74–87.

Doering, Z. and Pekarik, A. (1996) Questioning the entrance narrative, *Journal of Museum Education* 21 (3): 20–3.

Dohmen, G. (1996) *Lifelong Learning: Guidelines for a Modern Education Policy*, Bonn: Bundesministerium für Bildung, Wissenschaft und Forschung.

Donnelly, J.F. (2002) (ed.) *Interpreting Historic House Museums*, Walnut Creek, CA: Altamira Press.

Drummond, S. and Yeoman, I. (2001) *Quality Issues in Heritage Visitor Attractions*, Oxford: Butterworth-Heinemann.

Dugdale, E. (2004) For the child in all of us, *Interpretation Journal* 9 (2) Summer: 14–17.

Durbin, G. (ed.) (1996) *Developing Museum Exhibitions for Lifelong Learning*, London: The Stationery Office.

Durbin, G., Morris, S. and Wilkinson, S. (1990) *A Teacher's Guide to Learning from Objects*, London: English Heritage.

EdGov (2004) *Introduction: No Child Left Behind*, USA Department of Education website, accessed on 29/03/04 at www.ed.gov/nclb/overview/intro/index.html

EHTF (1999) *Making the Connections: A Practical Guide to Tourism Management in Historic Towns*, London: English Historic Towns Forum, English Tourism Council and English Heritage.

East Midlands Museum Hub/Childwise (2003) *East Midlands Museums Teacher Research*, Norwich: East Midlands Museum Hub/Childwise, accessed on 18/03/04 at www.emms.org.uk/EM-Hub/phase1-2.htm

East Midlands Museums Service (1996) *Knowing Our Visitors: A Market Study of East Midlands Museums*, Nottingham: East Midlands Museums Service.

English Tourism Council (2000a) *Action for Attractions*, London: ETC.

English Tourism Council (2000b) *Perspectives on English Tourism*, London: ETC.

European Commission (1994) *Growth, Competitiveness, Employment: The Challenges and Ways Forward into the 21st Century – White Paper*, Brussels: European Commission, accessed on 22/06/04 at http://europa.eu.int/en/record/white/c93700/contents.html

EVRSIG (2004) *Profiling Your Visitors: A Collaborative Initiative for Australian Cultural Institutions*, Museums Australia, accessed on 16/11/04 at http://amol.org.uk/evrsig/pdf/EVR-visitor-profile.pdf

Falk, J.H. (1998) Visitors: who does, who doesn't and why, *Museum News* March/April: 38–43.

Falk, J.H. (2002) Foreword, in Paris, S.G. (ed.) *Perspectives on Object-Centered Learning in Museums*, New York: Lawrence Erlbaum Associates, pp. ix–xiii.

Falk, J.H. and Dierking, L.D. (1992) *The Museum Experience*, Washington DC: Whalesback Books.

Falk, J.H. and Dierking, L.D. (eds) (1995) *Public Institutions for Personal Learning: Establishing a Research Agenda*, Washington DC: AAM.

Falk, J.H. and Dierking, L.D. (1997) School field trips: assessing their long-term impact, *Curator* 40 (3): 211–18.

Falk, J.H. and Dierking, L.D. (2000) *Learning from Museums: Visitor Experiences and the Making of Meaning*, Walnut Creek, CA: Altamira Press.

Falk, J.H. and Dierking, L.D. (2002) *Lessons without Limit: How Free-choice Learning Is Transforming Education*, Walnut Creek, CA: Altamira Press.

Falk, J.H., Moussouri, T. and Coulson, D. (1998) The effect of visitors' agendas on museum learning, *Curator* 41 (2): 107–20.

Ferguson, L. (2002) *On the Tourists' Back? The Relationship between Tourism and the Museum and Gallery Sector*, paper to the Museums Australia Conference 2002, copyright Australian War Memorial 2002, accessed on 08/01/04 at http://amol.org.au/evrsig/resources.html

Field, J. (2002) Governing the ungovernable: why lifelong learning policies promise so much yet deliver so little, ch. 10 in Edwards, R., Miller, N., Small, N. and Tait, A. (eds) *Supporting Lifelong Learning, volume III, Making Policy Work*, London: Routledge.

Fienberg, J. and Leinhardt, G. (2002) Looking through the glass: reflections of identity in conversations at a history museum, in Leinhardt, G., Crowley, K. and Knutson, K. (eds) *Learning Conversations in Museums*, New York: Lawrence Erlbaum Associates, pp. 167–211.

Fincham, G. (2003) *Museums and Community Learning*, London: NAICE.

Fines, J. and Nichol, J. (1997) *Teaching Primary History*, Oxford: Heinemann.

Finnegan, R. (2002) *Communicating: The Multiple Modes of Human Interconnection*, London: Routledge.

Fleming, D. (1998) Brave New World: the future for city history museums, ch. 8 in Kavanagh, G. and Frostick, E. (eds) *Making City Histories in Museums*, Leicester University Press, pp. 133–50.

Fox, C. (1999) Museums must do what schools will not, Association of Science and Technology Centres Newsletter, January–February 1999, accessed on 29/03/04 at www.astc.org/pubs/dimensions/1999/jan-feb/schools.htm

Freedman, G. (2000) The changing nature of museums, *Curator* 43 (4): 295–306.

Frochot, I. (2001) Measurement of service quality, ch. 10 in Drummond, S. and Yeoman, I. (eds) *Quality Issues in Heritage Visitor Attractions*, Oxford: Butterworth, pp. 154–71.

Frochot, I. (2004) An investigation into the influence of the benefits sought by visitors on their quality evaluation of historic houses' service provision, *Journal of Vacation Marketing* 10 (3): 223–37.

Frochot, I. and Hughes, H. (2000) Histoqual: the development of a historic houses assessment scale, *Tourism Management* 21 (2): 157–67.

Fyall, A., Garrod, B. and Leask, A. (eds) (2003) *Managing Visitor Attractions: New Directions*, Oxford: Butterworth-Heinemann.

Gibans, N.F. and Beach, B.K. (eds) (1999) *Bridges to Understanding Children's Museums*, progress report of Children's Museum: Bridges to the Future.

Giere, U. and Piet, M. (1997) *Adult Learning in a World at Risk: Emerging Policies and Strategies*, Hamburg: UNESCO Institute for Education.

Gilman, B.I. (1918) *Museum Ideals*, Boston MA: Museum of Fine Art.

GLLAM (2000) *Museums and Social Inclusion*, Leicester: Group for Large Local Authority Museums.

Goleman, D. (1995) *Emotional Intelligence*, New York: Bantam.

Goodey, B. (1994) Interpretive planning, ch. 26 in Harrison, R. (ed.) *Manual of Heritage Management*, Oxford: Butterworth, pp. 303–19.

Graham, J. (2004) Making sense together, *Interpretation Journal* 9 (2) Summer: 18–20.

Greenwood, J., Williams, A.M. and Shaw, G. (1989) *1988 Cornwall Visitor Survey*, Truro: Cornwall Tourist Board.

Grinder, A.L. and McCoy, E.S. (1985) *The Good Guide: A Sourcebook for Interpreters, Docents and Tour Guides*, Scottsdale AZ: Ironwood Press.

Gross, M.P. and Zimmerman, R. (2002) Park and museum interpretation: helping visitors find meaning, *Curator* 45 (4): 265–76.

Groundwater-Smith, S. and Kelly, L. (2003) *As We See It: Improving Learning in the Museum*, paper presented to the British Educational Research Annual Conference Edinburgh, September, 2003.

Group of Eight Industrial Nations (1999) *Köln Charter: Aims and Ambitions for Lifelong Learning*, 18 June 1999, Cologne: G8.

Griffin, J. (1999) *An Exploration of Learning in Informal Settings*, paper presented at National Association for Research in Science Teaching Annual Conference, Boston, March 28–31.

Gunther, C. (1999) Museumgoers: lifestyles and learning characteristics, in Hooper-Greenhill, E. (ed.), 2nd edition, *The Educational Role of the Museum*, London: Routledge, pp. 118–30.

Gurian, E.H. (2004) *Threshold Fear*, paper given at the 'Creative Space' conference, Leicester, UK, April.

Ham, S.H. (1992) *Environmental Interpretation: A Practical Guide*, Colorado: Fulcrum Books.

Harris Qualitative (1997) *Children as an Audience for Museums and Galleries*, report prepared for the UK Arts Council and Museums and Galleries Commission.

Harrison, R. (ed.) (1994) *The Manual of Heritage Management*, Oxford: Butterworth-Heinemann.

Harrison, R., Reeve, F., Hanson, A. and Clarke, J. (eds) (2002) *Supporting Lifelong Learning: vol. 1: Perspectives on Learning*, London: Routledge.

Hein, G. (1995a) The constructivist museum, *Journal of Education in Museums* 15: 21–3.

Hein, G. (1995b) Evaluating teaching and learning in museums, ch. 17 in Hooper-Greenhill, E. (ed.) *Museum, Media, Message*, London: Routledge, pp. 189–203.

Hein, G. (1996) Constructivist learning theory, in Durbin, G. (ed.) *Developing Museum Exhibitions for Lifelong Learning*, London: The Stationery Office, pp. 30–4.

Hein, G. (1998) *Learning in the Museum*, London: Routledge.

Herbert, D.T., Prentice, R.C. and Thomas, C.J. (eds) (1989) *Heritage Sites: Strategies for Marketing and Development*, Aldershot: Avebury.

Heritage Lottery Fund (u/d) *Audience Development Plans: Helping Your Application*, accessed at www.hlf.org.uk

Heritage Lottery Fund (u/d) *Access Plans*, accessed at www.hlf.org.uk

Hilke, D.D. (1988) Strategies for family learning in museums, in Bitgood, S., Roper Jr, J.T. and Benefield, A. (eds) *Visitor Studies: Theory, Research and Practice*, Jacksonville, FL: Centre for Social Design, pp. 120–25.

Hilke, D.D. (1993) Quest for the perfect methodology: a tragi-comedy in four acts, in Bicknell, S. and Farmelo, G. (eds) *Museum Visitor Studies in the 90s*, London: Science Museum, pp. 67–74.

Hill, K. (2001) Because it just makes sense: serving the museum visitor, in Adams, R. (ed.) *Museum Visitor Services Manual*, Washington DC: American Association of Museums.

Hirzy, E.C. (1995) *Museums in the Life of a City: Strategies for Community Partnerships*, Washington DC: American Association of Museums.

Honey, P. and Mumford, A. (1992) 3rd edition, *The Manual of Learning Styles*, Maidenhead, Berkshire: Honey.

Hood, M.G. (1983) Staying away: why people choose not to visit museums, *Museum News* April: 50–7.

Hood, M.G. (1993) After 70 years of audience research, what have we learned? Who comes to museums, who does not, and why?, in Thompson, D., Bitgood, S., Benefeld, A., Shettel, H. and Williams, R. *et al.* (eds) *Visitor Studies, Theory, Research and Practice*, 5: 77–87, Jacksonville, FL: Visitor Studies Association.

Hood, M.G. (1996) Audience research tells us why visitors come to museums – and why they don't, in *Toward 2000: Evaluation and Visitor Research in Museums*, Sydney: Powerhouse Museum.

Hooper-Greenhill, E. (1989) *Initiatives in Museum Education*, Leicester: Department of Museum Studies, University of Leicester.

Hooper-Greenhill, E. (1994a) *Museums and Their Visitors*, London: Routledge.

Hooper-Greenhill, E. (1994b) *Museum and Gallery Education*, Leicester: Leicester University Press.

Hooper-Greenhill, E. (ed.) (1996) *Improving Museum Learning*, Nottingham: East Midlands Museums Service.

Hooper-Greenhill, E. (ed.) (1999) 2nd edition, *The Educational Role of the Museum*, London: Routledge.

Hooper-Greenhill, E. (2000) *Museums and the Interpretation of Visual Culture*, London: Routledge.

Hooper-Greenhill, E. (2004) Measuring learning outcomes in museums, archives and libraries: the learning impact research project (LIRP), *International Journal of Heritage Studies* 10 (2): 151–74.

Horlock, N. (ed.) (2000) *Testing the Water: Young People and Galleries*, Liverpool University Press and Tate Gallery Liverpool.

IMLS (1999) *Survey on the Status of Educational Programming between Museums and Schools*, Washington: Institute of Museum and Library Services, accessed on 29/03/04 at www.edweek.org/ew/vol-18/24museum.h18

Januszczak, W. (1998) Culture section, *Sunday Times*, p. 2.

Johns, N. (1999) Quality, ch. 9 in Leask, A. and Yeoman, I. (eds) *Heritage Visitor Attractions: An Operation Management Perspective*, London: Cassell, pp. 127–43.

Johns, N. and Clark, S.L. (2001) Customer perception auditing, in Adams, R. (ed.) *Museum Visitor Services Manual*, Washington DC: American Association of Museums, pp. 17–22.

Johnson, P. (2000) The size-age-growth relationship in not-for-profit tourist attractions: evidence from UK museums, *Tourism Economics: The Business and Finance of Tourism and Recreation* 6 (3): 221–32.

Johnsson, E. (2003) *Teachers' Ideas about Learning in Museums*, London Museums Hub.

Johnsson, E. (2004) *Pupils Ideas about Museum Experiences*, London Museums Hub.

Kabos, A. (2003) Applying results of audience evaluation to develop design strategies that enhance museum visitor learning, in Kelly, L. and Barrett, J., *Uncover: Proceedings of the Uncover Graduate Research in the Museum Sector Conference 2002*, Australian Museum, Sydney and University of Sydney, pp. 17–22.

Kelly, L. (1998) *Separate or Inseparable? Marketing and Visitor Studies*, paper presented at ICOM, Melbourne, accessed on 08/01/04 at http://amol.org.au/evrsig/pdf/mprpap.pdf

Kelly, L. (2001a) *Developing a Model of Museum Visiting*, paper presented at the 'National cultures, national identity' Museums Australia Annual Conference, Canberra.

Kelly, L. (2001b) *Researching Learning and Learning about Research*, paper presented at the CERG symposium 'Changing identities, changing knowledges', University of Technology, Sydney, February 2001.

Kelly, L. (2002) *Play, Wonder and Learning: Museums and the Preschool Audience*, paper presented at the Australian Research in Early Childhood Education 10th Annual Conference, University of Canberra, January 2002.

Kelly, L. (2003) *Museums as Sources of Information and Learning: The Decision Making Process*,

presented at symposium 'Exhibitions as contested sites: the contemporary role of the museum', Australian Museum, Sydney, 28 November 2003.

Kelly, L. (2004) Museums, 'Dumbing down' and the Visitor Experience, currently unpublished draft.

Kelly, L. and Bartlett, A. (2002) *Youth Audiences (12–24) Research Summary*, accessed on 22/02/04 at www.amonline.net.au/amarc/pdf/research/youth.pdf

Kelly, L., Bartlett, A. and Gordon, P. (2002) *Indigenous Youth and Museums*, Sydney: Australian Museums Trust, accessed on 22/02/04 at www.amonline.net.au/amarc/research/indigenous_youth.htm

Kelly, L., Savage, G., Landman, P. and Tonkin, S. (2002) *Energised, Engaged, Everywhere: Older Australians and Museums*, a report for the Australian Museum, Sydney, and the National Museum of Australia, Canberra, accessed on 22/02/04 at www.amonline.net.au/amarc/pdf/research/fullreport.pdf

Kelly, L., Savage, G., Landman, P. and Tonkin, S. (2004) *Knowledge Quest: Australian Families Visit Museums*, a joint publication by the Australian Museum, Sydney, and the National Museum of Australia, Canberra.

Kirschenblatt-Gimlett, B. (1998) *Destination Culture: Tourism, Museums and Heritage*, Berkeley, CA: University of California Press.

Knowles, M. (1973) *The Adult Learner: A Neglected Species*, Houston TX: Gulf.

Knowles, M., Holton, E. and Swanson, A. (1998) 5th edition, *The Adult Learner: The Definitive Classic in Adult Education and Human Resource Development*, Houston TX: Gulf.

Knudson, D.M., Cable, T. and Beck, L. (1995) *Interpretation of Cultural and Natural Resources*, State College, PA: Venture Publishing.

Knutson, K. (2002) Creating a space for learning: curators, educators and the implied audience, in Leinhardt, G., Crowley, K. and Knutson, K. (eds) *Learning Conversations in Museums*, New York: Lawrence Erlbaum Associates, pp. 5–44.

Kolb, D.A. (1984) *Experiential Learning: Experience as the Source of Learning and Development*, Upper Saddle River, NJ: Prentice Hall.

Koncius, J. (2003) Where Jefferson and Henry strode, there's an anxious turn to trendy, *Washington Post*, Sunday 30 November 2003, p. F01.

Koran, J.J., Koran, M.L. and Ellis, J. (1989) Evaluating the effectiveness of field experiences 1939–1989, *Visitor Behaviour* 4 (2): 7–10.

Kotler, P. and Andreasen, A. (1996) 5th edition, *Strategic Marketing for Non-Profit Organisations*, New York: Simon and Schuster.

Kotler, N. and Kotler, P. (1998) *Museum Strategy and Marketing: Designing Missions, Building Audiences, Generating Revenue and Resources*, San Francisco CA: Jossey-Bass.

Kotler, P., Haider, D. and Rein, I. (1993) *Marketing Places*, New York: The Free Press.

Lake Snell Perry and Associates (2001) Americans identify a source of information they can really trust, unpublished report, Washington DC: American Association of Museums.

Lakota, R.A. (1976) Good exhibits on purpose: techniques to improve exhibit effectiveness, in Royal Ontario Museum, *Communicating with the Museum Visitor: Guidelines for Planning*, Toronto: Royal Ontario Museum.

Lamdin, L. (1997) *Elderlearning: New Frontier in an Aging Society*, Phoenix AZ: Oryx Press.

Laws, E. (1999) Visitor satisfaction management at Leeds Castle, Kent, ch. 20 in Leask, A. and Yeoman, I. (eds) *Heritage Visitor Attractions: An Operation Management Perspective*, London: Cassell, pp. 277–91.

Leask, A. and Yeoman, I. (eds) (1999) *Heritage Visitor Attractions: An Operation Management Perspective*, London: Cassell.

Leinhardt, G. and Knutson, K. (2004) *Listening in on Museum Conversations*, Walnut Creek, CA: Altamira Press.

Leinhardt, G., Crowley, K. and Knutson, K. (eds) (2002) *Learning Conversations in Museums*, New York: Lawrence Erlbaum Associates.

Leinhardt, G., Tittle, C. and Knutson, K. (2002) Talking to oneself: diaries of museum visits, in Leinhardt, G., Crowley, K. and Knutson, K. (eds) *Learning Conversations in Museums*, New York: Lawrence Erlbaum Associates, pp. 103–33.

Leonard, A. (2001) Visitor services defined, in Adams, R. (2001) *Museum Visitor Services Manual*, Washington DC: American Association of Museums, pp. 1–3.

Levy, B.A. (2002) Interpretation planning: why and how, in Donnelly, J.F. (ed.) *Interpreting Historic House Museums*, Walnut Creek CA: Altamira Press, pp. 43–60.

Lewis, W.J. (1994) 7th printing, *Interpreting for Park Visitors*, Ft Washington, PN: Eastern Acorn Press.

Light, D. and Prentice, R.C. (1994) Who consumes the heritage product? Implications for European heritage tourism, in Ashworth, G.J. and Larkham, P.J. (eds) *Building a New Heritage: Tourism, Culture and Identity in the New Europe*, London: Routledge, pp. 90–116.

LMCC (1991) *Dingy Places with Different Kinds of Bits: An Attitudes Survey of London Museums among Non-visitors*, London: London Museums Consultative Committee.

London Museums Agency (2003) *Holding up the Mirror: Addressing Cultural Diversity in London's Museums*, London: Helen Denniston Associates for London Museums Agency, October 2003.

Loomis, R.J. (1987) *Museum Visitor Evaluation: New Tool for Management*, Nashville TN: AASLH Management Series.

Loomis, R.J. (1993) Planning for the visitor: the challenge of visitor studies, in Bicknell, S. and Farmelo, G. (eds) *Museum Visitor Studies in the 90s*, London: Science Museum, pp. 13–23.

Loomis, R.J. (1996) How do we know what the visitor knows? Learning from interpretation, *Journal of Interpretation Research* 1 (1) accessed on 27/01/04 at www.journalofinterpretation research.org

Lord, B. and Lord, G. (2002) *The Manual of Museum Exhibitions*, Walnut Creek, CA: Altamira Press.

Low, T.L. (1942) *The Museum as a Social Instrument*, New York: Metropolitan Museum of Art.

Lynch, R., Burton, C., Scott, C., Wilson, P. and Smith, P. (2000) *Leisure and Change: Implications for Change in the 21st Century*, Sydney: Powerhouse Museum and University of Technology.

McCarthy, B. (1987) *The 4MAT System: Teaching to Learning Styles with Right/Left Mode Techniques*, Barrington IL: Excel.

McIntyre, J. (2003) *Where Do Australian Adults Learn?* Canberra: Adult Learning Australia, accessed on 24/03/04 at www.ala.asn.au/docs/oz_learn.pdf

McKercher, B. and du Cros, H. (2002) *Cultural Tourism: The Partnership between Tourism and Cultural Heritage Management*, New York: Haworth Hospitality Press.

McLean, K. (1993) *Planning for People in Museum Exhibitions*, Washington DC: Association of Science-technology Centres.

McManus, P.M. (1989) Oh yes they do! How visitors read labels and interact with exhibit text, *Curator* 32 (3): 174–89.

McManus, P.M. (1996) Visitors: their expectations and social behaviour, in Durbin, G. (ed.) *Developing Museum Exhibitions for Lifelong Learning*, London: The Stationery Office.

Maher, M. (1997) *Collective Vision: Starting and Sustaining a Children's Museum*, Washington DC: Association of Youth Museums.

Manning, C. (2002) *Revealing Hidden Treasures: New Adult Learning Alliances for Arts and Cultural Institutions*, paper presented at Uncover: graduate research in the museum sector conference, Sydney.

Martin, R.S. (2002) *25th Anniversary Museum Services Act*, accessed on 05/01/04 at www.imls.gov/whatsnew/current.

Marton, F., Hounsell, D. and Entwhistle, N. (1997) *The Experience of Learning*, Edinburgh: Scottish Academic Press.

Maslow, A.H. (1970) 2nd edition, *Motivations and Personality*, New York: Harper and Row.

Massey, S. (2004) *Community Mapping and Museums*, Canadian Museums Association, accessed on 21/03/04 at www.museum.ca

Matarasso, F. (2000) *Opening up the China Cabinet: Museums, Inclusion and Contemporary Society*, paper presented to UK Museums Association conference, October 2000.

Mathewson, D. (2001) *Museums and Schools: An Analysis of the Educational 'Game'*, paper presented at the annual conference of the Australian Association for Research in Education, Fremantle, December 2001, accessed on 28/03/04 at www.aare.edu.au/01pap/mat01510. htm

Maximea, H. (2002) Projecting display space requirements, in Lord, B. and Lord, G. (eds) *The Manual of Museum Exhibitions*, Walnut Creek CA: Altamira Press, pp. 76–90.

Merriam, S. (ed.) (2001) *The New Update on Adult Learning Theory*, San Francisco CA: Jossey-Bass.

Merriam, S. and Simpson, E. (1995) 2nd edition, *A Guide to Research for Educators and Trainers of Adults*, Malabar FL: Krieger.

Merriman, N. (1991) *Beyond the Glass Case*, Leicester University Press.

Miles, R. (1993) Grasping the greased pig: evaluation of educational exhibits, in Bicknell, S. and Farmelo, G. (eds) *Museum Visitor Studies in the 90s*. London: Science Museum, pp. 24–33.

Miles, R.S. (1988) *The Design of Educational Exhibits*, London: Unwin Hyman.

Millar, S. (1999) An overview of the sector, ch. 1 in Leask, A. and Yeoman, I. (eds) *Heritage Visitor Attractions: An Operations Management Perspective*, London: Cassell, pp. 1–21.

Miller, G. (1956) The magical number seven, plus or minus two: some limits on our capacity for processing information, *Psychological Review* 63 (2): 81–97.

Mills, K.H. and Paul, J.E. (1982) *Applied Visual Merchandising*, Upper Saddle River, NJ: Prentice Hall.

Mitchell, S. (ed.) (1996) *Object Lessons: The Role of Museums in Education*, Edinburgh: Scottish Museums Council.

Mitsakos, C. (1982) As others see us: an educator, *Museum News* 60: 22–3.

MLA (u/d) *Research Paper: The Drawbridge Group*, accessed on 23/02/04 at www.mla.gov.uk/information/research/draw03.asp

MLA (2001a) *Using Museums, Archives and Libraries to Develop a Learning Community: A Strategic Plan for Action*, draft for consultation, London: Resource.

MLA (2001b) *Inspiring Learning: A Framework for Access and Learning in Museums, Archives and Libraries*, London: Resource.

MLA (2001c) *Renaissance in the Regions*, London: Resource.

MLA (2002) *Neighbourhood Renewal and Social Inclusion: The Role of Museums, Archives and Libraries*, London: Resource.

MLA (2003) Measuring the outcomes and impact of learning in museums, archives and libraries, *The Learning Impact Research Project End of Project Paper*, 1 May 2003, accessed on 23/02/04 at http://www.mla.gov.uk/documents/insplearn_wp. 20030501.doc

Moffatt, H. and Woollard, V. (1999) *Museum and Gallery Education*, London: The Stationery Office.

Moon, J.A. (1999) *Reflection in Learning and Professional Development*, London: Kogan Page.

MORI (1999) *Visitors to Museums and Art Galleries in the UK*, London: Museums and Galleries Commission.

MORI (2001) *Visitors to Museums and Galleries in the UK*, London: Resource.

MORI/LGA (2001) *User Satisfaction Performance*

Indicators: A Pilot Survey of the Public, MORI and Local Government Association, accessed on 02/03/04 at www.lga.gov.uk/lga/research/documents/bvpis.pdf

Munley, M.E. (1986) *Catalysts for Change: The Kellogg Projects in Museum Education*, Washington DC: The Kellogg Projects in Museum Education.

Museum Practice (1997) The benefits of effective interpretation, *Museum Practice*, issue 5 2 (2): 32–94, London: Museums Association.

Museum Practice (2000) *Update: Interpretation*, issue 13 5 (1): 48–81, London: Museums Association.

Museums Australia (2003) *Submission to the National Museum of Australia: Review of Exhibitions and Public Programs*, Sydney: Powerhouse Museum, accessed on 26/01/04 at www.nma.gov.au

Museums Australia Strategic Planning Manual (u/d) accessed on 17/05/04 at www.amol.org.au/downloads/craft/publications/handtxt.pdf

National Assembly of State Arts Agencies website – Cultural Tourism, accessed on 22/02/04 at http://nasaa-arts.org/artworks/ct_contents.shtml

Newman, A. (2001) Social Exclusion Zone, *Museums Journal* September: 34–6.

Newman, A. (2004) Understanding the social impact of museums, galleries and heritage through the concept of capital, in Corsane, G. (ed.) *Issues in Heritage, Museums and Galleries: An Introductory Reader*, London: Routledge.

Newman, A. and Mclean, F. (2004) Presumption, policy and practice: the use of museums and galleries as agents of social inclusion in Great Britain, *International Journal of Cultural Policy* 10 (2): 167–81.

Newman, A. and Mclean, F. (2000) Museums as agents of social inclusion, in Museum Professionals Group, *Transactions* 32: 3–8.

Newman, A. and Mclean, F. (eds) (2004) Special issue on heritage and social exclusion, *International Journal of Heritage Studies* 10 (1).

Newman, A., Mclean, F. and Urquhart, G. (2005) Museums and the active citizen: tackling the problems of social exclusion (in press), *Citizenship Studies* 2005.

Newsom, B.Y. and Silver, A.Z. (eds) (1978) *The Art Museum as Educator*, Berkeley: University of California Press.

Northern Ireland Museums Council (2003) *Mapping Trends in Northern Ireland Museums*, Belfast:

NIMC, accessed on 05/06/04 at www.nimc.co.uk/trends.pdf

Northumbria University School of Information Studies (2002) *Neighbourhood Renewal and Social Inclusion: The Role of Museums, Archives and Libraries*, London: Museums, Libraries and Archives Council (available on the MLA website www.mla.gov.uk)

O'Connell, P.S. (1992) Decentralizing interpretation: developing museum education materials with and for schools, in *Patterns in Practice: Selections from the Journal of Museum Education*, Washington DC: Museum Education Roundtable, pp. 251–61.

OECD (1996) *Lifelong Learning for All*, meeting of the Educational Committee at Ministerial Level, 16/17 January 1996, Paris: Organisation for Economic Co-operation and Development.

Office for National Statistics (2000) *Social Trends 30*, year 2000 edition.

Oltman, M. (2000) Creating exhibits for the very young, in National Association for Interpretation, *Legacy* 11 (6) November/December: 14–19.

Parasuraman, A., Zeithaml, V.A. and Berry, L. (1991) Refinement and reassessment of the Servqual scale, *Journal of Retailing* 67 (4): 420–49.

Paris, S. (ed.) (1997) Understanding the visitor experience: theory and practice, part 1, *Journal of Museum Education*, 22 (2/3).

Paris, S. (ed.) (2002) *Perspectives on Object-Centered Learning in Museums*, Mahwah, NJ: Lawrence Erlbaum Associates.

Patmore J.A. (1983) *Recreation and Resources: Leisure Patterns and Leisure Places*, Oxford: Blackwell.

Phillips, W. (u/d) *What Visitors Value*, accessed on 27/02/04 at www.qm2.org/mbriefs/70.html

Piersenné, A. (1999) *Explaining Our World*, London: E. and F.N. Spon.

Pine, B.J. and Gilmore, J.H. (1999) *The Experience Economy*, Boston MA: Harvard Business School.

Piscitelli, B. and Anderson, D. (2000) Young children's learning in museum settings, *Visitor Studies Today* 3 (3): 3–10, accessed on 24/02/04 at http://eab.ed.qut.edu.au/activities/projects/museum/

Piscitelli, B. and Anderson, D. (2001) Young children's perspectives of museum settings and experiences, *Museum Management and Curatorship* 19 (3): 269–82, accessed on 24/02/04 at http://eab.ed.qut.edu.au/activities/projects/museum/

Playforth, S. (2003) *Meeting Disabled People*, London: Museums, Libraries and Archives Council (available on the MLA website www.mla.gov.uk) as part of the *Disability Portfolio*.

PLB Consulting (2001) *Developing New Audiences for the Heritage*, London: Heritage Lottery Fund, accessed on 23/02/03 at www.hlf.org.uk

Prentice, R. (1998) Recollections of museum visits: a case study of remembered cultural attraction visiting on the Isle of Man, *Museum Management and Curatorship* 17 (1): 41–64.

Prentice, R., Davies, A. and Beeho, A. (1997) Seeking generic motivations for visiting and not visiting museums and like cultural attractions, *Museum Management and Curatorship* 16 (1): 45–70.

Prentice, R.C. (1989) Pricing policy at heritage sites: how much should visitors pay?, ch. 7 in Herbert, D.T., Prentice, R.C. and Thomas, C.J. (eds) *Heritage Sites: Strategies for Marketing and Development*, Aldershot: Avebury, pp. 231–71.

Prentice, R.C. (1993) *Tourism and Heritage Attractions*, London: Routledge.

QUT Museums Collaborative (u/d) *Young Children's Interactive and Informal Learning in Museums: A Collaborative Research and Training Programme*, Queensland University of Technology (QUT) Museums Collaborative, Centre for Applied Studies in Early Childhood, accessed on 24/02/04 at http://eab.ed.qut.edu.au/activities/projects/museum/

Rabinovitch, V. (2003) Museums facing Trudeau's Challenge: the informal teaching of history, *Canadian Issues*, October 2003, accessed on 12/12/03 at www.civilisation.ca/academ/articles/rab1_01c.html

Ramberg, J.S., Rand, J. and Tomulonis, J. (2002) Mission, message and visitors: how exhibit philosophy has evolved at the Monterey Bay Aquarium, *Curator* 45 (4): 302–20.

Rand, J. (2001) Visitors' Bill of Rights, in Adams, R. (ed.) *Museum Visitor Services Manual*, pp. 13–14.

Regnier, V. (1997) Children's museums: exhibit issues, in Maher, M. (ed.) *Collective Vision: Starting and Sustaining a Children's Museum*, Washington DC: Association of Youth Museums.

Rennie, L.J. (1996) Visitor take-aways: what are the outcomes of visitors to museums and similar centres?, in *Toward 2000: Evaluation and Visitor Research in Museums*, Sydney: Powerhouse Museum.

Reussner, E. (2003) *Audience Research in the Australian Cultural Heritage Sector*, accessed on 20/12/03 at http://amol.org.au/evrsig/pdf/Audres-exsum.pdf

Reynolds, P. (1999) Design of the process and product interface, ch. 8 in Leask, A. and Yeoman, I. (eds) *Heritage Visitor Attractions: An Operation Management Perspective*, London: Cassell, pp. 110–26.

Richards, G. (ed.) (1996) *Cultural Tourism in Europe*, Wallingford: CABI Publishing.

Richards, G. (ed.) (2001) *Cultural Attractions in European Tourism*, Wallingford: CABI Publishing.

Rider, S. and Illingworth, S. (1997) *Museums and Young People*, London: Museums Association.

Roberts, L. (1997) *From Knowledge to Narrative: Educators and the Changing Museum*, Washington DC: Smithsonian Institution.

Rogers, A. (2002) Learning and adult education, ch. 1 in Harrison, R., Reeve, F., Hanson, A. and Clarke, J. (eds) *Supporting Lifelong Learning: vol. 1: Perspectives on Learning*, London: Routledge, pp. 8–24.

Rojek, C. (1995) *Decentring Leisure*, London: Sage.

Royal Ontario Museum (1976) *Communicating with the Museum Visitor: Guidelines for Planning*, Toronto: Royal Ontario Museum.

Rubenstein, R. and Loten, J. (1996) *Cultural Heritage Audience Studies: Sources and Resources*, Rubenstein and Associates for Heritage Policy and Research Division, Department of Canadian Heritage, accessed on 18/03/04 at www.pch.gc.ca/progs/arts/library/rubenste/index_e.cfm

Sachatello-Sawyer, B. and Fellenz, R. (2001) Listening to voices of experience: a national study of adult museum programs, *Journal of Museum Education* 26 (1): 16–21.

Sachatello-Sawyer, B., Fellenz, R.A., Burton, H., Gittings-Carlson, L., Mahony, J.L. and Woolbaugh, W. (2002) *Adult Museum Programs: Designing Meaningful Experiences*, Walnut Creek CA: Altamira Press.

Sandell, R. (ed.) (2002) *Museums, Society, Inequality*, London: Routledge.

Sandell, R. (2003) Social inclusion, the museum and the dynamics of sectoral change, *Museum and Society* 1 (1): 45–62.

Schauble, L., Leinhardt, G. and Martin, L. (1997) A

framework for organising a cumulative research agenda in informal learning contexts, in Paris, S. (ed.) Understanding the visitor experience: theory and practice, part 1, *Journal of Museum Education* 22 (2/3): 3–8.

Schwarzer, M. (1999) Schizophrenic agora: mission, market and the multi-tasking museum, *Museum News*, 78 (6) November/December: 40–7.

Scott, C. (2000) Positioning museums in the 21st century, ch. 3 in Lynch, R., Burton, C., Scott, C., Wilson, P. and Smith, P. (eds) *Leisure and Change: Implications for Change in the 21st Century*, Sydney: Powerhouse Museum and University of Technology, pp. 37–48.

Scottish Museums Council (2000) *Museums and Social Justice: How Museums and Galleries Can Work for Their Whole Communities*, Edinburgh: SMC.

Serrell, B. (1996) *Exhibit Labels: An Interpretive Approach*, Walnut Creek CA: Altamira.

Serrell, B. (1998) *Paying Attention: Visitors and Museum Exhibitions*, Washington DC: American Association of Museums.

Services to Industry Groups: Tourism (2003) *Edinburgh Visitor Survey, Summary Report 2001/2002*, Edinburgh: Edinburgh and Lothian Tourist Board.

Shanks, M. and Tilley, C. (1992) 2nd edition, Presenting the past: toward a redemptive aesthetic for the museum, ch. 4, in Shanks, M. and Tilley, C. (eds) *Re-constructing Archaeology: Theory and Practice*, London: Routledge, pp. 68–99.

Sharples, L., Yeoman, I. and Leask, A. (1999) Operations management, ch. 2 in Leask, A. and Yeoman, I. (eds) *Heritage Visitor Attractions: An Operation Management Perspective*, London: Cassell, pp. 22–38.

Silverman, L.H. (1995) Visitor meaning-making in museums for a new age, *Curator* 38 (3): 161–70.

Skinner, B.F. (1938) *The Behaviour of Organisms: An Experimental Analysis*, New York: Appleton-Century-Crofts.

Smithsonian (1996) *Museums for the New Millennium Conference*, Washington: Smithsonian Institution, accessed on 23/04/03 at: http://museumstudies.si.edu/millennium/proceed.htm

Smithsonian (2002) *Exhibition White Papers*, Washington DC: Smithsonian Institution, Office of Policy and Analysis.

Smithsonian (2002a) *The Making of Exhibitions: Purpose, Structure, Roles and Process*

Smithsonian (2002b) *Exhibitions and Their Audiences: Actual and Potential*

Smithsonian (2002c) *21st Century Role of National Museums: A Conversation in Progress*

Smithsonian (2002d) *Exhibition Standards*

Smithsonian (2002e) *Exhibition Development and Implementation: Five Case Studies*

Smithsonian (2002f) *The Costs and Funding of Exhibitions*

Smithsonian (2002g) *Exhibition Concept Models*

Smithsonian (2002h) *Marketing Exhibitions: Will They Come?*

Smithsonian (2002i) *Developing Interactive Exhibitions at the Smithsonian*

Smithsonian (2002j) *Three Studies of 'Explore the Universe'*

Smithsonian (2002k) *Capability Profiles of Exhibit Departments* all accessed at www.si.edu/OPANDA/rep_all.htm

Smithsonian (2004) *The Evaluation Of Museum Educational Programs: A National Perspective*, Washington: Smithsonian Institution, Office of Policy and Analysis, accessed on 24/04/04 at www.si.edu/OPANDA/Reports/Evaluationof MuseumEducationalPrograms.pdf

Stainton, C. (2002) Voices and images: making connections between identity and art, in Leinhardt, G., Crowley, K. and Knutson, K. (eds) *Learning Conversations in Museums*, New York: Lawrence Erlbaum Associates, pp. 213–57.

Stapf, B. (1999) Developing education strategies and support materials for children, in Moffatt, H. and Woollard, V. (eds) *Museum and Gallery Education*, London: The Stationery Office, pp. 43–55.

Stewart-Young, J. (2000) Building barriers in Walsall, *Museums Journal* June: 30.

Stone, D. (1993) The secondary art specialist and the art museum, *Studies in Art Education* 35 (1): 45–54.

Thomas, C.J. (1989) The role of historic sites and reasons for visiting, in Herbert, D.T., Prentice, R.C. and Thomas, C.J. (eds) *Heritage Sites: Strategies for Marketing and Development*, Aldershot: Avebury, pp. 62–93.

Thompson, D., Bitgood, S., Benefeld, A., Shettel, H. and Williams, R. (1993) (eds) *Visitor Studies:*

Theory, Research and Practice 5, Jacksonville, FL: Visitor Studies Association.

TIA (2003) *The Historic/Cultural Traveler 2003 Edition*, Washington DC: Travel Industry Association of America/Smithsonian Magazine.

Tilden, F. (1977), 3rd edition, *Interpreting our Heritage*, Chapel Hill, NC: University of North Carolina Press.

Tonkin, S. (2001) So what do people think of their birthday present? Early visitor survey results from the National Museum of Australia, Museums Australia Conference 2001, accessed on 2/03/04 at www.museumsaustralia.org.au/conference 2001/papers/tonkin_susan.pdf

Tunnicliffe, S.D. (1995) Talking about animals: studies of young children visiting zoos, a museum and a farm, unpublished doctoral dissertation, Kings College, London.

Underhill, P. (1999) *Why We Buy: The Science of Shopping*, London: Orion Business.

Utley, A. (2003) Influential teaching technique rubbished, *Times Higher Education Supplement* 28 November 2003.

Varine, H. de (1993) *Tomorrow's Community Museums*, lecture in the Senate Hall, University of Utrecht, 15 October 1993, accessed on 23/02/04 at www.hdg.de/Final/deu/page508.htm

Veverka, J. (u/d) *Using Interpretive Themes and Objectives Will Make Your Program Planning Easier and More Effective*, accessed on 14/01/03 at www.heritageinterp.com

Veverka, J. (1994) *Interpretive Master Planning*, Helena, MT: Falcon Press.

Victoria and Albert Museum (u/d) *Visitor Research: Developing the Gallery Experience: British Galleries Baseline Study; British Galleries Formative Studies; British Galleries Prototyping: AV, Low Tech Interactives, Text; British Galleries Prototyping: Computer Interactives; British Galleries Summative Evaluation;* accessed on 16/11/04 at www.vam.ac.uk/res_cons/research/visitor/index.html

Victoria and Albert Museum (2002) *Interactive Learning in Museums of Art*, accessed on 16/11/04 at www.vam.ac.uk/res_cons/research/learning/index.html

Walsh-Piper, K. (1989) Teachers and resource centers, in Berry, N. and Mayer, S. (eds) *Museum Education: History, Theory and Practice*, Reston: National Art Education Association, pp. 194–203.

Waterfield, G. (ed.) (2004) *Opening Doors; Learning in the Historic Environment*, Attingham Trust, accessed at www.attinghamtrust.org

Watson, L. (1999) *Lifelong Learning in Australia: Analysis and Prospects, Discussion Paper No. 1*, Canberra: University of Canberra.

Webb, R.C. (2000) The nature, role and measurement of affect, *Journal of Interpretation Research* 5 (2): 15–30.

Weil, S.E. (1994) Creampuffs and hardball: are you really worth what you cost?, *Museum News* September/October, 73 (5): 42–4, 62.

Weil, S.E. (1999) From being about something to being for somebody: the ongoing transformation of the American Museum, *Daedalus* 123 (3): 229–58.

Weil, S.E. (2002) *Making Museums Matter*, Washington DC: Smithsonian Institution Press.

Weil, S.E. (2003) Beyond big and awesome: outcome-based evaluation, *Museum News* November/December 2003: 40–53.

Wellington, J. (1990) Formal and informal learning in science: the role of interactive science centres, in *Physics Education* 25: 247–52.

Wong, J.L. (2002) Who we are, *Interpretation Journal* 7 (2): 4–7.

Woroncow, B. (2001) Heritage for all: ethnic minority attitudes to museums and heritage sites, paper presented to the ICOM Triennial Conference, Barcelona, July 2001, accessed on 22/01/04 at http://icom.museum/icme

Zeithaml, V.A., Parasuraman, A. and Berry, L.L. (1990) *Delivering Quality Service: Balancing Customer Perceptions and Expectations*, New York: Macmillan.

Index

Page numbers in *italics* indicate illustrations.